ART FUNDAMENTALS

Theory and Practice

Sixth Edition

ART FUNDAMENTALS

Theory and Practice

Otto G. | Robert E. | Philip R. | Robert O.
Ocvirk | Stinson | Wigg | Bone

School of Art/Bowling Green State University

 WCB Wm. C. Brown Publishers

Book Team

Editor *Meredith M. Morgan*
Developmental Editor *Raphael Kadushin*
Designer *Carol S. Joslin*
Art Editor *Donna Slade*
Production Editor *Kennie Harris*
Photo Editor *Carol M. Smith*
Permissions Editor *Carrie Husemann*
Visuals Processor *Joseph P. O'Connell*

 Wm. C. Brown Publishers

President *G. Franklin Lewis*
Vice President, Editor-in-Chief *George Wm. Bergquist*
Vice President, Director of Production *Beverly Kolz*
Vice President, National Sales Manager *Bob McLaughlin*
Director of Marketing *Thomas E. Doran*
Marketing Communications Manager *Edward Bartell*
Marketing Manager *Kathleen Nietzke*
Manager of Visuals and Design *Faye M. Schilling*
Production Editorial Manager *Colleen A. Yonda*
Production Editorial Manager *Julie A. Kennedy*
Publishing Services Manager *Karen J. Slaght*

CONTENTS

FIGURES

PREFACE

Although we, the authors, know of no publication magic associated with the number six, we feel that with this sixth edition of our book, the time is somehow ripe for a summary review of its contents and their evolution. As of this writing *Art Fundamentals* has been published for twenty-seven years. These have been eventful years for the world, and many of the events and their influence have been reflected in its art. We have tried to make the book reveal this changing art world. Of the numerous art styles that have emerged in that time, many are, from a contemporary perspective, indeterminate in their lasting value. Recent styles tend to rise and fall meteorically. At the same time, some that had long since fallen into disfavor have been revived. In the current art scene we can find many works with obvious roots in the past, while others seem to deliberately eschew tradition. We hope that the art values of both past and present are represented in this book.

Art Fundamentals had a very practical origin, and we try to preserve its practicality. The book was originally a series of lecture notes evolving from the classroom experiences and needs of the authors and their students. When publishing seemed a possibility, the notes were fleshed out and have been augmented to some degree with each successive edition. The book was intended as, and should continue to be, a users' book. It has been primarily a college text, although it has also been used successfully by high schools, art groups, and individuals.

Formal, or "compositional," factors have always been a significant component of *Art Fundamentals*. This consideration is not of penultimate importance to all artists. Times change and artists vary; some artists rebel against compositional strictures. Still, whenever an artist adds something or removes something from an artwork, there are effective and less effective ways of doing so. In addition, as the work grows, an increasing number of decisions must be made as to the right relationships to be established between its parts. These decisions affect the expression and unity of the work. Emerging artists need some direction in making such decisions.

Art relationships are best understood, we think, through dissecting and analyzing the constituent parts as assembled by the artist. When a work is "picked apart," it loses none of its meaning; on the contrary, we gain greater appreciation for the skill and insight of its creator. The organizational soundness of an artwork is apparent to almost anyone. The glue that holds it together derives from the artist's empathic response to the inherent qualities of, and interplay between, the artistic elements in use. This sensitivity is natural for some people, but needs development in others. We feel that it is most effectively encouraged through the early study of the capacities of the individual art elements—how can an element function in a two-dimensional or three-dimensional environment, and what is it capable of expressing when joined by its fellow elements? Our book postulates

that these questions are best answered by experience with the art elements, singly and in combination. This is, in large measure, the reason for the general arrangement of the book.

Early readers will remember that the first edition of *Art Fundamentals* required the user to paste in color reproductions contained in a pouch at the back of the book. Primitive, yes, but some people liked the feature because it enforced greater familiarity with the works! Nevertheless, with greater publishing expertise, this exercise in manual dexterity was soon rendered unnecessary. Now we have color reproductions of far greater size and accuracy. Our selection of illustrations, whether black-and-white or color, attempts to achieve a survey of art styles. Each work should clearly illustrate the point(s) made in the text. Sometimes additional support is provided by diagrams.

In this edition, for the first time, we have solved a problem that has nagged at the authors and readers alike. Heretofore, color works have been segregated in "signatures" that divorced them from their textual references. Now we have succeeded in juxtaposing most of these on the same, or adjoining page, greatly reducing the page turning that was previously necessary. We feel this is a great advance in achieving continuity.

Another change in this edition is in the accompanying instructor's manual, an item that seems to have gained favor among textbook users. Such a manual

could easily become an inflexible imposition of views and techniques. This might be acceptable for a scientific text, but not for one dealing with art, a subject hardly compatible with the scientific method. In this "trial balloon" manual, we have tried to reduce the content to a convenient and general overview of the book in its entirety. This synopsis is, however, interspersed with brief examples, explanations, and recommendations where necessary.

The vocabulary terms and the glossary have been with the book since the beginning. Discussions of art obviously mandate the use of terminology. There is not always agreement on the exact meaning of art terms, but we feel that as long as general understanding of a term and its application to the case in point is established, there need be no quibbling over universal approval. The key terms precede the chapters; if they are understood in advance, the reading of the chapter will be much more meaningful.

In our review of art styles in chapter 10, we have limited ourselves to the nineteenth and twentieth centuries—the twentieth for obvious reasons and the

nineteenth because it fueled so many of our present-day ideas. This concentration implies no lack of appreciation for previous periods of art, as the chronological outline at the end of the book will verify. The reader is encouraged to dig more deeply into the history of art, not only for knowledge and enjoyment, but because earlier art continues to afford a wealth of suggestions for the artist.

The projects that concluded the chapters in previous editions have been curtailed and are now used only as examples in the instructor's manual. Although some of our readers were grateful for the projects provided, most have opted to develop their own illustrative and exploratory activities. We, of course, support any of these that serve to enlighten. We also solicit your reactions to this slight shift in policy.

In the early editions of *Art Fundamentals,* the content and arrangement evolved rather quickly. Over the years we have made modifications that we think have been improvements. Our views have met with gratifying acceptance. We have, however, waged a constant struggle to clarify these views. This has meant

constant rewriting to make things more comprehensible to our students and to others who read us. The bulk of our audience has consisted of college students, and our writing has sought to put ideas within the grasp of that group. We have been accused variously of oversimplification and overcomplication— perhaps more often the latter. A textbook on art has the potential to make the subject seem highly academic. We want to avoid that implication. The creation of art should be exhilarating, even though alloyed by unavoidable periods of frustration and struggle. The creative process is something like work on a jigsaw puzzle, though certainly not as mechanical; in piecing together an artwork or a puzzle, the problem is to make the pieces fit! In art we must produce our own pieces to carry our message instead of using pieces that have been dealt us to repeat what has already been said. We hope that this book will help you find effective pieces for your puzzles.

ACKNOWLEDGMENTS

The traditional banquet speaker—probably familiar to us all—usually says, "We would like to acknowledge all of you tonight, but your numbers are too great." Such words, though greatly overused, are nevertheless our last refuge. As with our other editions, we have received support from many sources. Everyone who helped is special, but as usual, some are "more" special. Our thanks go to all, especially the book team at Wm. C. Brown Publishers, who gave the necessary nudges at critical times, and our reviewers, who helped smooth out the rough edges.

Reviewers

Jeff R. Bowman, University of Southern Mississippi

John Dinsmore, Kearney State College

David L. Faber, Wake Forest University

Betty Harris, Pima Community College

David Hollowell, University of California–Davis

William A. Marriott, University of Georgia

Raymond E. McNamara, West Virginia State College

Jack W. Plummer, University of Texas–Arlington

Robert G. Ward, Northeast Louisiana University

ART FUNDAMENTALS

Theory and Practice

1
INTRODUCTION

The Vocabulary of Art

abstract, abstraction
A term given to visual effects that derive their appearance from natural objects but have been simplified and/or rearranged to satisfy an artist's need for artistic organization or expression. *Abstraction* is a process of varying degrees; sometimes any resemblance to the original natural object is difficult to detect.

academic
A term applied to any kind of art that stresses the use of accepted rules for technique and form organization. It represents the exact opposite of the *creative* approach, which results in a vital, individual style of expression.

aesthetic, aesthetics
A term used in regard to the quality or sensation of pleasure, enjoyment, disturbance, or meaning that people can experience in viewing works of art. *Aesthetics* is a study of these emotions, involving the psychology, sociology, and philosophy of art. The philosophy of art analyzes the quality we call *beauty* and its locus.

content
The essential meaning, significance, or aesthetic value of an art form. Content refers to the sensory, psychological, or emotional properties we feel in a work of art, as opposed to our perception of its descriptive aspects alone.

craftsmanship
Aptitude, skill, or manual dexterity in the use of tools and materials.

design
A framework or scheme of pictorial construction on which artists base the formal organization of their total work. In a broader sense, design may be considered synonymous with *form*.

The term is also sometimes used to designate commercial art made to sell products, especially in the fields of advertising and illustration.

form
The arbitrary, inventive arrangement of all the visual elements according to principles that will develop *organic unity* in the total work of art.

form-meaning
The third component of a work of art, also called *content*. The expression or meaning the observer finds or experiences in the elements of form as well as in finished works of art.

medium, media
The material(s) and tool(s) used by the artist to create the visual elements perceived by the viewer.

naturalism
The approach to art in which all forms used by the artist are essentially descriptive representations of things visually experienced. True naturalism contains no interpretation introduced by the artist. The complete recording of the visual effects of nature is a physical impossibility, thus naturalistic style becomes a matter of degree.

nonobjective
A type of art that is entirely imaginative and not derived from anything visually perceived by the artist. The shapes, their organization, and their treatment by the artist are entirely personalized and, consequently, not associated by the observer with any previously experienced natural objects.

optical perception
A way of seeing, in which the mind has no other function than the natural one of providing the visual sensation of object recognition. *Conceptual perception*, on the other hand, refers to the artist's imagination and creative vision.

organic unity
A condition in a work of art in which all of its parts are so vital and interdependent that the artwork seems to take on a life of its own.

realism
A form of expression that retains the basic impression of visual reality but, in addition, attempts to relate and interpret the universal meanings that lie beneath surface appearances.

representation
A manner of expression by an artist in which the subject matter is presented through the visual elements so that the observer is reminded of actual objects.

style
The specific artistic character and dominant form trends that characterize a particular art movement or period of history. Style may also refer to artists' expressive use of media to give their works individual character.

subject
In a descriptive style of art, subject refers to the persons or things represented, as well as to the artist's experience, all of which serve as inspiration. In abstract or nonobjective forms of art, subject refers merely to the basic character of all the visual signs employed by the artist. In this case, the subject has little to do with anything experienced in the natural environment.

technique
The manner and skill with which artists employ their tools and materials to achieve a predetermined expressive effect. The ways of using media can affect the aesthetic quality of an artist's total concept.

The need and search for art

A study of the past proves that human beings have always had a need for art. From cave paintings to avant-garde works of the twentieth century, a great variety of styles have emerged. Many definitions and interpretations have been given to these styles, but regardless of the time or place of its creation, art has always been produced because an artist wanted to say something and chose a particular way of saying it. Over the years, artists have been variously praised, neglected, misunderstood, and criticized. The amount of art being created today is unrivalled by the past. In an attempt to give some insight into the subject, many books have been written. Some are intended for casual, enjoyable viewing, some for the general artistic enlightenment of the layman, some for passive end table display, and some for an introduction to the practice of art. Apparently many people want to be actively engaged in art but find that much of what they see is not meaningful to them; this probably adds to the inhibitions of our potential creators. Some of the inability to understand much of the art being created may be due to the enormous diversity of our world. Sophisticated printing and distribution techniques have made most of the art of the past and present available to us. In addition, television, radio, and air travel have contributed to a great cultural mixing. This is a far cry from the insularity of the periods before our century; in those days, people often had a better understanding and greater acceptance of what they saw because they saw so little.

In order to gain some appreciation for the many forms of art with which we are besieged today, one must understand the basics of art from which those forms have grown. This book seeks to provide that understanding through illustrated writings. Any explanation requires a rationale—a method for providing information. In this book the method is a general dissection of the nature and functions of the many factors involved in producing artworks. This is accompanied by an introduction to the principles that normally govern those factors. The authors have tried to avoid the pitfalls of stylistic favoritism in presenting a system for art structuring and self-evaluation. Structuring seems a bit cold when applied to a creative field, but structure is a necessity in all the artistic areas, including music, dance, and literature. Without structure, the expression could not come through and the work would be uninteresting.

The ingredients of art

Each art field has guiding disciplines for its structure. These disciplines can be applied and interpreted in various ways. In this book certain patterns and procedures of study have been chosen that are within the discipline of the visual arts. We feel that they can instruct in both the viewing and the creation of artworks. In this pattern the preliminary emphasis is on the components—subject matter, form, and content. This is followed by a review of the principles—harmony, variety, balance, movement, proportion, dominance, and economy. Following that, we look into the raw materials that are organized by the principles—the elements of line, shape, value, texture, and color. In theory and practice, the elements and principles cannot be totally divorced from each other; they must be considered collectively as they work together to produce the work of art. There is rarely any argument about the principles and elements of art, but there have been many ways of ordering and presenting them. Our methods, like any others, ultimately depend on the worker's capacity for study, practice, and self-evaluation.

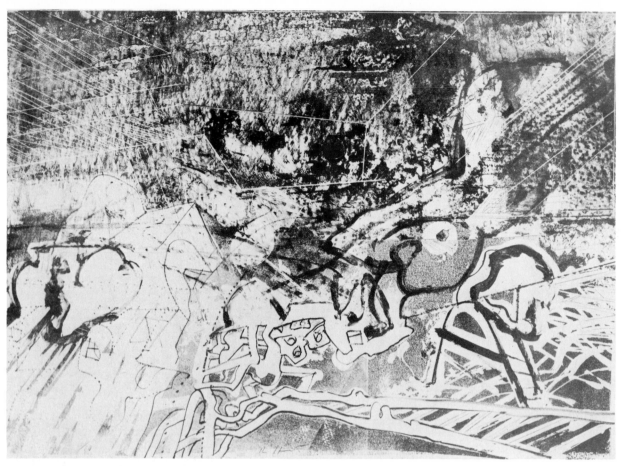

1.1
Richard Hunt. *Untitled.* 1978, print (lithograph), 15 × 22¼ in. Without the benefit of obvious subject, Richard Hunt has expressed an excitement with organic shape, line, and spatial relationships. He does not limit himself to superficial appearances but tries to reveal that which lies deeper.
Collection Otto Ocvirk.

Subject

A subject is a person, a thing, or an idea. The person or thing is, as expected, pretty clear to the average person, but the idea may not be. In abstract or semiabstract works, the subject may be somewhat perceivable, but in nonobjective works, the subject is the idea behind the form of the work, and it communicates only with those who can read the language of form (fig. 1.1). Whether recognized or not, the subject is important only to the degree that the artist is motivated by it. Thus, subject is just a starting point; the way it is presented or formed to give it expression is the important consideration.

Music, like any area of art, deals with subjects and makes an interesting comparison with the visual arts. In the latter, the subject is frequently the particular thing(s) viewed and reproduced by the artist. But at other times art parallels music in presenting a "nonrecognizable" subject; the subject is, of course, an idea rather than a thing. Music sometimes creates recognizable sounds—thunderstorms and bird songs in Beethoven's *Pastoral Symphony* or taxi horns in Gershwin's *An American in Paris*. Although rather abstractly treated, these may be the musical equivalents of recognizable subjects in artworks. By contrast, Beethoven's Fifth Symphony or Gershwin's Concerto in F are strictly collections of musical ideas. In the dance medium, choreography often has no specific subject, but dancing to the ballet *Rodeo* is, to a degree, subject-oriented. All of the arts have subjects that obviously should not be judged alone, but by what is done with them (fig. 1.2).

Form

The term *form* is used and misused in various ways when referring to art objects. Speaking of a piece of sculpture, one may refer to the individual forms that together make up the piece; or one may speak of the sculpture's form, meaning its total appearance (fig. 1.3). As used in this book, form means the latter: the totality

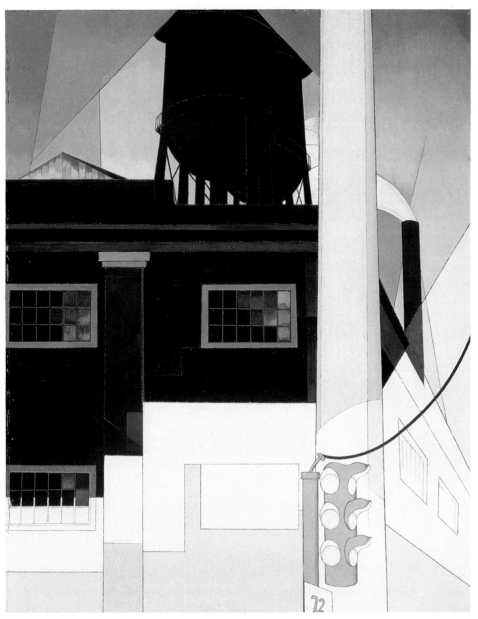

1.2
Charles Demuth. . . . And the Home of the Brave. 1931, oil on composition board, 76.2 × 70 cm. The subject, man-made structures, is clear enough; however, a work should not be judged by its subject alone, but by what is done with that subject.

Miss Georgia O'Keeffe Gift, 1948.650. © 1988 The Art Institute of Chicago. All Rights Reserved.

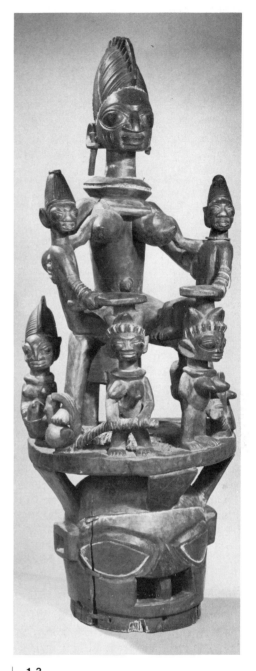

1.3
Areogun, African, Nigeria, Yoruba Tribe, Village of Osi, 1880–1954, EPA Society Mask. About 1900–1910, wood with polychrome painted decoration, 49½ in. high. To illustrate the different meanings of the term form, we can say that the forms in this piece of sculpture are its parts, largely figures—or that the form of the work consists of the total assembly of those parts.

The Toledo Museum of Art, Toledo, Ohio. Gift of Edward Drummond Libbey.

of the physical artwork. It involves all the visual devices available to the artist in the material of his or her choice. Using these devices, artists must make their arrangement and manipulation most effective for what is being expressed. Some artists arrange more intuitively than others, some more logically; but with experience, all of them develop an instinctive feeling for organization.

Form (including the principles of order) is so important to the creation and understanding of art that it is given a special, detailed chapter in this book. The principles of formal order are flexible, with no dogmatic rules; every work is different and has its own unique problems. Nevertheless, only through observance of the principles can a work be given a meaningful construction.

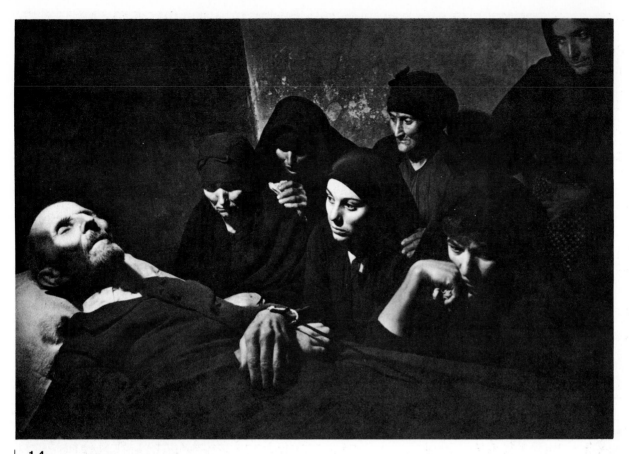

1.4

W. Eugene Smith. *Spanish Wake.* 1951, photograph. The emotional factor in the content of this photograph is quite evident (and with this particular subject would probably always be so), but the artist-photographer has enhanced the content by his handling of the situation.

W. Eugene Smith, © Black Star 1951.

Content

The emotional and intellectual message of an artwork is its *content* (fig. 1.4), an overall statement, expression, or mood read into the work by the observer. Content has form-meaning that arises from the application of the principles to the imagery of the elements. To many people, content is familiar association—that is, the feelings aroused by the work relative to the things being portrayed. This is obviously a limited concept, available only to those who have had experiences with those things. A much more comprehensive content occurs when the content is a product of the form-meanings utilized by the artist. This content can be found in realistic works as well as in those that are *abstract* or *nonobjective*.

Although all visual artworks require some degree of abstraction, some of them are more difficult to understand and appreciate. (Correction: The "appreciation" is sometimes revulsion and confusion!) Artists generally abstract in order to simplify, emphasize, and clarify through organization, but none of these goals are achieved if the observer's mind-set expects literal copying. When there is no resemblance to anything in the viewer's experience, the content may be totally missed. Actually, the objective (yes, there is one!) of nonobjective art is the content, as in all art. Nonobjective simply means that things are not presented objectively or realistically. They are, instead, wholly subjective. The understanding of form-meanings is an absolute necessity if one is to catch this kind of message.

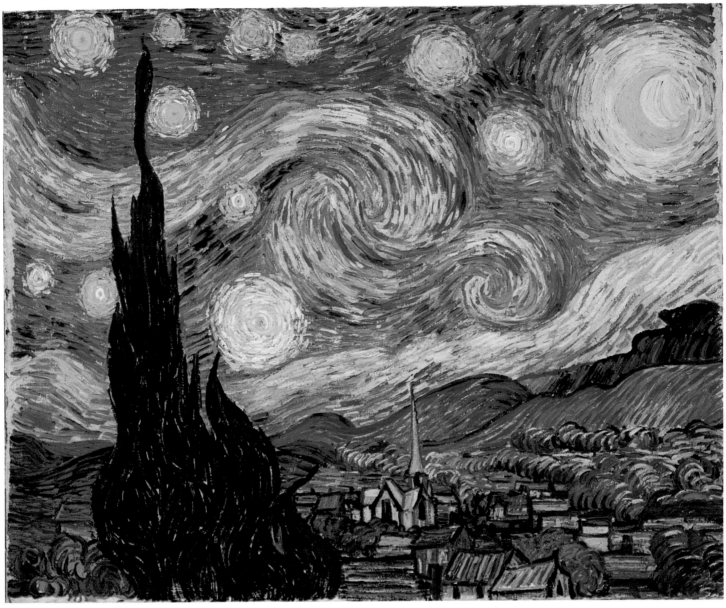

1.5

Vincent van Gogh. *The Starry Night*.
1889, oil on canvas, 29 × 36¼ in.
Landscape viewing can be a common
experience, but few if any of us see
landscapes with the perception and
intensity of Van Gogh.

Collection, The Museum of Modern Art, New
York. Acquired through the Lillie P. Bliss
Bequest.

Many times people expect visual art to
be recognizable, representing familiar
things such as houses, flowers, trees,
buildings, etc. Such objects are seen daily
solely through the eyes. Thus, when the
artist reproduces them faithfully, we see
what we think of as the real world. But in
art, the "real" goes beyond optics; reality
in art does sometimes include things we
see, but, more importantly, it includes our
responses to them. Artists are not much
interested in commonplace reality; they
are more concerned with unreality—or,
perhaps, hyper-reality (fig. 1.5). This
effect is sought in various ways in all the
arts, attempting to draw us out of our
standard existence into another, more
meaningful state of mind. Artists are
aided in this by familiar devices that have
come to be associated with the arts, such
as frames, stages, exaggerated costumes
and gestures, cosmetics, concert halls, and
galleries. All of these emphasize the idea
that in seeing and hearing the arts we are
not in our everyday world. All art, not
being real, is illusionary, and in
strengthening illusion, it also tries to
enlarge our feelings and perception.

1.6
Christo (Christo Javacheff). *Running Fence, Project for Sonoma and Marin Counties, California.* 1976, height 18 ft., length 24½ mi. There is no need to be embarrassed about feeling confused or defiant when viewing an artwork that seems "far-out"—only a need for continued exposure, thought, and study. Here Christo uses unique setting, media, and form to set up his unusual, thought-provoking statement.
© Christo 1976. Photo: Jeanne-Claude Christo.

Savoring the ingredients

When, in being subjective, the artist reaches below surface appearances and uses unfamiliar ways to find unexpected truths, the results can often be distressing for many of us. Such distress frequently follows changes in art styles. The artist is sometimes accused of being incompetent or a charlatan. Much of what we value in art today was once fought tooth and nail. General acceptance of the new comes about only when enough time has passed for it to be reevaluated. At this point, the new begins to lose its abrasiveness. Thus there is no need for embarrassment at feeling confused or defiant about an artwork that seems "far-out," but instead a need for continued exposure, thought, and study (fig. 1.6). We all have the capacity to appreciate the beautiful or the expressive. This capacity is illustrated by the taste we exercise in our personal lives. But we do need to enlarge our sensitivity and taste, making them more inclusive.

One way to extend our responses to art is by attempting to see the uniqueness in things. Gertrude Stein once said, "A rose is a rose is a rose." If we interpret this literally rather than poetically, we realize that every rose has a different character, even with identical breeding and grooming. Every object has its own uniqueness, be it a chair, a tree, or a person. One characteristic that sets the artist apart is the ability to see (and experience!) the subtle differences in things. By exposing those differences, the artist can make the ordinary seem distinctive, the humdrum exciting.

Another way to enlarge our visual arts sensitivity is by ridding ourselves of the expectation that all forms of art should follow the same rules. Photography might serve as an example. We know that many people judge a work of art by how closely it can be made to look like something. It is true that skillful artists create amazing resemblances, but the camera can win this game! The artist fights a losing battle with the camera if he or she plays by photography's rules. Artists are often proud of their ability to reproduce appearances, but most artists regard this skill as the lesser part of their ability. If making look-alikes is the key to art, it is strange that the best photographers are not content to simply point and shoot; instead, they look for the best view, blur focus, use filters, alter lighting, and make adjustments in developing (fig. 1.7). Photographers become artists when they are not satisfied with obvious appearances. So, too, do plastic and graphic artists.

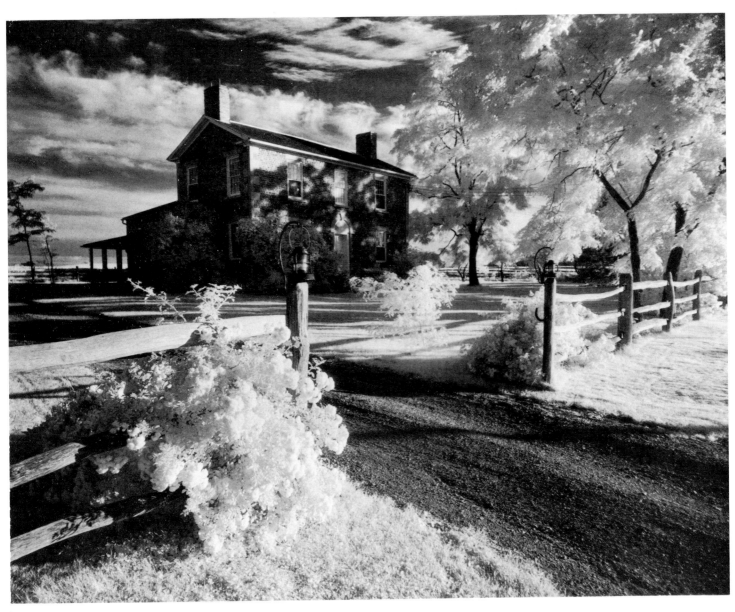

1.7
Minor White. *Cobblestone House, Avon, New York.* 1958, gelatin silver print.
Photographers may have the edge on other visual artists when it comes to recording
objective reality, but photographer-*artists* are not satisfied with obvious appearances and
use technical strategies to achieve their goals.

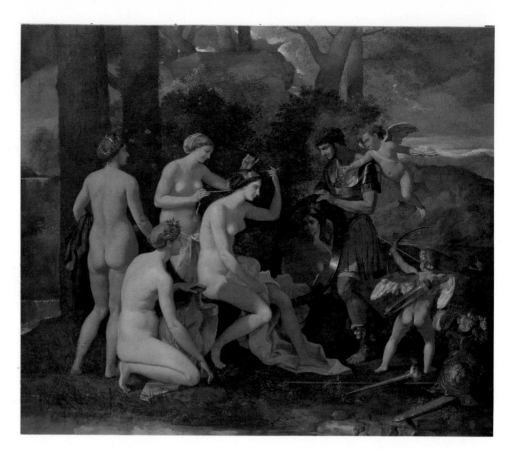

1.8

Nicolas Poussin. *Mars and Venus.* Circa 1633–34, oil on canvas, 62 × 74¾ in. Poussin has painted a legendary picture-story that could have been a factual statement, but a study of the work's design reveals that he was influenced by formal considerations.

The Toledo Museum of Art, Toledo, Ohio. Gift of Edward Drummond Libbey.

People also tend to associate visual art with literature, hoping it will tell a story in a descriptive manner. Many fine works have contained storytelling elements, but artists have no need or obligation to narrate. "Picture-stories" are only at their best when influenced by form considerations (fig. 1.8). The visual arts and literature do share certain elements. For the author, facts are nouns; for the visual artist, representational subjects are nouns. Nouns (facts) are informative, but provide nothing poetic for the author; there is always a need for verbs to establish action, moods, and meanings.

Similarly the visual artist's "subject-nouns" rarely inspire except, occasionally, by association. For the visual artist, the "verbs" are the combined effect of the elements and their principles; by manipulating these, a poetic effect very like that found in literature can be achieved.

In adapting to the rules peculiar to art, one must also place one's own taste on trial. This means accepting the possibility that what is unfamiliar or disliked may not necessarily be badly executed or devoid of meaning. Of course, one should not automatically accept what one is expected to like; instead, open-mindedness is required. Even artists and critics rarely agree unanimously about artists or their works. Fortunately, the authors of this book are generally of the same mind regarding art, but there are some disagreements! Even with training,

people's tastes, like flowers, do not turn out to be identical. The quality of art is always arguable and regrettably (?) unprovable. Perhaps the most reliable proof of quality comes only with time and the eventual consensus of sensitive people.

Aside from satisfaction, one of the dividends gained by a better understanding of the visual arts is that it puts us in touch with some remarkably sensitive and perceptive people. We always benefit from contact, however indirect, with the creations of world-class personalities. Einstein's perception exposed relationships that have reshaped our view of the universe. Mozart responded to sounds that, in an abstract way, summed up the experiences and feelings of the human race. Though not always of this same magnitude, artists too expand our frames of reference, revealing new ways of seeing and responding to our surroundings. When we view artworks knowledgeably, we are on the same wavelength with the artist's finely tuned emotions.

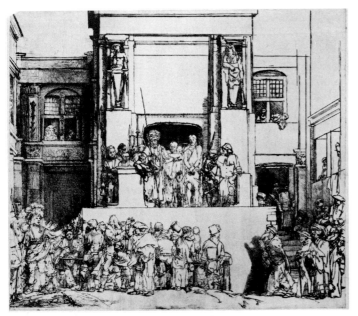
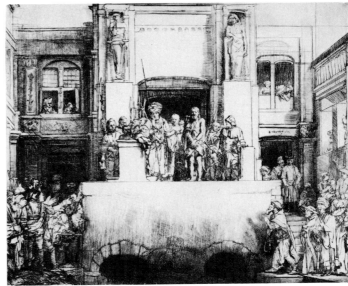

1.9 and 1.10
Rembrandt Harmensz van Ryn. *Christ Presented to the People.* **1606–09, print (etching).** Rembrandt searched for the most interesting and communicative presentation of his idea. In doing so, he made dramatic deletions and changes, which in this case involved scraping out a portion of the copper plate. Figure 1.9 is the first state of the work, and figure 1.10 is the last state.
Metropolitan Museum of Art, New York. Gift of Felix M. Warburg and his family, 1941.

The ingredients assembled

In this chapter we have mentioned some of the means by which an artist's emotions are made to surface. You have been introduced to the components, elements, and principles involved in making visual art. You have been given an idea of how all these factors enter into the expression of the artist's feelings. You have also been given some counsel on the attitudes to develop in order to share those feelings with the artist. Now, let us consider how these matters fit sequentially in developing a hypothetical work of art.

An artist must begin with an idea, or germ, that will eventually develop into the concept of the finished artwork. The idea may be the result of aimless doodling, a thought that has suddenly struck the artist, or a notion that has been growing in his or her mind for a long time. If this idea is to become tangible, it must be developed in a medium selected by the artist (clay, oil paint, watercolor, etc.).

The artist not only controls, but is controlled by, the medium. Through the medium, the elements of form emerge, with their intrinsic form-meanings (more on this in later chapters). These meanings may be allied with a nonobjective or, in different degrees, objective image; in either case, the bulk of the meaning will lie in the form created by the elements.

While developing the artwork, the artist will be concerned with composition, or formal structure, as he or she explores the most interesting and communicative way to present the idea (figs. 1.9 and 1.10). While so concerned, abstraction will inevitably occur—elements will be simplified, changed, added, eliminated, or generally edited. The abstraction happens with an awareness, and within the parameters, of the principles.

As the creative procedure unfolds (not always directly, neatly, and without stress or anguish!), the artist fervently hopes that the result will be *organic unity.* This is a new term, an all-inclusive one that implies the culmination of everything being sought in the work. Put simply, it means that every part not only fits, but that each one contributes to the overall content, or meaning. At this point, however arduous or circuitous the artist's route, the work is finished—or is it? Having given the best of themselves, artists are never sure of this! Perhaps the perspective of a few days, months, or even years will give the answer.

2
FORM

The Vocabulary of Form

approximate symmetry
The use of similar imagery on either side of a central axis. The visual relationships resemble each other but are varied to prevent visual monotony.

asymmetrical balance
A form of balance in which unlike ways and/or means are used to achieve a "felt" equilibrium.

balance
A feeling of equilibrium in weight, attention, or attraction that is achieved by using the various visual elements within an artwork to accomplish organic unity.

composition
The combination or structuring of form. Often used interchangeably with the term *design*.

dominance
The principle of visual organization that suggests that certain elements should assume more importance than others in the same design or composition. Some features are emphasized and others are subordinated.

elements of art
Line, shape, value, texture, and color. These are the basic visual signs that the artist uses, separately or in combination, to produce artistic imagery. Their use produces the visual language of art.

harmony
The related qualities of the visual elements of a composition. Harmony is achieved by repetition of characteristics that are the same or similar.

motif
A visual element, or combination of elements, that is repeated often enough in a composition to make it a significant feature of the artist's expression; a design that is repeated within a larger design. Motif is similar to theme or melody in a musical composition.

negative areas
The unoccupied or empty space left after the imagery has been created by the artist. However, when these areas have boundaries, they also function as design shapes in the total artistic structure.

pattern
The distinctive use of an element or group of elements (usually fairly closely knit) that, through repetition, becomes a featured part of a composition.

picture frame
The outermost limits or boundary of the picture plane.

picture plane
The actual flat surface on which the artist executes a pictorial image. In some cases the picture plane acts merely as a transparent plane of reference to establish the illusion of forms existing in a three-dimensional space.

positive areas
The art elements, or their combination, that produce the imagery in an artwork. Positive shapes may suggest recognizable objects, or they may merely be planned, nonrepresentational shapes.

repetition
The use of the same visual effect a number of times in the same composition. Repetition may produce the dominance of one visual idea, a feeling of harmonious relationship, an obviously planned pattern, or a rhythmic movement.

rhythm
A continuance, a flow, or a feeling of movement achieved by repetition of regulated visual units; the use of measured accents.

symmetrical balance
A form of balance achieved by using identical units placed in mirrorlike repetition on either side of a central axis.

unity
The total effect of a work of art that results from the interrelationships of all its component parts, with the appropriate ratio between harmony and variety giving a sense of oneness.

variety
The use of opposing, contrasting, changing, elaborating, or diversifying elements in a composition to add individualism and interest; the counterweight of *harmony* in a work of art.

Preliminary considerations in form organization

A completed work of art has three components—subject matter, form, and content. These components change only in the emphasis put on them. Their interdependence is so great that none should be neglected or given excessive attention. The whole work of art should be more important than any one of its components. In this chapter we study the component *form* in order to investigate the theories and the structural principles of visual order (fig. 2.1).

When we see images, we take part in visual forming (or ordering). In this act the eye and mind organize visual differences by integrating optical units into a unified whole. The mind instinctively tries to create order out of chaos. This order adds equilibrium to human visual experience that would otherwise be confusing and garbled.

Artists are visual formers with a plan. With their materials they arrange the elements (lines, shapes, values, textures, and colors) for their structure. The elements they use need to be controlled, organized, and integrated. Artists manage this through the binding qualities of the principles of organization: harmony, variety, balance, movement, proportion, dominance, economy, and space. The sum total of these, assuming the artist's plan is successful, equals *unity*. Unity in this instance means oneness, an organization of parts that fit into the order of a whole and become vital to it.

Form is the complete state of the work. The artist produces this overall condition using the elements of art structure, subject to the principles of organization. The artist's plan is usually a mix of intuition and intellect. Hopefully, the plan will effectively communicate the artist's feeling, even though it may change as the work progresses. The plan can be variously termed *composition* or *design* (fig. 2.2).

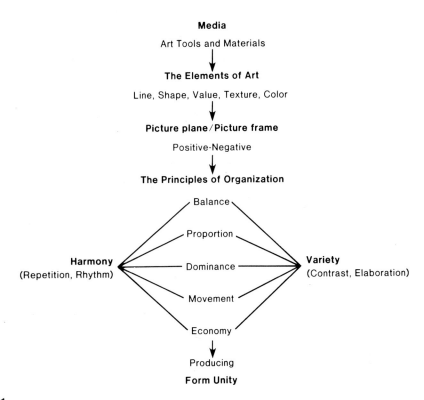

The Evolution of Form in Artworks

Media
Art Tools and Materials
↓
The Elements of Art
Line, Shape, Value, Texture, Color
↓
Picture plane / Picture frame
Positive-Negative
↓
The Principles of Organization

Balance
Proportion
Harmony — Dominance — **Variety**
(Repetition, Rhythm) (Contrast, Elaboration)
Movement
Economy
↓
Producing
Form Unity

2.1
Although this is a logical and common order of events in the creation of an artwork, artists often alter the sequence.

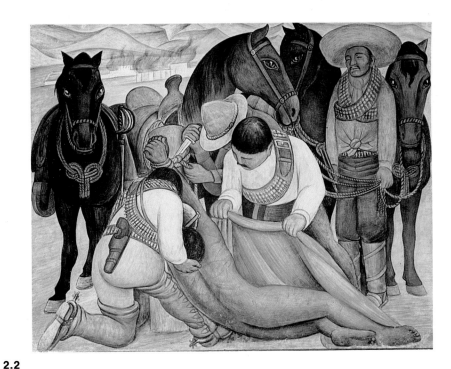

2.2
Diego Rivera. *The Liberation of the Peon.* 1931, fresco, 74 × 95 in. Here we see a politicized theme making use of appropriate and expected subject material. Without the effective use of form, the statement would be far less forceful.
The Philadelphia Museum of Art. Gift of Mr. and Mrs. Herbert Cameron Morris. Photograph by Alfred J. Wyatt.

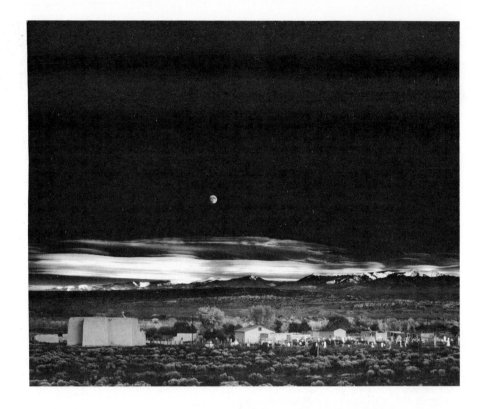

2.3
Ansel Adams. *Moonrise.* **Hernandez,**
New Mexico, 1944, photograph,
15½ × 19 in. The invention and
development of photography added an
important new medium to the repertoire of
artists in the nineteenth and early
twentieth centuries. Now the
accomplishments of photographers such
as Ansel Adams rank with those of well-
known painters, sculptors, and architects.

Media and technique

The nineteenth and twentieth centuries
have produced numerous advances in
scientific technology. These have spun off
into many areas, including art. Artistic
people have made use of new media and
techniques as aids to their creative
expression. One of the great visual
breakthroughs was the science of
photography. As a tool, the camera is not
as flexible as the brush, but photographic
innovations have served to broaden our
vision. The creative efforts of
photographic artists such as Edward
Steichen, Alfred Steiglitz, and Ansel
Adams are as well known today as are the
works of many of our important painters
and sculptors (fig. 2.3). From the
photographic experiments of such people
have come creative filmmaking,
xerography, and the artistic employment
of other photographically related media.

Of late, there has been a deluge of new
media and techniques. Some are
extensions of traditional approaches, while
others are without precedent. All have
been absorbed into the artist's inventory.
Traditional painting media have been
expanded by the addition of acrylics,
enamels, lacquers, pre-liquefied
watercolors, roplex, and other plastics.
Drawing media include new forms of
chalk, pastels, crayons, and drawing pens,
among many others. Sculptors now use
welding, plastics, composition board,
aluminum, stainless steel, and other
materials and techniques. The unique, or
nontraditional, media include video,
holography, computer-generated imagery,
and performances that mix dance, drama,
sound, light, and even the audience. Very
often the traditional and nontraditional
are mixed.

Although new and exotic techniques
and media have found their way into
artists' studios, they generally follow after
the artist has already mastered the more
traditional art forms. Nontraditional

media usually require specialized
knowledge (of a somewhat scientific
nature) and specialized skill development.
The pursuit of this skill and knowledge
can become an end in itself unless one has
the maturity required to reconcile it with
one's artistic aims. For this reason this
book on art fundamentals is principally
concerned with helping establish a
foundation in the more traditional aspects
of studio art.

Even the specialized skills required for
the mastery of traditional media take the
artist beyond the content of this book. In
studio practice the artist must consider
the effect of media and tools on imagery,
and how surfaces that carry this imagery
affect its total form. The natural texture
of a paper surface, for instance, may
dictate a particular medium and certain
tools. A pencil will produce a different
effect on smooth-surfaced paper than on
rough-surfaced (or "toothed") paper (fig.
2.4). Different grades of graphite in the
pencil can become a factor. In ink
drawing, a felt-tip pen has a different
expressive potential than a crow-quill pen.
The softening effect of water in the ink or
on the paper can drastically change the
meaning of an image.

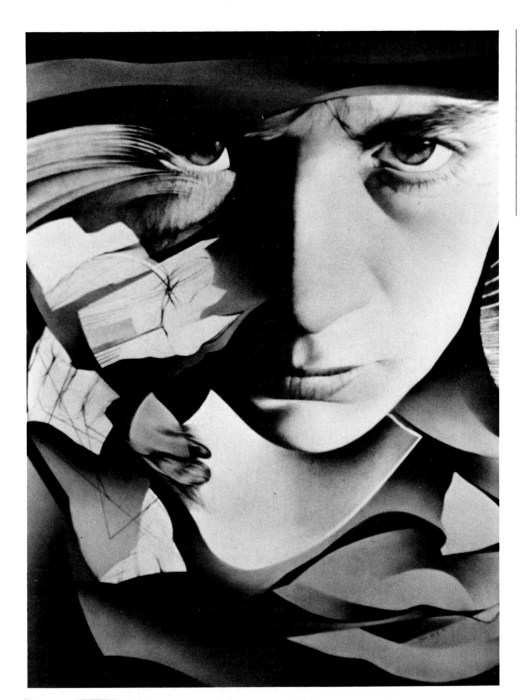

2.4

Thomas Hilty. *Margaret*. 1983, drawing (graphite, pastel, and Conte on museum board), 33½ × 40 in. This drawing shows the characteristic use of mixed media by the artist. He has skillfully blended and rubbed the materials to produce the effect of realistic, polished surfaces. The smooth texture of the museum board lends to the artist's technique a different effect than if it had been done on a coarser textured surface.

Courtesy of the artist.

The elements of art

The artist employs the media in composing the art elements—line, shape, value, texture, and color. These elements are the fundamental, essential constituents of any composite work of art. In this textbook the basic elements are thought to be so indispensable to art fundamentals that each will be examined individually in the chapters that follow. The artist's constant concern is with composing the elements. When dealing with objects, the artist reduces his subjects to elements. A chair might be seen as a shape or a group of lines, a wall as a value, and a floor as a color.

Space

The artist is always concerned about the type of space to be used. Some people regard space as an element, while others think of it as a by-product of the elements. Whichever classification one chooses, the importance of space will not diminish. If we follow the order in our diagram (see fig. 2.1), we see that a medium is necessary for the creation of an element and that, once an element (a line, for example) becomes visible, it automatically assumes a spatial position in contrast with its background. Chapter 8 will explain the different types of space and what the artist must do to achieve them.

2.5
Picture plane. Movement can take place on a flat surface as indicated by the vertical and horizontal arrows. The vertical lines represent an imaginary plane through which a picture is seen. The artist can also give the illusion of advancing and receding movement in space, as shown by the two large arrows.

2.6
Picture frame. The picture frame represents the outermost limits, or boundary, of the picture plane. These limits are represented by the edges of the canvas or paper on which the artist works, or by the margin drawn within these edges.

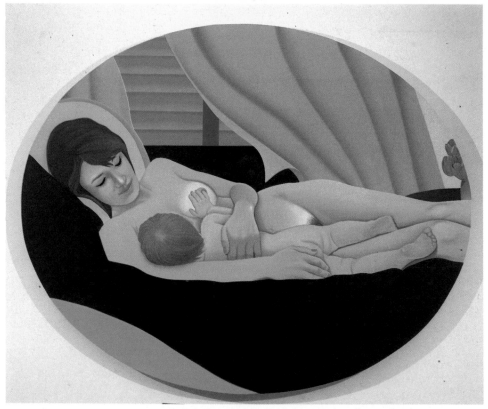

2.7
Tom Wesselman. *Barbara and Baby.* 1979–81, oil on canvas, 60 × 76¼ in.
Wesselman has used an unusual frame shape for a timeless subject. The organic shape evokes a feeling of birth and motherhood.
Tom Wesselman/VAGA, New York, 1988.

Picture plane

There are many ways to begin a work of art. It is generally accepted that artists who work with two-dimensional art begin with a flat surface.[1] To artists, the flat surface is the *picture plane* on which they execute their pictorial images (fig. 2.5). A piece of paper, a canvas, a board, or a plate may be representative of the picture plane. This flat surface may also represent an imaginary plane of reference on which an artist can create spatial illusions. The artist may manipulate forms or elements so that they seem flat on the picture plane, or extend the forms/elements so that they appear to exist in front of or behind the picture plane. In this way the picture plane is used as a basis for judging two- and three-dimensional space.

In three-dimensional art the artist begins with the material (metal, clay, stone, glass, etc.) and works it as a total form against the surrounding space, with no limitation except for the conceptual contour (see The Art of the Third Dimension, chapter 9).

Picture frame

A picture is limited by the *picture frame*—the outermost limit or boundary of the picture plane (fig. 2.6). The picture frame should be clearly established at the beginning of a pictorial organization. Once its shape and proportion are defined, all of the art elements and their employment will be influenced by it. The problem for the pictorial artist is to organize the elements of art within the picture frame on the picture plane.

[1]The first dimension refers to height, or the vertical system; the second dimension to width, or the horizontal system; the third dimension to the depth system; and the fourth dimension to time.

2.8
Larry Poons. *Orange Crush.* 1963, acrylic on canvas, 80 × 80 in. Although the majority of frame shapes are rectangles, Larry Poons has elected to use a square. This gives an expanding feeling to his mini-firmament. One of the artist's challenges is to vary placement, avoiding "dead," or static, areas.
Albright-Knox Art Gallery, Buffalo, New York. Gift of Seymour H. Knox, 1964.

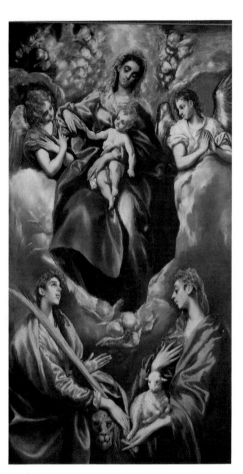

2.9
El Greco. *The Madonna and Child with Saint Martina and Saint Agnes.* Circa 1576–80, oil on canvas, 76⅛ × 40½ in. The rectangular frame shape, by its proportions, offers the artist a pleasing and interesting spatial arrangement. Here, El Greco has elongated his main shapes to repeat and harmonize with the vertical character of the picture frame.
National Gallery of Art, Washington, D.C. Widener Collection, 1942.

The proportions and shapes of picture frames used by artists are varied. Squares, triangles, circles, and ovals have been used as frame shapes, but the most popular is the rectangular frame, which in its varying proportions offers the artist an interesting two-dimensional space variety (figs. 2.7, 2.8, 2.9, and 2.10). Many artists select the outside proportions of their pictures on the basis of geometric ratios. These rules suggest dividing surface areas into odd proportions of two-to-three or three-to-five rather than into equal relationships. The results are pleasing visual and mathematical spatial arrangements. Most artists, however, rely on their instincts rather than on a mechanical formula. After the picture frame has been established, the direction and movement of the elements of art should be in harmonious relation to this shape. Otherwise, they will interrupt the movement toward pictorial unity.

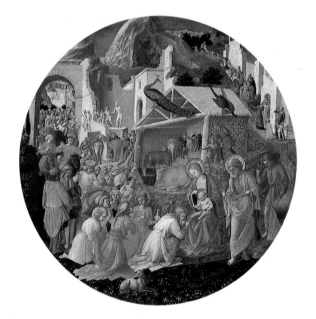

2.10
Fra Angelico and Fra Filippo Lippi. *The Adoration of the Magi.* Circa 1445, wood, diameter 54 in. The artists have used figures and architecture, and the direction and movement of the elements of art, in harmonious relation to a circular picture frame.
National Gallery of Art, Washington, D.C. Samuel H. Kress Collection.

2.11 and 2.12
Alfred Leslie. *Alfred Leslie*. 1982, oil on canvas, 84 × 60 in. The subject in this painting represents a positive shape that has been enhanced by careful consideration of the negative areas, or the surrounding space. In figure 2.12 the dark area indicates the negative shape and the white area the positive shape.
Courtesy of Alfred Leslie.

Positive-negative

All of the surface areas in a picture should contribute to total unity. Those areas that represent the artist's initial selection of element(s) are called *positive areas*. Positive areas may suggest recognizable objects or nonrepresentational elements. Unoccupied spaces are termed *negative areas* (figs. 2.11 and 2.12). The negative areas are just as important to total picture unity as the positive areas, which seem tangible and more explicitly laid down. Negative areas might be considered those portions of the picture plane that continue to show through after the positive areas have been placed in a framed space (fig. 2.13). In recent times some people use the words *field* for positive and *ground* for negative. They speak of a color field on white ground or a field of shapes against light-valued ground. Traditionally, foreground positions have been considered positive and background spaces negative (fig. 2.14).

The term *positive-negative* is important to beginners investigating art organization, since they usually direct their attention to positive forms and neglect the surrounding spaces. The resulting pictures are generally overcrowded, busy, and confusing.

When the artist's tool touches the picture plane, leaving a mark, two things happen. First, the mark divides, to some extent, the picture plane. Generally the mark is seen as a positive image, leaving the remainder to be perceived as a negative area. Secondly, the mark instantaneously takes a position in space with respect to the picture plane. Each of these results will continue to be important to the artist as the work develops.

2.13

Ellsworth Kelly. *Red and White*. 1961, oil on canvas, 62¾ × 84¼ in. In this nonfigurative (or nonobjective) work, some areas have been painted in, others not. It is very simple, probably deceptively so. To the viewer, the darks seem to be the negative shapes, although after some looking, this may reverse itself.

The Hirshhorn Museum and Sculpture Garden, Smithsonian Institution. Gift of Joseph H. Hirshhorn, 1972.

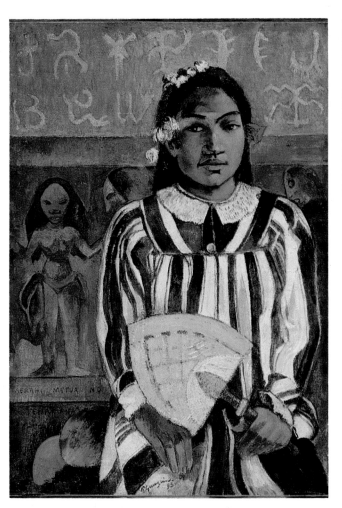

2.14

Paul Gauguin. *Ancestors of Tehamana*. 1893, oil on canvas, 76.3 × 54.3 cm. Items in the foreground (generally toward the bottom of the picture plane) are traditionally considered positive areas, whereas background (upper), unoccupied spaces are negative areas. This standardized view does not always apply, however, as can be seen by looking at other illustrations in this book.

Anonymous gift, 1980.613. © 1988 The Art Institute of Chicago. All Rights Reserved.

2.15
Francois Morellet. *Circles and Semi-Circles.* 1952, oil on wood, 15¾ × 27½ in. Were all of these shapes perfect circles, absolute harmony would prevail. However, some circles have been cropped (cut off by the picture plane), and an unexpected squiggle is moving through one of the levels. These factors produce variety, but the work is still largely harmonious because of the consistency of curved shapes.

Albright-Knox Gallery, Buffalo, New York. Charles W. Goodyear and Edmond Hayes Funds, 1981.

2.16
Victor Vasarely. *Orion.* 1956–62, paper on paper mounted on wood, 82½ × 78¾ in. Here, as in figure 2.15, are motifs—little compartments and circles. But there is considerable variety in the treatment of these motifs. The circles are tilted in various directions, and they vary in size, while the compartments are of different values and are sometimes outlined, sometimes not.

The Hirshhorn Museum and Sculpture Garden, Smithsonian Institution. Gift of Joseph H. Hirshhorn, 1966. Photo by Lee Stalswork.

The principles of organization

As explained earlier, the principles of organization are only guides. They are not laws with only one interpretation or application. These principles are the resources that organize the elements into some kind of action. The principles of organization may help in finding certain pictorial solutions for unity, but they are not ends in themselves, and following them will not always guarantee the best results. Artworks are a result of personal interpretation and should be judged as total visual expressions. In other words, the use of the principles is highly subjective or intuitive.

Organization in art consists of developing a unified whole out of diverse units. This is done by relating contrasts through certain similar means. For example, an artist might use two opposing kinds of lines, vertical and horizontal, in a picture. Since both the horizontal and vertical lines are already straight, this likeness would relate them. Harmonious means seem necessary to hold contrasts together. Unity and organization in art are dependent upon dualism—balance between harmony and variety. This balance does not have to be of equal proportions; harmony might outweigh variety, or variety might outweigh harmony (figs. 2.15, 2.16, 2.17, 2.18, and 2.19).

2.17
Jean Dubuffet. *De Vidoir en Registreur.*
1978, acrylic and paper, collage on
canvas, 79 × 114 in. This work is also
compartmented (for harmony) but uses
different sizes and shapes (for variety).
There is consistency in the character of the
lines, but enough variation to generate
interest.
Albright-Knox Art Gallery, Buffalo, New York.
George B. and Jenny R. Mathews Fund, 1979.

2.18
Paul Klee. *Fish Magic.* 1925, oil and
watercolor varnished, 38⅝ × 30¼ in.
The object shapes, through their repetition
and transitional variation, create
harmonious relationships. Variety in size
and treatment creates contrasting notes
that are balanced by the repetition of color
and shape.
Philadelphia Museum of Art: The Louise and
Walter Arensberg Collection.

2.19
Frank Stella. *Lac Laronge IV.* 1969, acrylic polymer on canvas, 108⅛ × 162 in. Stella
has harmonized the painting through his insistent use of the curve; he has provided variety
by using contrasting colors and shape sizes.
The Toledo Museum of Art, Toledo, Ohio. Gift of Edward Drummond Libbey.

2.20
The rectangles are related to this harmonious arrangement by repeating similar shape configurations. But they are also varied in size and set in opposing directions, which creates tension and interest.

2.21
Eva Hesse. *Repetition Nineteen III.* 1968, nineteen tubular fiberglass units, 19–20¼ in. high × 11–12¾ in. diameter. This work, as the title implies, exploits the repetitive dimensions of identical "can forms." These are then given variety by distorting the basic shapes.
Collection, The Museum of Modern Art, New York. Gift of Charles and Anita Blatt.

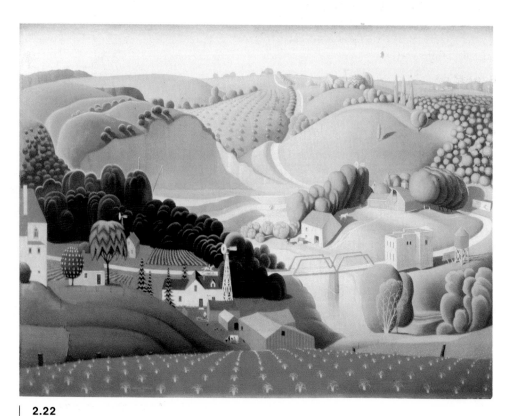

2.22
Grant Wood. *Stone City, Iowa.* Repetition is used in the organic curvilinear shapes of the hills and trees, which are varied in size. There are occasional punctuations of rectilinear (straight-line) shapes in the buildings and bridge. The flow of the organic shapes produces a rhythmic effect.
Joslyn Art Museum. Gift of Art Institute of Omaha, 1930.

2.23
Copper Giloth. *Bird in Hand.* **1983,
computer.** Repetition is found in the
pattern produced by the computer as well
as in the repeating images. Nevertheless,
the hands change position periodically,
producing some break in the repetition.
Courtesy of the artist.

Harmony

Rhythm and repetition act as agents for
creating order out of forces that are
otherwise in opposition. They relate
picture parts. Once the opposing forces on
a picture surface have been reconciled,
harmony results. Harmony is a necessary
ingredient of unity.

Repetition

Repetition and rhythm are inseparable;
rhythm is the result of repetition.
Repetition reemphasizes visual units. It
connects the parts and binds an artwork
together. Repetition creates attention or
emphasis, and it permits pause for
examination.

Repetition does not always mean exact
duplication, but it does mean similarity or
near likeness. Slight variation of a simple
repetition adds subtle interest to a pattern
that might otherwise be tiring (figs. 2.20,
2.21, 2.22, 2.23, and 2.24). Great
variation stimulates sustaining and
absorbing interest.

2.24
Ad Reinhardt. *Number 1, 1951.* **1951,
oil on canvas, 79⅞ × 34 in.** The visual
units in Reinhardt's painting are
rectangular modules. The repetition of this
motif creates harmony. Variety develops
out of subtle differences in scale and color.
The Toledo Museum of Art, Toledo, Ohio.
Museum Purchase Fund.

Rhythm

Rhythm is a continuance, or flow, derived from reiterating and measuring related, similar, or equal parts. Rhythm is recurrence, a measure such as meter, tempo, or beat. Walking, running, dancing, woodchopping, and hammering are human activities with recurring measures.

In art, if particular parts are recalled in a rhythmical way, a work is seen as a whole. Rhythm in this instance gives both unity and balance to a work of art (fig. 2.25).

Rhythm exists in many different ways on a picture surface. It may be simple, as when it repeats only one type of measure; it may be a composite of two or more recurring measures that exist simultaneously; or it may be a complex variation that repeats a particular accent. José Clemente Orozco charges his pictures with obvious rhythmical order (figs. 2.26 and 2.27). He uses several rhythmical measures simultaneously to create geometric unity. He welds his pictures together by repeating shape directions and edges, value differences, and color modifications.

2.25
These rectangles are set in a repetitious and rhythmic order. Repetition and rhythm are agents for creating harmony and unity.

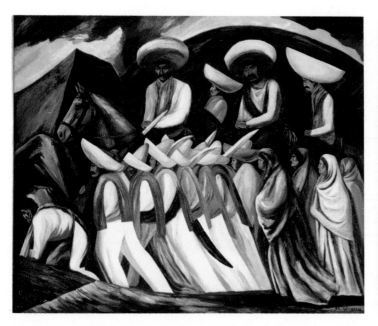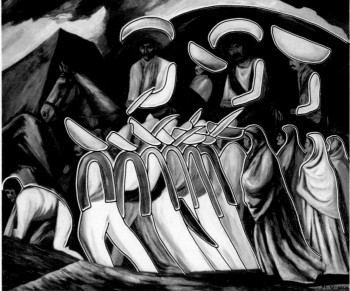

2.26 and 2.27
José Clemente Orozco. *Zapatistas.* **1931, oil on canvas, 45 × 55 in.** A continuous movement is suggested as the Zapatistas cross the picture surface from right to left. In passing, these figures form a repetitious beat, as their shapes, leaning in the same direction, create a rhythmic order. The drawing in figure 2.27 illustrates the major shapes arranged in continuous, flowing, rhythmic directions for harmony. The hats, blankets, and white trousers are motifs.

Collection, The Museum of Modern Art, New York. Given anonymously.

Motif

Dictionary descriptions of *motif* are perfectly applicable to its use in art—"a distinctive feature or element of a design or composition; a particular type of subject; the dominant idea of a work." A particular kind of grouping of the art elements can serve the artist as a motif. This grouping may result in a recognizable subject or a nonobjective image not unlike an insignia or a corporate logo. The motif is often the featured part of the overall composition of an artwork, and it is likely to be repeated several times within the composition. This repetition lends a touch of harmony to the work, but when repeated with some variation, variety is also served. This is quite noticeable in music, with the theme, or melody, serving as the motif. The theme occurs with slightly different configurations of notes and in different keys. An illustration in the visual arts would be the basic form of the human figure, draped and undraped (with different kinds of clothing), but always of the same general shape. In a realistic work this figure could be varied in its size, location, and relationships with the other, usually lesser, subjects (fig. 2.28).

2.28

Max Ernst. *The Hat Makes the Man.* Cologne, 1920, collage (pencil, ink, and watercolor), 14 × 18 in. The hats in this picture represent strong accents (motifs) in a system of accents and pauses. Notice the variety of style, size, and shape contour within the repetitive order.

Collection, The Museum of Modern Art, New York. Purchase.

2.29

Student work. *Patterns: Trees.* **Brush, pen, and ink.** Although the subject is trees, the distinctive pictorial characteristic of this work is the pattern produced by the tree relationships, a pattern that is repeated, though not identically, in all areas of the work, creating a unifying effect.

Pattern

The generally repetitive nature of pattern can be used to introduce harmony into a work of art. Rhythms and repetitions with alternating pauses and beats cause a flow, a connection between parts of a work. They serve to direct the eye movement from one motif to another. The net product is pattern (fig. 2.29).

The resultant pattern can be made up of regular repetitions, as in an allover pattern, or irregular repetitions. These repetitions may be composed of simple marks (a dot pattern), elements (a value, texture, or color pattern), or a series of complex designs (a paisley pattern or a geometric pattern). In most circumstances, patterns are associated with graphic, two-dimensional art, but they can also be produced in three-dimensional art. Although frequently used for commercial decoration, patterns are very useful to all artists.

Variety

Variety is the counterweight of harmony. It is the other side of organization essential to unity. While an artist might bring a work together with harmony, it is with variety that the artist achieves individualism and interest. In this instance, interest refers to the ability to arouse curiosity and hold a viewer's attention. If an artist achieves complete equality of visual forces, the work will usually be balanced, but it will also be static, lifeless, and without feeling. By adding variation to these visual forces, the artist introduces essential ingredients (such as diversion or change) for enduring attention.

Artists use variety to attract attention in different ways. For example, they may find variety by using opposition or contrast—setting opposing elements and/ or their parts in proximity for an intensified effect (figs. 2.30 and 2.31). Other artists may elaborate upon forces that seem formal and acceptable but lack enduring interest by reworking areas persistently to express themselves at greater length until an attractive solution is reached. The surfaces are enriched with interest by the extended changes, and the artist's concept usually develops dramatic strength and purposeful meaning.

Drab picture surfaces become more exciting as variations are introduced. In music, the higher the pitch, the greater

2.30
Peter Phillips. *Custom Painting No. 3.*
1964–65, oil on canvas, 84 ¼ × 69 in.
Variety is the hallmark in the use of the
elements in this painting. Zigzags mix with
spirals, while other rectilinear shapes are in
conflict with curvilinear shapes. Varied
colors also contribute to the highly
dynamic effect.

Des Moines Art Center. Gift of American
Republic Insurance Company, 1982.

2.31
George Sugarman. *Inscape.* **1964,**
polychromed wood, 24 × 144 × 108 in.
The balance between harmony and variety
can be tipped to favor either principle of
order depending on the artist's intention.
George Sugarman is an artist who pushes
his balance strongly in the direction of
variety. In this three-directional work,
Sugarman varies the shape contours and
colors of his assembled pieces with a
personal vigor. He arouses an initial
curiosity in his viewer that, after greater
reflection, provides enduring vitality.

Robert Miller Gallery, New York. Collection of the
artist.

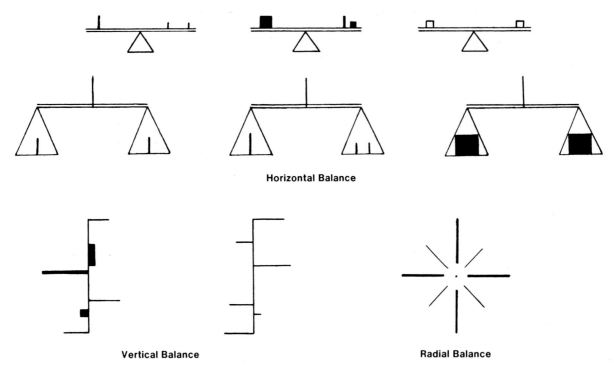

Horizontal Balance

Vertical Balance **Radial Balance**

2.32
Balance chart.

the number of vibrations. Similarly, in art, as contrasts are introduced, the "pitch" or excitement is increased; reduction in contrast lowers the vibration experienced. The frequency of contrasts in a given artwork might also be compared to the key signature in music. A musical key means that certain notes are more important than others; in art, some contrasts require greater emphasis than the rest.

Balance

Balance is so fundamental to unity that it is impossible to present the problems of organization without considering it. At the simplest level, balance suggests the gravitational equilibrium of a single unit in space or of pairs symmetrically arranged with respect to a central axis or point. Perhaps the balancing of pairs can be best compared to a weighing scale. A weighing scale has a beam poised on a central pivot (the fulcrum) so as to move freely and a pan attached to each end of the beam. When such a scale is used in art, balance is not achieved through an actual physical weighing process but through an observer who makes a visual

judgment based on past experiences and knowledge of certain principles of physics. With this type of scale, the forces are balanced left and right, or horizontally, with respect to the supporting crossline. In figure 2.32 the illustrations of the horizontal balance scale show a line of one physical dimension balancing or counterbalancing a line with the same (or equal) physical characteristics. These examples also point out the balance between lines, shapes, and values that have been modified. A second type of weighing scale, in which forces are balanced vertically, is also illustrated in figure 2.32. The third weighing device shown in the figure points out not only horizontal and vertical balance, but also the balance of forces distributed around a center point. This is a radial weighing scale.

In picture making, balance refers to the "felt" optical equilibrium among all parts of the work (that is, the viewer "feels" it). The artist balances forces horizontally, vertically, radially, and diagonally in all directions and positions (fig. 2.33).

Several factors, when combined with the elements, contribute to balance in a work of art. These factors or variables are

position or placement, size, proportion, character, and direction of the elements. Of these factors, position plays the lead role. If two shapes with equal physical qualities are placed near the bottom of a picture frame, the work will appear bottom-heavy or out of balance with the large upper space. Such shapes should be positioned to contribute to the total balance of all the picture parts involved. Similarly, the other factors can put a pictorial arrangement in or out of balance according to their use.

In seeking balance, we should recognize that the elements of art represent "moments of force." As the eye travels over the picture surface, it pauses momentarily at significant picture parts. These parts represent moving and directional forces that must counter-balance one another so that controlled tension results. In the painting *Handball* by Ben Shahn, the moments of force are felt in tension that exists between the two figures in the foreground and the number 1 at the top of the wall (fig. 2.34). These forces together support one another. The problem of visual balance has resulted in two basic types of organization: symmetrical and asymmetrical.

2.33
Balance in all directions—horizontal, vertical, radial, and diagonal.

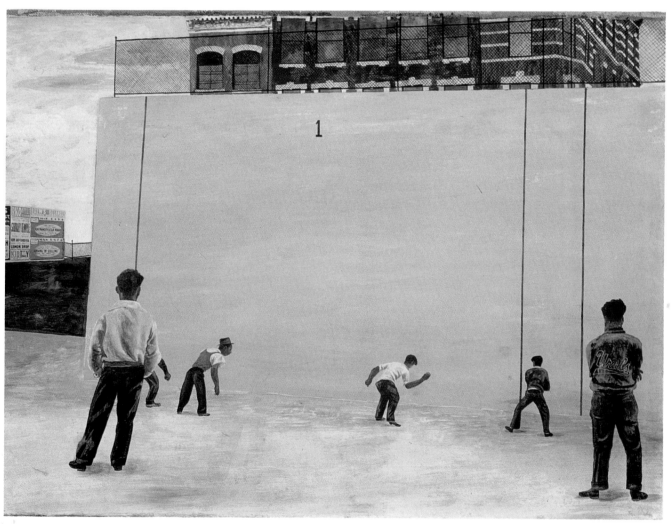

2.34
Ben Shahn. *Handball.* **1939, tempera on paper over composition board,**
22¾ × 31¼ in.
Collection, The Museum of Modern Art, New York. Abby Aldrich Rockefeller Fund.

2.35 and 2.36
Georgia O'Keeffe. *Lake George Window.* **1929, oil on canvas, 40 × 30 in.** The window, its moldings, and its shutters are equally distributed on either side of an imaginary vertical axis in mirrorlike repetition. Georgia O'Keeffe has balanced this painting symmetrically.
Collection, The Museum of Modern Art, New York. Acquired through the Richard D. Brixey Bequest.

Symmetrical (formal) balance

The beginner will find that symmetry is the simplest and most obvious type of balance. In pure symmetry, identical optical units (or forces) are equally distributed in mirrorlike repetition on either side of a vertical axis or axes (figs. 2.35 and 2.36). Because of the identical repetition, the effect of pure symmetrical balance is often dull, tiring, and boring. It is usually too monotonous for prolonged audience attention. However, by its use, unity is easily attained. In spite of these seemingly negative effects, interesting variations can be achieved through the creative use of the elements of art (figs. 2.37, 2.38, and 2 .39).

2.37
Burgoyne Diller. *First Theme.* **1963–64, oil on canvas, 72 × 72 in.** *First Theme* is a simplified, formal, symmetrical composition that relies on shape, size, value, and color relationships to express spatial relationships. The values and colors black, white, red, and yellow are used for maximum variety or contrast. Burgoyne Diller painted this in the Neo-Plastic style of Mondrian and Van Doesburg.
Albright-Knox Art Gallery, Buffalo, New York. Gift of Seymour H. Knox, 1969.

2.38
**Ron Resch. *Van Leer Model.* 1980,
computer.** However one turns this work,
the image remains basically the same. In
such imagery, much interest must be
worked into the elements in order to
compensate for the repetitious, mirrorlike
appearance.
From the artist.

2.39
Erté. *Twin Sisters.* 1982, print (serigraph), 40 × 55 in. The repetitious nature of this
symmetrical work is counterbalanced and relieved by the lively details, which hold interest
that might otherwise have been lost.
Circle Fine Art Corporation, Chicago, Illinois.

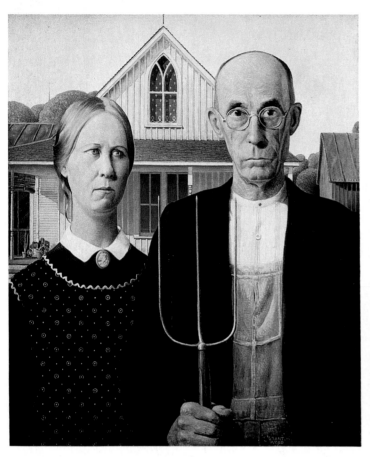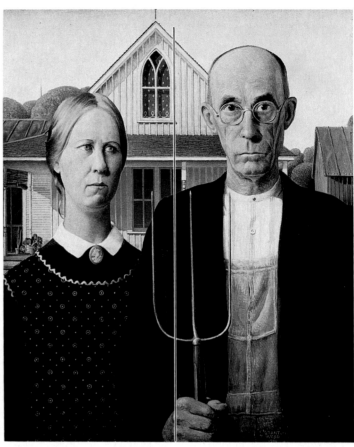

2.40 and 2.41

Grant Wood. *American Gothic.* 1930, oil on beaver board, 76 × 63.3 cm. The two figures in this picture create repetitious relationships so that their vertical axis is optically felt. This is approximate symmetry.

Approximate symmetry

The severe monotony of pure symmetry in pictorial arrangements is often relieved by a method called approximate symmetry (figs. 2.40 and 2.41). Here, the parts on either side of the axis or axes are varied in order to hold audience attention, but they are similar enough to make repetitious relationships and the vertical axis optically felt (figs. 2.42 and 2.43).

2.42

Nassos Daphnis. *11–67.* **1967, epoxy on canvas, 98 × 77 in.** The shapes and their sizes are the same except for the diagonal stripes passing behind the circle. Had identical stripes been provided, moving from upper left to lower right, the work would have been closer to symmetry. As it stands, the work shows approximate symmetry.

Albright-Knox Art Gallery, Buffalo, New York. Gift of Seymour H. Knox, 1969.

2.43

No attribution. *Master of the Gardner Annunciation, the Annunciation.* **1481, tempera on wood, 102.4 × 114.8 cm.** Although architectural details converge on a common point and the subjects are centered around this point, the figures are not the same, nor are the structural elements. Had they been, it would have been symmetrical. As they are not, it is approximate symmetry.

Isabella Stewart Gardner Museum/Art Resource, New York.

Radial balance

Another type of arrangement, called radial balance, can create true or approximate symmetry through repetitive association. In radial balance, forces are distributed around a central point. The rotation of these forces results in a visual circulation, adding a new dimension to what might otherwise be a static, symmetrical balance. Pure radial balance opposes identical forces, but interesting varieties can be achieved by modifying the spaces, numbers, and directions of the forces (figs. 2.44, 2.45, and 2.46). Although modified, the principle of repetition must still be stressed so that its unifying effect is utilized. Radial balance has been widely used in the applied arts. Jewelers often use radial patterns for stone settings on rings, pins, necklaces, and brooches. Architects have featured this principle in quatrefoils and "rose" windows in which the petals of flowers are radially arranged (fig. 2.47). Plates and vessels of all kinds evolve in a radial manner on the potter's wheel and frequently give evidence of this genesis. In two-dimensional work, the visual material producing the radial effect can be nonobjective or figurative.

2.44
Anuskiewicz. *Iridescence*. 1965, acrylic on canvas, 60 × 60 in. In radial balance there is frequently a radiation from some (usually central) source. That is clearly the case here, but note the various stresses placed on the rays as they move away from the square; the result is that the square seems to emit some mystic force, as with the obelisk in the movie *2001*.
Albright-Knox Art Gallery, Buffalo, New York. Gift of Seymour H. Knox, 1966.

2.45
Tom Defanti, Dan Sandin, and Mimi Shevitz. *Spiral PTL*. 1981, computer.
The core of this work is projecting (or radiating) outward-moving spirals that are varied by moving from solid to broken lines.
From the artists.

2.46

Simon Tookoome. *I Am Always Thinking about Animals.* **1973, stonecut and stencil, 54.5 × 78.6 cm.** Although opposition of identical forces is usually found in radial balance, this Canadian artist displays his imaginative native imprint within a radial arrangement.

Art Gallery of Ontario, Toronto. Gift of the Klamer family, 1978. Acc. no. 78/538. Photo by Carlo Catenazzi.

2.47

Rose window, Chartres Cathedral, Chartres, France. Circa mid-thirteenth century, stained glass. The rose windows of Gothic cathedrals are excellent examples of radial design. Originating at a central point, the glass panes flare out in all directions, producing an expanding effect.

SCALA/Art Resource, New York.

2.48
Burgoyne Diller. *First Theme.* **1962, oil on canvas, 106.7 × 106.7 cm.** The contradictory forces of similar shapes with differing color and size are weighted by the observer's instincts and intuition, arriving at an asymmetrical balance.

Painting and Sculpture Committee Purchase, 1964.39. © 1988 The Art Institute of Chicago. All Rights Reserved.

Asymmetrical (occult) balance

Asymmetrical balance means visual control of contrasts through felt equilibrium between parts of a picture. For example, felt balance might be achieved between a small area of strong color and a large empty space. Particular parts can be contrasting, provided that they contribute to the allover balance of the total picture. There are no rules for achieving asymmetrical balance; there is no center point and no dividing axis. If, however, the artist can feel, judge, or estimate the opposing forces and their tensions so that they balance each other in total concept, vital, dynamic, and expressive organization on the picture plane results. A picture balanced by contradictory forces (for instance, black and white, blue and orange, shape and space) compels further investigation of these relationships and thus becomes an interesting visual experience (figs. 2.48, 2.49, 2.50, and 2.51).

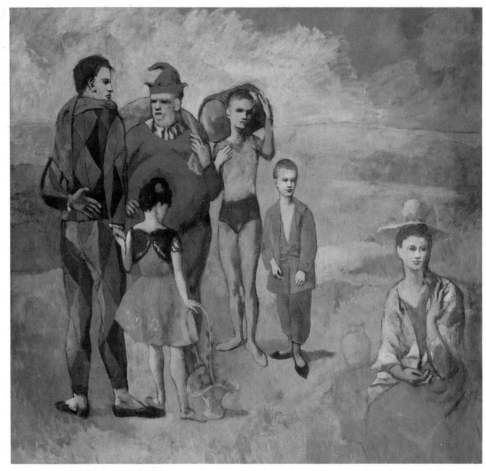

2.49
Pablo Picasso. *Family of Saltimbanques.* **1905, oil on canvas, 83¾ × 90⅜ in.**
Asymmetrical balance: Intuitive balance is achieved through juxtaposing the varying shapes and continuously distributing similar values and colors.

National Gallery of Art, Washington, D.C. Chester Dale Collection.

2.50
Ronald Kitaj. *Walter Lippmann.* **1966, oil on canvas, 72 × 84 in.** In concentration of subject matter, this painting is weighted toward the left; but the inverted pyramidal lines produce a degree of equilibrium, and the strongest darks are on the right, adding weight. The balance is achieved through dissimilar means.

Albright-Knox Gallery, Buffalo, New York. Gift of Seymour H. Knox, 1967.

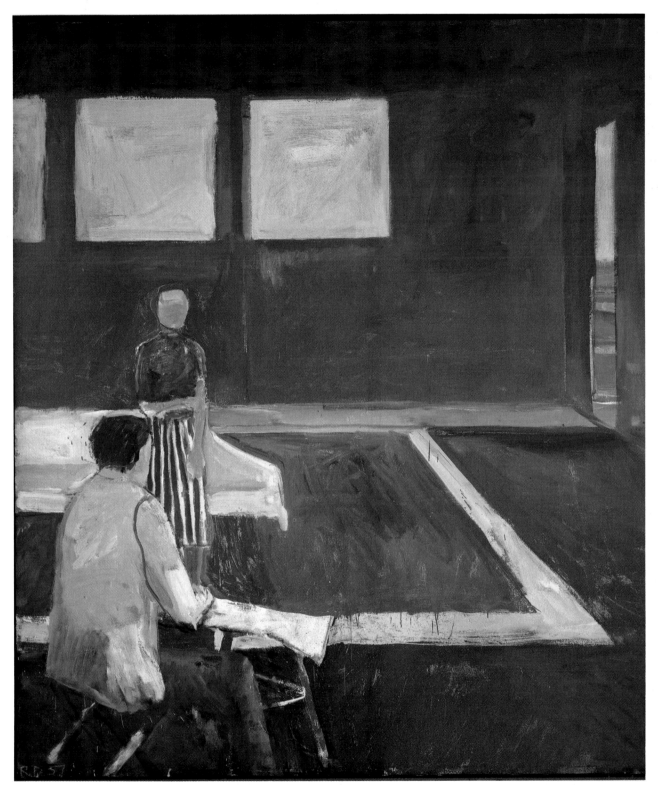

2.51

Richard Diebenkorn. *Man and Woman in Large Room.* 1957, oil on canvas, 71 × 62½ in. In a symmetrical or approximately symmetrical work, the figures would most likely be centered; here, instead, they are thrust to one side. The imbalance that this would be expected to create has been modified in various ways so that balance is restored.

Hirshhorn Museum and Sculpture Garden, Smithsonian Institution. Gift of Joseph H. Hirshhorn Foundation, 1966.

Proportion

Proportion deals with the ratio, or comparative magnitudes, of parts to one another. In art, the configurations of shapes or masses are difficult to compare with any accuracy, and the degree of proportion becomes a matter of judgment. Very often, proportional parts are considered in relation to the whole, and usually these parts have some consistent ratio. This is important in art because the artist seeks balance and logical relationships. If sizes are greatly different, as in a very large shape alongside a much smaller one, the work may seem to lack acceptable proportions. The two pears in figure 2.52 illustrate the awkwardness of such a juxtaposition. The larger pear is much too forceful in its demand on our attention; the smaller one loses significance. In using their judgment in determining satisfying proportions, artists rely on an educated intuition—adjusting sizes until they fit their surroundings and appear comfortable with each other.

Still, most artworks need to include a certain amount of emphasis, or dominance. When parts have too much equality, they become overly competitive and monotonous. Emphasis controls and sustains the observer's attention. In the Jerome Witkin painting (fig. 2.53), the artist has used enlargement for emphasis. The subject, a large physical man, is emphasized by the bulky torso with

2.52
Diagram of pears.

simple, light values, surrounded by the darker forms of head, arms, jacket, and pants. The result is a psychologically overpowering portrait.

The feeling of largeness we experience when looking at Witkin's portrayal is the result of relative scaling. He has considered the relationships of his work to what it represents. In this case, as in most, the comparison is based on what is known about size in the objective world. Also, the image seems about to burst the limits of the work's format. Thus the size of the working area can be utilized to affect the apparent reduction or enlargement of the subject. The physical size of the work can also be instrumental in affecting our understanding of its proportions if we compare it to our own size. Because of its small scale (5 × 5¾ in.), van Eyck's *St. Francis Receiving the Stigmata* acquires an intimate, even reverential quality (fig. 2.54).

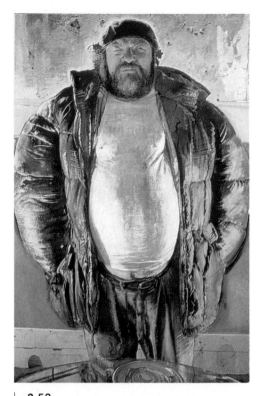

2.53
Jerome Paul Witkin. *Jeff Davies.* 1980, oil on canvas, 72 × 48 in. If there was ever a painting in which one subject dominated the work, this must be it. Most artworks do not need this degree of dominance, but Witkin evidently wanted a forceful presence—and got it.
Palmer Museum of Art, The Pennsylvania State University.

Chuck Close, on the other hand, tends to overwhelm us with his enormously large human heads (see fig. 2.55). With the overall size (the portraits range from five to eight feet in height), there is a proportional enlargement of facial details such as hairs and pores. The view of the artist in his studio (fig. 2.56) illustrates this overpowering magnification. The heads become heroic, intimidating, and in some respects, sordid.

To summarize: Proportional scaling is used to create emphasis and emotional effects, to attract attention, and to suggest spatial positions, as will be shown in later chapters.

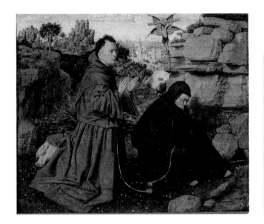

2.54
Attributed to Jan van Eyck. *St. Francis Receiving the Stigmata.* **No date, oil on paper, 5 × 5¾ in.** As can be seen from the dimensions of this work, van Eyck has created an amazing microcosmos. Despite the miniaturization, everything is in near-perfect scale. The radical scaling down creates a subdued, almost precious effect; there is no bombast or superficial heroism.
John G. Johnson Collection, Philadelphia.

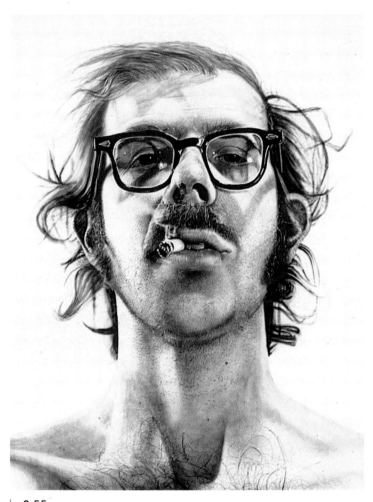

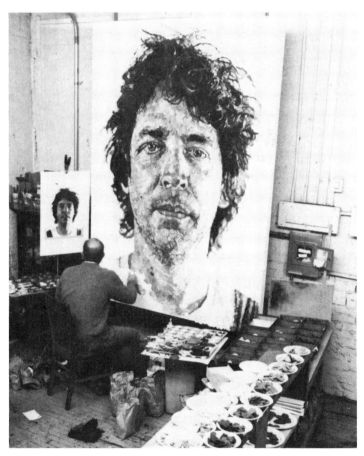

2.55
Chuck Close. *Self-Portrait.* **1968, acrylic on canvas, 107½ × 83½ in.** A super-realist such as this artist scrupulously depicts every facet of textural detail. The immediacy of the image is enhanced by the large scale of the work.
Collection Walker Art Center, Minneapolis; Art Center Acquisition Fund, 1969.

2.56
Chuck Close. *Jud.* **1982, pulp paper collage on canvas, 96 × 72 in.** When magnified by Close's painting, heads become geographical terrain with all of the expected (?) hillocks, gullies, and terrestrial features.
Courtesy of Pace Gallery, New York. Photograph by S. K. Yaeger.

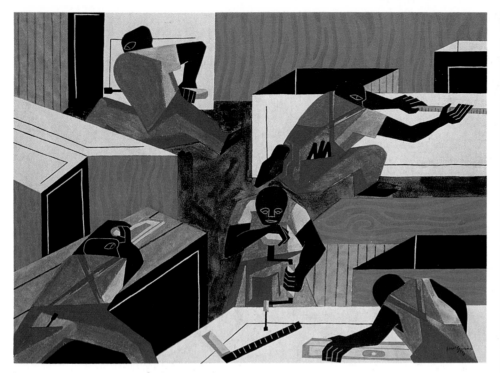

2.58
James Ensor. *Fireworks.* **1887, oil and encaustic on canvas, 40¼ × 44¼ in.** Centering, color brightness, dynamic movement, and the semi-radial shape make the fireworks eruption inescapably the dominant subject.

Albright-Knox Art Gallery, Buffalo, New York. Albright and Jenny R. Mathews Fund, 1971.

2.57
Jacob Lawrence. *Cabinet Makers.* **1946, gouache with pencil underdrawing on paper, 21¾ × 30 in.** The human figures here become the focal points, or "optical units" of greatest importance, because of their size and activity. The dominant area is where the two central figures merge. The other figures are lesser players, then the tables and tools.

The Hirshhorn Museum and Sculpture Garden, Smithsonian Institution. Gift of Joseph H. Hirshhorn, 1966. Photo by John Tennant.

Dominance

Any work of art that strives for interest must exhibit differences that emphasize the degrees of importance of its various parts. These differences result from medium and need. A musical piece, for example, can use crescendo; a dramatic production can use a spotlight. The means by which differences can be achieved in the visual arts are many. If we substitute the term *contrast* for difference, we can see that emphasis can be produced by contrast in scale, in character, and in the many physical properties of the elements.

Obviously, the artist intends to use contrast to call attention to the significant parts of the work, thus making them dominant. A work that neglects dominance implies that everything is of equal importance; it not only fails to communicate, but also creates a confusing visual image in which the viewer is given no direction. In a sense, all parts are important because even the secondary ones produce the norm against which the dominant parts are contrasted.

In dealing with dominance, artists have two problems. First, they must see that each part has the necessary degree of importance, and second, they must incorporate these parts with their varying degrees of importance into the rhythmic movement and balance of the work. In doing this, artists often find they must use different methods to achieve dominance. One significant area might derive importance from its change in value, whereas another might rely on its busy or exciting shape (figs. 2.57, 2.58, 2.59, and 2.60; see fig. 5.11). The basic order created by variations in dominance can be witnessed at every level of our lives—the star system in the entertainment field; the hierarchy of political, ecclesiastical, and civic organizations; the atomic system; the solar system—all in very different ways.

2.59

Michelangelo da Caravaggio. *Conversion of the Magdalene.* **No date, oil on canvas, 38½ × 52¼ in.** The contrast of the light value of the head and shoulders with the dark values of the background gives emphasis to the main figure of the Magdalene.

Detroit Institute of Art. Gift of the Kresge Foundation and Mr. and Mrs. Edsel Ford.

2.60

Paul Cézanne. *Chestnut Trees at Jas de Bouffan.* **1885–87, oil on canvas, 29¹⁄₁₆ × 36⅝ in.** Although some of the trees in this work are stronger than others, they are collectively seen as an individual unit that dominates the other parts. The dominance is achieved by size, dark values, and complex relationships. Secondary areas take their place in the dominance scale largely through reduced values and color strengths as they recede in space (atmospheric perspective).

The Minneapolis Institute of Arts. From the William Hood Dunwoody Fund.

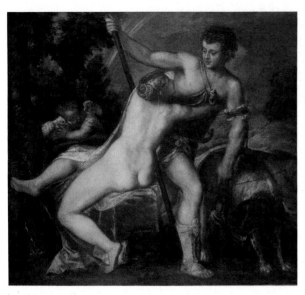
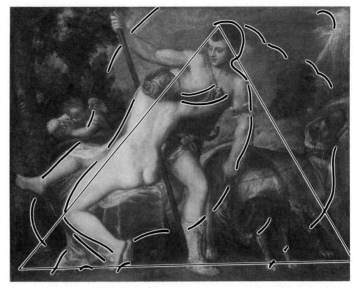

2.61 and 2.62

Titian. *Venus and Adonis*. Circa 1560, oil on canvas, 42 × 53½ in. The movement in this painting was planned by Titian to carry the spectator's eye along guided visual paths. These were created (as indicated by the accented lines in figure 2.62) by emphasizing the figure contours and the light values. The triangular shape made by the main figures serves as a pivotal motif around which secondary movements circulate.

National Gallery of Art, Washington, D.C. Widener Collection, 1942.

Movement

A picture surface is static; its parts do not move. Any animation in a work must come from an illusion created by the artist through placement and configuration of the picture parts. The written word is read from side to side, but a visual image can be read in a variety of directions. The directions are created by the artist out of a need for a means to bind the various parts together in rhythmic, legible, and logical sequence.

The movement should assure that all areas of the picture plane are exploited—that there are no dead spots. This goal is realized by directing shapes and lines toward each other in a not always obvious manner, so that the spectator is unconsciously swept along major and secondary visual channels. The movement should be self-renewing, constantly drawing attention back into the format (see "Pictorial representations of movement in time" in chapter 8 and figs. 2.61 and 2.62; 2.63 and 2.64).

Economy

Very often, as a work develops, the artist finds that the solutions to various visual problems result in unnecessary complexity. This problem is frequently characterized by the broad and simple aspects of the work deteriorating into fragmentation. This process seems to be a necessary part of the developmental phase of the work, but the result may be that solutions to problems are outweighed by a lack of unity.

The artist can sometimes restore order by returning to significant essentials, eliminating elaborate details, and relating the particulars to the whole. This is a sacrifice not easily made or accepted because, in breaking things down, interesting discoveries may have been made. But, interesting or not, these effects must be surrendered for greater legibility and a more direct expression. Economy has no rules, but rather must be an outgrowth of the artist's instincts. If something works with respect to the whole, it is kept; if it is disruptive, it must be reworked or rejected.

Economy is often associated with the term *abstraction*. Abstraction implies an active process of paring things down to the essentials necessary to the artist's style of expression. It strengthens both the conceptual and organizational aspects of the artwork. In a sense, the style dictates the degree of abstraction, though all artists abstract to some extent (fig. 2.65).

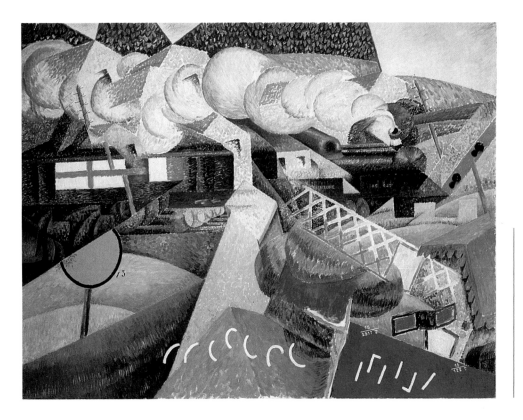

2.63

Gino Severini. *Red Cross Train Passing a Village.* 1915, oil on canvas, 35 × 45¾ in. The futurists were particularly interested in the dynamism of the modern age. Although this illustration is somewhat less violent in its movement that many of their works, it is hardly peaceful; shapes are placed in opposition and their character is highly varied.

The Solomon R. Guggenheim Museum, New York. Photo: Myles Aronowitz.

2.64

Käthe Kollwitz. "Losbruch" (Outbreak) from the series *Peasants' Revolt.* 1903, print (etching), 20¼ × 23½ in. In this intaglio print the figures surge forward like a relentless tide. The thrusting movement is probably the most significant factor in the work.

Courtesy Bowling Green State University, School of Art Collection.

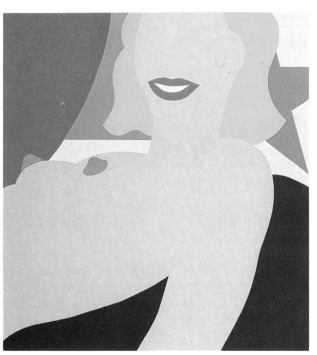

2.65

Tom Wesselman. *Study for First Illuminated Nude.* 1965, synthetic polymer on canvas, 46 × 43 in. Wesselman has reduced the image to the few details he considers crucial, thus practicing economy.

Hirshhorn Museum and Sculpture Garden, Smithsonian Institution. Gift of Joseph H. Hirshhorn, 1966. Photo by John Tennant.

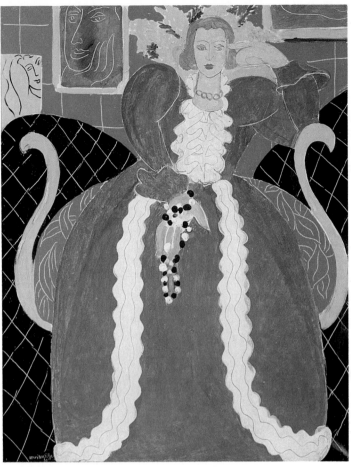

2.66
Henri Matisse. *Lady in Blue.* **1937, oil on canvas, 36½ × 29 in.** Those familiar with the evolution of this painting know that Matisse started with a fairly conventional and somewhat busy image of the figure, gradually simplifying it as it took shape. Some subdued ornamentation supplies interest, but it is basically an economical work.

Philadelphia Museum of Art. Gift of Mrs. John Wintersteen.

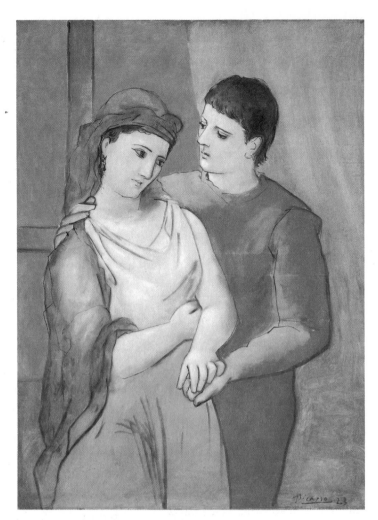

2.67
Pablo Picasso. *The Lovers.* **1923, canvas, 51¼ × 38¼ in.** Picasso has simplified the complex qualities of the surface structures of his two figures, reducing them to contour lines and flat color renderings. The artist abstracted (used economical means) the two lovers to strengthen the expressive bond between them.

National Gallery of Art, Washington, D.C. Chester Dale Collection.

Economy is easily detected in many contemporary art styles. The early modernists Henri Matisse and Pablo Picasso were among those most influential in the trend toward economical abstraction (figs. 2.66 and 2.67). The "field" paintings of Mark Rothko, Barnett Newman, and Clifford Still, the monochromatic black canvasses of Ad Reinhardt, and the hard-edged works of Ellsworth Kelly all clearly feature economy (see figs. 2.13 and 2.24). The sculptors of the Minimalist style (which itself bespeaks economy), Robert Morris, Ronald Bladen, Donald Judd, and Tony Smith, utilize severely limited geometric forms. They have renounced illusionism, preferring instead to create three-dimensional objects in actual space that excludes all excesses. The absence of elaboration results in a very direct statement.

In economizing, one flirts with monotony. Sometimes embellishments must be preserved or added to avoid this pitfall. But if the result is greater clarity, the risk (and the work!) are well worth it.

Form unity—A summary

The artist has selected a picture plane framed by certain dimensions. He has chosen his tools and materials, and with them has begun to create elements on the surface. As he does so, spatial suggestions appear that may conform to his original conception; if they do not, the process of adjustment begins. The adjustment accelerates and continues as harmony and variety are applied to balance, movement, proportion, dominance, and economy. As the development continues, the artist depends on his intellect, emotions, and instincts. The ratio varies from artist to artist and from work to work. The result is an artwork that has its own distinctive form. If the work is successful, its form has unity—all parts belong and work together.

A unified artwork develops like symphonic orchestration in music. The musical composer generally begins with a theme that is taken through a number of variations. Notations direct the tempo and dynamics for the performers. The individual instruments, in following these notations, play their parts in contributing to the total musical effect. In addition, the thematic material is woven through the content of the work, harmonizing its sections. A successful musical composition speaks eloquently, with every measure seeming irreplaceable.

Every musical element just mentioned has its counterpart in art. In every creative medium, be it music, art, dance, poetry, prose, or theater, the goal is unity. For the creator, unity results from the selection of appropriate devices peculiar to the medium and the use of certain principles to relate them. In art, an understanding of the principles of form-structure is indispensable. In the first chapters of this book, one can begin to see the vast possibilities in the creative art realm. Through study of the principles of form organization, beginners develop an intellectual understanding that can, through persistent practice, become instinctive.

The art elements (line, shape, value, texture, and color) on which form is based rarely exist by themselves. They join forces in the total work. Their individual contributions can be studied separately, but in the development of a work, the ways they relate to each other must always be considered. Because each of the elements makes an individual contribution and has intrinsic appeal, the elements are discussed separately in the following five chapters. In an academic sense, it is necessary to do this. But as you study an element, please keep in mind those that preceded it. At the end, all the elements must be considered both individually and collectively. This is a big task, but necessary for that vital ingredient, unity.

3

LINE

The Vocabulary of Line

calligraphy

Flowing, rhythmical lines that intrigue the eye as they enrich surfaces. Calligraphy is highly personal in nature, similar to the individual qualities found in handwriting.

contour

In art, the outer edge of an object or shape that is most often defined by line. Contour is considered by some to be synonymous with *outline*. The edge also may be indicated by the extremities of value, texture, color, or mass.

cross-contour

A line that can define surface undulations between the outermost edges of shapes or objects.

decorative

An effect that emphasizes the two-dimensional nature of any of the visual elements. Decorative art stresses the essential flatness of a surface.

graphic art

1. Any of the visual arts that involves the application of lines or strokes to a two-dimensional surface. 2. The two-dimensional use of the elements. 3. Two-dimensional art forms such as drawings, paintings, and prints. 4. Also may refer to the techniques of printing as used in newspapers, books, and magazines.

line

The path of a moving point; that is, a mark made by a tool or instrument as it is drawn across a surface. A line is usually made visible by the fact that it contrasts in value with the surface on which it is drawn.

mass

In graphic art, a three-dimensional form that appears to stand out from the space surrounding it. In the plastic arts, the physical bulk of a solid body of material.

nonrepresentational (art)

Works of art that do not remind us of things or actual objects. The opposite of representational art. (See *abstraction, nonobjective, representation,* "The Vocabulary of Art," chapter 1.)

plastic art

1. The three-dimensional use of the elements. 2. On a two-dimensional surface, plasticity is always an illusion created by the use of the visual elements in special ways. 3. Three-dimensional art forms such as architecture, sculpture, and ceramics.

Line: The elementary means of visual communication

The line-up—"This guy's giving me a line"—the long gray line—"He plays tackle on the line"—the bus line—"The line forms here.". . . These are some of the expressions that share the word *line* with our first art element. These verbal expressions imply that something is strung out or stretched a certain distance. You undoubtedly have stood in line for something and found your impatience turn to relief as that line became shorter. Your line ("queue" in Britain) may have been a single line (narrow) or two abreast (wider). Sometimes lines become straggly—but this had better not be the case in the military where perfectly straight alignment is enforced. Standing lines often exhibit differences in width due to the different sizes of people in the line or because the people are grouped together.

Art lines and "people lines" have certain features in common. Theoretically, a line is an extended dot; so, if only one person shows up, the dot is made. But, as other people are added, with their different dimensions and positions, the line's characteristics change. In art, these line variations are called *physical characteristics,* and they can be utilized by the artist to create form-meanings as well as to reproduce the appearance of the artist's subjects.

It is difficult to imagine line as existing in nature; nature contains only mass, which can be described in art by means of contour. For the artist, line is a graphic device that can function objectively by describing things or subjectively by suggesting emotional conditions and responses (fig. 3.1). Linear designs in the

form of ideograms and alphabets are used by all people as a basic means of communication, but the artist uses line in a more broadly communicative manner. Line operates in various ways in the visual arts, symbolizing an edge, as on a piece of sculpture; a meeting of areas where value, textural, or color differences do not blend; or a contour, as it defines a drawn shape (fig. 3.2). It may be plastic when suggesting space or calligraphic when enriching a surface (fig. 3.3). In addition, line can perform several of these functions at the same time. Its wide application includes the creation of value and texture, illustrating the impossibility of making a real distinction between the elements of art structure.

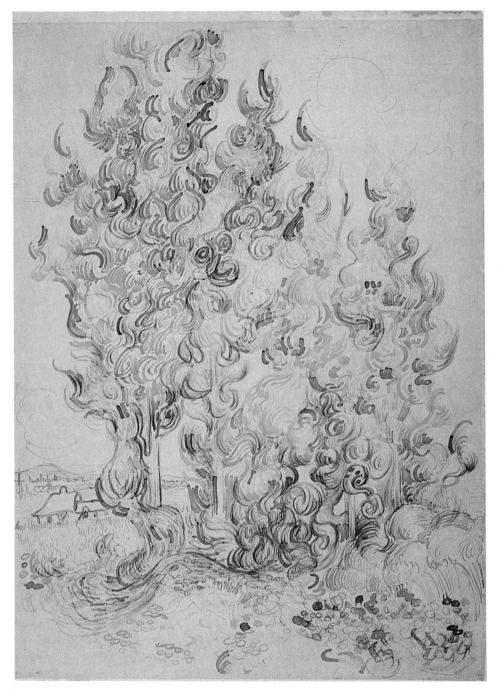

3.1
Vincent van Gogh. *Grove of Cypresses.* 1889, reed pen and ink over pencil on paper, 62.5 × 46.4 cm. By using broad-stroked lines and arranging them in a turmoil of flowing movement, Van Gogh has subjectively interpreted his impression of a wind-blown landscape.

Gift of Robert Allerton, 1927.543. © 1988 The Art Institute of Chicago. All Rights Reserved.

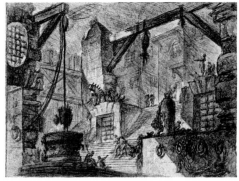

3.2
Giovanni Battista Piranesi. *Carceri* (first state). Circa 1750, print (etching), 16¼ × 22 in. Although this scene is the product of the artist's imagination, the objects are depicted objectively, with line defining their shapes, textures, and shadows.

National Gallery of Art, Washington, D.C. Rosenwald Collection.

3.3
Torii Kiyonobu. *Actor as a Monkey Showman.* No date, woodblock print, 13¼ × 6¼ in. The alterations of movement in the curved lines of this Japanese print are visually entertaining as well as calligraphic because of their subtle rhythmic quality.

Metropolitan Museum of Art, New York. Rogers Fund, 1936.

3.4

George Romney. *Lady Hamilton as a Bacchante.* **Oil on canvas, 63.5 × 77.2 cm.** Form-meanings arise from the line character, which is the product of the medium, tool, and the artist's application. In this painting a certain spirited feeling is created that would not have been present in an objective rendering.

3.5

Georges Mathieu. *Montjoie Saint Denis!* **1954, oil on canvas, 12 ft. 3⅝ in. × 35½ in.** These lines have something of the spirit of those in figure 3.4, but are wholly subjective. The form-meanings of color fortify the expression of the lines.

When lines are used to reproduce the appearance of a subject in an artwork, this appearance can be reinforced by the artist's selection of lines that carry certain form-meanings. In this way, the subject may be altered or enhanced, and the work becomes an interpretation of that subject (fig. 3.4). Form-meanings can also be used in conjunction with the other art elements (fig. 3.5).

Physical characteristics of line

The physical characteristics of line are many: Lines may be straight or curved, direct or meandering, short or long, thin or thick, zigzag or serpentine. The value of these characteristics to the artist is that they have certain built-in feelings and associations. When we say that a man is a "straight arrow," we mean he is straightforward and reliable; a "crooked" person, on the other hand, is devious and untrustworthy. Most of us can find adjectives to describe various kinds of lines; when we do, those words suggest that some kind of meaning resides in the lines—and this is the form-meaning previously cited.

Measure

Measure refers to the length and width of line. A line may be of any length and breadth. An infinite number of combinations of long and short, thick and thin lines can, according to their use, divide or unify the pictorial area.

Type

Any line is by its own nature a particular type. If the line continues in only one direction, it is straight; if it changes direction gradually, it is curved; if those changes are sudden and abrupt, an

angular line is created. Taking into consideration the characteristic of type as well as that of measure, we find that long or short, thick or thin lines can be straight, angular, or curved. The straight line in its continuity ultimately becomes repetitious and, depending on its length, either rigid or brittle. The curved line may curve to form an arc, reverse its curve to become wavy, or continue turning within itself to produce a spiral. Alterations of movement become visually entertaining and physically stimulating if they are rhythmical. A curved line is inherently graceful and, to a degree, unstable (see fig. 3.3). The abrupt changes of direction in an angular line create excitement and/or confusion (fig. 3.6). Our eyes frequently have difficulty adapting to an angular line's unexpected deviations of direction. Hence, the angular line is full of challenging interest.

Direction

A further complication of line is its basic direction, a direction that can exist irrespective of the component movements within the line. That is, a line can be a zigzag type but take a generally curved direction. Thus, the line type can be contradicted or flattered by its basic movement. A generally horizontal direction could indicate serenity and perfect stability, whereas a diagonal direction would probably imply agitation and motion (fig. 3.7). A vertical line generally suggests poise and aspiration. The direction of line is very important because in large measure it controls the movements of our eyes while we view a picture. Our eye movements can implement the continuity of relationships among the various elements and their properties.

3.6
Student work. *Cock Fight.* The abrupt changes of direction in the angular lines of this drawing create the excitement and tension of combat.
Bowling Green State University.

3.7
Mel Bochner. *Vertigo.* 1982, charcoal, Conte, crayon, and pastel on canvas, 108 × 74 in. Line, the dominant element in this work, is almost wholly diagonal. This imparts a feeling of intense activity and stress.
Albright-Knox Art Gallery, Buffalo, New York. The Charles Clifton Fund, 1982.

3.8
Student work. *Violinist.* A number of expressive qualities can be created by the manner in which the artist varies line character. The idea of a violinist is expressed in these line groupings.

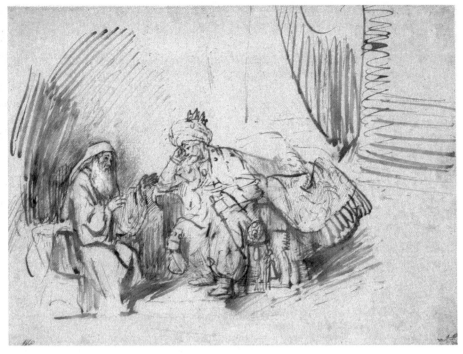

3.9
Rembrandt Harmensz van Ryn. *Nathan Admonishing David.* **No date, pen and brush with bistre, 7⁵⁄₁₆ × 9⁵⁄₁₆ in.** The crisp, biting lines of the pen are complemented by the broader, softer lines of the brush.
Collection, Metropolitan Museum of Art, New York. Bequest of Mrs. H. O. Havemeyer, 1929. The Havemeyer Collection.

Location

The control exercised over the measure, type, or direction of a line can be enhanced or diminished by the location of the line. According to its placement, a line can serve to unify or divide, balance or unbalance a pictorial area. A diagonal line might be soaring or plunging, depending upon its high or low position relative to the frame. The various attributes of line can act in concert toward one goal or can serve separate roles of expression and design. A fully developed work, therefore, may recognize and use all physical factors, although it is also possible for fewer to be used successfully. This is true largely because

of the dual role of these properties. For instance, unity in a work might be achieved by repetition of line length, at the same time that variety is being created through difference in the line's width, medium, or other properties.

Character

Along with measure, type, direction, and location, line possesses character, a term largely related to the medium with which the line is created. Different medium conditions can be used to create greater interest. Monotony can result from the consistent use of lines of the same character unless the unity so gained is balanced by the variation of other physical properties. Varied instruments,

such as the brush, burin, stick, and fingers, contain distinctive capabilities to be exploited by the artist (fig. 3.8). The artist is the real master of the situation, and it is the artist's ability, experience, intention, and mental and physical condition that will determine the effectiveness of line character. Whether the viewer sees lines of uniformity or accent, certainty or indecision, tension or relaxation, are decisions only the artist can make.

The nature of the medium is important in determining the personality or emotional quality of the line. The different expressive qualities inherent in the soft lines of brush and ink as opposed to the precise, firm lines of pen and ink can be easily seen (fig. 3.9).

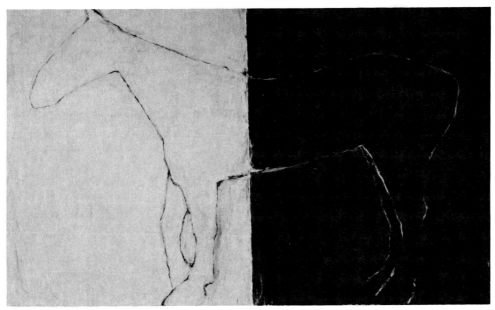

3.10
Susan Rothenberg. *United States.* **1975, acrylic and tempera on canvas, 114 × 189 in.** The line describing the horse in this painting is called a contour. Susan Rothenberg is a contemporary artist who is noted for her series of horses done in a manner that might be referred to as Minimalist Abstract.
Doris and Charles Saatchi, London.

Expressive properties of line

The qualities of line can be described by general states of feeling—gay, somber, tired, energetic, brittle, alive, and the like. However, in a work of art, as in the human mind, such feelings are rarely so clearly defined. An infinite number of conditions of varying subtleties can be communicated by the artist. The spectator's recognition of these qualities is a matter of feeling, which means that the spectator must be receptive and perceptive and have a reservoir of experiences.

Through composition and expression, individual lines come to life as they play their various roles. Some lines are dominant and some subordinate, but all are of supreme importance in a work of art. Although lines may be admired separately, their real beauty lies in the relationships they help to establish, the form that is created. This form can be representational or nonrepresentational,

but the recognition and enjoyment of the work on the abstract level is of first importance. Preoccupation with subject identification significantly reduces appreciation of the truly expressive art qualities.

Line as related to the other art elements

Line has additional physical characteristics that are closely related to the other art elements. Line can possess color, value, and texture, and it can create shape. Some of these factors are essential to the very creation of line, while others are introduced as needed. These properties might be thought of separately, but nevertheless, they cooperate to give line an intrinsic appeal, meaning that line can be admired for its own sake. Artists often exploit this appeal by creating

pictures in which the linear effects are dominant and all others subordinate. On the other hand, some works are virtually line-free, depending entirely on other elements.

Line and shape

In creating shape, line serves as the continuous edge of a figure, object, or mass. A line that describes an area in this manner is called *contour*. Contour lines might also separate shapes, values, textures, and colors (fig. 3.10).

A series of closely placed lines creates textures and toned areas. The relationships of the ends of these linear areas establish boundaries that transpose the areas into shapes.

Line and value

The contrast in light and dark that a line exhibits against its background is called *value*. Every line must have value to be visible. Groups of lines create areas that can differ in value. Lines can be thick, thin, or any width in between. Wide, heavy lines appear dark in value, while narrow lines appear light in value. Value changes can be controlled by varying the spaces between the lines. Widely spaced lines appear light, and closely spaced lines appear dark (fig. 3.11). Value differences also result from mixtures of media or from the amount of pressure exerted. Parallel lines, cross-hatching, and the like are examples of groups of single lines that create areas of differing value (figs. 3.12 and 3.13).

3.11
Group lines produce value. The upper row of blocks appears to become darker from left to right because the lines increase in width. In the second row of blocks, a similar effect is created because the lines on the right are positioned closer to each other.

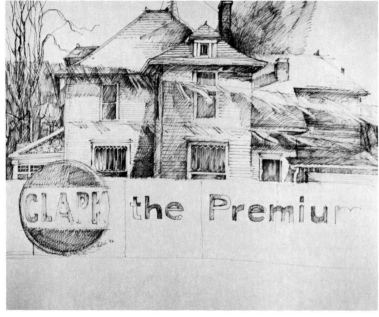

3.12
Glenn Felch. *House with Clark Sign*. 1972, India ink and colored felt pens on paper, 17 × 22 in. Values can be created by varying the spaces between the lines; the parallel quality of the lines also injects a degree of harmony.
Courtesy of the artist.

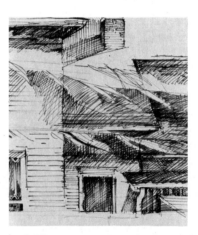

3.13
Glenn Felch. *House with Clark Sign* (detail). 1972, India ink and colored felt pens on paper. This enlargement of a section of figure 3.12 shows the importance of line in creating interesting areas of value differences.

Line and texture

When groups of lines combine to produce a flat or two-dimensional effect, *pattern* results. If, however, the result stimulates our sensation of touch by suggesting degrees of roughness or smoothness, the effect is called *texture* (fig. 3.14). Texture also resides within the character of various media and tools and gives them their distinctive qualities, which can be enhanced or diminished by the manner of handling. Brushes with a hard bristle, for instance, can make either sharp or rough lines, depending on hand pressure, amount of medium carried, and quality of execution. Brushes with soft hairs can produce smooth lines if loaded with thin paint or thick, blotted lines if loaded with heavy paint. Other tools and media can produce similar variations of line (fig. 3.15).

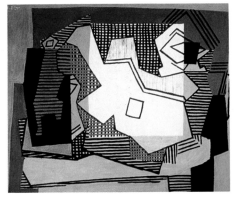

3.14
Pablo Picasso. *Still Life.* Circa 1907–08, pen and brown ink with charcoal and watercolor on ivory wove paper, 33.3 × 56.8 cm. The artist often uses groups of lines to suggest texture. When such groups are combined to produce a flat or two-dimensional effect, pattern results.
Gift of William N. Eisendrath, Jr. 1940.1047.
© 1988 The Art Institute of Chicago. All Rights Reserved.

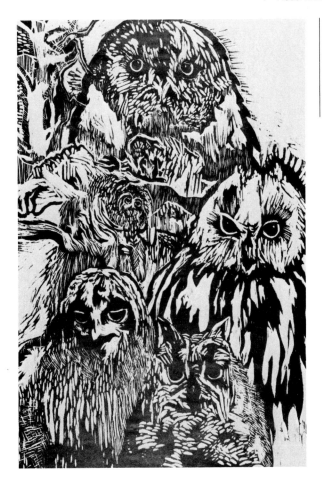

3.15
Student artist. *Owls.* Print (woodcut). When knives and gouges are used to cut the wood, the lines and textures created are usually somewhat different from those produced by another medium.
Bowling Green State University.

3.16

Dan Christensen. *GRUS.* 1968, acrylic on canvas, 123 × 99 in. Variations in the continuous curvilinear lines within this painting create illusions of open space. These variations include changes in the physical properties of the measure, direction, location, and character of the lines as well as changes in value and color.

The Hirshhorn Museum and Sculpture Garden, Smithsonian Institution. Gift of Joseph H. Hirshhorn, 1972. Photo by Lee Stalsworth.

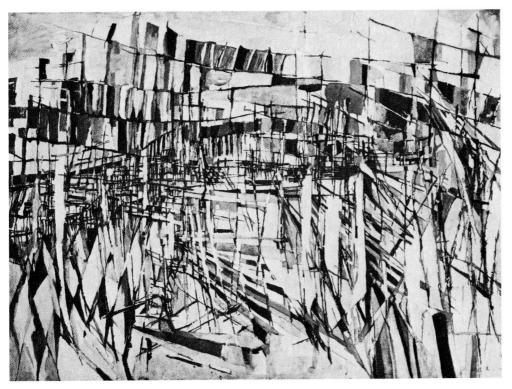

3.17
Maria Helena Vieira da Silva. *The City.* **1951, oil on canvas, 37¼ × 32¼ in.** The spatial illusion, of such obvious importance in this example, is largely the product of the physical properties of the lines strengthened by value shapes.

The Toledo Museum of Art, Toledo, Ohio. Gift of Edward Drummond Libbey.

Line and color

The introduction of color to a line adds an important expressive potential. Color can accentuate other line properties. A hard line combined with an intense color produces a forceful or even harsh effect. This effect could be considerably overcome if the same line were created in a gentler color. Color has become identified with various emotional states. Thus, the artist might use red to symbolize passion or anger, yellow to suggest cowardice or warmth, and so forth (see "Color and emotion," chapter 7).

Spatial characteristics of line

All of the physical characteristics of line contain spatial properties that are subject to control by the artist. Mere position within a prescribed area suggests space. Value contrast can cause lines to advance and recede (fig. 3.16). An individual line with varied values throughout its length may appear to writhe and twist in space. Because warm colors generally advance and cool colors generally recede, the spatial properties of colored lines are obvious. Every factor that produces line has something to say about line's location in space. The artist's job is to use these factors to create spatial order (fig. 3.17).

3.18

J. Seeley. *Stripe Song.* 1981, print (photo silk screen), 22 × 30 in. Seeley is an acknowledged master of the high-contrast image form. Combining the undeniable visual appeal of Op art with the implicit realism of the photographic image, his black-and-white linear abstractions are boldly decorative, highly complex, and a delightful treat for the eye. From the photographer.

Line and representation

Line creates representation on both abstract and realistic levels. We have dealt primarily with abstract definitions, but it is easy to see that the application can be simultaneously observed in a material context. For example, we have discussed the advancing-receding qualities of value in a line. If a particular line is drawn to represent the contours of a piece of drapery, the value contrast might describe the relative spatial position of the folds of the drapery (fig. 3.18). An artist drawing a linear portrait of a person might use line properties to suggest more than just a physical presence. The artist might also be able to convey—either satirically or sympathetically—much information about the character of the sitter. Thus, line in representation has many objective and subjective implications. All are the direct result of the artist's manipulation of the physical properties (fig. 3.19).

In its role of signifying ideas and conveying feelings, line moves and lives, pulsating with significant emotions. In visual art, line becomes a means for transcribing the expressive language of ideas and emotions. It describes the edges or contours of shapes, it diagrams silhouettes, it encompasses spaces and areas—all in such a way as to convey meaning.

Line is not used exclusively to express deep emotion and experience. Often, it depicts facts alone: an architect's plan for a building or an engineer's drawing of a bridge; lines drawn on maps to represent rivers, roads, or contours; or lines drawn on paper to represent words. Such use of line is primarily utilitarian, a convenient way of communicating ideas to another person. Whichever the emphasis—expression of human emotions or communication of factual materials—line is an important plastic element at the disposal of the artist (fig. 3.20).

3.19
Juan Gris. *Max Jacob.* 1919, pencil, 14⅜ × 10½ in. sheet. This drawing, done entirely in line, provides information on the physical presence as well as the psychological character of the sitter.
Collection, The Museum of Modern Art, New York. Gift of James Thrall Soby.

3.20
Steve Magada. *Trio.* 1966, oil on canvas, 29 × 36 in. Line is admired for its own sake. Magada has exploited this appeal by creating a picture in which the linear effects are dominant.
Courtesy Virginia Magada.

4

SHAPE

The Vocabulary of Shape

amorphic shape
Shape that has imprecise edges.

biomorphic shape
Irregular shape that resembles the freely developed curves found in live organisms.

Cubism
A term given to the artistic style that generally uses two-dimensional geometric shapes.

decorative shape
A two-dimensional shape that appears to lie flat on the picture plane.

geometric perspective
A drawing system based on geometry that is used to create the illusion of three-dimensional objects and space on the two-dimensional surface of the picture plane.

geometric shape
A shape that is related to geometry. Geometric shapes are usually simple, such as the triangle, the rectangle, and the circle.

intuitive space
A pictorial spatial illusion that is not the product of any mechanical system but relies, instead, on the physical properties of the elements and the instincts, or ''feel,'' of the artist.

mass
In pictorial art, the illusion of a solid body of matter, i.e., shapes, value, color, or textural areas, etc.

planar
Having to do with planes.

plane
A shape that is essentially two-dimensional, having height and width.

plastic shape
1. In the graphic arts, any shape suggesting the illusion of a three-dimensional shape surrounded by space. 2. In the plastic arts, any shape comprised of height, width, and thickness.

rectilinear shape
A shape whose boundaries usually consist entirely of straight lines.

shape
An area that stands out from the space next to or around it because of a defined boundary or because of difference of value, color, or texture.

subjective shape
Imaginative or personal shape(s) invented by the artist to suit some point of view not based on objects.

Surrealism
A style of artistic expression that emphasizes fantasy and whose subjects are usually experiences revealed by the subconscious mind.

three-dimensional shape
A shape having height, width, and depth. (See *plastic shape*.)

two-dimensional shape
An area confined to length and width and set apart by contrasts of line, value, color, and/or texture.

volume
A three-dimensional shape that occupies a quantity of space. On a flat surface, the artist can create only the illusion of a volume.

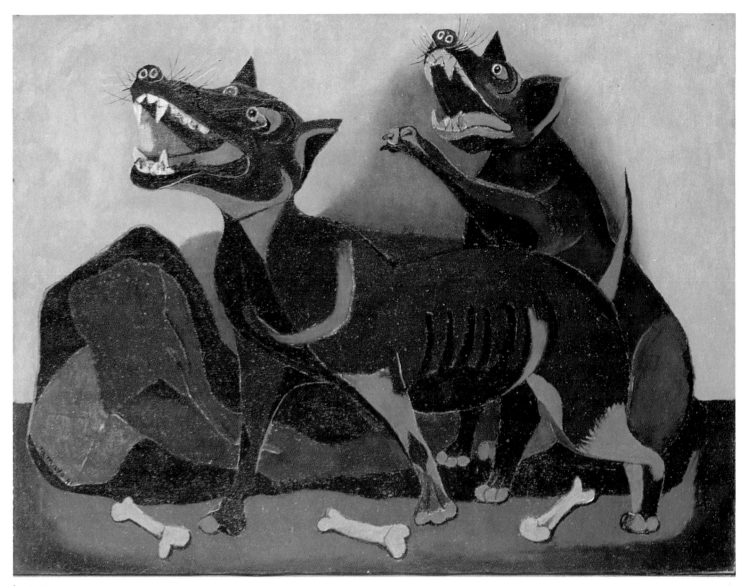

4.1
Rufino Tamayo. *Animals.* 1941, oil on canvas, 30⅛ × 40 in. Tamayo has created a
semifantasy by using semiabstract shapes to picture beasts, animal-like in general
appearance but of no recognizable species. The stark shapes emphasize the savage
environment.
Collection, The Museum of Modern Art, New York. Inter-American Fund.

Introduction to shape

Shapes are the building blocks of art
structure. Edifices of brick, stone, and
mortar are intended by the architect and
mason to have beauty of design, skilled
craftsmanship, and structural strength.
The artist shares these same goals in
creating a picture. Bricks and stones,
however, are tangible objects, whereas
pictorial shapes exist largely in terms of
the illusions they create. The challenge
facing the artist is to use the infinitely
varied illusions of shape to make
believable the fantasy inherent in all art.

In other words, an artwork is never the
real thing, and the shapes producing the
image are never real animals, buildings,
or people—the artist's subjects, if indeed
the artist uses subjects at all. The artist
may be stimulated by such objects and, in
many cases, may reproduce the objects'
basic appearances fairly closely. The
alterations of surface appearance required
to achieve compositional unity may result
in a *semifantasy* (fig. 4.1). On the other
hand, the artist may use shapes that are
not intended to represent anything at all,
or that, even though representational at

the outset, may eventually lead to a final
work in which copied appearances are
almost eliminated. This could be called
pure fantasy, because the final image is
entirely the product of the artist's
imagination. Capable artists, whatever the
degree of their fantasy, are able to
convince us that the fantasy is a possible
reality. Any successful work of art,
regardless of medium, leads a sensitive
observer into a persuasive world of the
imagination. In the visual arts, shapes
play an important part in achieving this
goal.

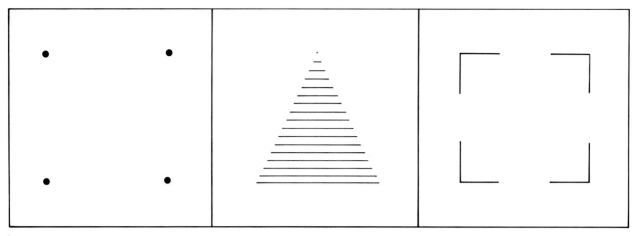

4.2
The psychological suggestion of shapes formed by dots and lines.

Definition of shape

We can begin to define shape in art as a line enclosing an area. Such use of line is called *outline* or *contour*. Even when we have only a few elements of form to go by, as illustrated by figure 4.2, our minds can adjust to read a visible effect of shape. Apparently, we have an instinctive need for order that enables our minds to fill in the parts that have been left out. Thus, we see these diagrams as shapes, even though no contours have been drawn in between the four corners of the square or around the tips of the lines forming the triangle. Our minds adjust quickly to these elementary forms that suggest shapes. The last diagram, in which gaps are left in the edges of what appears to be a square, is filled in mentally and then comes closest to illustrating our first definition of a shape as a line enclosing an area. But the diagrams imply that we have to qualify our first definition, since closure is not always a necessary condition of the form element shape.

If we wish to establish a more formal definition of shape, there are other ways of doing so in graphic or pictorial forms of art. Among the possible definitions are: any visually perceived area of value, texture, color, or line—or any combination of these elements. In pictorial forms of art, shapes are flat, or two-dimensional, images. In the three-dimensional or plastic forms of art (sculpture, architecture, environmental design), shapes are more often described as solids, or volumes. Three-dimensional artists quite often do their initial planning in terms of graphic imagery, thus they must be aware that the surface on which they work, the *picture plane,* is a shape. The picture plane conditions the use and characteristics of all shapes and other elements on it, as was already discussed at greater length in chapter 3.

Shapes in pictorial art sometimes have exact limits, as with the contour line in our first definition of shape, or they can be amorphic—that is, so vague or delicate that their edges cannot be determined with any degree of exactitude (fig. 4.3). Shapes in the plastic arts, however, are generally more positive than in the pictorial arts; their edges, or outer contours, are the determining factor, no matter what their degree of irregularity or ambiguity (fig. 4.4).

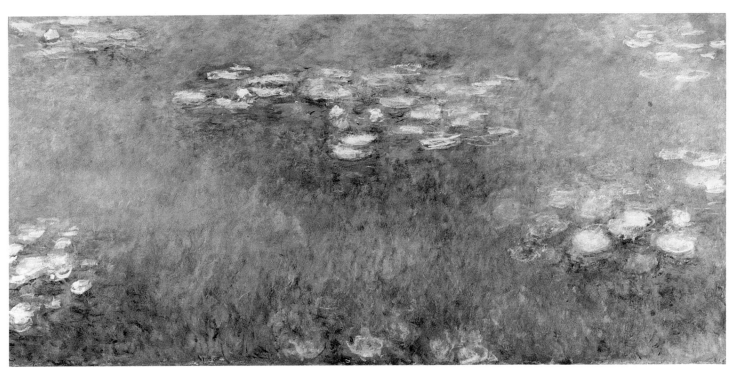

4.3

Claude Monet. *Les Nympheas* **(The Water Lilies). 1920–22, oil on canvas, 78¾ ×
167¾ in.** Had he chosen, Monet could have painted a more distinct version of the lilies in
the water, but he was much more interested in the effect of shimmering light on color
relationships, thus he painted them indistinctly, or as amorphic shapes.

The St. Louis Art Museum. Gift of the Steinberg Charitable Fund.

4.4

Chryssa. *Fragment for the Gates to
Times Square.* **1966, neon and
Plexiglas®, 81 × 34½ × 27½ in.** Despite
the irregularity and complexity of the
contours, lighting, and color of these
sculptural shapes, the edges of contours
read more clearly than is often the case in
the graphic arts.

Collection of Whitney Museum of American Art.
Gift of Howard and Jean Lipman. 66.135.
Photography by Geoffrey Clemente, Inc., New
York.

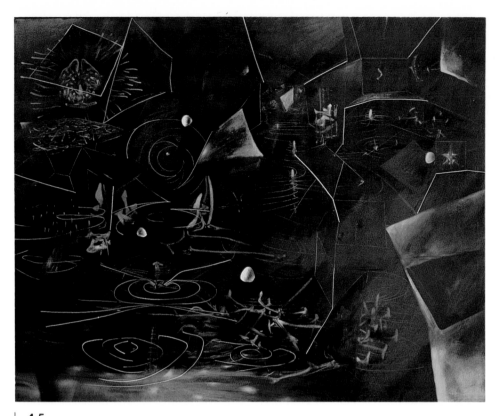

4.5

Matta. *Le Vertige d'Eros.* **1944, oil on canvas, 6 ft. 5 in. × 8 ft. 3 in.** Within the limits of the human mind's ability to conceive such things, Matta has given us a vision of a completely alien milieu. Though as far as imaginable from everyday reality, this environment seems possible, thanks to the facility of the artist.

Collection, The Museum of Modern Art, New York. Given anonymously.

Shapes can vary endlessly, ranging from different sizes of basic squares, rectangles, circles, and triangles to limitless combinations of angular and curving shapes of varying proportions. They can also be static and stable, or active and lively. Shapes can seem to contract or expand, depending on how they are used by the artist.

Shapes are classified into different categories or families depending on whether they are imaginary (subjective) or visible (objective). The configuration of a shape gives it a character that distinguishes it from others that are similar. When the shapes used by an artist imitate those shaped by natural forces (stones, puddles, leaves, clouds), they are called *naturalistic, representational, realistic,* or *objective.* When they seem to have been contrived by the artist, they are called *abstract, nonobjective,* or *nonrepresentational.* The distinction between objective and abstract shapes is not always easily made, because the variations of both are so vast.

Natural forms generally seem rounded. We see this in the elemental organisms encountered in biology (such as amoebas, viruses, and cells). Biological affinity for the curve led to the term *biomorphic* to describe the curvilinear shapes in art that suggest life. These lifelike shape families are also often labeled *organic* or *free forms* (fig. 4.5).

With the great interest aroused by Pure-Abstract art, the increasing awareness of the microcosm through science, and the growth of Freudian psychology, the biomorphic-type shape found great use in the hands of Surrealist artists. Their interests in the mystic origins of being and in the exploration of subconscious revelations, such as dreams, attracted them strongly to the biomorphic shape (fig. 4.6). Other artists (Matisse and Braque are examples) abstracted organic forms in a less symbolic and primarily decorative manner (fig. 4.7).

In contrast to the biomorphic shapes are *rectilinear* (straight-lined) shapes, called *geometric* because they are based on the standardized shapes used in mathematics. The precisionist, machinelike geometric shapes, with their sense of human inventiveness, appealed to the Cubists, who utilized them in their pictorial dissection and reformulation of the natural world (fig. 4.8).

From these examples, it is clear that, however shapes are classified, each shape or combination of shapes can elicit a variety of personalities according to their employment and our responses to them.

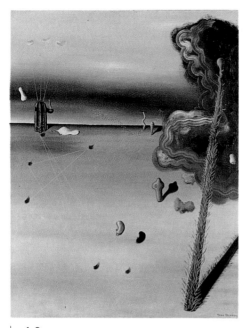

4.6
**Yves Tanguy. *Mama, Papa is Wounded!*
1927, oil on canvas, 36¼ × 28¾ in.**
Surrealists such as Yves Tanguy have
given considerable symbolic significance to
biomorphic shapes. Biomorphic shapes
remind us of basic organic matter or of
flowing and changing shapes in dreams.
Collection, The Museum of Modern Art, New
York. Purchase.

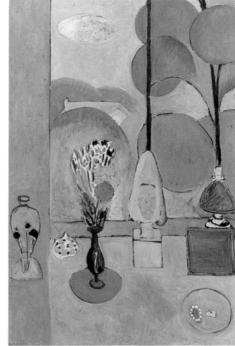

4.7
**Henri Matisse. *The Blue Window.*
Autumn 1911, oil on canvas, 51½ ×
35⅝ in.** Matisse has abstracted organic
forms for the purpose of decorative
organization.
Collection, The Museum of Modern Art, New
York. Abby Aldrich Rockefeller Fund.

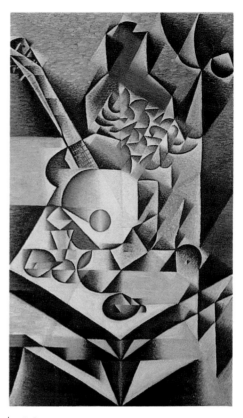

4.8
**Juan Gris. *Guitar and Flowers.* 1912, oil
on canvas, 44⅛ × 27⅝ in.** In direct
contrast to biomorphic shapes are the
rectilinear or straight-line shapes preferred
by the Cubists. Shape families such as
biomorphic and rectilinear are used by
artists to unify, through repetition, their
picture surface.
Collection, The Museum of Modern Art, New
York. Bequest of Anne Erikson Levene in
memory of her husband, Dr. Phoebus Aaron
Theodor Levene.

Use of shapes

We have implied that shapes are used by
artists for two fundamental purposes: to
suggest a physical form they have seen or
imagined, and to give certain visual
qualities or expressions to a work of art.
The physical utilization of shape in art
entails some of the following purposes:

1. To achieve order, harmony, and
 variety—all related to the
 principles of design discussed in
 chapter 3.
2. To create the illusion of space,
 volume, and mass on the surface of
 the picture plane in pictorial art.
3. To extend observer attention or
 interest span.

The last usage listed requires further
clarification. Where the arts of music,
theater, and dance evolve in time, the
visual arts are usually time-fixed. Thus
the time of an observer's oneness or
mental unity with most works of art is
extremely limited. This is particularly
true in the pictorial or graphic arts,
although not so much with one form of
sculptural art, the mobile. Since mobiles
are a movable, not static, form of
sculpture, they can hold the viewer's
attention longer. Historically, the staticity
of the visual arts has been a matter of
much concern to artists, leading to many
attempts at overcoming it using various
visual devices.

Shape and principles of design

If artists wish to create order or unity and
increase attention span, they have to
conform to certain principles of order or
design. In observing these principles, they
are often forced to alter shapes from their
natural appearances. It is in this respect
that shapes can be called the building
blocks of art structure. Just as with line,
our first element of artistic form, shapes
have multiple purposes in terms of visual
manipulation and their psychological or
emotional effects. These purposes, as
suggested, vary with both the artist and
the viewer.

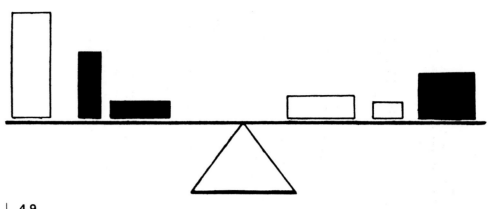

4.9
This diagram shows amounts of force, or weight, symbolized by shapes.

The principles determining the ordering of shapes are common to the other elements of form. In their search for significant order and expression, artists modify the elements until:

1. The desired degree and type of balance is achieved.
2. The observer's attention is controlled, both in direction and duration.
3. The appropriate ratio of harmony and variety results.
4. The space concept achieves consistency throughout.

These principles are important enough to merit additional investigation.

Balance

As artists seek compositional balance, they work with the knowledge that shapes have different visual weights depending on how they are used. Although this principle of form organization was treated at some length in chapter 3, it may be helpful to reexamine balance in regard to shape by reusing the example of the seesaw, or weighing scale, as depicted in figure 4.9. We see that placing shapes of different sizes at varying distances from the fulcrum can create a sense of balance or imbalance. Since no actual weight is involved, we assume that the sensation is intuitive, or felt, as the result of the various properties composing the art elements. For example, a dark value adds weight to a shape, while substituting a narrow line for a wider line around it reduces the shape's apparent weight.

The seesaw is an example of how a few basic elements can operate along only one plane of action. Developed artworks, on the other hand, contain many diverse elements working in many directions. The factors that control the amounts of directional and tensional force generated by the various elements are: placement, size, accents or emphasis, and general shape character (including associational equivalents to be discussed under "Duration and relative dominance" later in this chapter). The elements are manipulated by the artist until the energy of their relationships results in dynamic tension.

Control of attention

Direction Artists can use the elements of form to generate visual forces that will control the movement of our eyes as we view their work. Pathways are devised to provide transition from one pictorial area to another. The artist usually tries to make our eye movements over these eye paths rhythmic, thereby providing both pleasurable viewing and a strong unifying factor for the work. The character of rhythmic viewing depends upon the nature of the artist's expressive intentions—jerky, sinuous, swift, or slow (figs. 4.10 and 4.11).

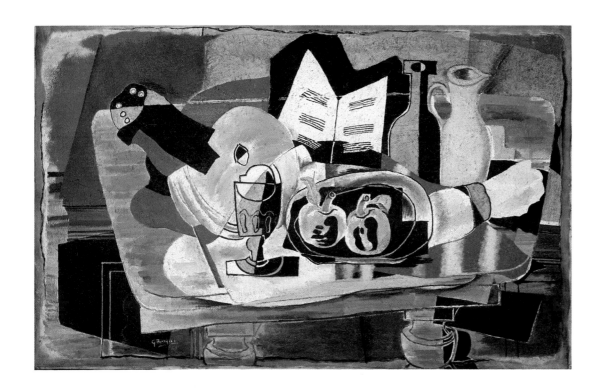

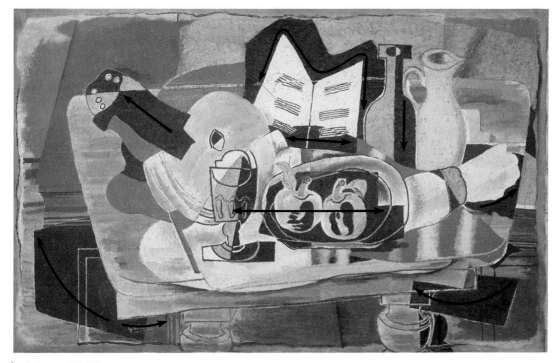

4.10 and 4.11
Georges Braque. *Still Life: The Table.* **1928, oil on canvas, 32 × 51½ in.** This painting
by the French Cubist Georges Braque has many elements that contain direction of force.
The simplified grouping of darks in figure 4.10 illustrates the controlled tension resulting
from the placement, size, accent, and general character of the shapes used by the artist. In
figure 4.11 the black arrows show the predetermined eye paths by which the artist created
visual transition and rhythmic movement.

National Gallery of Art, Washington, D.C. Chester Dale Collection.

Duration and relative dominance The unifying and rhythmic effects provided by eye paths are also modified by the number and length of the pauses in the eye journey. A viewing experience is more monotonous if the planned pauses are of equal *duration*. The artist, therefore, attempts to organize pauses so that their lengths are related to the importance of the sights to be seen on the eye journey (fig. 4.12). The duration of a pause is determined by the pictorial importance of the area. A number of factors can control duration. In a portrayal of the Crucifixion, we would expect an artist to make the figure of Christ dominant (fig. 4.13). Artists can control *dominance* through contrast, size, value, shape, location, color, or combinations of any of these. Modification of the physical properties of any of the elements invariably affects spectator attention. Artists develop dominance in a work on the basis of their feelings, and they reconcile the various demands of the design principles with those of relative dominance. The degree of dominance is usually in direct proportion to the amount of visual contrast. Relative dominance acts the same way in both representational and nonrepresentational work (figs. 4.13 and 4.14). The factor (size, for example) makes Christ dominant in figure 4.13 and would also work to make the circle dominant in figure 4.14. There is, however, another factor—association, or similarity—that tends to qualify the attention given to shapes or other elements. The oval tree shapes in Gauguin's *The Yellow Christ,* for instance, afford a contrast to Christ's Y-shape that is more dominant than size (see fig. 4.13). In an abstract work of art, an oval shape may well receive more attention if by some chance it reminds us of a head. Although artists may try to avoid such chance interpretations, they cannot always be foreseen. At other times artists can use the innate appeal of associational factors to advantage, weighing them in the balance of relative dominance and forcing them to operate for the benefit of the total organization.

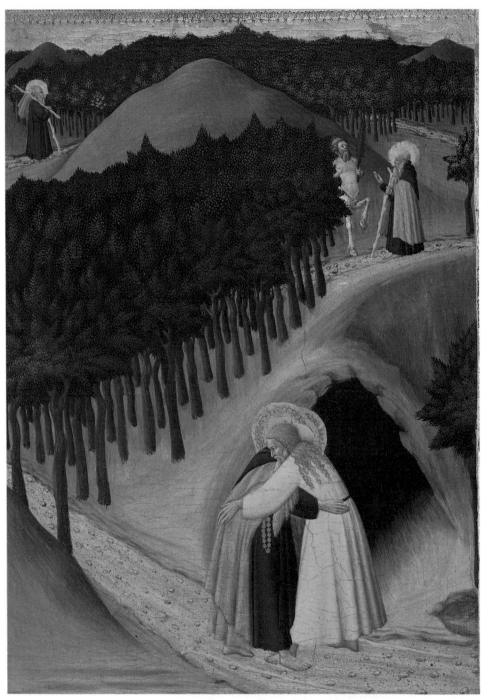

4.12

Sassetta and assistant. *The Meeting of Saint Anthony and Saint Paul.* Circa 1440, wood, 18¾ × 13⅝ in. In this painting by the Renaissance artist Sassetta, "station stops" of varied duration are indicated by contrasts of value. In addition, eye paths are provided by the edges of the natural forms that lead from figure to figure. This painting also illustrates a shallow space concept deriving from the Middle Ages.

National Gallery of Art, Washington, D.C. Samuel H. Kress Collection.

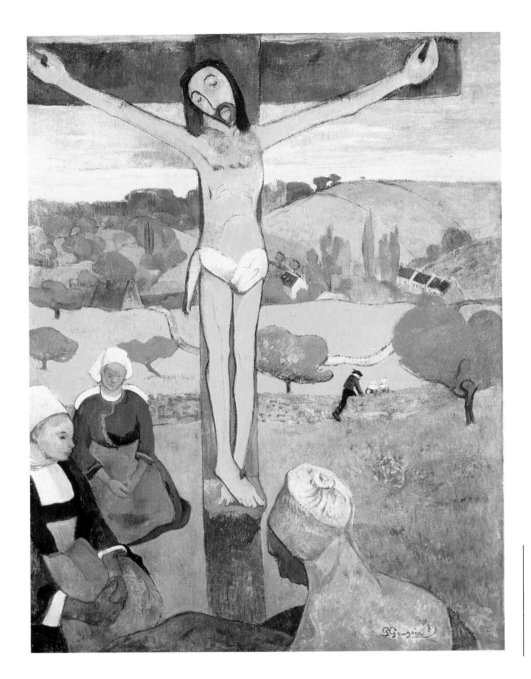

4.13
**Paul Gauguin. *The Yellow Christ*. 1889,
oil on canvas, 36¼ × 28⅞ in.** Gauguin
has made the figure of Christ paramount
through size, location, shape, and color
differences.

Albright-Knox Art Gallery, Buffalo, New York.
Consolidated. Purchase Funds, 1946.

4.14
**Herve Huitric and Monique Nahas.
Carouline. 1982, computer print, 20 ×
24 in.** The principles of duration and
relative dominance are enhanced in this
computer-generated print by the relative
centering of the principal shapes and their
strong value contrast with the background.

Courtesy of the artists.

4.15
Diagrams illustrating ways that rectilinear planes can suggest the illusion of space.

4.16

Use of planar shapes to create the illusion of space. (*A*) Curvilinear or circular planes overlapped, suggesting shallow space. (*B*) Curvilinear planes placed on edge and tilted to suggest a deeper effect of space. The circles become elliptical in shape. (*C*) Straight-edged or rectilinear planes formed to suggest the illusion that they float in deep space (see fig. 4.15 for a shallower space effect). (*D*) Elliptical planes suggesting volumes. The example on the left shows how they would also appear from different eye levels. The example on the right suggests a bottle and its cross sections according to relative eye levels. In line drawings of such planes, the planes are accented by thickening the near edges, aiding the illusion of spatial direction. Variations of value, size, texture, and color could further enhance or diminish the spatial illusion if added to the planar shapes.

A

B

C

D

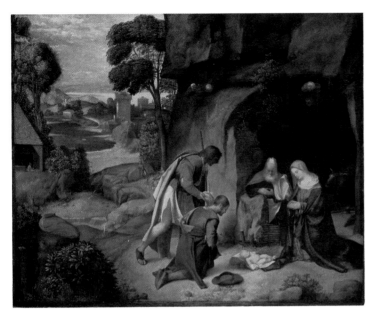

4.17
Giorgione. *The Adoration of the*
Shepherds. **Circa 1505–10, wood, 35¾**
× 43½ in. Giorgione reflects the period of
the early sixteenth century when the
concept of space was primarily concerned
with the illusion of distance.

The National Gallery of Art, Washington, D.C.
Samuel H. Kress Collection.

4.18
John Marin. *Phippsburg, Maine.* **1932,**
watercolor, 19⅞ × 15¼ in. Marin is an
example of a present-day artist who
prefers to emphasize the essential flatness
of his painting surface. He does this by
limiting his space.

Metropolitan Museum of Art, New York. Alfred
Stieglitz Collection, 1949.

Shapes and space

Pictorial depth: The plane

The simplest and probably most useful
shape in pictorial forms of art is the
plane. The surface on which artists work
is called the picture plane, as mentioned
earlier. In addition to being a working
surface, a planar shape is often used to
simplify the vast number of points,
masses, or shapes in nature. Planes can
create more economical, stable, and
readily ordered units. Beyond this, planes
are extremely useful in creating the
illusion of pictorial depth and plastic form
on the two-dimensional picture plane.

Planes vary from flat, two-dimensional
shapes (decorative shapes) to those that
seem to occupy space (volumes). Artists
use all kinds of shapes to achieve either
decorative or plastic effects of shape and
space. Rectilinear shapes may look flat
when lying on the surface of the picture
plane, but even a simple overlapping of

two or more can give them a sense of
depth. The addition of size, color, value,
and texture contrasts can effect an
impression of depth even more definitively
(fig. 4.15).

Curvilinear planes, those planar shapes
made up of ovals, circles, or other
biomorphic qualities, can also create
shallow effects of space or, through their
curving nature, suggest movements into
depth. When either rectilinear or
curvilinear planes are given a
foreshortened or perspective appearance
by tilting them into depth and making the
near end look larger than the distant one,
we have a much stronger visual statement
of depth than we get from the decorative
use of planes (fig. 4.16).

Every work of pictorial art contains
actual or implied shapes and, with them,
some degree of spatial illusion. Artists
throughout history have reflected the

controlling concepts of their times in their
use of pictorial space. According to these
concepts, spatial phenomena have ranged
from decoratively flat and shallow to
illusionistically infinite (figs. 4.17, 4.18;
see figs. 4.7 and 4.12). The last hundred
years have witnessed the transition from
deep space to shallow space favored by
many contemporary artists. Some artists
feel that shallow space permits greater
organizational control of the art elements
and is more in keeping with the essential
flatness of the working surface in pictorial
forms of art (see figs. 4.7, 4.12, and 4.18
again). However, all spatial concepts are
amply in evidence today, indicating the
diversity of our contemporary art scene.
Space concepts are used arbitrarily, and
even in combination when necessary, to
achieve the desired results.

4.19
Three-dimensional shapes or volumes suggested by planes.

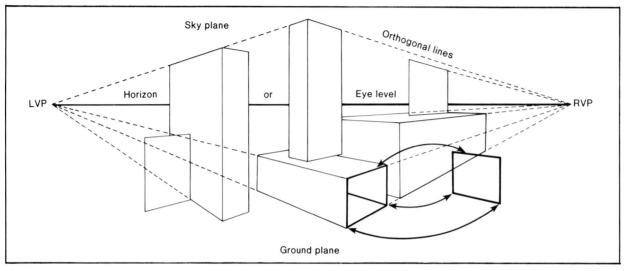

4.20
A drawing showing the essential difference between planes and volumes. Planes are shapes having only two dimensions (height and width), whereas volumes, which are made up of planes, have the effect of solidity, or three dimensions (height, width, and depth). The component planes (sides) of volumes may be detached and inclined back in space at any angle as indicated by the arrows in the drawing. The drawing is also an example of two-point perspective. Object edges are shown as solid lines; orthogonals (vanishing lines) as broken. Vanishing points (LVP and RVP) show where object edges converge at the eye level or horizon line representing infinity. The eye level divides the picture space into planes representing the ground and sky.

Planes and volumes

When two or more planes are arranged in relation to one another to give the appearance of the thickness that converts them into volumes, there is an automatic implication of space (see diagrams, fig. 4.19). The planes that constitute the sides of these volumes could be detached from the parent mass and tilted back into space at any angle and to any depth (fig. 4.20). In fact, such planes do not even have to

appear closed or joined at the corners of a volume in order to afford an appearance of solidity (see fig. 4.19).

The effect of solidity created through the juxtaposition of planes makes the plane less substantial than the volume, but more flexible in the pictorial exploration of space. However, regardless of spatial suggestion, both volumes and planes are shapes whose roles in the two-dimensional arrangement of pictorial works of art must be considered.

Geometric perspective

Geometric perspective, often called *linear perspective,* is the graphic artist's principal system for creating the illusion of three-dimensional volumes existing in space. It was the invention of three artists working together in fifteenth-century Italy, or the Early Renaissance: Masaccio, a painter; Donatello, a sculptor; and Brunelleschi, a painter-turned-architect (figs. 4.21 and 4.22).

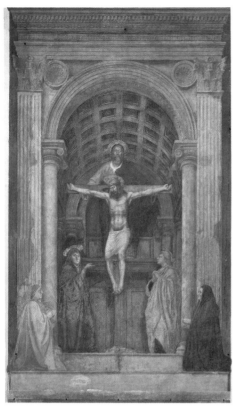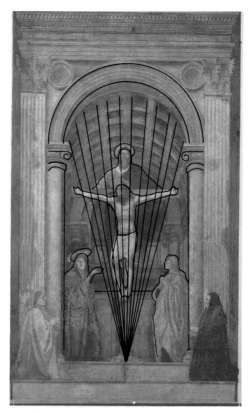

4.21 and 4.22

Masaccio. *Trinity with the Virgin, St. John and Donors.* **1427, fresco. Santa Maria Novella, Florence, Italy.** According to some art history experts, Masaccio's fresco is the first painting created in correct geometric perspective. The single vanishing point lies approximately below the feet of Christ, as indicated by the overlay in figure 4.22.

Nimatallah/Art Resource, New York.

Employing their knowledge of geometry (then one of the most important elements in the classical education of every student), they conceived a method of creating an illusion of nature more realistic than any other that had appeared in Western art for more than a thousand years. In their concept, the perspective drawing of shapes likens the picture plane to a window; picture framing or matting acts as the window frame. Imaginary sight lines (orthogonals) extend from the artist or viewer's position through the edges of the planes constituting the volumes (mostly rectilinear ones that appear in natural and human-invented forms, such as rows of trees, streets, or buildings) receding in space. These sight lines are angled from the outer extent of the vertical axis of the artist's eyes downward and upward toward a fixed point or points on the horizontal axis of the eyes. Since a theorem in geometry states that parallel lines vanish at infinity, the horizontal axis of the eyes corresponds to the eye level at which the artist is drawing the perceived view of nature, or to the horizon that the artist actually sees or imagines in nature. The point(s) on the horizon or eye level line drawn on the picture plane are thus termed the *vanishing points.* (They are usually abbreviated to VP for convenience in drawings utilizing geometric perspective.) The horizon on the picture plane demarcates upper and lower divisions called the *ground plane* and the *sky plane* (see fig. 4.20).

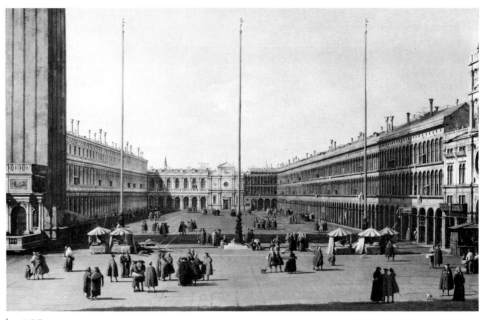

4.23

Antonio Canaletto. *The Piazza of St. Mark's, Venice.* **Circa 1735–45, oil on canvas, 29¾ × 46¾ in.** The appearance of planes and volumes in space determined by the systematic procedures of geometric perspective is well illustrated in this painting by an eighteenth-century Venetian artist. It is basically in one-point perspective.

The Detroit Institute of Arts. Purchase. Founders' Society Purchase. General Membership Fund with a donation from Edsel B. Ford.

Major systems of perspective The three major systems of geometric perspective are: one-point, two-point, and three-point. One-point perspective is used when the artist wants the objects drawn to appear as if one face is parallel with the picture plane (fig. 4.23). In this system, the vanishing point is placed on the horizon line (eye level) a little to the right or left of center, so as not to divide the picture too symmetrically (monotonously). In the Masaccio painting, the eye level is very low in the picture plane, while Christ's body is slightly turned to offset symmetry a bit (see figs. 4.21 and 4.22). Hallways, or any long views of the interior and exterior of buildings, lend themselves well to one-point perspective drawings.

Two-point perspective is most often employed when the exteriors of buildings or of any other object, human-made or natural, appear to be at an angle to the lines of sight, or when the artist wishes them to appear at angular positions in depth on the picture plane, as in the Hopper painting of the old house (fig. 4.24).

Three-point perspective, consisting of a third point above eye level, is used when one wishes to draw a tall form that recedes upward in space, like a skyscraper (figs. 4.25 and 4.26). Or it may be used to give a view down along a form that appears to become smaller as it recedes far below the eye level of the artist or observer. A third point is also often used when there is an angular plane within a two-point perspective drawing, such as on a gable or truss-roofed house.

Disadvantages of geometric perspective Geometric perspective has been a traditional drawing device used by artists for centuries. During that time the system has evolved and undergone modifications in attempts to make it more flexible or more realistic in depicting natural appearances. Geometric perspective has been most popular during periods of scientific inquiry and reached its culmination in the mid-nineteenth century. Despite its seeming virtue of accurately depicting natural appearances, the method has certain disadvantages that, in the opinion of some artists, outweigh its usefulness. Briefly, the liabilities of geometric perspective are as follows:

1. It is never an honest statement of actual shape or volume as it is known to be.
2. The only appearances that can be legitimately portrayed are those that can be seen by the artist-observer from one position in space.

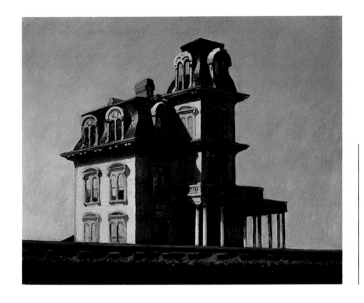

4.24

**Edward Hopper. *House by the Railroad.*
1925, oil on canvas, 24 × 29 in.** This
painting of an old mansion, with its
nostalgic overtones of time having passed
it by, is set at an angle to the picture
plane, demonstrating the use of two-point
perspective.

Collection, The Museum of Modern Art, New
York. Given anonymously.

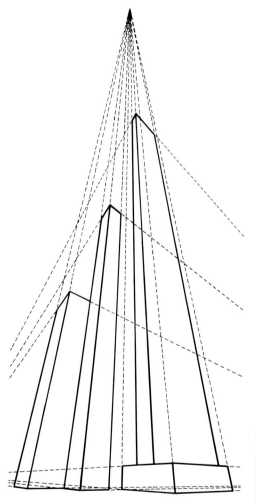

4.25
This diagram illustrates three-point
perspective. By extending the dashed
orthogonals, the vanishing points will be
found approximately at the edges of the
page.

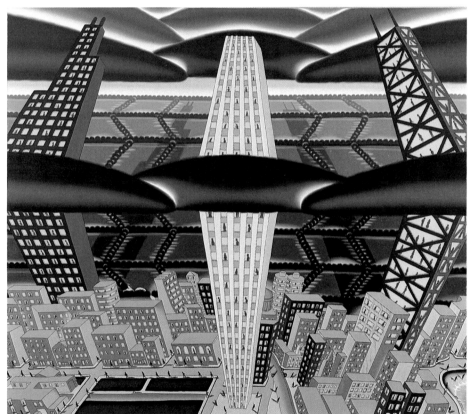

4.26
**Roger Brown. *Land of Lincoln.* 1978, oil
on canvas, 71½ × 84 in.** Here is how a
contemporary artist has used three-point
perspective to give a strange, almost
unearthly effect. It employs both an aerial
(bird's eye) view and a frog's eye view of
the buildings.

Courtesy of Guy and Helen Barbier, Geneva,
Switzerland.

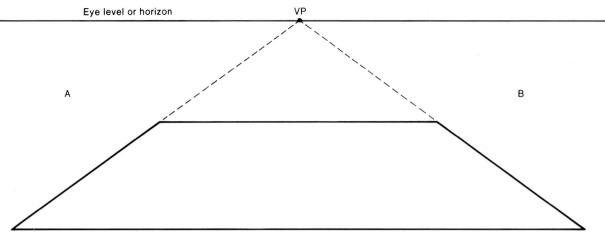

Eye level or horizon VP

A B

4.27

Disadvantages of perspective diagram. The extreme reduction of scale within a single object resulting from converging edges (such as in walls, floors, or table tops) causes another type of distortion that reduces the design areas available to the artist. For example, this diagram indicates that a rectangular table top depicted in perspective becomes a trapezoid and leaves spatial vacuums at areas *A* and *B*.

3. The necessary recession of parallel lines toward common points often leads to monotonous visual effects.
4. The extreme reduction of scale within a single object that results from the convergence of line is another type of perspective distortion (fig. 4.27).

These disadvantages are mentioned only to suggest that familiar modes of vision are not necessarily those that function best in a work of art.

Intuitive space

Although planes and volumes play a strong part in creating illusions of space through their use in geometric perspective, they can also be used to produce intuitive space, which is independent of strict rules and formulas. Intuitive space is thus not a system, but a product of the artist's instinct for manipulating certain space-producing devices. The devices that aid the artist in controlling space include overlap, transparency, interpenetration, inclined planes, disproportionate scale, and fractional representation (see Space, chapter 8). In addition, the artist may exploit the inherent spatial properties of the art elements. The physical properties of the art elements tend to thrust forward or backward the items they help define. By marshalling these spatial forces in any combination as needed, the artist can impart a sense of space into the pictorial image while adjusting relationships. The space derived from this method is readily sensed by everyone, although judged by the standards of the more familiar linear perspective, it may seem strange, even distorted. Nevertheless, intuitive space has been the dominant view of space during most of the history of art; it rarely implies great depth, but makes for tightly knit imagery within a relatively shallow spatial field (fig. 4.28).

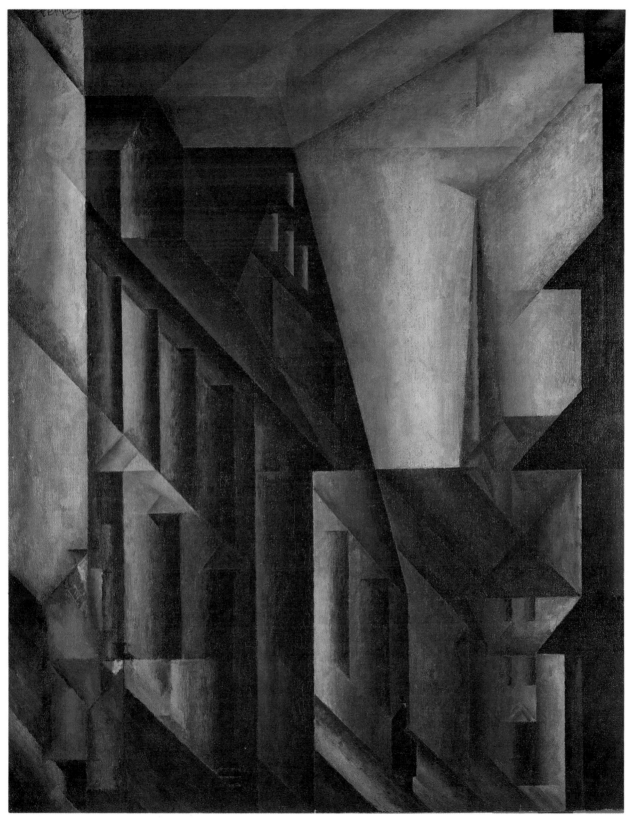

4.28
Lyonel Feininger. *Street near the Palace.* **1915, oil on canvas, 39½ × 31½ in.** In this painting the artist has used intuitive (or suggested) methods of space control, including overlapping planes, transparencies, and planes that interpenetrate one another and incline into space.

The Norton Simon Foundation.

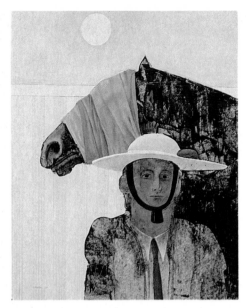

4.29
Morris Broderson. *Picador with Horse.* **1967, mixed media, 33 × 26 in.**
Courtesy the Ankrum Gallery, Los Angeles.

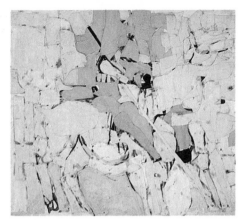

4.30
Conrad Marca-Relli. *The Picador.* **1956, oil and collage on canvas, 47¼ x 53 in.** Artists differ in their responses to subject matter. It is often a matter of degree as to how much artists use their imagination and how much their perceptual vision. Such differences of response, and the concepts that result, are apparent in contrasting the similar subjects in figures 4.29 and 4.30. Different attitudes toward the subject resulted in different shape selections.

Hirshhorn Museum and Sculpture Garden, Smithsonian Institution. Gift of Joseph H. Hirshhorn, 1966. Photo by Lee Stalsworth.

4.31
Ernest Trova. *Three Men in a Circle.* **1968, oil on canvas, 68 × 68 in.** The circular elements generate subconscious and generally indefinable reactions that are in contrast to a rectilinear style.

Courtesy the Owens-Corning Collection. Owens-Corning Fiberglas Corporation, Toledo, Ohio.

Shape: Content, meaning, or expression

Whereas the physical effects created by artists are relatively easily defined, the qualities of expression or character provided by shapes in a work of art are so varied (due to individual responses) that only a few of the possibilities can be suggested. In some cases, our responses to shapes are quite commonplace; in others, our reactions are much more complex since we share our own personality traits with them: shyness, aggressiveness, awkwardness, poise, and so forth. These are just some of the characteristics or meanings we can find in shapes. Artists, naturally, make use of such shape qualities in developing their works of art.

It is hardly conceivable that an architect would use shapes to suggest natural forms in buildings. It has been done, but very rarely throughout art history. On the other hand, sculptors and pictorial artists almost always use natural forms in their respective media. Yet evidence indicates that they are not always interested in using shapes to represent known objects. Artists more often tend to present what they conceive or imagine to be real, rather than what they perceive, or see objectively, to be real. This has been particularly evident in the twentieth century, with whole movements in the arts being based on the nonrepresentational use of shapes—from the Abstract movement of the early 1900s to the Conceptual movement of the seventies and eighties.

Thus, conception and imagination have always been parts of artistic expression. It is usually a matter of degree as to how much artists use their imagination, and how much their perceptual vision; in trying to say something through their use of subject and form, artists find that their points cannot be made without editing the elements (or "grammar") of form/expression. So while the work of those artists who are more devoted to some degree of actual appearances might seem quite natural, comparison with the original subject in nature may still show considerable disparities (figs. 4.29 and 4.30). Artists therefore go beyond literal copying and transform object shapes according to their personal style or language of form (figs. 4.31, 4.32, 4.33, and 4.34; see fig. 4.5).

4.32
Charles Burchfield. *The East Wind.*
1918, watercolor, 17½ × 21⅝ in. The
shapes used by Burchfield in this painting
are partly psychological and partly
symbolic. These shapes suggest the
qualities of an approaching spirit-ridden
storm.

Albright-Knox Art Gallery, Buffalo, New York.
Bequest of A. Conger Goodyear.

4.33
**Jack Brusca. *Untitled.* 1969, acrylic on
canvas, 30 × 30 in.** The precise, hard-
edge geometric shapes in this work are a
heritage from the Cubists.

Courtesy the Owens-Corning Collection. Owens-
Corning Fiberglas Corporation, Toledo, Ohio.

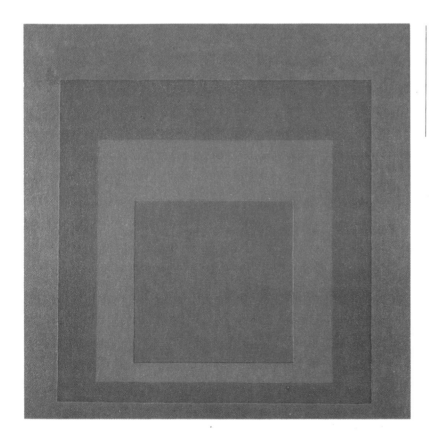

4.34
**Josef Albers. *Homage to the Square:
Star Blue.* 1957, oil on board, 29⅞ ×
29⅞ in.** The shape meaning of a square
lies not in likeness or association, but in
the relationships developed by the artist.

Contemporary Collection of the Cleveland
Museum of Art.

4.35
Pat Sutton. *Yaqui.* **1969, synthetic polymer on canvas, 80¾ × 117¾ in.** Many shapes are not meant to represent or even symbolize; instead, they are intended to provoke form-meanings of a very general (and sometimes indescribable) kind.

Hirshhorn Museum and Sculpture Garden, Smithsonian Institution. Gift of Joseph H. Hirshhorn, 1972. Photo by John Tennant.

Just as the configuration of a shape gives it the character that distinguishes it from other shapes, so configuration also changes a shape's expressive meaning. The abstract artists of the present century seem to have been influenced by the "streamlining" of machinery, for example, to create pristine, clear-cut shape relationships. Our reactions to these, or the meanings we find in them, vary with our own psychological conditioning. Many people react adversely to simple shapes like those in Brusca or Albers paintings (see figs. 4.33 and 4.34). While both artists use similar shapes, there are detectable visual differences that change the shapes' meanings. Even the extremities of the shapes become important, hence our terms soft-edge and hard-edge. The colors, as well as application of media, their texture, and darkness or lightness (value), can all affect whatever feeling or lack of it we intuit in such works of art. Endless examples of the use of shapes, both in terms of natural and objective, or nonobjective and abstract, indicate how varied expression can be. The student only has to glance around a class in which all members are working on a similar exercise to see the variety of personal styles. How much more can be expected, in terms of endless expressive potential, when viewing the work of trained artists?

All of the principles involved in ordering shapes are of little value until one becomes aware of the various meanings that can be revealed through relationships made possible by the language of art. Much of this awareness, of course, comes through practice, as in learning any language.

Artists usually select their shapes to express an idea, but they may initially be motivated by the psychological suggestions of shape, as in the Matta and Burchfield paintings (see figs. 4.5 and 4.32). Shapes contain certain meanings within themselves, some readily recognizable, others more complex and less clear. Some common meanings

ascribable to squares, for instance, are: perfection, stability, stolidity, symmetry, self-reliance, and monotony. Although squares may have different meanings for different people, many common sensations are shared when viewing them (see fig. 4.34). Similarly, circles, ovals, rectangles, and a vast array of other shapes possess distinctive meanings; their meaningfulness depends on their complexity, their application, and the sensitivity of those who observe them (figs. 4.35 and 4.36). How different are our reactions to the biomorphic shapes favored by the Surrealists compared to those of the Hard-Edge Geometric Abstractionists like Noland (fig. 4.37)? That we are sensitive to shape meaning is witnessed in psychologists' use of the familiar inkblot test, which is designed to aid in evaluating emotional stability. The existence of these tests points out that shapes can provoke emotional responses on different levels. Thus the artist might use either abstract or representational shapes to create desired responses. By using the knowledge that some shapes are inevitably associated with certain objects and situations, the artist can set the stage for a pictorial or sculptural drama.

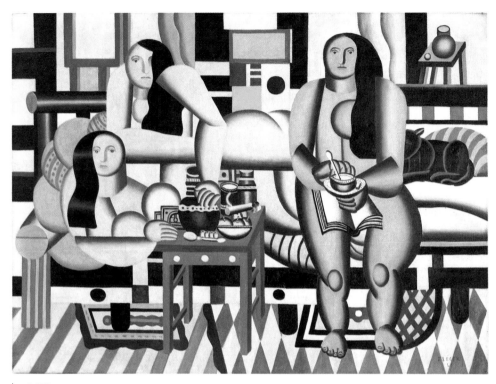

4.36
Fernand Léger. *Three Women.* **1921, oil on canvas, 6 ft. ¼ in. × 8 ft. 3 in.** The Cubist painter Léger commonly used varied combinations of geometric shapes in very complex patterns. Here, due to his sensitive design, he not only overcomes a hard-edged shape effect, but retains a feminine meaning or expression.
Collection, The Museum of Modern Art, New York. Mrs. Simon Guggenheim Fund.

4.37
Kenneth Noland. *Wild Indigo.* **1967, acrylic on canvas, 89 × 207 in.** Noland's hard-edge, nonobjective painting is descended from Cubist works like Léger's. Without the benefit of any representation, the meanings we intuit in such a work are less obvious and emotional. Compared to a biomorphic work such as Matta's *Le Vertige d'Eros* (see fig. 4.5), with its soft edges and emotional implications, we must seek meaning in Noland by a more cerebral approach.
Albright-Knox Art Gallery, Buffalo, New York. Charles Clifton Fund, 1972.

5
VALUE

The Vocabulary of Value

cast shadow
The dark area that occurs on a surface as a result of something being placed between that surface and a light source.

chiaroscuro
A technique of representation that blends light and shade to create the illusion of objects in space or atmosphere.

decorative value
A term given to a two-dimensional light-and-dark pattern. Decorative value usually refers to areas of dark or light that are confined within definite boundaries, rather than to the gradual blending of tones.

highlight
The portion of an object that, from the observer's position, receives the greatest amount of direct light.

local value
The natural or characteristic value of a surface that is determined by a shape's normal color, independent of any effect created by the degree of light falling on it.

shadow, shade, shading
The darker value on the surface of a form that gives the illusion that a portion of the form is turned away from the source of light.

tenebrism
A style of painting that exaggerates or emphasizes the effects of chiaroscuro. Larger amounts of dark value are placed close to smaller areas of highly contrasting light values in order to concentrate attention on certain important features.

three-dimensional value pattern
Value relationships that create the illusion of objects existing in depth.

two-dimensional value pattern
Value relationships in which the changes of light and dark seem to occur only on the surface of the picture plane.

value
The relative degree of lightness or darkness.

value pattern
The total effect of the relationships of light and dark within the pictorial field.

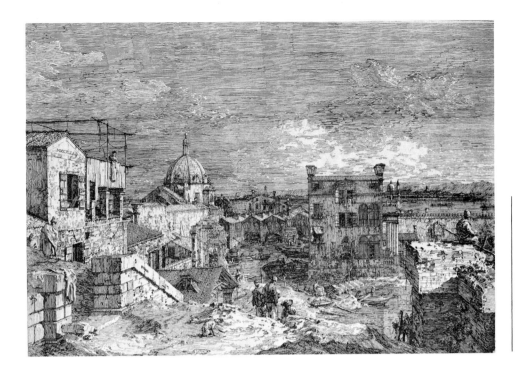

Introduction to value relationships

The best definition of *value* for the purpose of this book is found in the dictionary, which states that value in pictorial art is the relationship of one part or detail to another with respect to lightness or darkness. Artistic vision is concerned with both *chromatic* experiences (reds, greens, yellows, and other hues) and *achromatic* experiences (white, black, and the limitless shades of gray). Value is an integral part of both these experiences. Value is also called tone, brightness, shade, or even color, but these terms have only limited convenience and accuracy in an art context.

Anyone who studies art must consider the relationship of value to the other elements of art form: line, color, texture, and shape. All of these elements must exhibit some value contrast in order to remain visible.

The particular value of a line could be the result of the medium used or the pressure exerted on the medium by the artist. For example, the degree of value of a pencil line would be determined by the hardness of the graphite or the force with which it is used. Value can be created by placing lines of the same or different qualities alongside or across each other to produce generalized areas of value (sometimes called hatching or cross-hatching; fig. 5.1). Shapes are also created and distinguished by the use of value. In reproducing textures, the shadows and highlights peculiar to the particular surfaces are copied. The values

in abstract textures depart to some degree from the values of the objects being represented.

The intoxicating effects of a particular color often blind people to the fact that color's very existence is entirely dependent upon the presence of value. A standard yellow, for example, is of far greater lightness than a standard violet, although both colors may be modified to a point at which they become virtually equal. A common weakness in painting is the unfortunate disregard for the pattern created by the value relationships of the colors; black-and-white photographs of paintings often reveal this deficiency very clearly. On the other hand, black-and-white works of art are commonplace and perfectly acceptable.

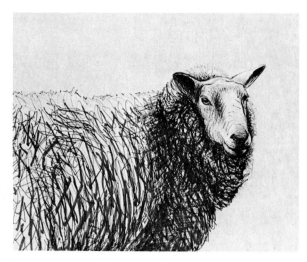

5.2
**Henry Moore. *Sheep #43*. 1972, blue
black ballpoint and felt pen, 8 × 9¾ in.**
The degree of line concentration indicates
the value of the subject; where tightly
bunched shadows are suggested, the
forms of the animal are defined.
Courtesy Mary Moore.

5.3
**Russell F. McKnight. *Intercepting Light*.
1984, photograph, 5½ × 5 in.** A solid
object receives more light from one side
than from another because that side is
closer to the light source, thus intercepting
the light and casting shadows on the other
side.
From the photographer.

Descriptive uses of value

One of the most useful applications of
value is in describing objects, shapes, and
space (fig. 5.2). Descriptive qualities can
be broadened to include psychological,
emotional, and dramatic expression.
Artists from time immemorial have been
concerned with value as they deal with
the problem of translating light playing
about the earth and its inhabitants.
Objects are usually perceived in terms of
the characteristic patterns that occur
when those objects are exposed to light
rays. Objects, at least according to
customary occurrence, cannot receive
light from all directions simultaneously. A
solid object gets more light from one side
than from another because that side is
closer to the light source and thus
intercepts the light and casts shadows on
the other side (fig. 5.3).

Light patterns vary according to the
surface of the object receiving the light. A
spherical surface demonstrates this,
exhibiting an even flow from light to dark.
An angular surface shows sudden
contrasts of light and dark values. Each
basic form has a basic highlight and
shadow pattern. Evenly flowing tone
gradation invokes a sense of a gently
curved surface. An abrupt change of tone
indicates a sharp or angular surface (fig.
5.4).

Cast shadows are the dark areas that
occur on an object or a surface when a
shape is placed between it and the light
source. The nature of the shadow created
depends upon the size and location of the
light source, the size and shape of the
interposed body, and the character of the
forms on which the shadows fall.
Although cast shadows offer very definite
clues to the circumstances of a given
situation, they only occasionally give an

ideal indication of the true nature of the
forms (fig. 5.5). The artist normally uses,
reuses, or creates shadows that aid in
descriptive character, enhance the
effectiveness of the design pattern, and/or
contribute substantially to the mood or
expression.

Although contemporary artists have
generally rejected the use of value to
describe form in a traditional chiaroscuro
or descriptive sense, a few of them,
particularly the New Realists, do use
value in this manner. When value is used
to describe volume and space, it can be
called *plastic value*. Artists such as
Wayne Thiebaud, Philip Pearlstein, and
Alex Katz, for example, are obviously
influenced by photography and cinema
(fig. 5.6). Neither of these disciplines, it
should be noted, remains in the disrepute
in which some early twentieth-century
artists held them as part of their rejection
of all descriptive reality.

5.4
Russell F. McKnight. *Light and Dark.*
1984, photograph, 5½ × 5 in. This
photograph illustrates the even gradation
of light to dark on a spherical surface and
the sudden contrast of light and dark on
an angular surface.
From the photographer.

5.5
Russell F. McKnight. 1984, photograph,
5½ × 5 in. Light can cast overlapping
shadows that tend to break up and hide
the true character of object forms. The
unplanned shapes of shadows such as
these often disorganize compositional
unity.
From the photographer.

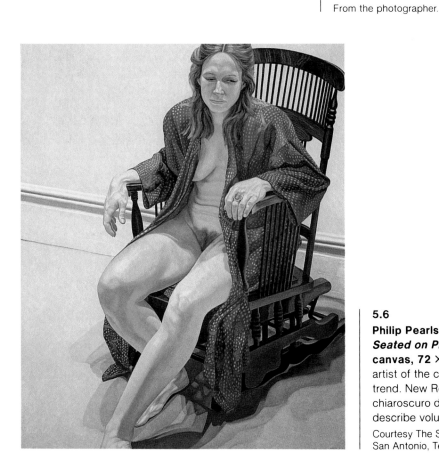

5.6
Philip Pearlstein. *Female Model in Robe,*
***Seated on Platform Rocker.* 1973, oil on**
canvas, 72 × 60 in. This painting is by an
artist of the contemporary New Realist
trend. New Realists use a kind of
chiaroscuro derived from photography to
describe volume and space or plastic form.
Courtesy The San Antonio Museum Association,
San Antonio, Texas.

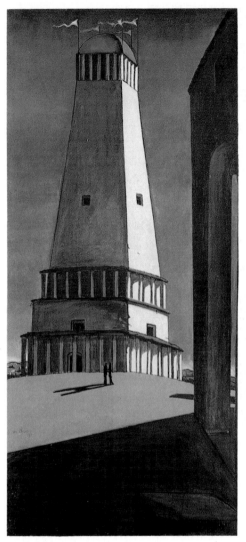

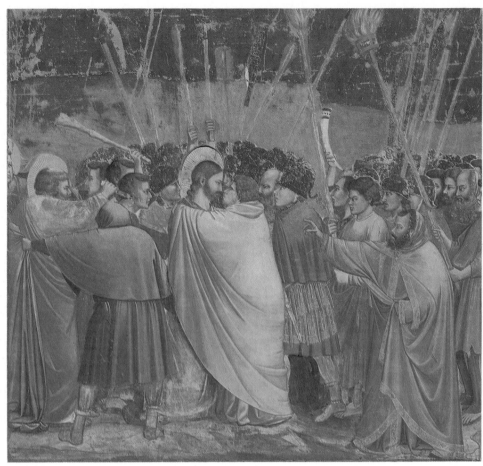

5.8
Giotto. *The Kiss of Judas.* **1304–13, fresco.** Although line and shape predominate in Giotto's works, some early attempts at modeling with chiaroscuro value can be seen.

Scala/Art Resource, New York.

5.7
Giorgio de Chirico. *The Nostalgia of the Infinite.* **1913–14? (dated on painting 1911), oil on canvas, 53¼ × 25½ in.** Giorgio de Chirico often used shadow effects, strong contrasts of value, and stark shapes to enhance the lonely, timeless nostalgia that is so much a part of his poetic expression.

Collection, The Museum of Modern Art, New York. Purchase.

Expressive uses of value

The type of expression sought by the artist ordinarily determines the balance between light and dark in a work of art. A preponderance of dark areas creates an atmosphere of gloom, mystery, drama, or menace, whereas a composition that is basically light will produce quite the opposite effect. Artists other than naturalists tend to avoid exact duplication of cause and effect in light and shadow because this practice may create a series of forms that are monotonously light or dark on the same side. The shapes of highlights and shadows are often revised to produce desired degrees of unity and contrast with adjacent compositional areas. In summary, lights and shadows exist in nature as the by-products of strictly physical laws. Artists must adjust and take liberties with lights and shadows to create their own visual language (fig. 5.7).

Chiaroscuro

Chiaroscuro refers to the technique of representation that makes obvious use of contrasting lights and darks. The term also alludes to the way artists handle those atmospheric effects to create the illusion that the objects are surrounded on all sides by space. Chiaroscuro developed mainly in painting, beginning with Giotto (1276–1335), who used darks and lights for modeling but expressed shape and space in terms of line (fig. 5.8). Masaccio, Fra Angelico, and Pollaiuolo, the early Florentine masters, carried chiaroscuro a

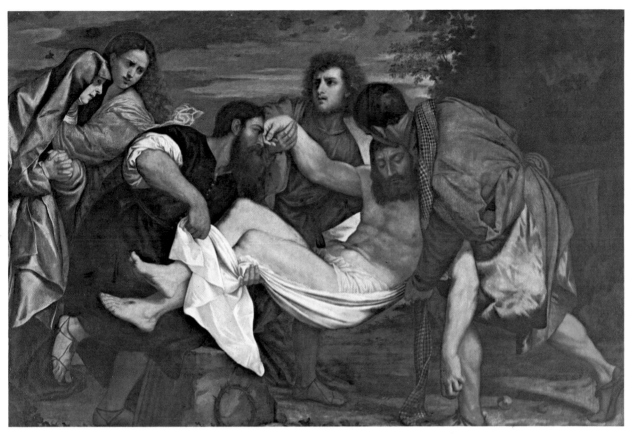

5.9
Titian. *The Entombment of Christ* (copy). 16th century, oil on canvas, 54 × 82½ in.
The great Venetian Titian subordinated line (contrasting edges with value) and enveloped
his figures in a tonal atmosphere that approaches tenebrism.

The Detroit Institute of Arts, Gift of James E. Scripps.

step further by expressing structure and
volume in space with an even, graded
tonality. Leonardo da Vinci employed a
much bolder series of contrasts in light
and dark but always with soft value
transitions. The great Venetian painters,
such as Giorgione, Titian, and Tintoretto,
completely subordinated line and
suggested compositional unity through an
enveloping atmosphere of dominant
tonality (fig. 5.9).

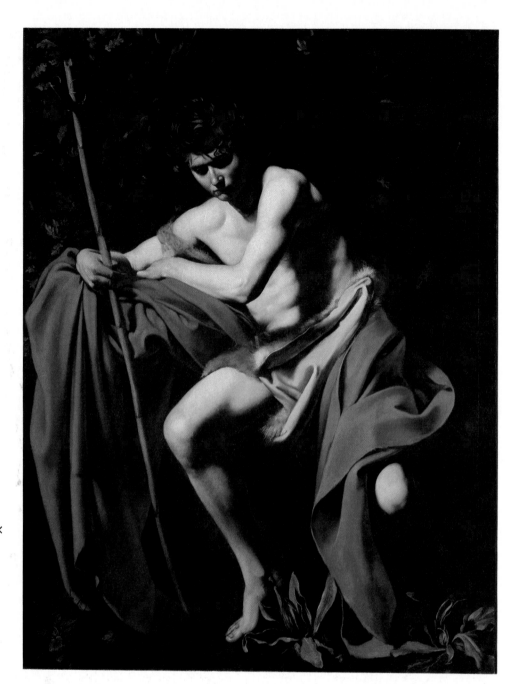

5.10

Michelangelo da Caravaggio. *St. John the Baptist.* **1604, oil on canvas, 68¼ ×
52 in.** Caravaggio was essentially the leader in establishing the dark-manner of painting in the sixteenth and seventeenth centuries. Several of the North Italian painters before his time, however, such as Correggio, Titian, and Tintoretto, show evidence of the tendency toward darker value composition.

The Nelson-Atkins Museum of Art, Kansas City, Missouri. Nelson Fund.

Tenebrism

Painters who used violent chiaroscuro are called *tenebrists*. The first tenebrists were an international group of painters who, early in the seventeenth century, were inspired by the work of Michelangelo da Caravaggio (fig 5.10). Caravaggio based his chiaroscuro on Correggio's work and instituted the so-called *dark-manner* of painting in Western Europe. Rembrandt became the technical adapter and perfector of this dark-manner, which he learned from migratory artists of Germany and southern Holland (fig. 5.11). The dark-manner made value an instrument in the characteristic exaggeration of baroque painting. The strong contrasts lent themselves well to highly dramatic, even theatrical, work of this type. Later, the dark-manner evolved into the pallid, muddy monotone that pervaded some nineteenth-century Western painting. The tenebrists and their followers were very much interested in peculiarities of lighting, particularly how lighting affected mood or emotional expression. They deviated from standard light conditions by placing the implied light sources in unexpected locations, creating unusual visual and spatial effects. In the hands of superior artists such as Rembrandt, these effects were creative tools; in lesser hands, they became captivating tricks or visual sleight of hand.

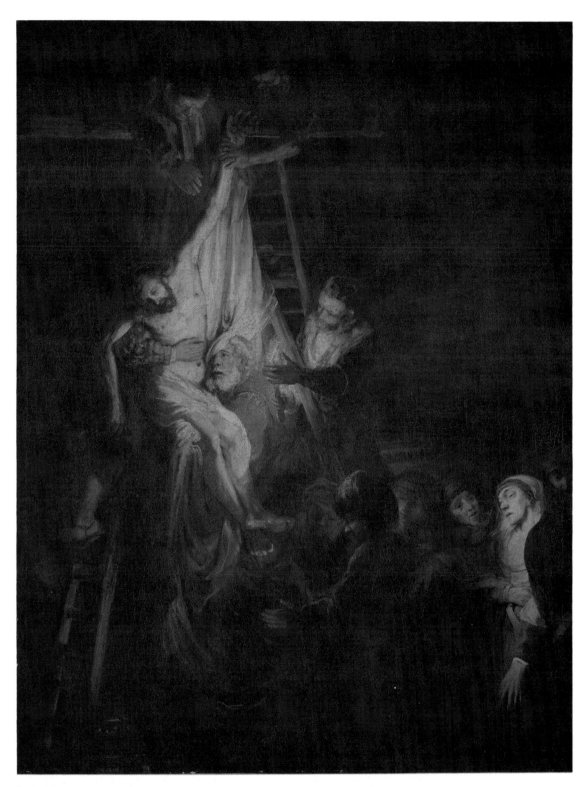

5.11
Rembrandt Harmensz van Ryn, after. *The Descent from the Cross.* **Circa 1655**
(altered at a later date), oil on canvas, 56¼ × 43¾ in. Rembrandt often used inventive,
implied light sources that deviated from standard light conditions to enhance the mood or
emotional expression.
National Gallery of Art, Washington, D.C. Widener Collection.

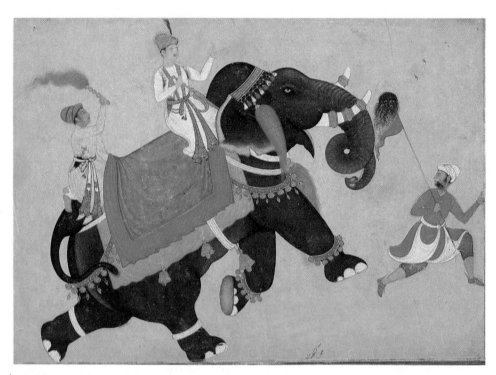

5.12

Signed: Work of Khemkaran. *Prince Riding an Elephant.* **Mughal, period of Akbar, 1556–1605, leaf from an album, gouache on paper.** South Asian artists often disregard the use of light (illumination) in favor of decorative value compositions.
Metropolitan Museum of Art, New York. Rogers Fund, 1925.

Decorative value patterns

Art styles that stress decorative effects usually ignore conventional light sources or neglect representation of light altogether. If light effects appear, they are often in composite, a selection of appearances based on their contribution to the total form of the work. This admixture is characteristic of the artworks of children and of primitive and prehistoric tribes, traditional East Asians, and certain periods of Western art, notably the Middle Ages. Many contemporary artworks are completely free of illusionistic lighting. An artwork that thus divorces itself from natural law is obviously based on pictorial invention, imagination, and formal considerations. It is not necessarily divorced from emotional impact (as witness, Medieval art), but the emotion speaks primarily through the forms and is consequently less extroverted.

The trend away from illumination values gained strength in the nineteenth century partly as a result of the interest in art forms of the Middle East and East Asia (fig. 5.12). It was given a Western scientific interpretation when Edouard Manet, a realist, observed that a multiplicity of light sources tended to flatten object surfaces. He found that this light condition neutralized the plastic qualities of objects, thus minimizing gradations of value (figs. 5.13 and 5.14). As a result, he laid his colors on canvas in flat areas, beginning with bright, light colors and generally neglecting shadow. Some critics have claimed this to be the basic technical advance of the nineteenth century because it paved the way for nonrepresentational uses of value and helped revive interest in the shallow space concept (fig. 5.15).

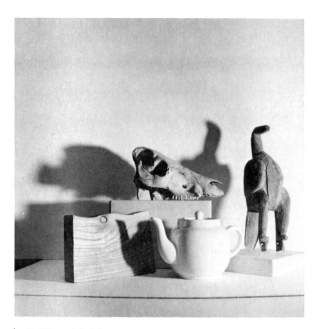 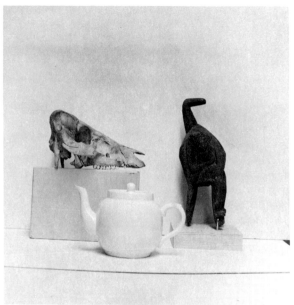

5.13 and 5.14
Russell F. McKnight. *Effect of Light on Objects.* **1984, photograph, 5½ × 5 in.** The photograph in figure 5.13 demonstrates how light from one source emphasizes the three-dimensional qualities of an object and gives an indication of depth. The cast shadows also give definite clues to the descriptive and plastic qualities of the various objects. The photograph in figure 5.14 shows the group of objects under illumination from several light sources. This form of lighting tends to flatten object surfaces and produce a more decorative effect.

From the photographer.

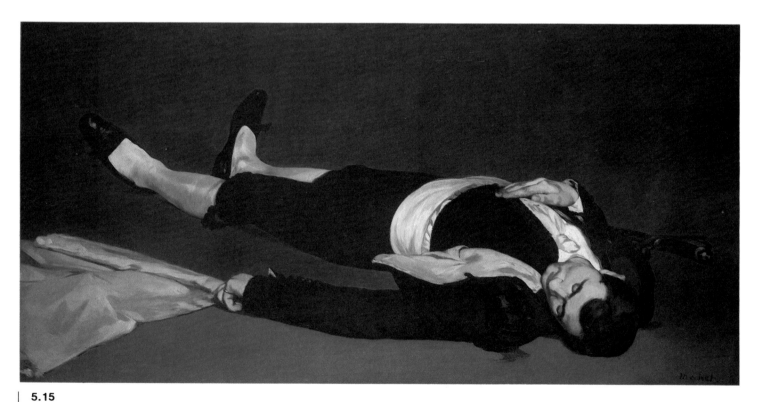

5.15
Edouard Manet. *The Dead Toreador.* **Circa 1864, oil on canvas, 29⅞ × 60⅜ in.** Manet, a nineteenth-century naturalist, was one of the first artists to break with traditional chiaroscuro, employing, instead, flat areas of value. These flat areas meet abruptly in comparison to the blended edges used by artists previous to Manet. This was one of the basic technical advances of nineteenth-century art.

National Gallery of Art, Washington, D.C. Widener Collection.

5.16
Juan Gris. *Breakfast.* 1914, pasted paper, crayon, and oil on canvas, 31⅞ × 23½ in. Gris, an example of a later Cubist, not only simplified shape into larger, more dominant areas, but gave each shape a characteristic value, producing a carefully conceived light-dark pattern. He also made use of open composition, in which the value moves from one shape into the adjoining shape, as can be seen in this example.

Collection, The Museum of Modern Art, New York. Acquired through the Lillie P. Bliss Bequest.

Compositional functions of value

The idea of carefully controlled shallow space is well illustrated in the works of the early Cubists and their followers. In those paintings, space is given its order by the arrangement of flat planes abstracted from subject material. In the initial stages of this trend, the planes were shaded individually and semi-illusionistically, although giving no indication of any one light source. Later, each plane took on a characteristic value and, in combination with others, produced a carefully conceived two-dimensional light/dark pattern. Eventually, the shallow spatial effect was developed in terms of three-dimensional pattern (or balance) through attention to the advancing and receding characteristics of value (fig. 5.16). The explorations of these early twentieth-century artists helped focus attention on the intrinsic significance of each and every element. Value was no longer forced to serve primarily as a tool of superficial transcription, although it continued to be of descriptive usefulness. Most creative artists today think of value as a vital and organic participant in pictorial

organization, affecting dominance, creating two-dimensional pattern, establishing mood, and producing spatial unity (fig. 5.17).

Open and closed compositions

The emotive possibilities of value schemes are easy to see, particularly as the schemes relate to closed or open composition. In *closed-value* compositions, values are limited by the edges or boundaries of shapes. This serves to clearly identify and, at times, even isolate the shapes. In *open-value* compositions, values can extend beyond shape boundaries into adjoining areas. This helps integrate the shapes and unify the composition (fig. 5.18). The artist may employ closely related values for hazy, foglike effects, or dramatically contrasting values for sharply crystallized shapes. Thus, value can run the gamut from decoration to violent expression. It is a multipurpose tool, and the success of the total work of art is in large measure based on the effectiveness with which the artist has made value serve these many functions.

5.17
Henri Matisse. *Nuit de Noël.* 1952, stained-glass window commissioned by *Life,* 1952. Metal framework, 11¾ × 54¾ × ⅝ in., executed in workshop of Paul and Adeline Bony (Paris) under artist's supervision. Here, Matisse chose to use a two-dimensional value pattern instead of traditional chiaroscuro.

Collection, The Museum of Modern Art, New York. Gift of Time, Inc.

5.18
Larry Rivers. *The Greatest Homosexual.* 1964, oil, collage, pencil, and colored pencil on canvas, 80 x 61 in. In this work values pass freely through and beyond the contour lines that normally serve as boundaries of color separation. This is an example of open composition.

Hirshhorn Museum and Sculpture Garden, Smithsonian Institution. Gift of Joseph H. Hirshhorn, 1966. Photo by John Tennant.

6

TEXTURE

The Vocabulary of Texture

abstract texture

A texture derived from the pattern observed in an actual texture, which is then altered by the artist to better suit his or her artistic needs.

actual texture

A surface that can be experienced through the sense of touch (as opposed to a surface visually simulated by the artist).

artificial texture

A texture made by man, as opposed to one produced by nature.

collage

An art form in which the artist creates the image, or a portion of it, by adhering real materials that possess actual textures to the picture plane surface.

genre

Subject matter that concerns everyday life, domestic scenes, sentimental family relationships, etc.

illusionism

The imitation of visual reality created on the flat surface of a picture plane by the use of perspective, light-and-dark shading, etc.

invented texture

A texture whose only source is the imagination of the artist. It generally produces a decorative pattern and may be confused with an abstract texture.

natural texture

Texture that is created as the result of nature's processes.

paint quality

The use of paint to enrich a surface through textural interest. Interest is created by ingenuity in handling paint for its intrinsic character.

papier collé

A technique of visual expression in which scraps of paper having various textures are pasted to the picture surface to enrich or embellish areas. The textures are often not textures at all, but decorative patterns, similar to the artist's invented textures (for example, the printing on a piece of adhered newspaper).

simulated texture

The copying, or imitation, of object surfaces.

tactile

A quality that refers to the sense of touch.

texture

The surface character of a material that can be experienced through touch or the illusion of touch. Texture is produced by natural forces or through an artist's manipulation of the art elements.

trompe l'oeil

A technique that copies nature with such exactitude that the subject depicted can be mistaken for natural forms.

Introduction to texture

Texture is an experience that is always with us. Whenever we touch something, we feel its texture. By concentrating on your hands and fingers holding this book, you will realize that you are experiencing texture. If your fingers are against the open side, they will feel the ridged effect of the stacked pages; if on the surface of a page, its smoothness. By looking around the room in which you sit, you will find many textures. In fact everything has a texture, from the hard glossiness of glass through the semiroughness of a lamp shade to the soft fluffiness of a carpet. If your room happens to contain a painting or art reproduction, the work most likely illustrates textures that can be seen, not felt—but that are made to look as if they could be felt.

The relationship of texture to the visual arts

Texture is unique among the art elements because it activates two sensory processes. It is most intimately and dramatically known through the sense of touch, but we can also see texture and thus, indirectly, predict its feel. In viewing a picture, we may recognize objects through the artist's use of characteristic shapes, colors, and value patterns. But we may also react to the artist's rendering of the surface character of those objects. In such a case we have both visual and tactile experiences (fig. 6.1).

Whether the artist is working in the two-dimensional or three-dimensional field, our tactile response to the work is always a concern (fig. 6.2). Three-dimensional sculptors become involved with the problem of texture by their choice of material and the type and degree of finish they use. If they wish, sculptors can recreate the textures that are characteristic of the subject being interpreted. By cutting into the surface of the material, they can suggest the surface qualities of hair, cloth, skin, and other textures (fig. 6.3).

6.1
Jan Davidsz. de Heem. *Still Life with View of the Sea.* **1646, oil on canvas, 23⅜ × 36½ in.** The amazingly natural appearances in Dutch and Flemish still-life paintings are largely due to the artists' careful simulation of surfaces.
The Toledo Museum of Art, Toledo, Ohio. Gift of Edward Drummond Libbey.

6.2
Andrew Newell Wyeth. *The Hunter.* **1943, tempera on masonite, 33 × 33⅞ in.** Skillful manipulation of the medium can effectively simulate actual textures.
The Toledo Museum of Art, Toledo, Ohio. Elizabeth C. Mau Bequest Fund.

6.3
William Zorach. *Head of Christ.* **1940, stone (peridotite), 14¾ in. high.** Zorach has polished portions of the surface of this bust to bring out the natural textural quality of granite. He has roughened selected surfaces in order to simulate subject characteristics.
Collection, The Museum of Modern Art, New York. Abby Aldrich Rockefeller Fund.

The nature of texture

The sense of touch helps inform us about our immediate surroundings. Our language, through such words as smooth, rough, soft, and hard, demonstrates that touch can tell us about the nature of objects. Texture is really surface, and the feel of that surface depends on the degree to which it is broken up by its composition. This determines how we see it and feel it. Rough surfaces intercept light rays, producing lights and darks. Glossy surfaces reflect light more evenly, giving a less broken appearance (fig. 6.4).

Types of texture

The artist can use four basic types of texture: actual, simulated, abstract, and invented.

Actual texture

Actual texture is the "real thing"; it is the way the surface of an object looks and feels. Generally, the emphasis is on the way it feels to the sense of touch, but we can get a preliminary idea of the feel by viewing the object (fig. 6.5). Historically, actual texture has been a natural part of three-dimensional art, but it has rarely been present in the graphic arts. An exception could be the buildup of paint on the surface of a canvas as in a Van Gogh work in which the paint actually forms projecting mounds or furrows (fig. 6.6). The usual artistic application of actual texture involves fixing a textured object to the working surface. When this is done, the texture simply represents itself, although a texture may sometimes be used out of context by displacing an expected texture. The adhering of textures to two-dimensional art probably began with Picasso and Braque in the early twentieth century. In 1908 Picasso pasted a piece of paper to a drawing. This is the first known example of *papier collé*. This practice later expanded to include the use of tickets, portions of newspapers, menus, and the like.

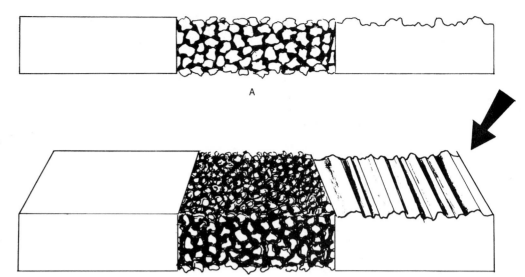

A

B

6.4

(*A*) A cross section of three materials. On the left is a hard, smooth substance; in the middle is cinderblock; and on the right is weathered wood. The upper surface's texture can be clearly seen and could be felt if stroked. (*B*) The same cross section and its upper plane. The arrow indicates the light source. The texture is defined by the highlights and shadows created by this illumination. The material to the left, being smooth, produces no shadows (if glossy, it would show reflections). The small stones in the cinderblock cast shadows among them. The undulations in the weathered wood have shadows on the left side and highlights on the right. The nature of the texture in materials is defined by light and shadow patterns.

6.5

Gyorgy Kepes. *Moss Map.* 1971, oil and sand on canvas, 48 × 48 in. Sand, mixed with the paint, is supported by a careful selection of color to create a total effect similar to surfaces we might see in nature.

Courtesy the Owens-Corning Collection. Owens-Corning Fiberglas Corporation, Toledo, Ohio.

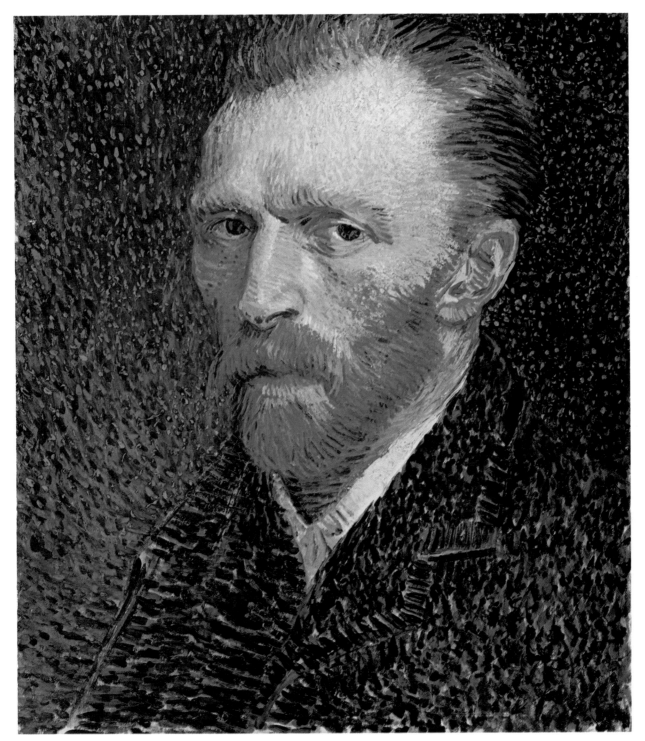

6.6

Vincent van Gogh. *Self-Portrait*. Circa 1886/87, oil on cardboard mounted on cradel panel, 41.0 × 32.5 cm. The massing of paint on Van Gogh's canvases creates actual textures. Paint was often applied directly from the tube or built up and scraped clean with the palette knife. The ribbons of paint in Van Gogh's work follow or create the rhythm sensed in nature, and frequently simulate natural forms.

6.7
Georges Braque. *Still Life.* **Circa 1917–18, pasted newspaper, paper, gouache, oil, and charcoal on canvas, 51¼ × 29 in.** This Cubist painter pioneered in the papier collé and collage forms—works of art created by fastening actual materials with textural interest to a flat working surface. These art forms may be used to simulate natural textures but are usually created for decorative purposes.

Philadelphia Museum of Art. The Louise and Walter Arensberg Collection.

6.8
Robert Rauschenberg. *Fossil for Bob Morris, New York.* **1965, paper, metal, plastic, rubber, and fabric on canvas, 84⅞ × 60⅝ in.** Collage features the actual textures or real objects secured to the picture plane. These are often augmented by painted and drawn passages.

Hirshhorn Museum and Sculpture Garden, Smithsonian Institution. Gift of Joseph H. Hirshhorn, 1972. Photo by John Tennant.

6.9

Max Weber. *Chinese Restaurant*. 1915, oil on canvas, 40 × 48 in. This painting shows the concern for surface enrichment that grew out of the use of actual textures. In this example of rococo Cubism, many areas are given a decorative patternization that in most cases does not seem to derive from anything but the artist's need for decoration.

Collection of the Whitney Museum of American Art. Gift of Gertrude Vanderbilt Whitney, 31.382.

Papier collé soon led to *collage,* consisting of actual textures in the form of rope, chair caning, and other articles of greater substance than paper. Sometimes these were used in combination with simulated textures (fig. 6.7). The use of papier collé and collage is not always accepted easily; it leads to an uncertainty that can be perplexing. The problem created by mixing objects and painting is: What is real—the objects, the artistic elements, or both? Do the painted objects have the same reality as the genuine objects? Whatever the answers, the early explorations of the Cubists (the style of Picasso and Braque circa 1906–1910) stimulated other artists to explore new attitudes toward art and made them much more conscious of surface (fig. 6.8). A concern for pattern arising out of interest in texture eventually flowered in the works of many artists (fig. 6.9). In the art of today, we find many forms of surface applications.

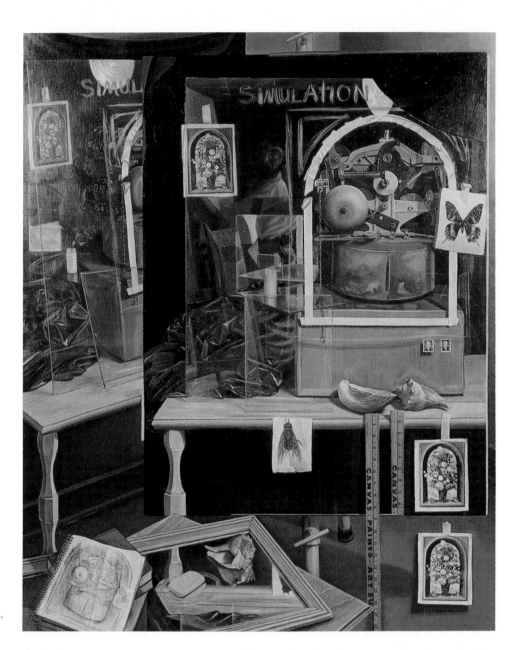

6.10

Gary Schumer. *Simulation.* **1979, oil,
42½ × 52½ in.** As the title implies, the
artist is concerned with, among other
things, the simulation of textures to be
found in our environment.

Courtesy the Owens-Corning Collection. Owens-
Corning Fiberglas Corporation, Toledo, Ohio.

Simulated texture

A surface character that looks real, but in
fact is not, is said to be *simulated*. Every
surface has characteristic light-and-dark
features as well as reflections. When these
are skillfully reproduced in the artist's
medium (as in the case of the
seventeenth-century Dutch painters), they
can often be mistaken for the surfaces of
real objects. Simulation is a copying
technique, a skill that is readily developed
and can be quite impressive; but it is far
from being the sum total of art.

Simulated textures are useful in making
things identifiable and they serve as an
enrichment. In addition, tactile enjoyment
is experienced when viewing them. The
Dutch and Flemish artists produced
amazingly naturalistic effects in still-life
and genre paintings. Their work shows
the evident relish with which they moved
from one textural detail to another.
Simulated textures are often associated
with *trompe l'oeil* paintings, obvious
attempts to "fool the eye" (fig. 6.10).

6.11

Pablo Picasso. *Dog and Cock.* **1929, oil on canvas, 60⅞ × 30⅛ in.** Some of the texture in this work appears to be invented (we can't be sure), but some of it is clearly abstracted, as in the dog's fur and the chicken's feathers. The texture is close enough to the original to be recognized as derived from it.

Yale University Art Gallery. Gift of Stephen Carlton Clark, B.A. 1903.

6.12

Kenneth Knowlton and Leon Harmon. *Computerized Nude.* **1971, computer.** This reproduction of a photograph by a specially programmed computer has not only a range of dark and light values, but also a variety of interesting textures. It illustrates the concept that invented textures in themselves can give an ordinary subject a certain amount of aesthetic value.

Printed with permission of AT&T Bell Laboratories, Murray Hill, New Jersey.

Abstract texture

Very often artists may be interested in using texture, but instead of simulating textures, they *abstract* them. Abstract textures usually display some hint of the original texture but have been modified to suit the artist's needs in a given situation. The result is often a simplified version of the original, emphasizing pattern. Abstract textures normally appear in abstract works where the degree of abstraction is consistent throughout. In these works they function in a decorative way; obviously they don't attempt to "fool the eye," but they serve the same enrichment role as simulated textures do. Besides helping the artist simplify his or her material, abstract textures can be used to accent or diminish areas (relative dominance) and to help control movement. They can be a potent compositional tool (fig. 6.11).

Invented texture

An artist who has the same level of skill as the simulator (but probably more imagination) can invent a texture and make it appear to have a precedent where none exists. In such a case, it may be difficult to classify the texture; although the texture is created rather than recreated, it has still derived from some source. When used in a realistic or semirealistic work, the invention would probably resemble a subject texture. On the other hand, in some invented textures such references are not intended. These textures would most likely show up in abstract works where one might not know whether they were invented or abstracted.

Usually the uses of invented textures are much the same as those cited for abstract textures. In the hands of a Surrealistic artist, it is possible that they could be inserted in an unlikely context for a surprise or shock effect. Invented textures are entirely the product of the artist and are, consequently, only present because of his or her need for them (fig. 6.12).

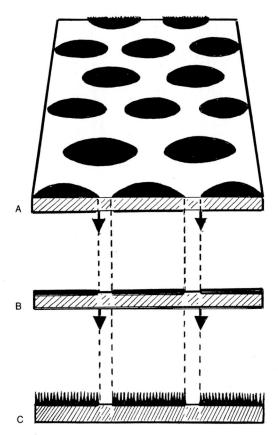

6.13
(A) Piece of material with light-and-dark pattern. (B) Cross section of material A, assuming it to be a piece of wallpaper. The dark spots are ink; the ink sits on the surface and penetrates the material. (C) Cross section of material A, assuming it to be a piece of carpet. The pattern comes from color changes and tufted areas (texture). Thus we have both pattern and texture in this example.

Texture and pattern

Because texture is interpreted by lights and darks, there is a very fine line between texture and pattern (which is similarly created). Pattern ordinarily does not have texture; according to the dictionary, it is essentially a decorative design. This implies that it is not concerned with surface but with appearance. Pattern mainly serves the artist as ornament, disregarding any tactile possibilities. But some overlapping occurs because texture can create pattern—that is, they can exist together (fig. 6.13).

6.14
This illustration shows several types of related patterns. As with most patterns, these are made up of repeated motifs, and are basically flat. Space can be read into some patterns (as with these), but spatial illusions are not ordinarily the concern of patterned areas.

From *The Principles of Pattern* by Richard M. Proctor. Copyright © 1969 by Van Nostrand Reinhold Company. Reprinted by permission of the publisher.

Pattern usually suggests a repetition, sometimes rather random, sometimes more controlled. A corn planter places corn seeds repetitiously in a field. As the corn grows, the stalks produce a pattern on the field. The three-dimensional stalks also create a texture. An aerial view of the field from a considerable height would primarily show the pattern, but when seen from lower altitudes, the texture would become more visible. Unless it is slick, texture is normally identified with a three-dimensional disruption of a surface, whereas pattern is generally thought of in two-dimensional (or flat) terms (figs. 6.14 and 6.15).

Simulated texture can serve to illustrate the dual character of texture. Imagine an artist who is going to paint a picture that includes an old barn door.

6.15
In this woven material one can see repeated motifs creating pattern, but in this case that pattern is the product of three-dimensional textures that demonstrate the pattern through the highlights and shadows of the fibers.

From *The Principles of Pattern* by Richard M. Proctor. Copyright © 1969 by Van Nostrand Reinhold Company. Reprinted by permission of the publisher.

The door is so weathered and eroded that its wood grain stands out prominently; it would feel rough if stroked. The roughness results from the ridges and valleys formed by weathering. The ridges and valleys are visible to us because they are defined by light and shadow. In rendering (or simulating) the door texture, the artist arranges lights and darks so that the grain of the door is reproduced. Once the paint has dried, the artist appears to have performed a magical feat of skillful imitation. The painted door has been made to look rough but is in fact smooth, as can be confirmed by stroking the canvas. In figure 6.16, the artist has simulated a texture and, at the same time, produced the wood grain pattern in a chair.

6.16
**Russell F. McKnight. *Weathered Chair.*
1983, photograph, 5⅝ × 8⅛ in.** This
texture is not natural to the wood, but
rather was created by outside forces. The
process induced by exposure and aging
have caused the surface shellac or varnish
to reticulate, producing a patterned
texture.

From the artist.

6.17
**Pavel Tchelitchew. *Hide-and-Seek.*
1940–42, oil on canvas, 6 ft. 6½ in. × 7
ft. ¾ in.** A personal textural style is greatly
responsible for much of the emotional
quality in this painting. Here, instead of
obvious invented patterns, we find a subtle
textural treatment of organic matter that
evokes a feeling of biological mystery.

Collection, The Museum of Modern Art, New
York. Mrs. Simon Guggenheim Fund.

Texture and composition

Relative dominance and movement

The sense of touch aside, texture is seen
as variations of light and dark. These
variations, in addition to their reference to
texture, are often exciting and attractive.
When this attraction draws our attention,
it may create a problem because it is
competing with other areas of the
artwork. If the texture area is too strong
in its hold on our attention, other areas,
possibly more important ones, may not
get the attention they deserve; the texture
must then be diminished. On the other

hand, if an area is "dead," or not
attractive, a texture can be supplied or
emphasized to make it come to life.

Our attention is constantly being
maneuvered about on the surface of an
artwork by (among other things) the
degree of emphasis given the various
areas of that surface. The movement of
our eyes is directed from one attractive
area to another, passing over, or through,
the "rests" (or de-emphasized areas). The
control of textures obviously can be a part
of the directional thrusts that move
through the work; it shares this role with
the other art elements. The abstract
textures in Picasso's *Dog and Cock* draw
our eyes to the more significant parts of
the painting (see fig. 6.11).

Psychological factors

Textures can provoke psychological or
emotional responses in us that may be
either pleasant or unpleasant. In doing
this, the textures are usually associated
with environments, experiences, objects,
or persons from our experience. Textures
have symbolic or associative meanings.
When we say a person is "slippery as a
snake" or "a roughneck," tactile
sensations are being related to personality
traits. Thus, textures can be used as
supplementary psychological devices in
art. The artist can also use textures to
stimulate our curiosity, shock us, or make
us reevaluate our perceptions (fig. 6.17).

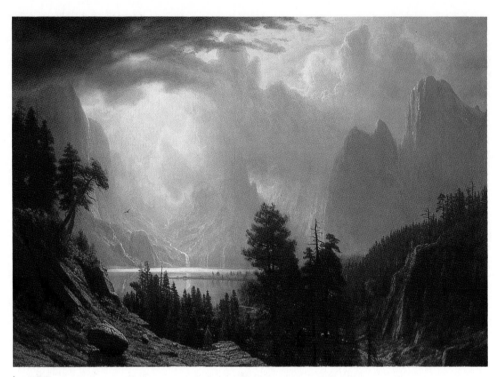

6.18

Albert Bierstadt. *Untitled Landscape.* No date, oil on canvas, 27¾ × 38½ in. The foreground areas move forward because of their greater contrasts and clarity, while other areas are thrust into space by grayness and details only faintly suggested.

Columbus Museum of Art, Ohio. Bequest of Rutherford H. Platt.

Texture and space

Texture can also help define space. The character of the texture of leaves helps us know whether a tree is near us or in the distance. When textures appear blurred and lack strong contrasts, they make objects seem distant, but if they are sharp and have strong contrasts, they make them move forward. This is one of the principles of *atmospheric perspective,* long a commonplace in academic painting. A less academic artist might use textures from far and near to produce controlled variations or surprising contradictions (fig. 6.18).

Texture and art media

Most of this discussion has dealt with the graphic arts, but textural possibilities are also considered in making other kinds of artworks. The architect balances the smoothness of steel and glass with the roughness of stone, concrete, and brick. The ceramist works with glazes, aggregates in the clay, and various incised and impressed textures. Jewelers, using their own techniques, show concern for texture when making pins, rings, necklaces, brooches, and bracelets. Printmakers use transferred textures that are printed after being etched into the printing plate. Sculptors manipulate the textures of clay, wood, metal, and other natural and artificial materials. From this we can see that texture is involved with all art forms, as it is in many life experiences—however unconscious of them we may be.

7

COLOR

The Vocabulary of Color

analogous colors

Colors that are closely related in hue. They are usually adjacent to each other on the color wheel.

color

The character of a surface that reflects a certain wavelength of light identified as red, or green, or blue, etc.

color tonality

A particular selection and arrangement of color schemes or color combinations; involves hue, value, and intensity relationships.

color triad

Three colors spaced an equal distance apart on the color wheel. The twelve-color wheel has a *primary triad*, a *secondary triad*, and two *intermediate triads*.

complementary colors

Two colors directly opposite each other on the color wheel. A *primary color* is complementary to a *secondary color* that is a mixture of the two remaining primaries.

hue

Designates the common name of a color and indicates its position in the spectrum or on the color wheel. Hue is determined by the specific wavelength of the color in a ray of light.

intensity

The saturation or strength of a color determined by the quality of light reflected from it. A vivid color is of high intensity; a dull color, of low intensity.

local (objective) color

The natural color of an object as seen by the eye (green grass, blue sky, red fire, etc.).

neutralized color

A color that has been grayed or reduced in intensity by being mixed with any of the neutrals or with a complementary color.

neutrals

Surface hues that do not reflect any single wavelength of light, but rather all of them at once. A strong reflection of all color wavelengths produces white. When large amounts of light of all color wavelengths are reflected, light grays result; when small amounts of light wavelengths are reflected, dark grays result. The absence of all color wavelengths produces black. No single color is noticed—only a sense of light or dark such as white, gray, or black.

pigments

Color substances, usually powdery in nature, that are combined with liquid vehicles to produce paint.

simultaneous contrast

When two different color tones come into direct contact, the contrast intensifies the difference between them.

spectrum

The band of individual colors that results when a beam of light is broken into its component wavelengths of hues.

split-complement

A color and the two colors on either side of its complement.

subjective colors

Selected colors that have nothing to do with objective reality, but instead express the feelings of the artist.

value

The lightness or darkness of a color. Value indicates the quantity of light reflected.

The nature of color

Color is the element of form that arouses universal appreciation and the one to which we are most sensitive. Color appeals instantly to children as well as adults; even infants are more attracted to brightly colored objects. The average layperson, although frequently puzzled by what he or she calls "modern" art, usually finds its color exciting and attractive. This person may question the use of distorted shapes, but seldom objects to the use of color, provided it is harmonious in character. In fact, a work of art can frequently be appreciated for its color style alone.

Color is one of the most expressive elements because its quality affects our emotions directly and immediately. When we view a work of art, we do not have to rationalize what we are supposed to feel about its color; we have an immediate emotional reaction to it. Pleasing rhythms and harmonies of color satisfy our aesthetic desires. We like certain combinations of color and reject others. In representational art, color identifies objects and creates the effect of illusionistic space. Color differs from the other elements in that it is based on scientific facts that are exact and easily systematized. We will examine these basic facts, or characteristics, of color relationships to see how they help give form and meaning to the subject of an artist's work.

The source of color

Color begins with and is derived from light, either natural or artificial. Where there is little light, there is little color; where the light is strong, color is likely to be particularly intense. When the light is weak, such as at dusk or dawn, it is difficult to distinguish one color from another. Under bright, strong sunlight, such as in tropical climates, colors seem to take on additional intensity.

Every ray of light coming from the sun is composed of waves that vibrate at different speeds. The sensation of color is aroused in the human mind by the way our sense of vision responds to the different wavelengths. This can be experimentally proven by observing a beam of light that passes through a triangularly shaped piece of glass (a prism) and then reflects from a sheet of white paper. The rays of light bend, or refract, as they pass through the glass at different angles (according to their wavelengths) and then reflect off the white paper as different colors. Our sense of vision interprets these colors as individual stripes in a narrow band called the *spectrum*. The major colors easily distinguishable in this band are red, orange, yellow, green, blue, indigo, and violet. (Scientists use the term indigo for the color artists call blue-violet.) These colors, however, blend gradually so that we can see several intermediate colors between them (figs. 7.1 and 7.2).

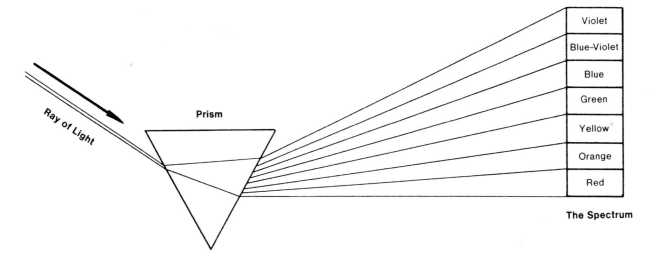

7.1
The rays of red have the longest wavelength and those of violet the shortest. The angle at which the rays are bent, or refracted, is greatest at the violet end and least at the red.

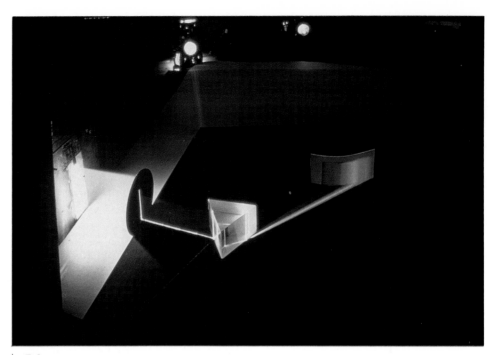

7.2

Prism and Spectrum. **1944, 35 mm color photo of a beam of light shining through a prism, 4 × 5 in.** A beam of light passes through a triangularly shaped piece of glass (prism). The rays of light are bent, or refracted, as they pass through the glass at different angles (according to their wavelengths), producing a rainbow array of hues called the spectrum.

Fritz Goro Photograph, *Life* Magazine. © 1966 Time Inc.

The colors of the spectrum are pure, and they represent the greatest intensity (brightness) possible. If we could collect all these spectrum colors and mix them in a reverse process from the one described in the previous paragraph, we would again have white light. When such colored rays of light are recombined (or mixed), the system is called *additive* because the mixed hues are obtained by adding light rays instead of absorbing or subtracting them. The pigments or coloring matter the artist uses are not as strong in intensity or as pure as the spectrum colors because pigments usually reflect from their surfaces more than just one dominant color, or they reflect a certain amount of white, which dilutes the intensity of the color. A mixture of all the pigment colors will not produce white, but rather gray, which in a sense is an impure or darkened form of white.

Since all of the colors are present in a beam of light, how are we able to distinguish a single color as it is reflected from a natural object? Any colored object has certain physical properties called *color quality* or *pigmentation* that enable it to absorb some color waves and reflect others. A green leaf appears green to the eye because the leaf reflects the green waves in the ray of light while absorbing all the other colors. A pigment has this property, and when applied to the surface of an object, gives that object the same property.

Color in art depends on pigments and, therefore, can only approximate the intensity of the spectrum colors of light. From now on when we discuss color, we will be referring to the artist's pigment rather than to the sensation of colored light.

Neutrals

All objects, of course, do not have the quality of color. Some are black, white, or gray, which do not look like any of the colors of the spectrum. No color quality is found in these colors; they differ merely in the quantity of light they reflect. Because we do not distinguish any one color in black, white, and gray, they are called *neutrals*. These neutrals actually reflect all the color waves in a ray of light. One neutral, absolute black (seldom seen), reflects no light at all and consequently has no color. White can be called the total addition of color because it results when a surface reflects all of the color waves in light to an equal degree. Black, then, is usually called the absence of color because it results when a surface absorbs all of the color rays equally and reflects none of them. If white represents

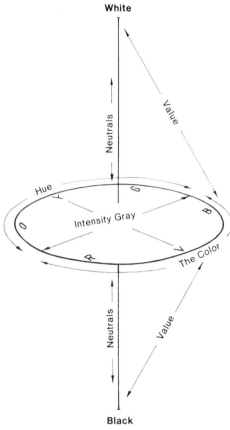

White

Value

Neutrals

Hue

Intensity Gray

The Color

Neutrals

Value

Black

7.3

This diagram demonstrates the three physical properties of color. We can see all of the color variations as existing on a three-dimensional solid (a double cone). As the colors move around this solid, they change in hue. When these hues move upward or downward on the solid, they change in value. As all of the colors on the outside move toward the center, they become closer to the neutral values, and there is a change in intensity (see also fig. 7.4).

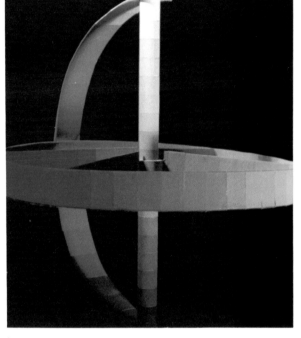

7.4

3-D color model. A three-dimensional model illustrating the three main characteristics of color (see also fig. 7.3).

Photo courtesy of Ronald Coleman.

100 percent reflection of light, then any gray is an impure white because it is created by only partial reflection of all the color waves. If the amount of light reflected is great, the gray is light; if the amount reflected is little, the gray is dark. The neutrals are affected by the quantity of light reflected, whereas color is concerned with the quality of light reflected.

Physical properties of color

As previously mentioned, the spectrum contains red, orange, yellow, blue, green, and violet. These are only a few colors, yet we know that hundreds of color variations exist. Children or beginners working with color are likely to use only a few simple, pure colors. They do not realize that simple colors can be varied.

Every color actually exists in many forms, although these forms continue to bear their simple color names. Many reds, for example, differ in character from pure red. Every color the artist uses must be described in terms of three physical properties: *hue, value,* and *intensity* (figs. 7.3 and 7.4).

Hue

Hue is the characteristic of a color that indicates its position on the color wheel. Hue also refers to the color names that differentiate colors having different wavelengths of light. For example, yellow is a hue that differs from green (another hue) and has a different wavelength. A color's hue can be changed by mixing it with another color; this actually changes the wavelength of the ray of light. Yellow added to green creates a yellowish green, or a change in hue. Also, yellow mixed with blue creates green, and the amount of yellow used determines the kind of green that results. Yellow, yellow-green, green, and blue-green are all different hues because they have different wavelengths. However, when pigments of these colors are mixed, the resulting colors each contain the common hue yellow. Such variations are called analogous hues (fig. 7.5; see fig. 7.9D).

Many colors can be created by mixing two other colors. Three colors, however, cannot be created from mixtures; these are the hues red, yellow, and blue, known as the *primary colors* (fig. 7.6A). When the three primaries are mixed in pairs, or all together, in equal or unequal amounts, they can produce all of the possible colors.

A mixture of the three primaries should, theoretically, result in white; actually, it produces a neutral gray, which may be considered a darkened form of white. The important point is that the three primaries neutralize each other so that the resulting tone does not resemble any one hue. Mixing any two primaries produces a *secondary color:* orange results from mixing red and yellow; green results from mixing yellow and blue (fig. 7.6B). In addition, certain intermediate colors are created by mixing a primary color with a neighboring secondary color. The number of *intermediate colors* is unlimited, because a change of proportion in the amount of primary or secondary colors used will change the resultant hue. In other words, not just one yellow-green is possible from mixing green and yellow. If more yellow is used, a different yellow-green results than when more green is used (fig. 7.6C).

To systematize color relationships, the hues are often shown arranged around a wheel (fig. 7.5). The three primary colors are equally spaced apart on this wheel, with yellow usually placed at the top. The three secondary colors are put between the primaries from which they are mixed. An intermediate color is placed between each primary color and each secondary color, resulting in a twelve-color wheel. The hues of the colors change as we move around the color wheel because the wavelengths of the light rays that produce these colors change. The closer together colors appear on the color wheel, the closer their hue relationships; the farther apart, the more contrasting they are in character. The hues directly opposite each other afford the greatest contrast and are known as *complementary colors.*

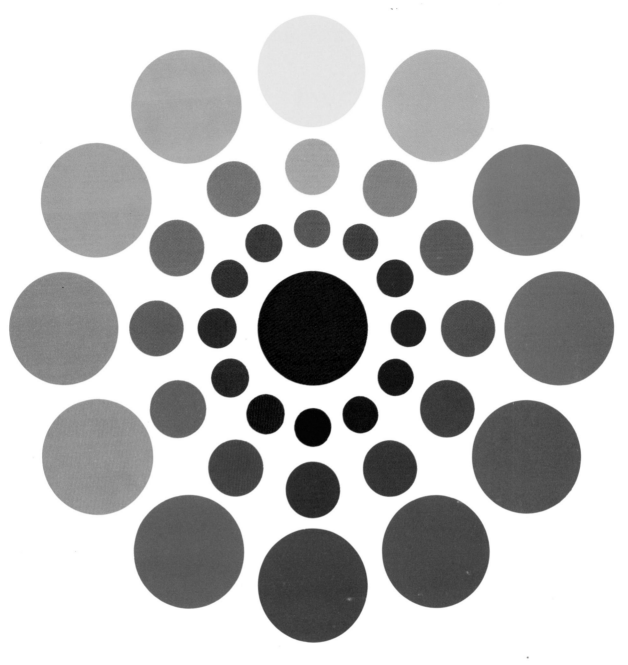

7.5
This color wheel includes the primary, secondary, and tertiary hues—the "standard" hues; of course, the possible number of hues is infinite. As one moves from a hue to its opposite on the color wheel, the smaller circles indicate the lessening of intensity due to the mixing of these opposites, or complementaries.

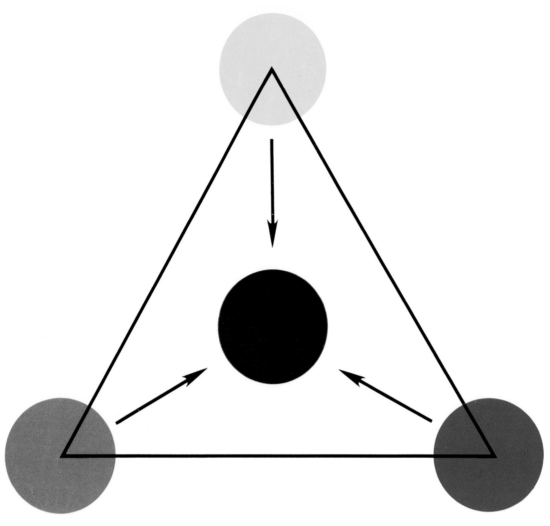

7.6A
Primary triad. When the colors of the primary triad are mixed together, the resulting color is gray.

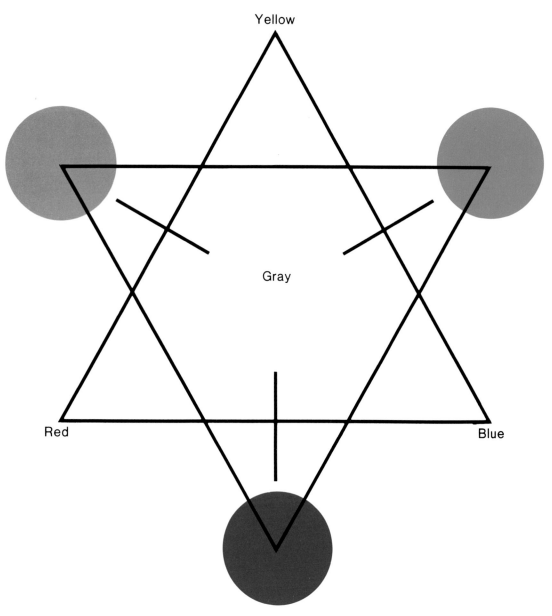

Yellow

Gray

Red

Blue

7.6B
Secondary triad.

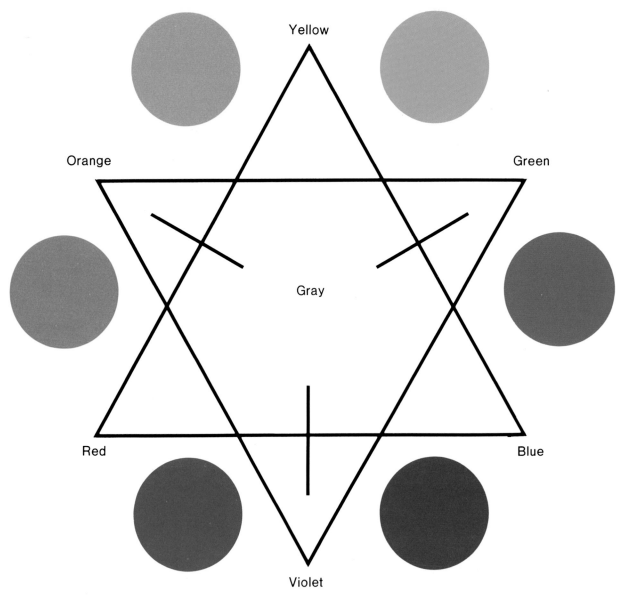

7.6C
Intermediate colors.

Value

A wide range of color tones can be produced by adding black or white to a hue. This indicates that colors have characteristics other than hue. The property of color known as *value* distinguishes between the lightness and darkness of colors, or the quantity of light a color reflects. Many value steps can exist between the darkest and lightest appearance of any one hue. To change the tone value of a pigment, we must mix with it another pigment that is darker or lighter. The only dark or light pigments available that would not also change the color's hue are black and white.

Each of the colors reflects a different quantity of light as well as a different wavelength. A large amount of light is reflected from yellow, whereas a small amount of light is reflected from violet. Each color at its maximum intensity has a normal value that indicates the amount of light it reflects. It can, however, be made lighter or darker than normal by adding white or black, as previously noted. We should know the normal value of each of the colors in order to use them effectively. This normal value can be most easily seen when the colors of the wheel are placed in relationship to a scale of neutral values from black to white (fig. 7.7).

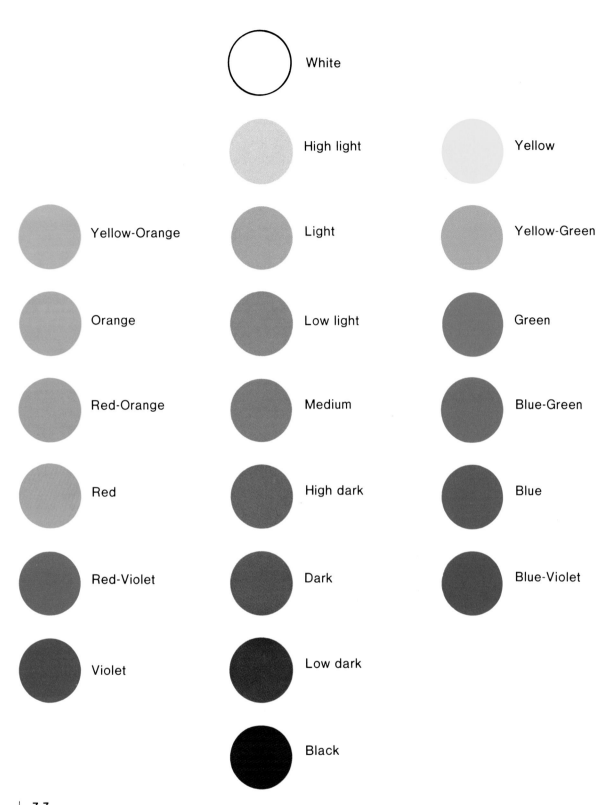

White

High light

Yellow

Yellow-Orange

Light

Yellow-Green

Orange

Low light

Green

Red-Orange

Medium

Blue-Green

Red

High dark

Blue

Red-Violet

Dark

Blue-Violet

Violet

Low dark

Black

7.7
Color values. This chart indicates the relative normal values of the hues at their maximum intensity (purity or brilliance).

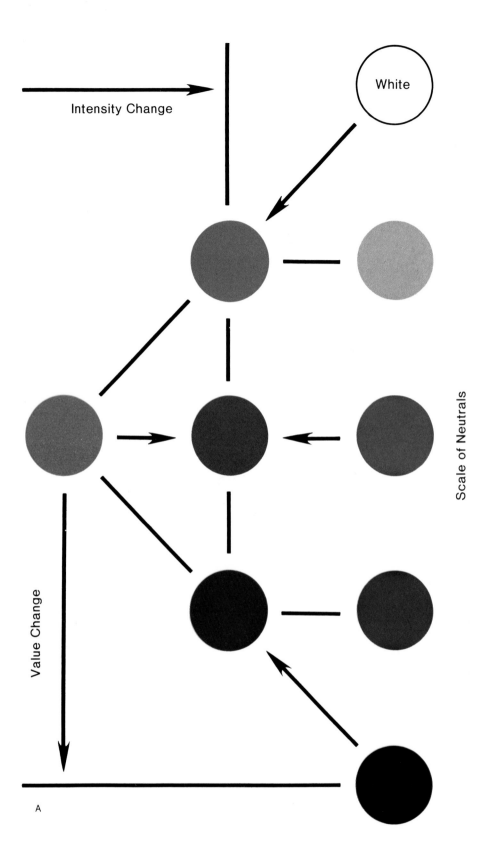

Intensity Change

White

Scale of Neutrals

Value Change

A

7.8
Diagrams *A* (left) and *B* (facing page) illustrate the four means of changing the intensity of color. (*A*) As white (a neutral) is added to bright red, the value is changed, but the resulting color is lowered in intensity. In the same way, the addition of black to bright red creates a dark red closer to the neutral scale because the intensity is changed. When a neutral gray is added to the spectrum color, the intensity is lowered, but the value is neither raised nor lowered. (*B*) This diagram indicates change of intensity by adding to a color a little of its complement. For instance, by adding a small amount of green to red, a gray red is produced. In the same way, a small amount of red added to green results in a gray green. When the two colors are balanced (not necessarily equal amounts), the resulting mixture is a neutral gray.

Intensity

The third property of color, *intensity* (sometimes called *saturation* or *chroma*), refers to the quality of light in a color. We use the term intensity to distinguish a brighter tone from a duller one of the same hue; that is, to differentiate a color that has a high degree of saturation or strength from one that is grayed or neutralized. The saturation point, or the purest color, is actually found in the spectrum produced by a beam of light passing through a prism. However, the artist's pigment that comes closest to resembling this color is said to be at maximum intensity. The purity of the light waves reflected from the pigment produces the variation in brightness or dullness of the color. For example, a pigment that reflects only the red rays of light is an intense red, but if any of the complementary green rays are also reflected, the red's brightness is dulled or neutralized. If the green and red rays balance each other equally, the resulting tone is a neutral gray. Consequently, as a color loses its intensity, it tends to approach gray.

There are four ways to change the intensity of colors when mixing pigments (fig. 7.8A). Three of these involve adding to the hue pigment a neutral (black, white, or gray). As white is added to any hue, the tone becomes lighter in value, but it also loses its brightness or intensity.

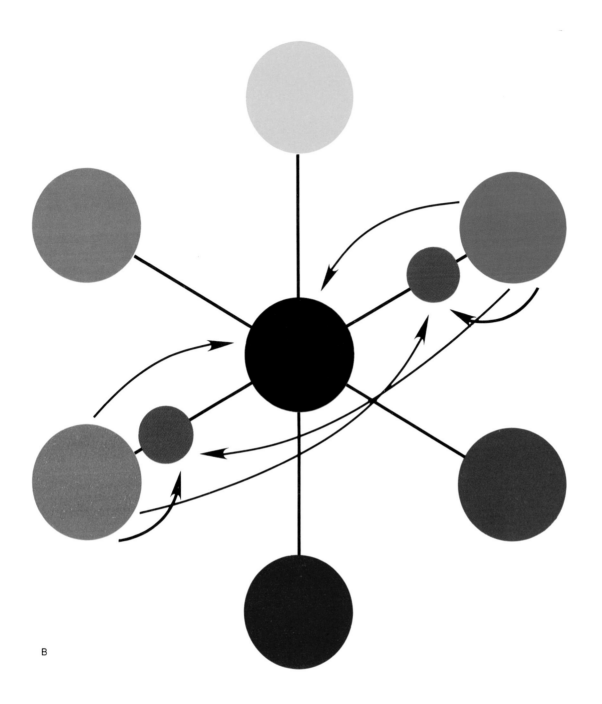

B

In the same way, when black is added to a hue, the intensity diminishes as the value darkens. We cannot change value without changing intensity, although these two properties are not the same. The third method of changing intensity involves mixing the hue pigment with a neutral gray of the same value. The resulting mixture is a variation in intensity without a change in value. The color becomes less bright as more gray is added but it will not become lighter or darker in tone. The fourth way to change the intensity of any

hue is by adding the complementary hue. Mixing two hues that occur exactly opposite each other on the color wheel, such as red and green, blue and orange, or yellow and violet, results in a neutral gray. This is because the complementary colors represent an equal balance of the three primaries. The dominating hue in the mixture of two complementary colors gives its specific character to the resulting tone. Consequently, this tone, instead of being a pure gray, is a grayed or

neutralized form of the color used in the larger amount. When hues are neutralized by mixing complements, the resulting colors have a certain liveliness of character not present when they are neutralized with a gray pigment. This interesting character is enhanced when the complementary tones are not actually mixed but are merely placed close together in little dots of broken color. The mixture then takes place in the visual perception of the observer (fig. 7.8B).

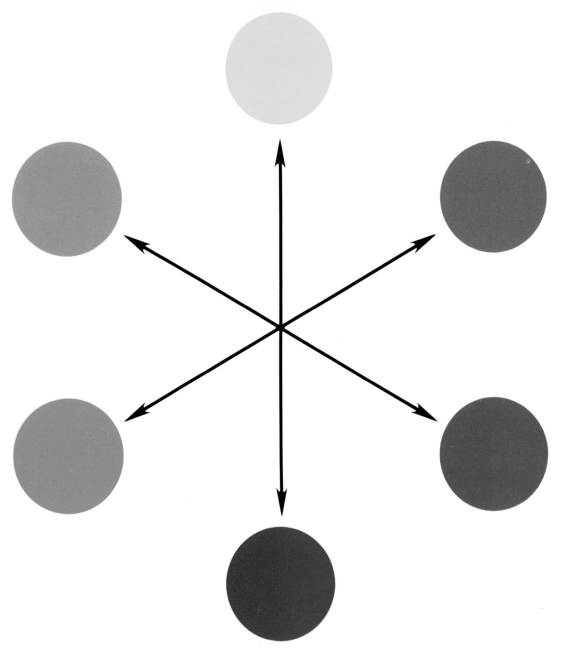

7.9A
Complementary colors (extreme contrast).

Color relationships

The successful use of color depends upon an understanding of color relationships. A single color by itself has a certain character, but that character may be greatly changed when the color is seen with other colors. Colors may be closely related or contrasting, but the contrast can vary considerably in degree. The greatest contrast in hue occurs when two colors that appear directly opposite each other on the color wheel (complementaries) are used together (fig. 7.9A). A *split-complement* system (the color and two colors on either side of its complement) results in a variation that has less contrast. There is a shorter interval between colors and, consequently, less contrast when three colors spaced equally apart on the color wheel are used together. The first group, known as the *primary triad,* consists of red, yellow, and blue. The second group, or *secondary triad,* is composed of orange, green, and violet. The contrast is more striking in the primary triad. In the secondary triad, although the interval between hues is the same, the contrast is softer. This effect probably occurs because any two hues of the triad share a common color: orange and green both contain yellow; orange and violet both contain red; and green and violet both contain blue. Colors that appear next to each other on the color wheel have the shortest interval and consequently the most harmonious relationship. This is because three or four neighboring hues always contain one common color that dominates the group; they are analogous colors (figs. 7.9B, 7.9C, and 7.9D).

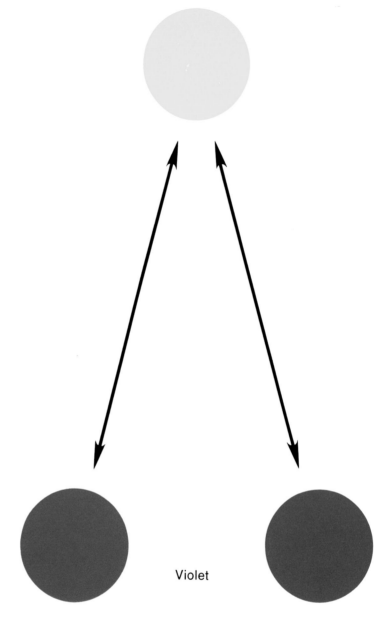

Violet

7.9B
Split-complementary colors. This example shows yellow and its split-complementary colors, red-violet and blue-violet, on either side of yellow's complement, violet.

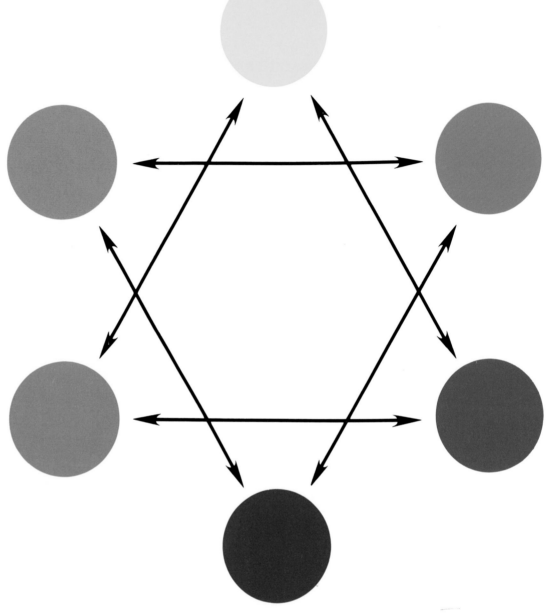

7.9C
Triadic color interval (medium contrast).

Orange

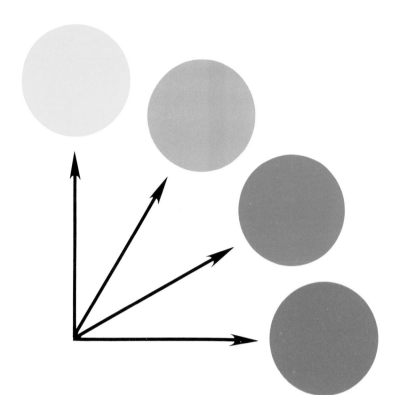

Red

Blue

Violet

7.9D
Analogous colors (close relationships).

7.10

Munsell Color Tree. 1972, clear plastic chart, 10½ × 12 in; base size 12 in. diameter; center pole size 12⅝ in. high; chip size ¾ × 1⅜ in. The Munsell system in three dimensions. The greatest intensity of each hue is found in the color vane farthest from the center trunk. The value of each vane changes as it moves from top to bottom of the tree. The center trunk changes only from light to dark. The colors change in hue as they move around the tree.

Courtesy Macbeth, a division of Kollmorgen Corporation, Baltimore, Maryland.

Other color systems

Humans' perennial fascination with, and consequent analysis of, color has resulted in the development of a number of color systems. One of the most successful was formulated in the early 1900s by the American artist Albert Munsell. Munsell's system showed the relationships between different color tints and shades. The system was an attempt to give names to the many varieties of hues that result from mixing different colors with each other or with the neutrals. American industry adopted the Munsell system in 1943 as its material standard for naming different colors. The system was also adopted by the United States Bureau of Standards in Washington, D.C.

In the Munsell system the five basic hues are red, yellow, green, blue, and purple (violet). The mixture of any two of these colors that are adjacent on the color wheel is called an intermediate color. For example, the mixture of red and yellow is the intermediate color red-yellow. The other intermediate hues are green-yellow, blue-green, purple-blue, and red-purple.

To clarify color relationships, Munsell devised a three-dimensional color system that classifies the different shades or variations of colors according to the qualities of hue, value, and intensity (or chroma). His system is in the form of a tree. The many different color tones are seen as transparent plastic vanes that extend from the center trunk like tree branches. The center trunk is a scale of neutral tones that begin with black at the bottom and rise through grays to white at the top. The color tone at the outer limit of each branch represents the brightest hue possible at each level of value (fig. 7.10).

The most important part of the Munsell color system is the color notation, which describes each color in terms of a letter and numeral formula. The hue is indicated by the notation found on the inner circle of the color wheel. The value of the colors is indicated by the numbers on the central trunk shown in figure 7.10. The intensity, or chroma, is shown by the numbers on the vanes that radiate from the trunk. These value and intensity relationships are expressed by fractions, with the upper number representing the value and the lower number indicating the intensity (chroma). For example, 5Y8/12 is the notation for a bright yellow.

It is interesting to compare the Munsell color wheel with the one used in this book (fig. 7.11; see fig. 7.5). Munsell places blue opposite yellow-red and red opposite blue-green, while we place blue opposite orange and red opposite green. In another system, Wilhelm Ostwald places blue opposite yellow. Each system is designed for a particular purpose. Munsell used his circular arrangement in accordance with certain strict rules for standardizing many industrially used colors. Ostwald devised his system in relation to psychological harmony and order. In this book the circular arrangement is based on a less complicated subtractive system of artist-pigmented colors. Diametrically opposing colors that the artist uses should be complementary and when mixed should produce a gray. This system of mixing color is known as the *subtractive process* because the second color, when mixed with the first color, subtracts or absorbs more light waves from a white light than the first color. The British have published a standard color wheel entitled "Powder Pigments for Artists' Use" that is arranged like the wheel in this book.

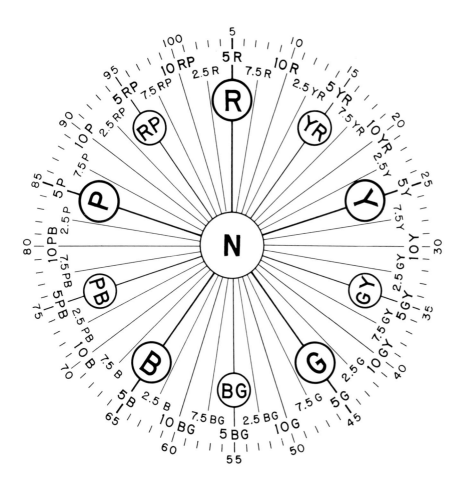

7.11

Munsell Color Wheel. This diagram shows the relationships of the hues on the wheel in terms of a specific type of notation as explained in the text.

Courtesy Macbeth, a division of Kollmorgen Corporation, Baltimore, Maryland.

Space does not permit discussion of other color systems here, but a substantial number of color theorists have explored the color field. Among them are Isaac Newton, Johann Goethe, Arthur Schopenhauer, M. E. Chevreul, Eugene Delacroix, J. C. Maxwell, Johannes Itten, and Faber Birren.

Warm and cool colors

All of the colors can be classified into one of two groups: warm colors or cool colors. Red, orange, and yellow are associated with the sun or fire, and thus are considered warm. Any colors containing blue, such as green, violet, or blue-green, are associated with air, sky, and water; these are called cool. The quality of warmth or coolness in a color may be affected or even changed by the hues around or near it. The artist may mix a color on a palette and then find that it appears entirely different when juxtaposed on the canvas with other colors.

Simultaneous contrast

The effect of one tone upon another is sometimes called the *Rule of Simultaneous Contrast.* According to this rule, whenever two different color tones come into direct contact, the contrast intensifies the difference between them. This effect is most noted, of course, when the colors are directly contrasting in hue, but it occurs even if the colors have some degree of relationship. For example, a yellow-green surrounded by green appears yellow, but if it is surrounded by yellow, it seems more noticeably green. The contrast can be in the characteristics of intensity or value as well as in hue. A grayed blue looks brighter if placed against a gray background; it looks grayer or more neutralized against a bright blue background. The most obvious effect occurs when complementary hues are juxtaposed: blue is brightest when seen next to orange, and green is brightest when seen next to red. When a warm tone

is seen in simultaneous contrast to a cool tone, the warm tone appears warmer and the cool tone cooler. A color always tends to bring out its complement in a neighboring color. When a neutralized gray made up of two complementary colors is placed next to a strong positive color, it tends to take on a hue that is opposite to the positive color. When a person wears a certain color of clothing, the complementary color in that person's complexion is emphasized.

All of these changes in appearance make us realize that no one color should be used for its character alone, but must be considered in relation to the other colors present. For this reason it is better to develop a color composition all at once rather than to try to finish one area completely before going on to another. Only after understanding the basic facts of color and the effects of color relationships can we explore color's function as an element of form in composition.

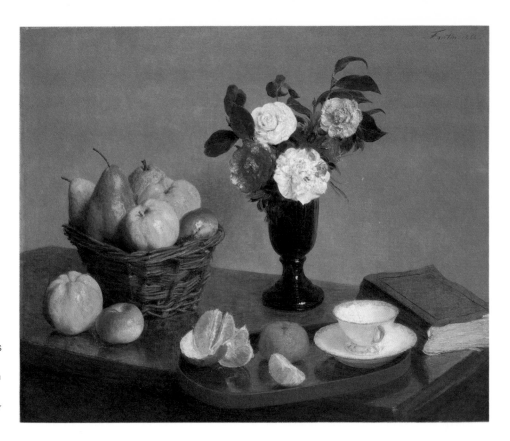

7.12

Henri Fantin-Latour. *Still Life.* **Dated 1866, oil on canvas, 24⅜ × 29½ in.** This still life is painted in local color, color that simulates the natural hues of the objects in nature.

National Gallery of Art, Washington D.C. Chester Dale Collection.

Uses of color

Being familiar with the sources of color and its principal properties is of little value unless we understand how the artist uses these facts. Color serves several purposes in artistic composition. These purposes, however, are not always separate and distinct, but frequently overlap and interrelate. Color can be used in the following ways:

1. To give spatial quality to the pictorial field.
 a. Color can supplement, or even substitute for, value differences to give plastic quality.
 b. Color can create interest through the counterbalance of backward and forward movement in pictorial space.
2. To create mood and symbolize ideas.
3. To serve as a vehicle for expressing personal emotions and feelings.
4. To attract and direct attention as a means of giving organization to a composition.
5. To accomplish aesthetic appeal by a system of well-ordered color relationships.
6. To identify objects by describing the superficial facts of their appearance.

The last function, that of describing superficial appearances, was considered most important when painting was seen as a purely illustrational art. For a long period in the history of Western art, color was looked upon as something that came from the object being represented. In painting, color that is used to indicate the natural appearance of an object is known as *local color* (fig. 7.12). A more expressive quality is likely to be achieved when the artist is willing to disassociate the color surfaces in the painting from the object to which the color conventionally belongs. An entirely subjective color treatment can be substituted for local color. The colors used and their relationships are invented by the artist for purposes other than mere representation (fig. 7.13). This style of treatment may even deny color as an objective reality; that is, we may have purple cows, green faces, or red trees. Most of the functions of color are subjective; they are of particular importance in contemporary art and should be examined separately.

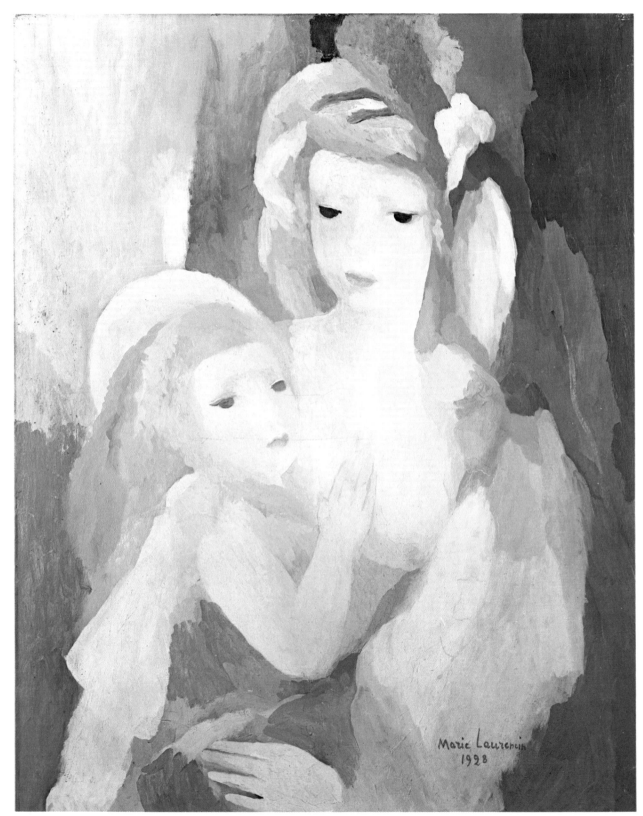

7.13
Marie Laurencin. *Mother and Child.* 1928, oil on canvas, 32 × 25½ in. This French artist used color to construct a personal (or subjective) interpretation that sets the charming mood of the painting.

The Detroit Institute of Arts, City of Detroit Purchase.

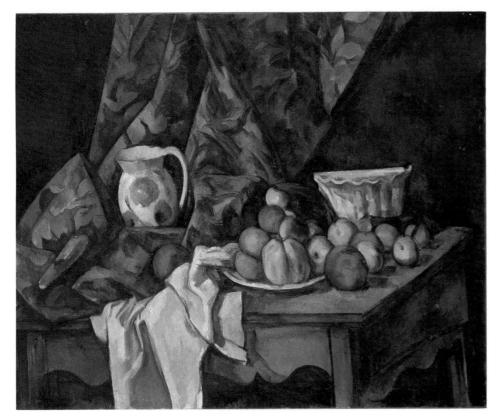

7.14

Paul Cézanne. *Still Life with Apples and Peaches.* **Circa 1905, oil on canvas, 32 ×
39⅝ in.** Cézanne used changes of color as a means of modeling form. Cool colors indicate
recession rather than a mere darkening of the characteristic tones.

National Gallery of Art, Washington, D.C. Gift of Eugene and Agnes Meyer.

space to give content (meaning) to a
painting, although no actual objects are
represented. Color, along with line, value,
and texture, is another way to accomplish
this purpose.

Color and emotion

A second function of color involves its
ability to create mood, symbolize ideas,
and express personal emotions. Color
itself, as found upon a canvas, can express
a mood or feeling, even though it is not
descriptive of the objects represented.
Light, bright colors make us feel happy
and gay, while cool, dark, or somber
colors are generally depressing. The
different hues of the spectrum have
different emotional impacts. Psychologists
have found that red is happy and exciting,
whereas blue is dignified, sad, or serene.
Also, different values and intensities of
the hues in a color tonality may affect its
feeling tone. A decided value range
(strongly contrasting light or dark hues)
gives vitality and directness to a color
scheme; closely related values and low
intensities suggest subtlety, calmness, and
repose (figs. 7.15 and 7.16). We cannot
escape the emotional effects of color
because it appeals directly to our senses.

Artists may also take advantage of the
power of color to symbolize ideas, thus
making their work stronger in content or
meaning. Such abstract qualities as
virtue, loyalty, honesty, evil, and
cowardice are symbolized by the colors
that have come to be traditionally
associated with them. In many cases we
do not know the origin of these
associations but are nevertheless affected
by them. For example, blue is associated
with loyalty and honesty (true blue), red
with danger, yellow with cowardice
(yellow streak), black with death, green
with life or hope, white with purity or
innocence, and purple with royalty or
wealth. Some colors have many different
associations. Thus, red can connote fire,
danger, bravery, sin, passion, or violent
death. The colors in a painting may
enhance the impact of the subject matter
by suggesting meanings associated with
them (fig. 7.17).

The plastic quality of color

As used by the present-day artist, color
that does not describe the surface of an
object may give the essential reality of the
object's plastic character. This ability to
build a form comes from the advancing
and receding characteristics of certain
colors. When placed upon a surface,
colors actually seem to have a spatial
dimension. For example, a spot of red on
a flat surface appears to be in front of
that surface; a spot of blue, similarly
placed, seems to sink back into the
surface. In general, warm colors advance,
and cool colors recede. The character of
such effects, however, can be altered by
differences in the value and/or intensity
of the color. These spatial characteristics
of color were first noted by the French
artist Paul Cézanne in the latter part of
the nineteenth century. He admired the
sparkling brilliancy of the Impressionist
artists of the period but thought their

work had lost the solidity of earlier
painting. Consequently, he began to
experiment with expressing the bulk and
weight of forms by modeling with color
tones. Previous to Cézanne's experiments,
the traditional academic artist had
modeled form by changing values in
monotone (one color). The artist then
tinted these tones with a thin, dry local
color that was characteristic of the object
being painted. Cézanne discovered that a
change of color on a form could serve the
purpose of a change of value and not lose
the intensity of expression. He felt that
the juicy richness of positive colors
expressed the actual structure of a solid
object. Later, contemporary artists
realized that Cézanne's advancing and
receding colors could also create those
backward and forward movements in
space that give liveliness and interest to
the picture surface (fig. 7.14). Many
abstract artists have used the
relationships of balance and movement in

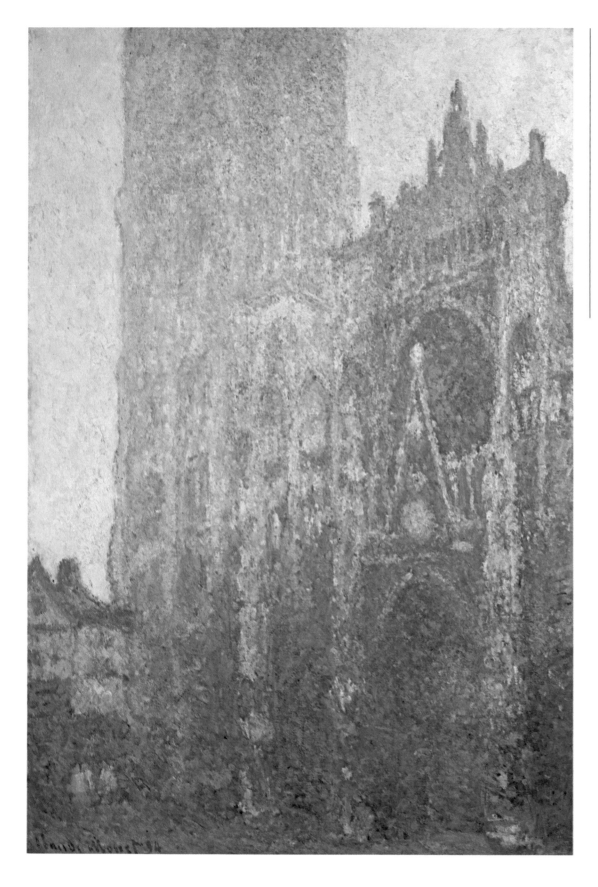

7.15
Claude Monet. *La Cathedrale de Rouen le Portail et la Tour d'Albane, Le Matin.* **1894, oil on canvas, 42 × 29 in.** Monet, with the interest in light characteristic of the Impressionists, often painted the same subjects at different times of the day. As a result, the hues, values, and intensities are markedly affected, as can be seen by comparing this painting with figure 7.16 (next page). Structure is dissolved in the artist's preoccupation with color, light, and atmosphere. Galerie Beyeler, Basel.

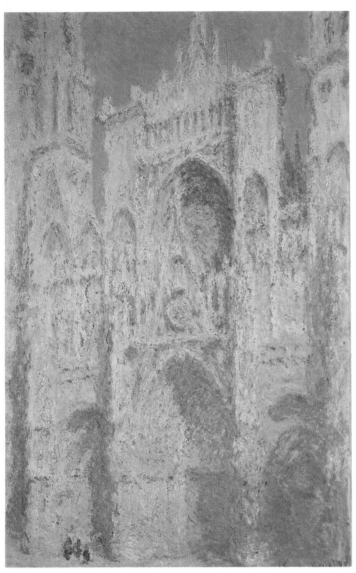

7.16
Claude Monet. *Rouen Cathedral, West Facade, Sunlight.* **1894, oil on canvas, 39½ × 26 in.**
National Gallery of Art, Washington, D.C. Chester Dale Collection.

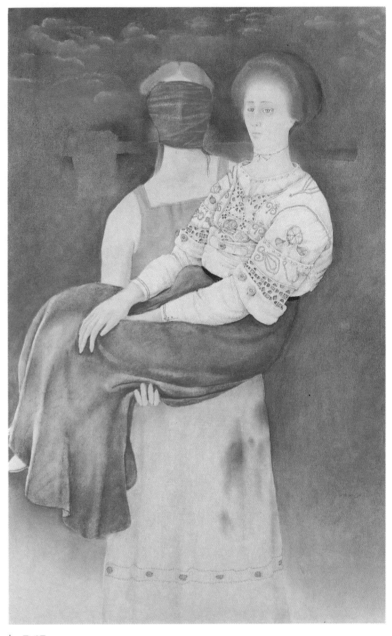

7.17
Morris Broderson. *Lizzie Borden and the Ghost of Her Beloved Mother.* **1968, pastel and pencil, 40 × 26 in.** The personal style of this artist is fraught with imminent mystery, partly due to his use of predominantly blue color hues.
Courtesy the Ankrum Gallery, Los Angeles.

In addition to expressing meanings by association, color may express an artist's personal emotions. Most truly creative artists evolve a personal style of color tone that comes primarily not from the subject but from their feelings about the subject. Albert Pinkham Ryder expressed what he felt about the sea in a very original style of color. John Marin's color is essentially suggestive in character, with little expression of form or solidity. It is frequently delicate and light in tone, in keeping with the medium (watercolor) with which he works. The color in the paintings of Vincent van Gogh is usually

vivid, hot, intense, and applied in snakelike ribbons of pigment (fig. 7.18). His use of texture and color accounts for the intensely personal style of his work. The French artist Renoir used a luminous, shimmering color in painting human flesh so that his nudes have a glow that is not actually present in the human figure. The emotional approach to color appealed particularly to the Expressionist painters, who used it to create an entirely subjective treatment having nothing to do with objective reality.

The aesthetic appeal of color tonality

The final function of color involves its ability to evoke sensations of pleasure because of its well-ordered system of tonality (fig. 7.19). This appeal refers to the sense of satisfaction we derive from seeing a well-designed rug or drapery material whose color combination is harmonious. The same appeal can be found in a purely nonobjective painting. There are no exact rules for arriving at pleasing effects in color relationships, but there are some guiding principles. We can develop the ability to create pleasing color by studying and analyzing color schemes that appeal to us. This study should be followed by experiment and practice in color organization. The problem is, first, the selection of hues to be used together in a composition and, second, their arrangement in the pictorial field in the proper amounts for color balance. No color is important in itself; each is always seen on the picture surface in a dynamic interaction with other colors. Combinations and arrangements of color express content or meaning; consequently, any arrangement ought to have a definite aesthetic appeal. In talking about pleasing color, we must realize that there can be brutal color combinations as well as refined ones. These brutal combinations can be satisfying if they accomplish the artist's purpose of exciting us rather than calming us. Some of the German Expressionist painters have proven that brutal, clashing color schemes can have definite aesthetic value when used in a purposeful manner (fig. 7.20).

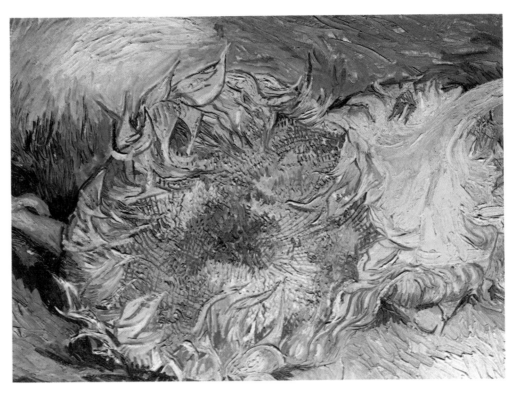

7.18
Vincent van Gogh. *Sunflowers.* 1887, oil on canvas, 24 × 17 in. During the late 1880s, Van Gogh developed a mature style dominated by hot and lively hues painted with a verve that indicates his personal discovery and passion for the sunny climate of Mediterranean France.
Metropolitan Museum of Art, New York. Rogers Fund, 1949.

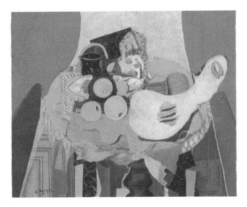

7.19
Georges Braque. *Still Life with Fruit and Mandolin.* 1938, oil on canvas, 114.3 × 147.3 cm. The Cubist painter Braque commonly achieves aesthetically pleasing arrangements of color and value areas. His inventive hues are probably the choicest of early twentieth-century painting, and his selective placement is equally significant.
The Gift of Mary and Leigh Block, 1988.141.6. © 1988 The Art Institute of Chicago. All Rights Reserved.

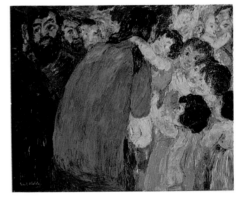

7.20
Emil Nolde. *Christ among the Children.* 1910, oil on canvas, 34⅛ × 41⅞ in. The Expressionists usually employed bold, clashing hues to emphasize their emotional identification with a subject. Intense feeling is created by the use of complementary and near-complementary hues.
Collection, The Museum of Modern Art, New York. Gift of Dr. W. R. Valentiner.

Color balance

All good color combinations have some relationships and some contrasts. Where colors are related in hue, they can exhibit contrast in value and/or intensity. The basic problem is the same one present in all aspects of form organization: variety in unity. There must be relationships between the color tones, but these relationships must be made alive and interesting through variety. A simple way to create unity and balance is by repeating similar color tones in different parts of a composition. An important aspect of color balance is based upon our perception of complementary hues. If we look fixedly at a spot of intense red for a few moments and then shift our eyes to a white area, we see an afterimage of the same spot in green-blue, its complement. The phenomenon can be noted when any pair of complementary colors is used. This psychological fact is the basis for our use of a note of complementary color to balance the dominating hue in many color schemes (fig. 7.21).

The pleasing quality of a color pattern frequently depends on the amounts or proportions of color used. In general, equal amounts of different colors are not as interesting as a color arrangement where one color, or one kind of color, predominates (fig. 7.22). We are often confused by color schemes in which all of the tones demand equal importance, because we cannot find a dominant area on which to fix our attention. The dominance of any one color in a pattern can be due to its hue, its value, or its intensity; dominance can also be affected by the character of the surrounding hues (fig. 7.23). A small, dark spot of color, through its lower value, can dominate a large, light area. A spot of intense color, though small, can balance a larger amount of a grayer, more neutralized color. Also, a small amount of warm color usually dominates a larger amount of cool color, although both may be of the same intensity. Complementary colors, which of course vie for our attention through simultaneous contrast, can be made more attractive if one of them is softened or neutralized.

7.21
**Noriyoshi Ishigooka. *Spring in the Chateau du Repas.* 1987, oil on canvas, 16.1 ×
130.3 cm.** Larger areas of green and yellow dominate in this double complementary use of color. Smaller areas of their complements, red and violet, balance the total color pattern.
Collection, Pierre Gohill Corporation.

7.22

Fernand Léger. *Propellers.* **1918, oil on canvas, 31⅞ × 25¾ in.** Although a variety of strong colors appear in this painting, the careful repetition of a key hue (yellow) creates harmony and color balance.

Collection, The Museum of Modern Art, New York. Katherine S. Dreier Bequest.

7.23

Maurice Utrillo. *Street in Sannois.* **Circa 1911, oil on canvas, dimensions unframed 21½ × 29¼ in.** Blue is a dominant hue in this painting by Utrillo. He achieves a dynamic balance by using smaller areas of complements and neutral white.

Virginia Museum of Fine Arts, Richmond. Collection of Mr. and Mrs. Paul Mellon. Acc. no. 83.55.

Color combinations

Any attempt to base the aesthetic appeal of color pattern on certain fixed theoretical color harmonies will probably not be successful. The effect depends as much on how we distribute our tones as on the relationships among the tones themselves. Most combinations, however, can be reduced to two basic types of color organization. In the first, the unity of the hues is dominant; in the second, hue combinations that depend on strong contrast and variety of color are used. In the unified color scheme, enough variety must be introduced to keep the effect from becoming too monotonous; in the contrasting color scheme, the basic problem is to unify the contrasts without destroying the general strength and intensity of expression. In the first type of color pattern, the hue intervals are closely related as in analogous colors; in the second type, the hue intervals are further apart, the greatest possible interval being that between two complementary colors.

Unified color patterns

Unity is often produced in a color scheme by stressing one hue only. Naturally, variety can only be achieved by using contrasting values or intensities (fig. 7.24). This scheme can be varied by introducing a small amount of a subordinate contrasting hue or even a contrasting neutral such as white or black (fig. 7.25). Another way to relate colors and achieve unity is by keying a number of colors toward one hue (see fig. 7.24). This one hue will be a harmonizing factor if a little of it is mixed with every color used in the combination. The same effect can be created by glazing over a varicolored pattern with a single tone of color, which becomes the key color. A third type of unified pattern is found when all warm or all cool colors are used in combination (see fig. 7.25). Again, however, a small amount of a complementary color or a contrasting neutral can add variety to the color pattern (fig. 7.26). As a rule, where warm and cool colors are balanced against each other in a composition, it is better to allow one temperature to dominate.

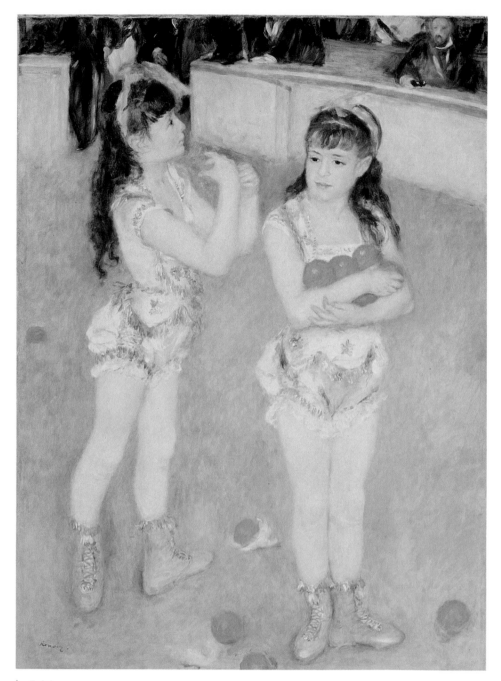

7.24

Pierre-Auguste Renoir. *Two Little Circus Girls.* 1879, oil on canvas, 131.5 × 99.5 cm.
Here, unity is achieved by the French artist Renoir through a dominantly warm color scheme keyed toward yellow to invoke a sense of childhood grace and charm. Although very slight traces of cool color are found in the painting, variety is basically achieved through modulations of value.

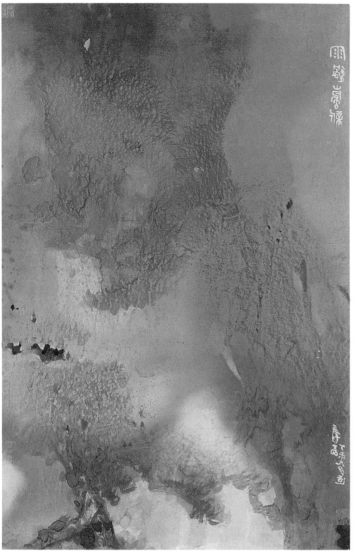

7.25
Chang Dae Chien. *Mountain after Rain.*
1970, watercolor, approx. 50 × 32 in.
This contemporary Chinese artist obviously
follows some of the artistic traditions of his
homeland. This painting is largely
analogous in hue (blues and greens),
faintly punctuated by other colors.
Courtesy Ankrum Gallery, Los Angeles.

7.26
Paul Jenkins. *Phenomena Shield and*
***Green.* 1969, acrylic on canvas, 40 ×**
26 in. Analogous (related) colors can
produce harmony, while touches of a
complementary color contribute variety.
Courtesy the Owens-Corning Collection, Owens-
Corning Fiberglas Corporation, Toledo, Ohio.

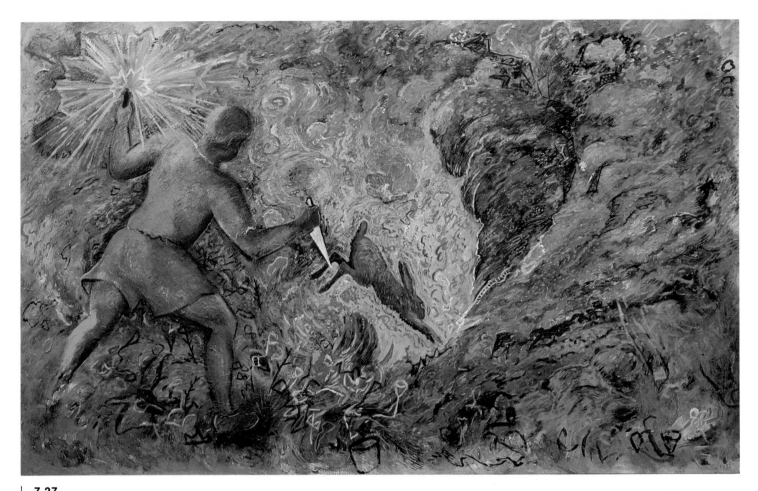

7.27

Sandro Chia. _Rabbit for Dinner._ 1981, oil. Italian Sandro Chia, a Neo-Expressionist, uses contrasting hues to charge his emotional picture. The hues are neutralized with black to achieve unity without losing liveliness.

Collection Stedelyk Museum, Amsterdam.

Contrasting color patterns

Color schemes based upon strong contrasts of hue or intensity have great possibilities for expressive effect (fig. 7.27). These contrasts can sometimes be controlled by the amount of contrasting color used. Where the basic unity of a color pattern has been established, strong contrasts of color can be used in small accents; their size, then, prevents them from disturbing the basic unity of the color theme. Another commonly used method of controlling contrasts is to separate all or a part of the tones by a neutral line or area. Absolute black or white lines are the most effective neutrals for this purpose because they are so

positive in character themselves. They not only tie together the contrasting hues, but also enhance their color character because of value contrast. The neutral black leading between the brilliant colors of stained glass windows is an example of this unifying character. Such modern painters as Georges Rouault and Max Beckmann found a black line effective in separating their highly contrasting colors (fig. 7.28; see fig. 10.29). A similar unifying effect can be brought about by using a large area of neutral gray or a neutralized color as a background for clashing contrasts of color.

Finally, we should remember that combinations of color frequently defy the exactness of any rules but are still satisfying to the eye. Artists use color as they do the other elements of art structure—to give a highly personalized meaning to the subject matter of their work.

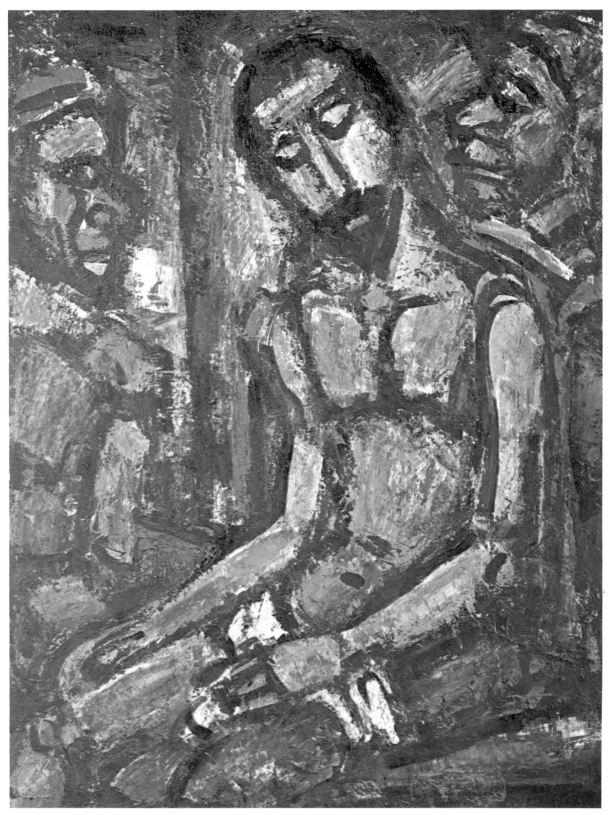

7.28
Georges Rouault. *Christ Mocked by Soldiers.* 1932, oil on canvas, 36¼ × 28½ in. In
this Expressionist contrast of clashing complements, the pattern and harmony are stabilized
through heavy neutralizing lines of black suggested to Rouault by medieval stained glass.
Collection, The Museum of Modern Art, New York. Given anonymously.

8
SPACE

The Vocabulary of Space

atmospheric (aerial) perspective
The illusion of deep space produced in graphic works by lightening values, softening details, reducing value contrasts, and neutralizing colors in objects as they recede.

decorative space
The space that exists across the picture plane without any suggestion of depth.

four-dimensional space
A highly imaginative treatment of forms that gives a sense of intervals of time or motion.

fractional representation
A device used by various cultures (notably the Egyptians) in which several spatial aspects of the same subject are combined in the same image.

infinite space
A concept in which the picture frame acts as a window through which objects can be seen receding endlessly.

interpenetration
The movement of planes, objects, or shapes through each other, locking them together within a specific area of space.

intuitive space
The illusion of space that the artist creates by manipulating certain space-producing devices, including overlapping, transparency, interpenetration, inclined planes, disproportionate scale, fractional representation, and the inherent spatial properties of the art elements.

orthographic drawing
A two-dimensional graphic representation of an object showing a plan, a vertical elevation, and/or a section.

plastic space
A concept in which the visual elements on the surface of the picture plane give the illusion of having relationships in depth as well as in length and breadth.

shallow space
The illusion of limited depth. With shallow space, the imagery moves only a slight distance back from the picture plane.

space
Boundless or unlimited extension in all directions; void of matter. Artists use the term to describe the interval, or measurable distance, between preestablished points.

three-dimensional space
Space that seems to have thickness and depth as well as length and breadth.

transparency
The situation in which a distant plane or shape can be seen through a nearer one.

two-dimensional space
The space across a surface that has no suggestion of depth. Also called *decorative space*.

Introduction to space

Some people consider space an element of two-dimensional art, while others see it as a product of the elements. Whichever its category, the presence of space is felt in every work of art, and is something that must concern every artist. In this text, space is conceived of as a product rather than a tool; it is created by the art elements. The importance of space lies in its function, and a basic knowledge of its implications and use is essential for every artist. Space as discussed in this chapter is limited to the graphic fields—that is, two-dimensional surface arts such as drawing, painting, printmaking, and the like. The space that exists as an illusion in the graphic fields is actually present in the plastic areas of sculpture, ceramics, jewelry, architecture, and so forth. Their three-dimensional space concepts are discussed in chapter 9.

8.1

Leonidas Maroulis. *68–388*. 1988, oil on canvas, 63 × 60 in. The planes in this work seem parallel to the picture surface. Spatial devices are missing except for the prominent white diagonal shape that fosters the illusion that the red shape on which it rests is tilted back into space.

Photograph courtesy of Vorpal Gallery, San Francisco and New York.

8.2

Henri Matisse. *The Knife Thrower* from *Jazz*. 1947, color stencil, 15⅞ × 25½ in. No depth was intended in this decorative and ornamental abstraction. The flatness of the shapes is exaggerated by avoiding modeling, but vitality is maintained by varying contour, value, and color. A silhouetted effect is the dominant feature.

Philadelphia Museum of Art. Purchased: McIlhenny Fund.

Spatial perception

All spatial implications are mentally conditioned by the environment and experience of the viewer. Vision is experienced through the eyes but interpreted by the mind. Perception involves the whole pattern of nerve and brain response to a visual stimulus. We use our eyes to perceive objects in nature and to continually shift our focus of attention. In so doing, two different types of vision are used: *stereoscopic* and *kinesthetic*. Having two eyes set slightly apart from each other, we see two different views of the objective world at the same time. The term stereoscopic refers to our ability to overlap these two slightly different views into one image. This visual process creates an illusion of three-dimensional depth, making it possible to judge distances.

With kinesthetic vision we experience space in the movements of the eye from one part of a work of art to another. While viewing a two-dimensional surface, we unconsciously attempt to organize its separate parts so that they can be seen as a whole. In addition, we explore object surfaces with eye movements in order to make mental recognition of them. Objects close to the eye require more ocular movement than those farther away, and this factor adds spatial illusion to our kinesthetic vision.

Major types of space

Two types of space can be suggested by the artist: *decorative space* and *plastic space*.

Decorative space

The term decorative space, although often needed as a convenience, is in fact a misnomer. Decorative space is the absence of real space as we know it and is confined to the flatness of the picture plane. As the artist adds art elements to that plane (or surface), the illusion created may be that of flatness, thus "decorative." If the illusion suggests greater depth, the space becomes shallow, deep, or infinite. In fact, a true decorative space is inconceivable; any art element used in conjunction with others will seem to advance and recede. Decorative space, though sometimes useful in describing essentially flat pictorial effects, is not accurate. Thus, decorative space for the artist is space of quite limited depth (figs. 8.1 and 8.2).

8.3

Box of space (side). The box represents the imaginary "box of space" behind each picture. Overall, the diagram simulates a simple landscape, *A* being the picture plane, *B* the ground plane (slightly rolling), *C* large hills or mountains, and *D* the sky. (See figure 8.4 to verify this effect.) Note that the building is presented as projecting from the picture plane. Artists can create this effect of protrusion. Sometimes it is called a "violation" of the picture plane; at other times "trompe-l'oeil" (fool the eye). The planes represented here could be equipped with wheels because the artist can move them back and forth by manipulating the elements.

8.4

Box of space (front). This is roughly what we would see if the box of space in figure 8.3 were viewed from the front. It simulates atmospheric perspective somewhat, because the foreground plane has been made darker. The sky has been left vacant; if given a value, it would shrink the space a little.

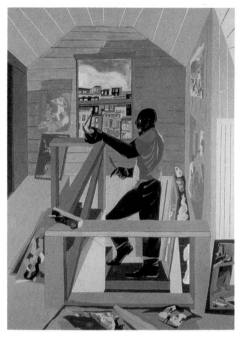

8.5

Jacob Lawrence. *The Studio.* 1977, gouache on paper, 30 × 22 in. The use of shapes with solid colors and values, generally lacking in traditional shading, creates an overall feeling of flatness. In addition, a stagelike effect arises from the shallow perspective.

Courtesy Terry Dintenfass, Inc.

Plastic space

The term plastic is applied to all space imagery other than decorative. Artists base much of their work on their experiences in the objective world, and it is a natural conclusion that they should explore the spatial resources.

Divisions of plastic space

Since varying degrees of spatial locations are possible with regard to depth, artists make their suggestions of plastic images and locations according to their needs and feelings. As a result, the categorizations of depth locations cannot be specific or fixed but must be broadened to general areas.

Shallow space Awareness of the picture surface usually limits the space of a composition. Varying degrees of limited space are possible. Limited space, or *shallow space,* can be compared to the feelings one might experience if confined to a box or stage. The space is limited to the placement of the sides or walls. For consistency, any compositional objects or figures that might appear in the boxlike or stagelike confines could be narrowed in depth, or flattened (figs. 8.3 and 8.4). In the contemporary painting *The Studio* by Jacob Lawrence, the single figure has been flattened and placed in a confined room (fig. 8.5). This artist interweaves his flat figure in the shallow room space (fig. 8.6).

Asian, Egyptian, and medieval artists used comparatively shallow space in their art. Early Renaissance paintings were often based on shallow sculptures that were popular in their time (fig. 8.7). Many modern artists have elected to use shallow space on the theory that it allows more positive control and is more in keeping with the flatness of the working surface. Gauguin, Matisse, Modigliani (fig. 8.8), and Beckmann are typical advocates of limited spatial concepts.

Deep and/or infinite space An artwork that emphasizes deep space denies the picture plane except as a starting point from which the space begins. The viewer seems to be moving into the far distances of the picture field. This spatial feeling is

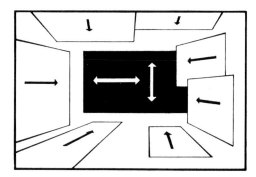

8.6
Shallow space. As a variation on the concept of shallow space, artists occasionally define the planes that make up the outer limits of a hollow boxlike space behind the picture plane. The diagram shows this concept, although in actual pictorial practice, a return to the picture plane would be made through objects occupying the space defined. The back plane acts significantly as a curtain that prevents penetration into deep space.

similar to looking through an open window over a landscape that rolls on and on into infinity. The infinite quality of illusionistic space is created by using spatial indications that are produced by certain relationships of art form. Size, position, overlapping images, sharp and diminishing details, converging parallels, and perspective are the traditional methods of indicating deep spatial penetration (see fig. 6.18).

Infinite spatial concepts, allied with atmospheric perspective, dominated Western art from the beginning of the Renaissance (about 1350) to the middle of the nineteenth century. During this period, generations of artists, such as Uccello, Botticelli, Ruisdael, Brueghel, Rembrandt, Poussin, and Corot, to name only a few, developed and perfected the deep space illusion because of its obvious accord with visual reality (fig. 8.9). Present-day art is largely dominated by the shallow space concept, but many contemporary artists work with strongly recessed fields. Any space concept is valid if it demonstrates consistent control of the elements in relation to the spatial field chosen.

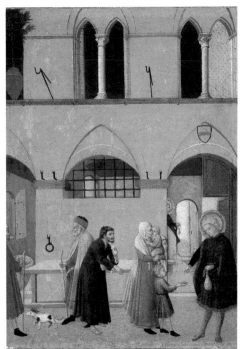

8.7
Sassetta and assistant. *St. Anthony Distributing His Wealth to the Poor.* Circa 1440, paint on wood, 18⅝ × 13⅝ in. A shallow stagelike space is achieved in this early Renaissance painting. The work is composed in terms of two flat planes represented by the figures in front and the architectural structure in back.
National Gallery of Art, Washington, D.C. Samuel H. Kress Collection.

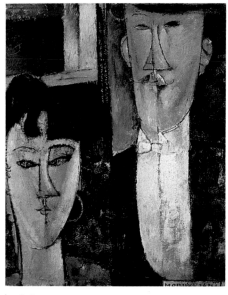

8.8
Amedeo Modigliani. *Bride and Groom.* 1915–16, oil on canvas, 21¾ × 18¼ in. Modigliani dealt with simplified monumental forms given plasticity by subtle linear and value treatment and enriched by sensitive paint application. The space behind the figures is usually limited to broad, severe shapes that restrict the vision of the viewer to a narrow corridor of space.
Collection, The Museum of Modern Art, New York. Gift of Frederic Clay Bartlett.

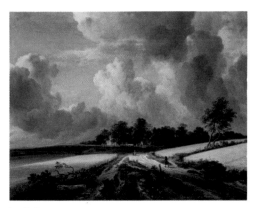

8.9
Jacob van Ruisdael. *Wheatfields.* Circa 1670, oil on canvas, 51¼ × 39⅝ in.
Early Dutch landscape painting, which aimed at the maximum illusion of visual reality, emphasized the infinite space concept. Diminishing sizes of objects and hazy effects of atmospheric perspective give the viewer a sense of seeing into far distances.
Metropolitan Museum of Art, New York. Bequest of Benjamin Altman, 1913 (14.40.623).

8.10

Ron Davis. *Parallelepiped Vents #545.* **1977, acrylic on canvas, 114 × 180 in.**
The strict order of linear perspective is not observed here, but space is achieved by other means under the control of the artist's instincts.

Courtesy of the Los Angeles County Museum of Art. Museum Purchase. Art Museum Council Fund.

Traditional types of space indication

Artistic methods of spatial representation are so interdependent that an attempt to isolate and examine all of them here would be impractical and inconclusive, and might leave the reader with the feeling that art is based on a formula. Thus, we will confine this discussion to those spatial indications that are fairly standard.

Our comprehension of space, which comes to us through objective experiences, is enlarged, interpreted, and given meaning by our intuitive faculties. Spatial order develops when the artist senses the right balance and the best placement, then selects vital forces to create completeness and unity. Obviously, then, this process is not a purely intellectual one but a matter of instinct or subconscious response (fig. 8.10).

Since the subjective element plays a part in controlling space, we can readily see that emphasis on formula here, as elsewhere, can quench the creative spirit. Art is a product of human creativity and is always dependent on individual interpretations and responses. Space, like other qualities in art, may be either spontaneous or premeditated, but is always the product of the artist's will. If an artist has the impassioned will to make things so, they will usually be so, despite inconsistency and defiance of established principles. Therefore, the methods of spatial indication discussed in the following pages are those that have been used frequently and that guarantee one effect of space, though not necessarily one that is always exactly the same. These traditional methods are presented merely to give the student a basic concept of the more significant spatial forces.

Size

We usually interpret largeness of scale as meaning nearness. Conversely, a smaller scale suggests distance. If two people were to stand at distances of five and fifteen feet from us, the nearer figure would appear larger than the other. Ordinarily we would interpret this difference in scale not as one large and one small person (although this could play a part in our perception), but as two people of approximately the same size placed at varying distances from us (fig. 8.11). Therefore, if we are to use depth-scale as our guide, a figure must assume a scale that corresponds to its distance from us, regardless of all other factors (fig. 8.12). This concept of space has not always been prevalent. In many broad periods and styles of art, and in the works of children, large scale is assigned according to importance, power, and strength, regardless of spatial location (fig. 8.13).

8.11

Figures in space. These shadow figures grow smaller as they recede into space. The illusion of space is enhanced by the horizon line according to which spatial depths are often judged. As the figures are divided roughly in half, we can estimate (assuming six-foot figures) that the viewer's position is about three feet high.

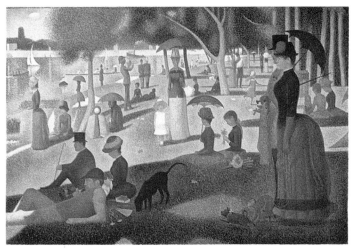

8.12

Georges Seurat. *Sunday Afternoon on the Island of La Grande Jatte.* 1884–86, oil on canvas, 207.6 × 308.0 cm. The obvious progression of sizes in the figures of Seurat's painting is a strong indication of spatial recession. At the same time, these figures are carefully placed to give balance to the pattern of space and shape relationships. Another characteristic of this picture is its use of small dabs or dots of color, inherited from the Impressionist technique, to express the illusion of light, color, and atmosphere.

Helen Birch Bartlett Memorial Collection, 1926.224. © 1988 The Art Institute of Chicago. All Rights Reserved.

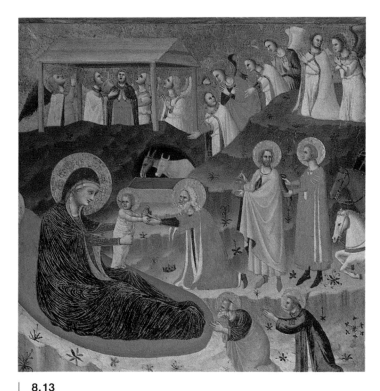

8.13

Master of the Blessed Clare (Riminese School). *The Adoration of the Magi.* Circa 1340, tempera, 31¼ × 31½ in. (including frame). The importance of the Madonna accounts for the unexpectedly large scale of her figure. This disporportionate size produces a strange conflict with the semirealistic space in which the size of the angels is more in harmony. The adjustment of size to equal importance is known as hieratic scaling.

Samuel H. Kress Collection. Lowe Art Museum, University of Miami.

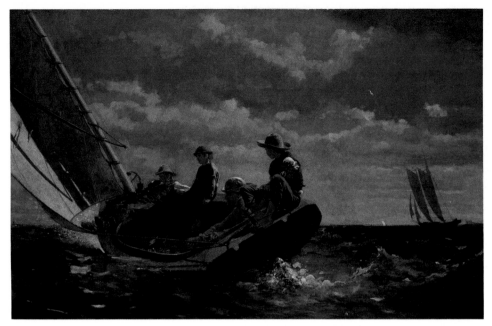

8.14

Winslow Homer. *Breezing Up (A Fair Wind).* **1876, oil on canvas, 24⅛ × 38⅛ in.**
The horizon line in this painting separates the space into a ground plane below and a sky plane above. The smaller size and higher position of the distant boat help achieve the spatial effect.
Courtesy the National Gallery of Art, Washington, D.C. Gift of W. L. and May T. Mellon Foundation.

8.15
Placement of squares. A line across the picture plane reminds us of the horizon that divides ground plane from sky plane. Consequently, the lower shape seems close and the intermediate shape more distant, while the upper square is in a rather ambiguous position because it touches nothing and seems to float in the sky.

Position

Many artists and observers automatically infer that the horizon line, which provides a point of reference, is always at eye level. The position of objects is judged in relation to that horizon line. The bottom of the picture plane is seen as the closest visual point, and the degree of rise of the visual units up to the horizon line indicates subsequently receding spatial positions (fig. 8.14). Evidence suggests that this manner of seeing is instinctive (resulting from continued exposure to the objective world), for its influence persists even in viewing greatly abstracted and nonobjective work (fig. 8.15). The alternative, of course, is to see the picture plane as entirely devoid of spatial illusion and the distances of the visual elements as actually measurable across the flat surface. It is difficult to perceive in this way even when we discipline ourselves to do so, for it requires us to divorce ourselves entirely from ingrained environmental factors.

Overlapping

Another way of suggesting space is by overlapping planes or volumes. If one object covers part of the visible surface of another, the first object is assumed to be nearer. Overlapping is a powerful indication of space, because once used, it takes precedence over other spatial signs. For instance, one ball placed in front of a larger ball appears closer than the larger ball, despite its smaller size, as shown in figure 8.16.

Transparency

The overlapped portion of an object is usually obscured from our view. If, however, that portion is continued and made visible through the overlapping plane or object, the effect of *transparency* is created. Transparency, which tends to produce a closer spatial relationship, is clearly evident in the upper triangle in the painting by Jack Brusca (see fig. 4.33). It is most noticeable in the works of the Cubists and other artists who are interested in shallow space (fig. 8.17; see figs. 5.16 and 10.39).

Interpenetration

Interpenetration occurs when planes or objects pass through each other, emerging on the other side. It provides a very clear statement of the spatial positioning of the planes and objects involved, and can create the illusion of either shallow or deep space (figs. 8.18 and 8.19).

8.16
Overlapping.

8.17
Square planes with overlapping and transparency. The small shape on the left seems distant from its partner partly because of its smaller size and partly because of its position further up the picture plane. The smaller shape in the lower group is closer because of its overlapping, but its smaller size makes it retreat and seem to push against the other shape; the space is shallow. In the upper group, the top shape is considerably distanced from the one that overlaps it, while the other small shape, though overlapped, is drawn fairly close to the large shape by its transparency.

8.18
Interpenetrating planes. The passage of one plane or volume through another automatically indicates a spatial situation.

8.19
Al Held. *C-P-1.* 1978, acrylic on canvas, 5 × 5 ft. The spatial effects in this work are quite subtle and do not subscribe to any formal space-producing technique. Within the overall effect of space, it is possible to discern areas of overlapping, interpenetration, and transparency.
Courtesy Andre Emmerich Gallery, Inc.

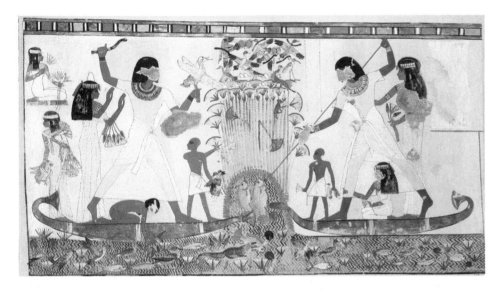

8.20
Egyptian reproduction. *Fishing and Fowling.* **Wall painting, XVIII Dynasty, circa 1415 B.C., Thebes; tomb of Menena, scribe of the fields of the lord of two lands; copy in tempera; (T.69); height 101 cm., width 89 cm. (1:1 scale with original).** This work illustrates the Egyptian concept of pictorial plasticity as a combination of various representative views of the figure combined in one image (fractional representation) kept compatible with the flatness of the picture plane. The arbitrary positioning of the figures and their disproportionate scale add to this effect.
Egyptian Expedition of the Metropolitan Museum of Art, Rogers Fund, 1930 (30.4.48).

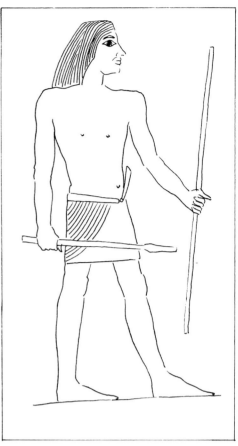

8.21
Fractional representation. This drawing illustrates the Egyptian technique of fractional representation of the human figure. The head is in profile, but the eye full-face. The upper body is frontal, gradually turning until the lower body from the hips down is seen from the side. This drawing combines characteristic views of the body; in order to see all these views, one would have to move around the body.

Fractional representation

Fractional representation can best be illustrated by studying the treatment of the human body by Egyptian artists. Here we can find, in one figure, the profile of the head, a frontal eye, the front of the torso, and a side view of the hips and legs. This is a combining of the most representative aspects of the different parts of the body (figs. 8.20 and 8.21). Fractional representation is a spatial device revived in the nineteenth century by Cézanne, who used its principles in his still-life paintings (see "Plastic image" later in this chapter). It was employed by many twentieth-century artists, most conspicuously Picasso. The effect is flattening in Egyptian work, but plastic in the paintings by Cézanne since it is used to move us "around" the subjects.

Sharp and diminishing detail

Because we do not have the eyes of eagles and because we view things through the earth's atmosphere, we are not able to see near and distant planes with equal clarity at the same time. A glance out the window confirms that close objects appear sharp and clear in detail, whereas those at great distances seem blurred and lacking definition. Artists have long been cognizant of this phenomenon and have used it widely in illusionistic work. In recent times they have used this method and other traditional methods of space indication in works that are otherwise quite abstract. Thus, in abstract and nonobjective conceptions, sharp lines, clearly defined shapes and values, complex textures, and intense colors are associated with foreground or near positions. Hazy lines, indistinct shapes, grayed values, simple textures, and neutralized colors are identified with background locations. These characteristics are often included in the definition of atmospheric perspective (fig. 8.22).

8.22
Doug Maguire. *Sleeping Eye.* 1987, oil on linen, 56½ × 72½ in. The clarity of the
weeds, grasses, and flowers in the foreground and the darkness of the trees in the
middleground, contrasted with the haziness of the background, contribute to the spatial
effect of the atmospheric perspective.

Courtesy Katharina Rich Perlow Gallery, New York.

8.23
Converging parallels.

8.24
Richard Balabuck. *Home Again.* 1982, computer print (photo silk screen), 20 × 24 in.
The principle of converging parallels is closely related to the rule of perspective but is not restrictive in a creative sense.

From the artist. Produced with the assistance of the Computer Graphics Research Group, Ohio State University.

Converging parallels

The space indicated by converging parallels can be illustrated using a rectangular plane such as a sheet of paper or a tabletop. By actual measurement, a rectangle possesses one set of short parallel edges and one set of long parallel edges (fig. 8.23). If the plane is arranged so that one of the short edges (A) is viewed head-on, its corresponding parallel edge (B) will appear much shorter. Since these edges appear to be of different lengths, the other two edges (C and D) that connect them must seem to converge as they move back into space. Either set of lines, when separated from the other set, would continue to indicate space quite forcefully. The principle of converging parallels is found in many works of art that do not abide by the rules of perspective. It is closely related to perspective, but does not contain its restrictions (fig. 8.24).

Geometric perspective

Geometric perspective is a system for converting sizes and distances of known objects into a unified spatial order. Its use involves the application of other spatial indications, such as size, position, and converging parallels. Since the Renaissance, geometric perspective has been the principal device for spatial representation in Western art (fig. 8.25).

The general understanding of perspective did not originate with the Renaissance, but the wave of scientific inquiry that swept many countries during that period brought this spatial system to a point of high refinement. Renaissance artists focused their attention on one view, a selected portion of nature seen from one position at a particular moment in time. The use of vanishing points, eye level, and guide lines gave this view mathematical exactitude (fig. 8.26). To a certain extent, artists became prisoners of the system they had helped produce. Because of its inflexible rules, perspective emphasizes

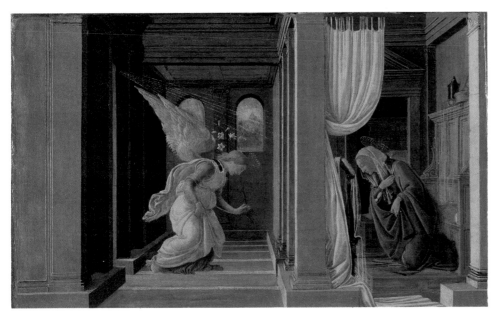

8.25

Sandro Botticelli. *Annunciation.* **Circa 1490, tempera on wood, 9⅜ × 14⅜ in.** In the tradition of much art of the Renaissance period, perspective in the form of receding planes creates space and directs our attention to the major subjects, which are often at or near an assumed vanishing point.

The Metropolitan Museum of Art, Robert Lehman Collection, 1975 (1975.1.74).

8.26

One-point perspective. In this simple diagram, linear perspective controls the image. This is done in one-point perspective, the vanishing point being the point of convergence at the right. This point determines the reduction in size of the telephone poles and road. By carrying this method one step further, the distances between the poles diminish as they recede in space.

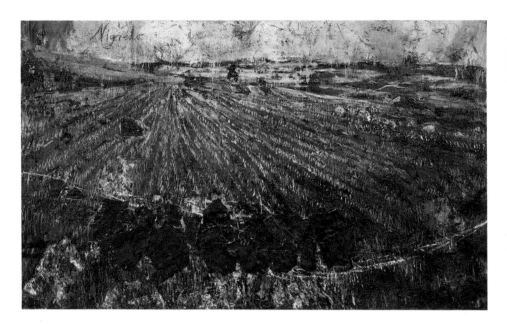

8.27

Anselm Kiefer. *Nigredo.* 1984; oil, acrylic, emulsion, shellac, straw on photograph, mounted on canvas, with woodcut; 130 × 218½ in. Kiefer uses perspective as an aid to help him draw his viewer through the essence of his expression.

Philadelphia Museum of Art. Gift of the Friends of the Philadelphia Museum of Art in celebration of their Twentieth Anniversary.

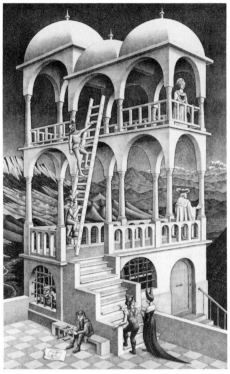

8.28

M. C. Escher. *Belvedere.* 1958, lithograph, 46 × 29.5 cm. From his early youth, Escher practiced the graphic technique of perspective and for many years strived to master that skill. Later he found ideas he could communicate by extending his perspective technique. In this print, he became fascinated with changing his graphic view of the three-dimensional world. He knew it was impossible to see the front and back of a building simultaneously, yet he managed to draw such an impossible building.

Courtesy of Vorpal Gallery, Soho, New York. Photographed by D. James Dee.

accuracy of representation, an emphasis that does not favor creative expression. If, however, artists see perspective as an aid rather than an end in itself, as something to be used when and if the need arises in creating a picture, it can be very useful (fig. 8.27). Many fine works of art ignore perspective or show "faults" in the use of the system. In such a case the type of spatial order created by perspective is not compatible with the aims of the artist (fig. 8.28). Perspective, then, should be learned by artists simply so that it is available to them.

The traditional East Asian artist is a dramatic countertype to the Renaissance artist of the West. Ancient canons prescribed convergence of parallel lines as they approach the spectator, creating a reverse perspective. This type of presentation closes the space in depth so that the picture becomes a stage and the spectator an actor-participant in an active spatial panorama that rarely loses its identification with the picture plane (figs. 8.29 and 8.30). Similar space concepts have been employed in the West during various historical periods. Ideas on pictorial space usually agree with the prevailing mental climate of the society that produces the art. In this sense, space is a form of human expression.

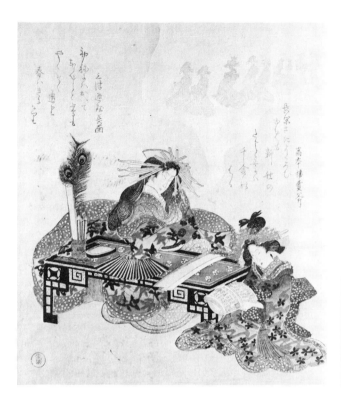

8.29

Kubo Shunman. *Courtesans Dreaming.*
This Japanese artist deliberately reversed normal perspective in the table in order to limit the depth of space in the painting.

Metropolitan Museum of Art, New York. Bequest of Mrs. H. O. Havemeyer, 1929. The H. O. Havemeyer Collection.

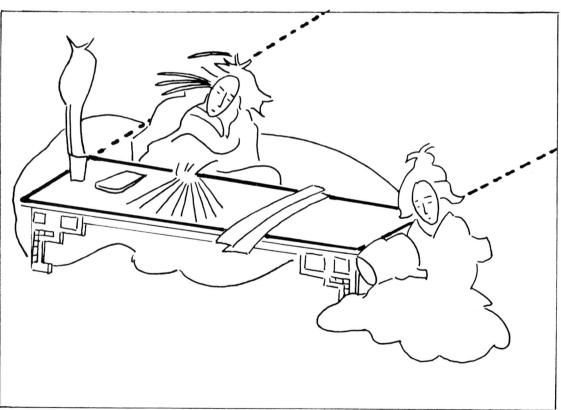

8.30
A simple analysis of *Courtesans Dreaming* shows that if the lines defining the ends of the table are extended (dotted lines) into space, they will never meet as they would in the linear perspective of the Western artist. The closer end of the table is no larger than the other. These characteristics are typical of the open perspective of East Asian art.

8.31
Wassily Kandinsky. *In the Black Square.* June 1923, oil on canvas, 38⅜ × 36⅝ in.
Kandinsky has varied the physical properties of the abstract elements so that they take different positions in space.
The Solomon R. Guggenheim Museum, New York. Photo: Carmelo Guadagno.

8.32
Lines of various physical properties. Vertical, horizontal, and some diagonal lines often seem to occupy a fixed position in space. Wavy, spiral, serpentine, and zigzag lines appear to move back and forth in space. Alterations in line thickness also modify spatial position.

Spatial properties of the art elements

The spatial effects that arise from using the elements of art structure must be recognized and controlled. Each of the elements possesses inherent spatial qualities, but the interrelationship among elements yields the greatest spatial feeling. Many types of spatial experiences can be achieved by manipulating the elements—that is, by varying their position, number, direction, value, texture, size, and color. The resultant spatial variations are endless (fig. 8.31).

Line and space

Line, by its physical structure, implies continued direction of movement. Thus, line helps indicate spatial presence. Since, by definition, a line must be greater in length than in breadth (or else it would be indistinguishable from a dot or a shape), it tends to emphasize one direction. The extension of this dominant direction in a single line creates continuity, moving the eye of the observer from one unit or general area to another. Line can be a transition that unifies the front, middle, and background areas.

In addition to direction, line contains other spatial properties. Long or short, thick or thin, and straight, angular, or curved lines take on different spatial positions and movements in contrast with one another. The indications of three-dimensional space mentioned earlier in this chapter are actively combined with the physical properties of line. A long thick line, for instance, appears larger (a spatial indication) and hence closer to the viewer than a short thin line. Overlapping lines establish differing spatial positions, especially when they are set in opposite directions (that is, vertical against horizontal). A diagonal line seems to move from the picture plane into deep space, whereas a vertical or horizontal line generally appears comparatively static (fig. 8.32). In addition, the plastic qualities of overlapping lines can be increased by modulating their values. The plastic illusion invariably suggests change of position in space. A single line similarly can be modulated in value and dimension to add to its plastic qualities.

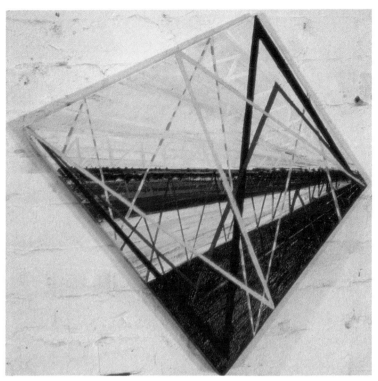

8.33
Vivien Abrams. *Changing Dynamics.*
1984, oil on masonite, 21¾ × 21½ ×
21¼ in. The overlapping and convergence
as well as the physical properties of the
lines in this work have been orchestrated
to create a strong illusion of space.
Luise Ross Gallery, New York.

8.34
**Robert Shuler. *Leucoryx.* 1950, print
(engraving), 12 × 14¾ in.** Variation of
line width suggests movement in space.
When the line serves for mass, the spatial
movement modifies the line's plastic
qualities, causing it to take on new
dimensions.
Courtesy of the artist.

The spatial indication of line
convergence that occurs in mechanical
perspective is in evidence wherever a
complex of lines occurs. The spatial
suggestions arising out of this general
principle are so infinitely varied that
particular effects are usually the product
of the artist's intuitive explorations. Wavy,
spiral, serpentine, and zigzag line types
adapt to all kinds of space through their
unexpected deviations of direction and
accent. They seem to move back and
forth from one spatial plane to another.
Unattached single lines define their own
space and may have plastic qualities
within themselves. Lines also clarify the
spatial dimensions of solid shapes (figs.
8.33 and 8.34).

8.35
Planes in space. In this example, the outlines of the two-dimensional shapes (or planes) are varied in thickness and placement, while two edges converge toward the back to give the effect of three-dimensional space. The overlapping planes enhance the effect of hollowing out behind the picture plane.

8.36
Flat planes. Since the shape outlines consist of horizontals and verticals repeating the essential two-dimensional nature of the picture plane (as determined by the horizontals and verticals of the border), this diagram is an example of two-dimensional space-shape relationships.

Shape and space

Shape may refer to planes, solids, or volumes, all of which occupy space and are therefore entitled to consideration in this chapter. A plane, although physically two-dimensional, may create the illusion of three-dimensional space (fig. 8.35). The space appears two-dimensional when the plane seems to lie on the picture surface (fig. 8.36). The space appears three-dimensional when its edges seem to converge at a point toward the front or the back of the picture plane.

Solids, volumes, and masses automatically suggest three dimensions. Such shapes express the space in which they must exist and actually become a part of it. Planes, solids, and volumes can be made to take a distant position by diminishing their size in comparison to others in the frontal picture areas and by neutralizing their value, color, intensity, and detail. This treatment relates back to the indications of space outlined earlier in this chapter (figs. 8.37 and 8.38).

8.37

Planes and solids in space. The relationship of planes in this diagram describes an effect of solids or volumes that in turn seem to occupy space. The size, overlapping, and placement of these volumes further increase the effect of solidity. The horizontal shaded lines indicate an imaginary position for the picture plane, causing the near-volume to project into the observer's space, or in front of the picture plane.

8.38

Al Held. *B/WX*. 1968, acrylic on canvas, 114 × 114 in. Although the physical properties of the lines in this work are consistent throughout, their arrangement causes the enclosed shapes to be seen in different spatial positions as in an optical illusion. This is somewhat similar to Op art.

Albright-Knox Art Gallery, Buffalo, New York. Gift of Seymour H. Knox, 1969.

Value and space

The plastic effect of value can be used to control pictorial space. When a light source is assumed to be in front of a work, the objects in the foreground appear light. The middle and background objects become progressively darker as they move away from the picture plane (fig. 8.39). When the light source is located at the back of the work, the order of values is reversed (fig. 8.40). The order of value change is consistent in gradation from light to dark or from dark to light.

In the natural world, foreground objects are seen with clarity and great contrast, while distant objects are ill-defined and gray. Therefore, neutral grays, when juxtaposed with blacks or whites, generally take a distant position (see fig. 6.18).

Cast shadows are sometimes helpful in describing plastic space, but they may be spatially confusing and even injurious to the design if not handled judiciously (fig. 8.41; see fig. 5.5).

Value-modeling can be abstract in the sense that it need not follow the objective natural order of light and dark. Many artists have totally ignored this natural order, using instead the inherent spatial position that results from the contrast of dark and light (fig. 8.42).

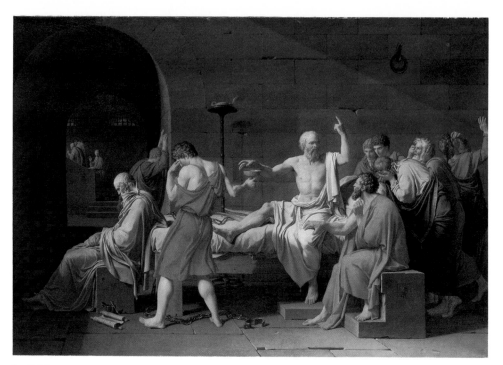

8.39

Jacques-Louis David. *The Death of Socrates.* 1787, oil on canvas, height 51 in., width 77¼ in. Except for the figure of Socrates, who is in the brightest light, the figures in the foreground are in the lightest value positions. The figures in the middle and background become progressively darker as they recede to the farthest spatial positions.

The Metropolitan Museum of Art, Wolfe Fund, 1931. Catherine Lorillard Wolfe Collection (31.45).

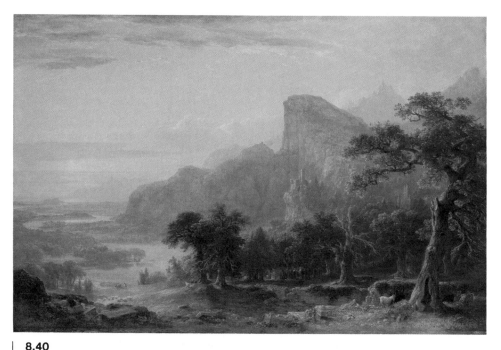

8.40

Asher Brown Durand. *Thanatopsis.* 1850, oil on canvas, 39½ × 61 in. In this landscape painting, the values range from dark in the foreground to light in the background, reversing the usual sequence. The back lighting makes for a very dramatic effect.

The Metroplitan Museum of Art, New York. Gift of J. Pierpont Morgan, 1911 (11.156).

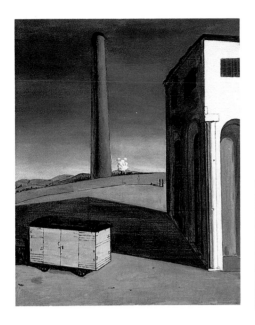

8.41

Giorgio de Chirico. ***The Anguish of Departure.*** **1913–14, oil on canvas, 33½ × 27½ in.** The large diagonal overlapping shadow sets the tone of the spatial and dramatic structure of this de Chirico scene.

Albright-Knox Art Gallery, Buffalo. Room of Contemporary Art Fund, 1939.

8.42

Tony King. ***Map: Spirit of '76.*** The format, with its papier collé surface, is perfectly flat, but the use of light-and-dark values creates a strongly three-dimensional illusion.

Courtesy the Owens-Corning Collection. Owens-Corning Fiberglas Corporation, Toledo, Ohio.

8.43

Pablo Picasso. *Femme Assise (Seated Woman).* **1927, oil on canvas, 130.8 × 97.8 cm.** Because of their obviously decorative quality, abstract textures emphasize the flatness of the picture plane. Background and foreground forms become closely integrated so that little sense of spatial recession is felt by the observer.

Art Gallery of Ontario, Toronto: Purchase, 1964. Acc. no. 63/44. Photo: Carlo Catenazzi, AGO. © ARS N.Y./SPADEM, 1989.

Texture and space

Because of the surface enrichment that texture produces, it is frequently a temptation to think of this element purely in terms of decorative usefulness. Actually, texture functions plastically by describing the depth position of surfaces. Generally speaking, sharp, clear, and bold textures advance, while fuzzy, dull, and minuscule textures recede. When modified through varied use of value, color, and line, texture significantly contributes to the total pictorial unity.

Texture is one of the visual signs used to produce the decorative surface so valued in contemporary art. The physical character of texture is related to allover patterned design and, as such, operates effectively on decorative surfaces. When patterned surfaces are repeated and distributed over the entire pictorial area, the flatness of the picture plane becomes vitally important. Many works of Pablo Picasso illustrate the contemporary use of texture surfaces to preserve the concept of the flat picture plane (fig. 8.43).

Color and space

One outstanding contribution of modern artists has been their reevaluation of the plastic potentialities of color. Color is now integrated directly into the form of the picture in a positive and direct manner in order to model the various spatial planes of surface areas (see chapter 7). Since the time of Cézanne, there has been a new awareness of the advancing characteristics of color in art. Prior to then, deep space was considered as beginning with the picture plane and receding from it. Today many artists, chiefly through the use of color, deal with the spaces on or in front of the picture plane. Hans Hofmann, the contemporary abstractionist, often used intense colors to advance shapes beyond the picture plane (fig. 8.44).

Analogous colors, because they are closely related, create limited spatial movement; contrasting colors enlarge the space and provide varied accents or focal points of interest. Both exploit the limitless dimensions of space.

Recent concepts of space

Every great period in the history of art has espoused a particular space concept. These spatial preferences reflect basic conditions within the civilization that produced them. Certain fundamental space attitudes seem to recur in varied forms throughout recorded history. During the period of their influence, these attitudes become a norm of vision for people, gradually conditioning them to see art in the same way. When an epic social change ushers in a new space attitude, it is at first resisted by the public but eventually becomes the standard filter through which people view things. These changes were fairly cyclical and even predictable through the Renaissance. The acceleration of change prompted by the cataclysmic revelations of modern science has now produced new concepts that are without precedent. Today, artists are groping for ways to understand and interpret these ever-widening horizons, and as they do, their explorations are met by characteristic recalcitrance from the public (fig. 8.45).

8.45
René Magritte. *La Lunette D'Approche.* 1963, oil on canvas, 69⁵⁄₁₆ × 45¼ in. On close inspection it seems that this work is deliberately inconsistent in its use of space. As a Surrealist, Magritte often created ambiguous and unexpected effects to titillate our senses.

Hickey and Robertson, Houston. Courtesy of The Menil Collection.

The search for a new spatial dimension

Artists of the Renaissance, conditioned by the outlook of the period, set as their goal the optical, scientific mastery of nature. They sought to accomplish this by reducing nature, part by part, to a static geometric system. By restricting their attention to one point of view, artists were able to develop perspective and represent some of the illusionary distortions of actual shapes as seen by the human eye.

Modern artists, equipped with new scientific and industrial materials and technology, have extended the search into nature initiated by the Renaissance. They have probed nature's inner and outer structure with microscope, camera, and telescope. The automobile and the airplane have given them the opportunity to see more of the world than any of their predecessors saw. The radically changed environment of the artist has brought about a new awareness of space. It has become increasingly evident that space cannot be described from the one point of view characteristic of the Renaissance, and the search continues for a new graphic vocabulary to describe visual discoveries. Since one outstanding feature of the modern world is motion, contemporary artistic representation must move, at least illusionistically. Motion has become a part of space, and this space can be grasped only if a certain period of time is allotted to cover it. Hence, a new dimension has been added to spatial conception—the fourth dimension, which combines space, time, and motion, and presents an important graphic challenge. This challenge is to discover a practical method for representing things in motion from every viewpoint on a flat surface. In searching for solutions to this problem, artists have turned to their own experiences as well as to the work of others.

8.46

Paul Cézanne. *Still Life with Ginger Jar, Sugar Bowl, and Oranges.* 1902–06, oil on canvas, 23⅞ × 28⅞ in. Cézanne was concerned with the plastic reality of forms as well as with their organization into a unified design. Although the plate, jar, and pot are in the same picture, they are depicted from different viewpoints. For example, Cézanne felt that the plate would have greater reality if drawn as seen from a higher angle; the jar placed behind it, however, seems to be observed from a lower viewpoint.

Collection, The Museum of Modern Art, New York. Lillie P. Bliss Collection.

Plastic image

Paul Cézanne, the nineteenth-century Post-Impressionist, was an early pioneer in the attempt to express the new dimension. His aim was to render objects in a manner more true to nature. This nature, it should be pointed out, was not the Renaissance world of optical appearances; instead, it was a world of forms in space, conceived in terms of a plastic image (fig. 8.46). In painting a still life, Cézanne selected the most characteristic viewpoint of all his objects; he then changed the eye levels, split the individual object planes, and combined all of these views in the same painting, creating a composite view of the group. Cézanne often shifted his viewpoint of a single object from the right side to the left side and from the top to the bottom, creating the illusion of looking around it. To see these multiple views of the actual object, we would have to move around it or revolve it in front of us; this act would involve motion, space, and time.

The Cubists adopted many of Cézanne's pictorial devices. They usually showed an object from as many views as suited them. Objects were rendered in a type of orthographic drawing, divided into essential views that could be drawn in two dimensions, not unlike the Egyptian technique previously cited (see "Fractional representation"). The basic view (the top view) is called a *plan*. With the plan as a basis, the elevations (or profiles) were taken from the front and back, and the sections were taken from the right and left sides. The juxtaposition of these views in a painting illustrated the

Plan

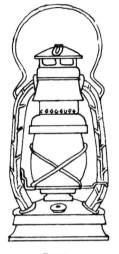

Front
elevation

Side
elevation

8.47
Tom Haverfield. *Kerosene Lamp.* Circa 1960, pen and ink, 9 × 12 in. In this work objects are rendered in a type of orthographic drawing that divides them into essential views able to be drawn in two dimensions.
Courtesy of the artist.

8.48
Tom Haverfield. *Kerosene Lamp II.* Circa 1960, pencil on paper, 14 × 18 in. The juxtaposition of orthographic views illustrates the movement of objects in space. Such a composite drawing shows much more of an object than would normally be visible.
Courtesy of the artist.

movement of the objects in space. Such a painting was a composite that showed much more of the object than would normally be visible. The technique seems a distortion to the lay spectator conditioned to a static view, but within the limits of artistic selection, everything is present that we would ordinarily expect to see (figs. 8.47 and 8.48).

In the works of the Cubists, we find that a picture can have a life of its own, and that the creation of space is not essentially a matter of portrayal or rendering. The Cubist works step by step to illustrate that the greater the departure from object resemblance, the clearer the spatial order. One of the offshoots of this discovery was the synthetically designed picture—a picture that divorces itself from its model (fig. 8.49).

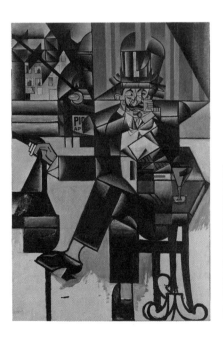

8.49
Juan Gris. *The Man in the Cafe.* 1912, 50½ × 34⅝ in. Spatial movements formed in this abstractly designed painting give variety and interest to the pattern relationships. Natural spatial relationships have been compromised with a more subjective interpretation of the objects represented.
The Philadelphia Museum of Art. Louise and Walter Arensberg Collection.

Pictorial representations of movement in time

From time immemorial, artists have grappled with the problem of representing movement on the stationary picture surface. In the works of prehistoric and primitive humans, these efforts were not organized, but were isolated attempts to show a limited phase of observed movement.

In an early attempt to add movement to otherwise static figures, Greek sculptors organized the lines in the draperies of their figures to accent a continuous direction. By means of this device, the eye of the observer is directed along a constant edge or line.

The artists of the Medieval and Renaissance periods illustrated the life and passion of Christ by repeating a series of still pictures. The representation of the different phases of Christ's life (either in sequence form or combined in a single work) created a visual synopsis of his movement, the space he covered, and the time he took to cover it. These pictures were antecedents of modern comic-strip and motion picture techniques that actually fill the gaps between the still views in the final product (figs. 8.50, 8.51, and 8.52).

Another representational device that suggests movement is the superimposition of many stationary views of the figure or its parts in a single picture. This technique catalogs the sequence of position of a moving body, indicating the visible changes.

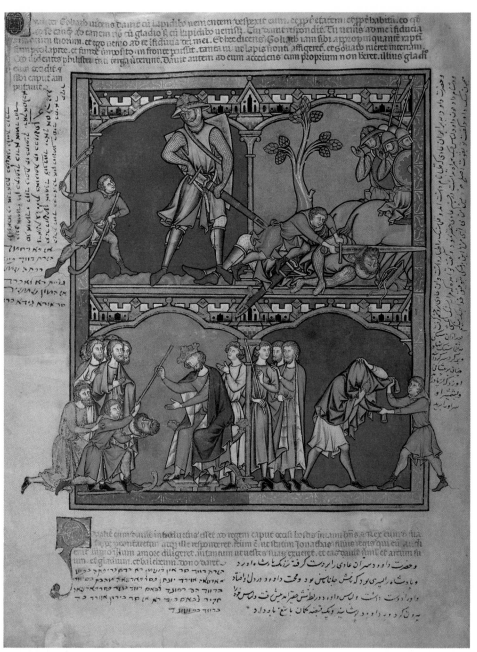

8.50

Unknown. *David and Goliath*. Circa 1250, Paris, 152 × 117 in. (dimensions of manuscript). The element of time is present here, but in a conventional episodic manner. The order of events proceeds in a style similar to that of a comic strip.

The Pierpont Morgan Library, New York, M.638F28V.

8.51

Roger Brown. *Giotto and His Friends (Getting Even).* **1981, oil on canvas, 72 × 96⅜ in.** Contemporary artist Roger Brown has used the historical technique of segmental narrative. Each segment of the work is a portion of an unfolding story.

Private Collection. Photo courtesy of the Phyllis Kind Galleries, Chicago and New York. Photo credit: William H. Bengtson.

8.52

Roger Brown. *Surrounded by Nature.* **1986, oil on canvas, 48 × 72 in.** In contrast to Roger Brown's other work (fig. 8.51), the segmental aspect of this narrative is compacted into one image. Brown produces contradictory spatial qualities that suggest ''map-like'' feelings. The standardized subject sizes he produces reduce spatial illusion, whereas the same subjects positioned lower in the painting seem closer than those in higher parts.

Courtesy of the Phyllis Kind Gallery, Chicago, IL.

8.53

Marcel Duchamp. *Nude Descending a Staircase, No. 2.* **1912, oil on canvas, 58 × 35 in.** The subject in Duchamp's painting is not the human body itself, but the type and degree of energy a body emits as it passes through space.

Philadelphia Museum of Art. The Louise and Walter Arensberg Collection.

8.54

Giacomo Balla. *Leash in Motion.* **1912, oil on canvas, 35⅜ × 43¼ in.** To suggest motion as it is involved in time and space, Balla invented the technique of repeated contours. This device soon became commonly imitated in newspaper comic strips, thus losing aesthetic uniqueness.

Albright-Knox Art Gallery, Buffalo, New York. Bequest of A. Conger Goodyear and Gift of George F. Goodyear, 1964.

Twentieth-century artists have attempted to fuse the different positions of the figure by filling out the pathway of its movement. Figures are not seen in fixed positions but as moving paths of action. The subject in Marcel Duchamp's *Nude Descending a Staircase* is not the human body, but the type and degree of energy a human body emits as it passes through space. This painting signified important progress in the pictorialization of motion because the plastic forces are functionally integrated with the composition (fig. 8.53).

The Futurists (see "Futurism," chapter 10) were devoted to motion for its own sake. They included not only the shapes of figures and objects and their pathways of movement, but also their backgrounds.

These features were combined in a pattern of kinetic energy. Although this form of expression was not entirely new, it provided a new type of artistic adventure—simultaneity of figure, object, and environment (figs. 8.54 and 8.55).

The exploration of space in terms of the four-dimensional space-time continuum is in its infancy. As research reveals more of the mysteries of the natural world, art will continue to absorb and apply them according to their effects on human relationships. It is reasonable to assume that even more revolutionary concepts will emerge in time, producing great changes in art styles. The important point to remember is that distortions and unfamiliar forms of art expression do not occur in a vacuum—they usually represent earnest efforts to apprehend and interpret our world in terms of the latest frontiers of understanding.

8.55
**Gino Severini. *Dynamic Hieroglyphic of the Bal Tabarin.* 1912, oil on canvas with
sequins, 63⅝ × 61½ in.** The works of the Futurists were devoted to motion for its own
sake. They included not only the shapes of figures and objects and their pathways of
movement, but also their backgrounds. These features were combined in a pattern of
kinetic energy.

Collection, The Museum of Modern Art, New York. Acquired through the Lillie P. Bliss Bequest.

9
THE ART OF
THE THIRD DIMENSION

The Vocabulary of the Third Dimension

addition
A term that means building up, assembling, or putting on material.

atectonic
A condition characterized by considerable amounts of space. Open, as opposed to massive (or *tectonic*).

Bauhaus
Originally a German school of architecture that flourished between World War I and World War II. The Bauhaus attracted many leading experimental artists from both the two- and three-dimensional fields.

casting
A sculptural technique in which liquid materials are shaped by being poured into a mold.

glyptic
1. The quality of an art material like stone, wood, or metal that can be carved or engraved. 2. An art form that retains the tactile, color, and tensile quality of the material from which it was created. 3. The quality of hardness, solidity, or resistance found in carved or engraved materials.

manipulation
To shape by hands or tools; sometimes means *modeling.*

mobile
A three-dimensional moving sculpture.

modeling
A sculptural term meaning to shape a pliable material.

patina
1. A natural film, usually greenish, that results from oxidation of bronze or other metallic material. 2. Colored pigments and/or chemicals applied to a sculptural surface.

sculpture
The art of shaping expressive three-dimensional forms. "Man's expression to man through three-dimensional form" (Jules Struppeck, *The Creation of Sculpture,* 1952).

silhouette
The area between or bounded by the contours, or edges, of an object; the total shape.

substitution
In sculpture, replacing one material or medium with another; see also *casting.*

subtraction
A sculptural term meaning to carve or cut away materials.

tectonic
The quality of simple massiveness; lacking any significant extension.

void
The penetration of an object to its other side, allowing for the passage of space through it; an enclosed negative shape.

Basic three-dimensional concepts

In the preceding chapters, our examination of art fundamentals was limited mostly to the graphic arts. These art forms (drawing, painting, photography, printmaking, etc.) have two dimensions (height and width), exist on a flat surface, and generate sensations of space mainly through illusions created by the artist. This chapter deals with the unique properties of three-dimensional artwork and the creative concepts that evolve from these properties.

In three-dimensional art, the added dimension is that of actual depth. This depth results in a greater sense of reality and, as a consequence, increases the physical impact of the work. This is true because a graphic work is limited to one format plan, always bounded by a geometrically shaped picture frame, while a three-dimensional work is limited only to the outer extremities of its multiple positions and/or views. The three-dimensional format, although more complicated, offers greater freedom to the artist and greater viewing interest to the spectator.

Since actual depth is fundamental to three-dimensional art, one must be in the presence of the artwork to fully appreciate it. Words and graphic representations of three-dimensional art are not adequate substitutes for actual experience. Written and two-dimensional descriptions are flat, rigid, and representative of only one viewpoint; however, they do visually remind us of, or give clues about, actual sensory experiences. In this text, and particularly in this chapter, we use two-dimensional descriptions, in the form of text and photographic reproductions, as the most convenient means of conveying the three-dimensional experience. But we emphatically encourage readers to implement actual observation and practice when using this book.

Practicing artists and art authorities designate the three-dimensional qualities of objects in space with such terms as form, shape, mass, and volume. The term *form* here can be misleading because its meaning differs from the definition applied in earlier chapters. In a broad structural sense, form is the sum total of all the media and techniques used to organize the three-dimensional elements within an artwork. In this respect, a church is a total form and its doors are contributing shapes; similarly, a human figure is a total form, while the head, arms, and legs are contributing shapes. In a more limited sense, form may refer to a contour, a shape, or an object. *Shape,* when used in a three-dimensional sense, may refer to a positive or open negative area. By comparison, *mass* invariably denotes a solid physical object of relatively large weight or bulk. Mass may

9.1
Piece of alabaster. This piece of stone represents a three-dimensional mass of raw unsculptured material.

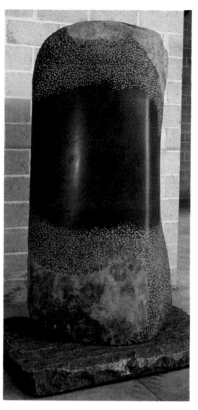

9.2
Isamu Noguchi. *The Stone Within.* 1982, basalt, 75 × 38 × 27 in. The sculptor Noguchi has subtracted just enough stone in this work to implant his concept of a minimal form while preserving the integrity of the material and its heavy, weighty mass.

The Isamu Noguchi Foundation. Photographed by Michio Noguchi

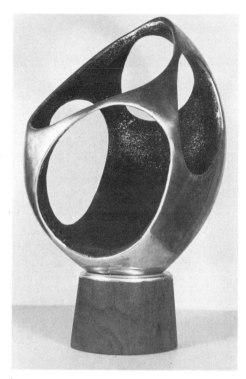

9.3
John Goforth. *Untitled.* 1971, cast aluminum, 15¾ in. high with base. The volume incorporates the space, both corporeal and incorporeal, occupied by the work.

Courtesy of the artist.

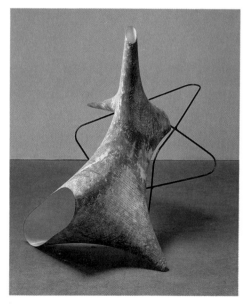

9.4
Steve Keister. *Bather.* 1987; spandex, epoxy paint, epoxy resin, fiberglass, bondo, and found objects; 52¾ × 64¼ × 42¾ in.; BH 4387. The ends of the main form of this sculpture have been left open to give the viewer an awareness of its interior and its thin shell. This interior interrelates with the spaces that surround the linear rods.

Courtesy Blum Helman Gallery, New York.

also refer to a coherent body of matter, like clay or metal, that is not yet shaped or to a lump of raw material that could be modeled or cast (fig. 9.1). Stone carvers, accustomed to working with glyptic materials, tend to think of a heavy, weighty mass (fig. 9.2); modelers, who manipulate clay or wax, favor a pliable mass. *Volume* is the amount of space the mass, or bulk, occupies, or the three-dimensional area of space that is totally or partially enclosed by planes, linear edges, or wires (fig. 9.3). Many authorities conceive of masses as positive solids and volumes as negative open spaces. For example, a potter who throws a bowl on a turntable adjusts the dimensions of the interior volume (negative interior space) by expanding or compressing the clay planes (positive mass). The sculptor who assembles materials may also enclose negative volumes to form unique relationships (fig. 9.4).

In the larger view, most objects in our environment have three-dimensional qualities, although in many cases these qualities are so minuscule that we tend to

disregard them. The wide variety of three-dimensional objects can be divided into natural and human-made forms. Although natural forms may stimulate the thought processes, they are not in themselves creative. Artists invent forms to satisfy their need for self-expression. In the distant past, most three-dimensional objects were created for utilitarian purposes. They included implements such as prehistoric stone axes, pottery, hammers and knives, and objects of worship. Nearly all these human-made forms possessed qualities of artistic expression; many depicted the animals their creators hunted. These historic objects are now considered an early expression of the sculpture impulse.

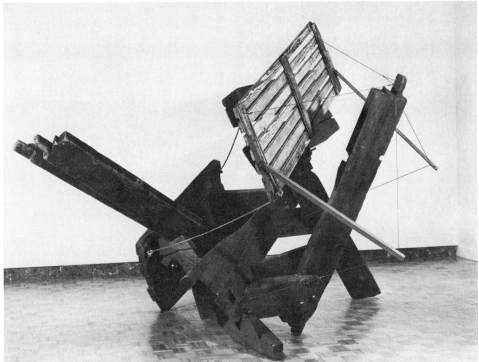

9.6
Mark di Suvero. *Tom.* 1960–61; wood, metal, rope, cable, and wire construction; 9 × 10 × 12 ft. Recent sculpture exploits every conceivable material that suits the intentions of the artist.

Courtesy of the Detroit Institute of Art. Gift of Friends of Modern Art and Mr. and Mrs. Walter Buhl Ford II Fund.

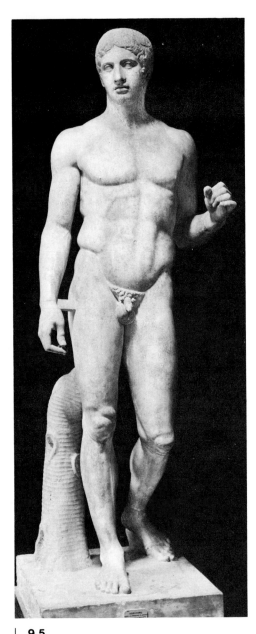

9.5
Polyclitus of Argos. *Doryphoros* (Roman copy). 450–440 B.C., marble, 6 ft. 6 in. Polyclitus wrote a theoretical treatise and demonstrated a new system of proportions for the ideal man, which took the form of a young man walking with a spear. (The spear is no longer extant.) The Greeks called the figure "Doryphoros." The Polyclitus style was characterized by harmonious and rhythmical composition.

National Museum, Naples, Alinari/Art Resource, New York.

Sculpture

The term sculpture has had varied meanings throughout history. The word derives from the Latin verb "sculpere," which refers to the process of carving, cutting, or engraving. The ancient Greeks' definition of sculpture also included the modeling of pliable materials such as clay or wax to produce figures in relief or in-the-round. The Greeks developed an ideal standard for the sculptured human form, which was considered the perfect physical organization—harmonious, balanced, and totally related in all parts. The concept of artistic organization was part of the definition of sculpture (fig. 9.5).

Modern sculpture has taken on new qualities in response to the changing conditions of an industrialized age. Science and machinery have made sculptors more conscious of materials and technology, and more aware of the underlying abstract structure in their art.

Sculpture is no longer limited to carving and modeling. It now refers to any means of giving intended form to all types of three-dimensional materials. These means include welding, bolting, riveting, gluing, sewing, machine hammering, and stamping. In turn, three-dimensional artists have expanded their range of sculptural forms to include planular, solid, and linear constructions made of such materials as steel, plastic, wood, and fabric (fig. 9.6). The resulting sculptures are stronger (even though made of lighter materials) and more open. They also have expanded spatial relationships. Three-dimensional forms like wire constructions and mobiles have changed the definition of sculpture that, previous to the nineteenth century, would have included only solid, heavy, and sturdy glyptic forms. Michelangelo di Buonarroti, an innovative sculptor within his Renaissance time frame, thought only in terms of massive materials and heavy figures (fig. 9.7).

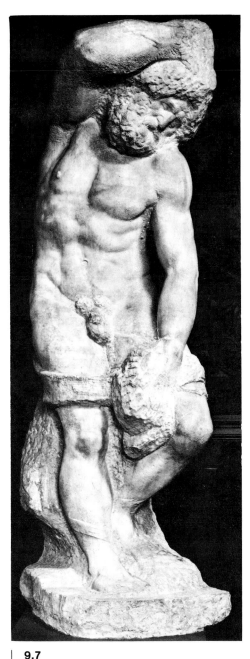

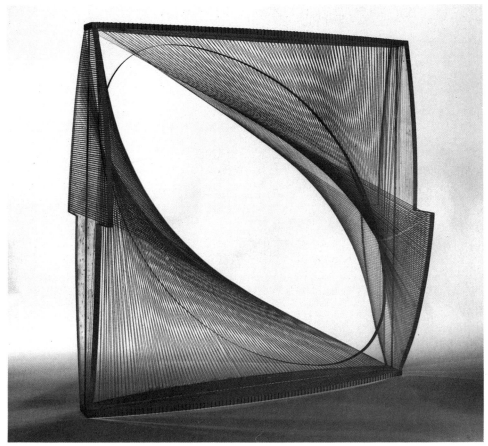

9.8
Naum Gabo. *Linear Construction in Space No. 1* (Variation). 1942–43 (fabricated circa 1957–58), Plexiglas with nylon monofilament, 24¾ × 24¾ × 9½ in. Naum Gabo was an early pioneer in the Constructivist movement. He created sculptures free of traditional figures with new materials like the sheet plastic seen here.

From the Patsy R. and Raymond D. Nasher Collection, Dallas, Texas.

9.7
Michelangelo. *Prisoner.* Michelangelo developed the idea of heavy, massive sculpture and enlarged the sizes of human body parts for expressive purposes. The tectonic composition was in keeping with the intrinsic nature of the stone material.

R. Galleria Antica, Moderna. Alinari photo.

The diversity of newfound materials and techniques has led to greater individual expression and artistic freedom. Sculptors experiment with new theories and create objects to please themselves. They have found new audiences and new markets (fig. 9.8).

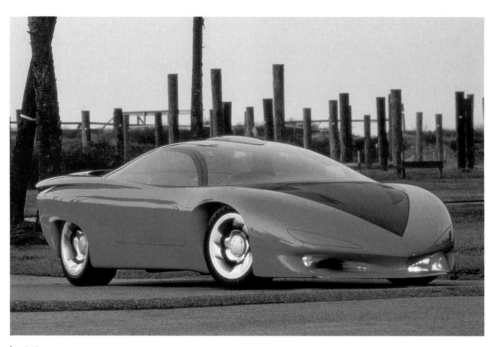

9.9

Pontiac Banshee concept car. New concepts in automobile design are determined by advances in technology, engineering, economics, and visual appearance. The 1988 concept car for General Motor's Pontiac was the Banshee, a futuristic performance coupe with realistic design and engineering features that could appear in the next generation of the popular Firebird series as it approaches the turn of the century.

Courtesy of public relations department/Pontiac Division/General Motors Corporation/Pontiac, MI.

Other three-dimensional areas

The bulk of this book has addressed works of pure or fine art that have no practical function. But sensitivity to the sculptural (and/or artistic) impulse is not confined to the fine arts; it permeates all three-dimensional structures. The same abstract quality of expressive beauty that is the foundation for a piece of sculpture can underlie such functional forms as automobiles, television receivers, telephones, industrial equipment, window and interior displays, furniture, and buildings (fig. 9.9). Artist-designers of these three-dimensional products organize elements, shapes, textures, colors, and space according to the same principles of harmony, proportion, balance, and variety. Although form principles can be applied to useful objects, the need for utility often restricts the creative latitude of the artist.

The famous architect Louis Sullivan made the oft-repeated remark that "form follows function." This concept has influenced several decades of design, changing the appearance of tools, telephones, silverware, chairs, and a vast array of other familiar and less familiar items. Sometimes this concept is misapplied. The idea of streamlining is practical when designing moving objects such as trains and cars, but has no logical application on spoons or lamps. Although streamlining is helpful in eliminating irrelevancies from design, even simplification can be overdone. The Bauhaus notion of the house as a "machine for living" helped architects rethink architectural principles, but it also produced many cold and austere structures against which there was inevitable reaction.

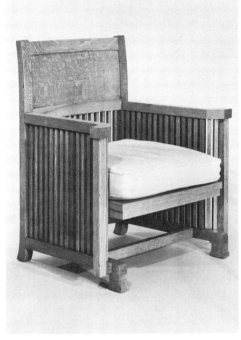

9.10
Armchair designed by Frank Lloyd Wright for the Ray W. Evans house, Chicago, Illinois. Circa 1908, oak, 86.9 × 58.5 × 57.1 cm. To Wright, form and function were inseparable, thus a chair, which functions for sitting, should be considered along with the whole architectural environment. This armchair, an integral part of an enclosure of interior space to be lived in, was designed by Wright in the original scheme of the Ray Evans House.

9.11
Michael Coffey. *Aphrodite.* 1978, a rocking lounge chair, laminated mozambique, 90 in. wide, 54 in. high, 28 in. deep. A useful article can be affected by the style of contemporary sculpture.

Contemporary designers are very aware of the functional needs of the objects they plan. Consequently, they design forms that express and aid function. However, designers also know that these objects need to be aesthetically pleasing. All of this points out that the creator of functional objects must be able to apply the principles of fundamental order within the strictures of utilitarian need. Frank Lloyd Wright, the celebrated American architect, combined architecture, engineering, and art in shaping his materials and their environment. The unity of his ideas is expressed in the chair he designed for the Ray Evans House (fig. 9.10). The sophisticated design Wright projected into an ordinary object with formal balance like the chair can be seen in his highly selective repetitions, proportional relationships, and detail refinement.

The balance that exists between design, function, and expressive content within an object varies with each creator. For instance, when designing his rocking lounge chair, Michael Coffey strongly emphasized expressive form without totally sacrificing the function of reclining comfort (fig. 9.11). At first glance, we are taken by the visual format of the dominant outer contour of the chair and its open shape. This unique chair resembles many freely expressed contemporary sculptures. Expressive form follows function in a new and creative way.

Tremendous developments have taken place in the general areas of three-dimensional design in which works usually serve some functional purpose.

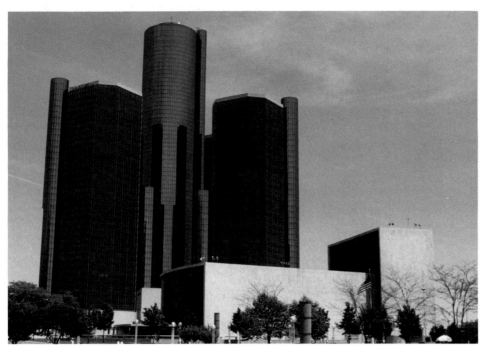

9.12
John Portman. Renaissance Center, Detroit, Michigan. 1977. Architect John Portman designed these high-level towers with steel, reinforced concrete, marble, and glass construction.

9.13
Marcel Breuer. Bell Tower, St. John's Abbey and University, Collegeville, Minnesota. Circa 1967, reinforced concrete. This structure, based on the traditional campanile of Romanesque cathedrals, is typical of the contemporary approach to three-dimensional design in architecture.

St. John's Abbey and University, Collegeville, Minnesota.

Architecture

Recent technological innovations and new building materials have given architects greater artistic flexibility. Thanks to developments in the steel and concrete industries, buildings can now be large in scale without projecting massive, weighty forms. With the advent of electric lighting, vast interior spaces can be illuminated. Because of air conditioning, buildings can be completely enclosed or sheathed in glass. Cantilevered forms can be extended into space. Sophisticated free-form shapes can be created with the use of precast concrete. All of these structural improvements have allowed architects to think and plan more freely. Contemporary public buildings that demonstrate these developments include the Lincoln Center for the Performing Arts in New York City, the Kennedy Center in Washington, D.C., the Jefferson Westward Expansion Memorial in St. Louis, the Los Angeles City Hall and Civic Center, and the Renaissance Center in Detroit (fig. 9.12). In many ways architects today are "building sculptors," and their designs require a thorough grounding in artistic principles as well as an understanding of engineering concepts (fig. 9.13).

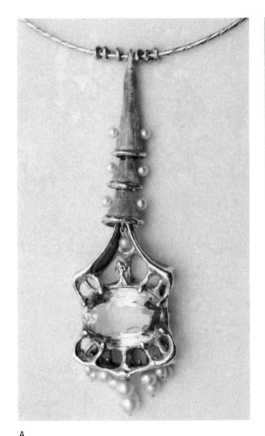

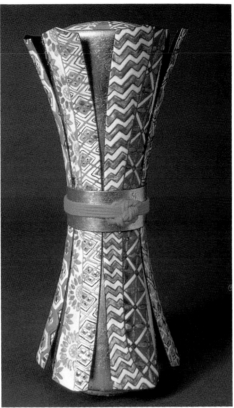

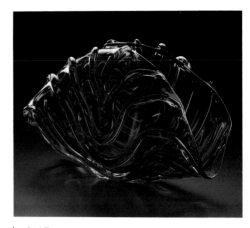

A B

9.14
Harold Hasselschwert. (*A*) Pendant Necklace. 1972; cast silvergilt with transparent enamel, cultured pearls, and a 55-carat rutilated kunzite; 4½ in. height of pendant. (*B*) Obi Mock Urn. 1986; copper enamel mounted on turned pine with gold leaf over venet-red and tied with cotton cord. Articles of metalwork are sculptural in concept. The necklace is meant to be worn, while the urn is intended to be freestanding.
Courtesy of the artist.

Metalwork

Most of the changes in metalworking (jewelry, small bowls, etc.) have been in concept rather than technique. Although traditional techniques are still in use, modern equipment has made procedures simpler and more convenient. To a large degree, fashion determines the character of metalwork, but it is safe to say that contemporary work is larger and more sculpturally oriented than most work of the past. Constant cross-fertilization occurs among the art areas, and metalwork is not immune to these influences. The metalworker benefits from studying the principles of both two- and three-dimensional art (fig. 9.14).

Glass design

Glassworking is similar to metalworking now that modern equipment has simplified traditional techniques. Designing glass objects, however, is very much an art form of present times. Many free-form and figurative pieces have the look of contemporary sculpture. Colors augment the designs in a decorative, as well as an expressive, sense. Thus, the principles of art structure are integrated with the craft of the medium (fig. 9.15).

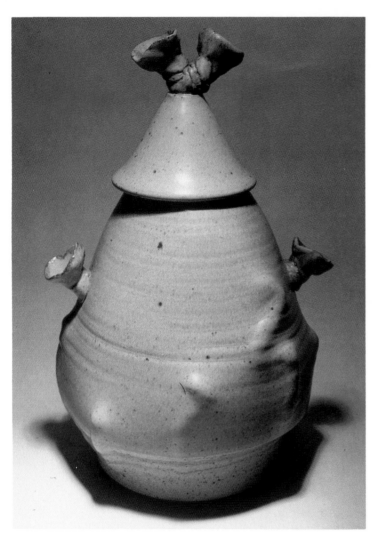

A

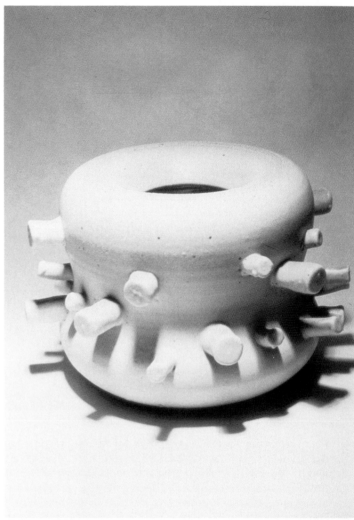

B

9.16
Don Ehrlichman. (*A*) Marnajar. 1988, cone 9 red. stoneware, 14 × 9 in. (*B*) *Spoke Jar*.
1988, cone 9 red. stoneware, 9 × 11 in. Three-dimensional qualities are important
considerations for Don Ehrlichman as he incorporates surface projections in his ceramic
works. In *Marnajar* the potter pushed the clay from the inside to create outward thrusting
accents, while in *Spoke Jar* he added clay to the outer surfaces.
Both courtesy of the artist.

Ceramics

In recent years the basic shape of the
ceramic object has become more
sculptural as ceramic work has become, in
many cases, less functional. The ceramist
must be equally aware of three-
dimensional considerations and of the
fundamentals of graphic art, since designs
are often incised, drawn, or painted on the
surface of the piece (fig. 9.16).

Fiberwork

Fiberwork, which traditionally produced
only flat objects such as rugs and
tapestries, has undergone a considerable
revolution recently. It has become
increasingly three-dimensional, partic-
ularly as its function has diminished.
Woven objects now include a vast array of
materials incorporated into designs of
considerable scale and bulk. Traditional as
well as contemporary concepts of
fiberwork require an understanding of
both two-dimensional and three-
dimensional principles (fig. 9.17).

Product design

A relative newcomer on the art scene,
product design is usually concerned with
commercial applications. The designer
produces works that are based on function
but geared to consumer appeal. To be
contemporary in appearance and thus
attractive to consumers, products must
exploit all the design principles of the age
(fig. 9.18). The designs of common
objects in our daily environment are the
products of the designer's training in
these principles.

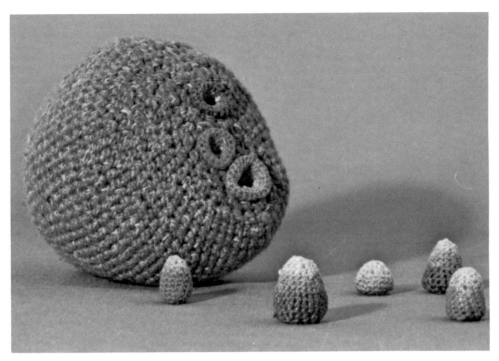

9.17
Kathleen Hagan. *Crocheted Series #5.* 1979. Contemporary textile design frequently goes beyond its largely two-dimensional traditions.
Courtesy of the artist.

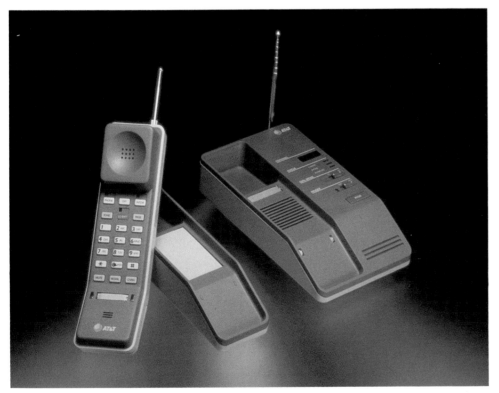

9.18
Telephone, 1988. This example of a product design incorporates three-dimensional shape relationships that were engineered and designed for contemporary consumption.
Reproduced with permission of AT & T Archives.

Components of three-dimensional art

Subject, form, and content, the components of graphic art, function in much the same manner in the plastic arts. The emphasis placed on each of the components, however, may vary. For example, the depiction of a human being may be a suitable subject for the sculptor, but human beings are meant to be served by the architect, ceramist, or metalsmith. The architect provides shelter, the ceramist utensils, and the metalsmith ornamentation.

Formal organization is more complex in three-dimensional art than in the graphic arts. Actual materials developed in actual space through physical manipulation exist in a tactile as well as a visual sense. The resultant complexities expand the content or meaning of the form and add greater aesthetic dimension.

Materials and techniques

Materials and techniques also play larger roles in three-dimensional art than in graphic art. In the last hundred years, the range of three-dimensional materials has expanded from basic stone, wood, and bronze to steel, plastic, fabric, glass, laser beams (holography), fluorescent and incandescent lighting, etc. Such materials have revealed new areas for free explorations within the components of subject, form, and content. But they have also increased our responsibilities for fully understanding three-dimensional materials and their accompanying technologies. The nature of the materials puts limitations on the structures that can be created and the techniques that can be used. For example, clay modelers adapt the characteristics of clay to their concept. They manipulate the material with their hands, a block, or a knife to produce a given expression or idea. Modelers don't try to cut the clay with a saw. They understand the characteristics of their material and adapt the right tools and techniques to control it. They also know that materials, tools, and techniques are not ends in themselves but necessary means for developing a three-dimensional work.

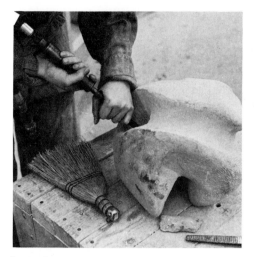

9.19
Subtracting stone. In the subtractive process, the raw material is removed until the artist's conception of the form is revealed. Stone can be shaped manually or with an air hammer, as above.
Photograph courtesy of Ronald Coleman.

The four primary technical methods for creating three-dimensional forms are: subtraction, manipulation, addition, and substitution. Although each of the technical methods is developed and discussed separately in this book, many three-dimensional works are produced using combinations of the four methods.

Subtraction

Artists cut away materials capable of being carved (glyptic materials), such as stone, wood, cement, plaster, clay, and some plastics. They may use chisels, hammers, torches, saws, grinders, and polishers to reduce their materials (fig. 9.19). It has often been said that when carvers take away material, they free form and a sculpture emerges. The freeing of form by the subtraction method, although not simplistic, does produce unique qualities that are characteristic of the artist's material.

Manipulation

Widely known as *modeling,* manipulation is based on the type of materials used. Clay, wax, and plaster are common media that are pliable or can be made pliable during their working periods. Manipulation is a direct method for creating form.

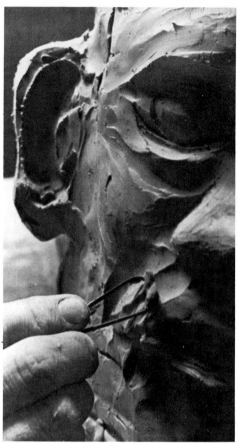

9.20
In the manipulation technique, clay is removed with a loop tool. Clay may be applied to the surface with fingers, hands, or other tools.

Artists can use their hands to model a material like clay into a form that, when completed, will be a finished product. For expanded control, special tools, such as wedging boards, wires, pounding blocks, spatulas, and modeling tools (wood and metal), are used to work manipulative materials (fig. 9.20).

Manipulative materials respond directly to human touch, leaving the artist's imprint, or are mechanically shaped to imitate other materials. Although many artists favor the honest autographic qualities of pliable materials, others—especially those in business and manufacturing—opt for the economics of quick results and fast change. Techniques and materials are important in that they contribute to the final form.

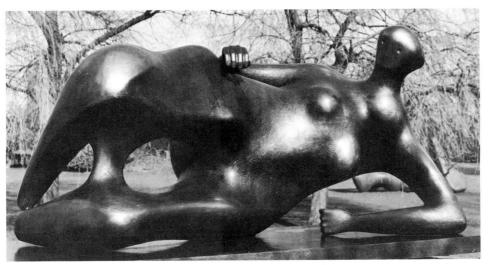

9.21
Henry Moore. *Reclining Woman: Elbow.* **1981, bronze, edition of 9, length 87 in.**
This is an example of a bronze cast. Henry Moore prepared a model for this sculpture, which was then taken to a foundry where a mold was made and a cast poured.
© Henry Moore Foundation 1989. Reproduced by kind permission of the Henry Moore Foundation.

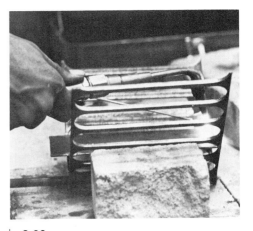

9.22
Welding. In the additive process, pieces of material are attached to each other and the form is gradually built up. Welded pieces such as the one illustrated are often, though not always, more open than other sculptural techniques.
Photograph courtesy of Ronald Coleman.

Because most common manipulative materials are not durable, they usually undergo further technical change. For instance, clay may be fired in a kiln or cast in a more permanent material like bronze (fig. 9.21).

Addition

Methods of addition may involve greater technology and, in terms of sculpture (nonfunctional), have brought about the newest innovations. When using additive methods, artists add materials that may be pliable and/or fluid, such as plaster or cement. They assemble materials like metal, wood, and plastic with tools (welding torch, soldering gun, a stapler, etc.) and fasteners (bolts, screws, nails, rivets, glue, rope, or even thread) (fig. 9.22).

Since three-dimensional materials and techniques are held in high esteem today, the additive methods, with their great range, freedom, and diversity, offer many challenging three-dimensional form solutions.

Substitution

Substitution, or casting, is almost always a technique for reproducing an original three-dimensional model. Sometimes an artist alters the substitution process to change the nature of the cast. Basically,

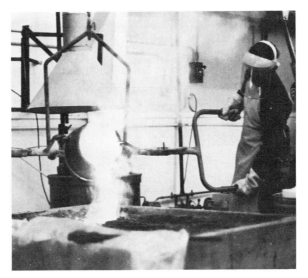

9.23
Substitution technique. In the substitution process, molten metal is poured into a sand mold that was made from a model.
Photograph courtesy of Ronald Coleman.

in this technique, a model in one material is exchanged for a duplicate form in another material, called the *cast,* and this is done by means of a mold. The purposes of substitution are first, to duplicate the model and second, to change the material of the model, generally to a permanent one. For example, clay or wax can be exchanged for bronze (fig. 9.23), fiberglass, or cement. A variety of processes (sand casting, plaster casting,

lost-wax casting, etc.) and molds (flexible molds, waste molds, piece molds, etc.) are used in substitution. Substitution is the least creative or inventive of the technical methods since it is imitative; the creativity lies in the original, not in the cast.

Besides acquiring a knowledge of three-dimensional materials and their respective techniques, artists must also be aware of the elements of form.

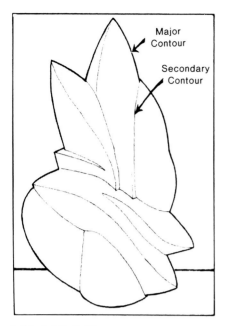
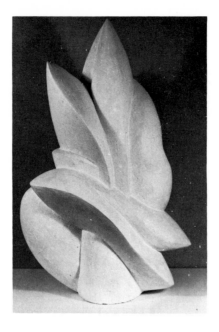
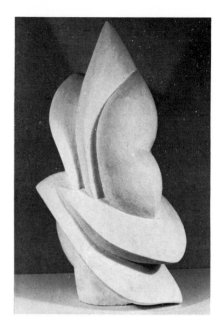

9.24, 9.25, 9.26

Major and secondary contours. In figure 9.24 the major contour surrounds the silhouette, or the total visible area, of the work. Secondary contours enclose internal masses. In figures 9.25 and 9.26 (student work, plaster), each change in position reveals new aspects of a three-dimensional work, or sculpture in the round.

The elements of three-dimensional form

Three-dimensional form is composed of the visual elements—shape, value, space, texture, line, color, and time. The order of listing is different from that for two-dimensional art and is based on significance and usage.

Shape

The artist working in three dimensions instinctively begins with shape. Shape, a familiar element in the graphic arts, takes on expanded meaning in the plastic arts. It implies the totality of the mass or volume lying between its contours, including any projections and depressions. It may also include interior planes. We can speak of the overall space-displacing shape of a piece of sculpture or architecture, of the flat or curved shape that moves in space, or of a negative shape that is partially or totally enclosed.

These shapes are generally measurable areas limited by and/or contrasted with other shapes, values, textures, and colors. The three-dimensional artist should clearly define the actual edges of shape borders. Ill-defined edges often lead to viewer confusion or disinterest. Shape edges guide eye attention through, around, and over the three-dimensional surface.

In three-dimensional art the visible shape depends on the viewer's position. A slight change of position results in a change in shape. A *major contour* is the outer limit of the total three-dimensional work as seen from one position (figs. 9.24, 9.25, and 9.26). *Secondary contours* are perceived edges of shapes or planes that move across and/or between the major contours. Some three-dimensional works are constructed so that the secondary contours are negligible (fig. 9.27).

A shape may be a negative space—a three-dimensional open area that seems to penetrate through or be contained by solid material. Open shapes can be areas that surround or extend between solids. Such open shapes are often called *voids*. Alexander Archipenko, Henry Moore, and Barbara Hepworth, prominent twentieth-century sculptural innovators, pioneered the use of void shapes (fig. 9.28). Voids provided new spatial extensions for these artists; they revealed interior surfaces, opened direct routes to back sides of the sculpture, and reduced excessive weight. Void shapes should be considered integral parts of the total form. In linear sculpture, enclosed void shapes become so important that they often dominate the width, thickness, and weight of the materials that define them (fig. 9.29).

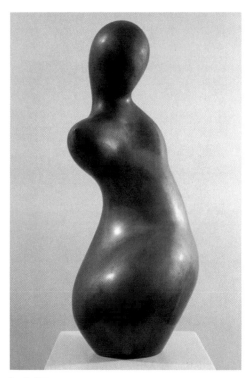

9.27
Hans Jean Arp. *Torsifruit*. 1960, bronze, edition of ten, 29 × 12 × 11½ in. The major contour of *Torsifruit* is its outermost edge. Secondary contours are nonexistent or, at best, minimal.

Courtesy Kent Fine Art, New York.

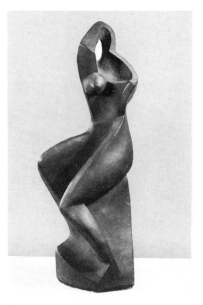

9.28
Alexander Archipenko. *Woman Doing Her Hair*. Circa 1958, bronze casting from plaster based on original terra cotta of 1916. This is a significant example of sculptural form where the shape creates negative space, or a void. Archipenko was one of the pioneers of this concept, which helped establish the fourth-dimensional use of time-motion in space a short time later.

Courtesy the Kunst Museum, Dusseldorf, Germany.

9.29
Richard Lippold. *Variation within a Sphere, No. 10, the Sun*. 22-carat gold-filled wire, height 11 ft., width 22 ft., depth 5½ ft. Development of welding and soldering techniques for use in sculpture made the shaping and joining of thin linear metals possible, as in this work by Lippold.

Metropolitan Museum of Art. Fletcher Fund, 1956.

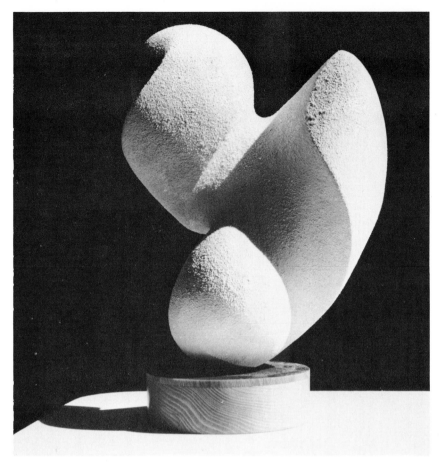

9.30
Student work. *Untitled.* A piece of sculpture "paints" itself with values. The greater the projections and the sharper the edges, the greater and more abrupt the contrasts.
Photograph courtesy of Ronald Coleman.

Value

As the artist physically manipulates three-dimensional shapes, contrasting values appear through the lights and shadows produced by the forms. Value is the quantity of light actually reflected by an object's surfaces. Surfaces that are high and facing a source of illumination are light, while surfaces that are low, penetrated to any degree, or facing away from the light source appear dark. Any angular change of two juxtaposed surfaces, however slight, results in changed value contrasts. The sharper the angular change, the greater the contrast (fig. 9.30).

When any part of a three-dimensional work blocks the passage of light, shadows result. The shadows change when the position of the work or of its source of illumination changes. If a work has a substantial high and low shape variation and/or penetration, the shadow patterns are more likely to define the work, regardless of the position of the light source. Sculptors who create mobiles are examples of artists interested in continuously changing light and shadow. The intensity of light markedly changes the shadow effect.

Value changes can also be affected by adding a pigmented medium to the surface of a three-dimensional work. Light pigments generally strengthen the shadows, while dark pigments weaken them. The more lightly pigmented media work best on pieces that depend on secondary contours; darker pigmentations are most successful in emphasizing the major contours. Thin linear structures that depend more on background contrast appear in strong dark or light silhouetted value (fig. 9.31).

9.31
Richard Lippold. *Primordial Figure.* **1947–48, brass and copper wire, 96 × 24 × 18 in.** The dark value of the background is an important factor in the visibility of this linear sculpture.

Collection of the Whitney Museum of American Art. Purchase, with funds from the Friends of the Whitney Museum of American Art and Charles Simon, 62.67.

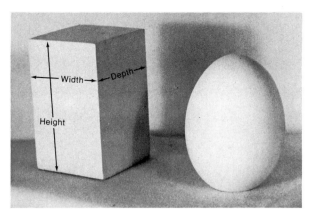

9.32
Rectangular and ovoidal shapes.

9.33
Stacked bricks.

9.34
Separated bricks.

Space

Space may be characterized as a boundless or unlimited extension of occupied areas. When artists use space, they tend to limit its vastness. They may mark off extensions in one, two, or three dimensions, or measurable distances between preestablished elements. Three-dimensional artists use objects to displace space and to control spatial intervals and locations. The rectangular and ovoidal shapes in figure 9.32 are examples of space-controlling objects. The weight of these solids is felt and established by the dimensions of the planes, which, whether flat or rounded, seem to define spatial dimensions. The two shapes seen together create spatial interval. Although the two solids are three-dimensional, their spatial indications are minimal. Greater interest and, in turn, greater spatial qualities, could be added to the two shapes by manipulating their surfaces. If material were cut away, the space would move inward, and if material were added, the space would move outward.

In figure 9.33 the four bricks have been arranged in a very restricted manner to form a large, minimal rectangular solid. The individual bricks are distinguished only by the linelike crack edges visible in the frontal and side planes. These linear edges are reminiscent of graphic linear renderings.

The four bricks illustrated in figure 9.34 are separated by indentations similar to the mortar joints made by masons. These gaps, although relatively shallow, nevertheless produce distinctively clearer and darker edges than those shown in figure 9.33. Line engravers use a similar technique in handling metal plates (fig. 9.38). Although the darker edges indicate greater three-dimensional variation than the first stack of bricks showed, they still have decided limitations. The channeled edges in an engraved plate can be felt.

9.35
Crooked bricks.

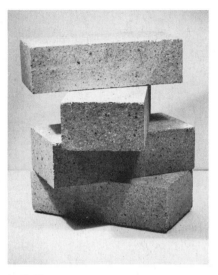

9.36
Slanted bricks.

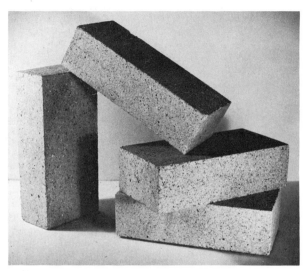

9.37
Crossed bricks.

9.38
Engraving. The engraver uses a burin to cut furrows in the metal that will hold ink and produce a line. The engraved plate is a very shallow sculptural relief that is used to produce linear illusion in the print.

Many shallow relief sculptures function in a similar way (fig. 9.39).

The bricks in figure 9.35 utilize even more space. They are positioned so that the planes moving in depth are contrasted with the frontal and side planes, moving toward and away from the viewer. The light that strikes the grouping produces stronger shadows and more interesting value patterns. This arrangement can be compared to the qualities of high relief sculpture. The play of deep shadows against the lights on projecting parts of a high relief sculpture can increase the expressive or emotional qualities of the sculpture (fig. 9.40).

Although still in a compact and closed arrangement, the rotation of the bricks in figure 9.36 makes possible new directions and spatial relationships. The work is becoming more truly sculptural as contrasts of movement, light, and shadow increase. In a way, this inward and outward play of bricks is similar to what the sculptor creates in a freestanding form. Such works are no longer concerned with simple front, side, and back views, but with multiple axes and multiple views.

Although all the brick illustrations are actually freestanding, or in-the-round, the first two examples show surface characteristics closer to the condition of relief, as was previously indicated. Some authorities use the terms freestanding and sculpture in-the-round interchangeably to mean any three-dimensional work of art not attached to a wall surface (see fig. 9.30).

The variety of brick positions in figure 9.37, particularly the diagonally tipped brick, creates far greater exploitation of space than the other groupings. The void, or open space, emphasizes the three-dimensional quality of the arrangement by producing a direct link between the space on each side.

Although the fundamentals of three-dimensional form are the principal concern of this chapter, this emphasis should not imply that the plastic arts are superior to the graphic arts. Such an evaluation is not determined by dimensions or media. Artists determine and select whatever means will help them reach their creative goals.

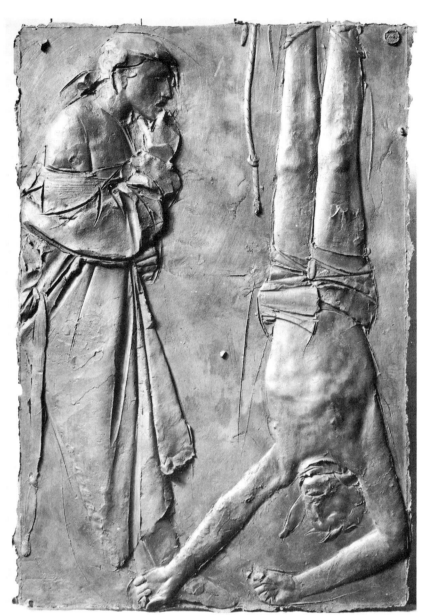

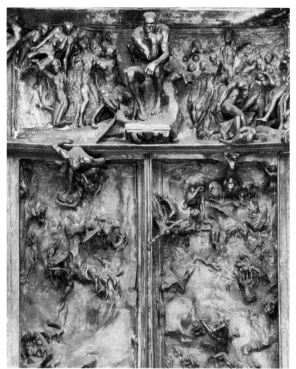

9.40
Auguste Rodin. *The Gates of Hell*
(detail). Bronze. In this high relief, the
forms nearly break loose from the
underlying surface.

Rodin Museum, Philadelphia, Pennsylvania. Gift
of Jules E. Mastbaum.

9.39
Giacomo Manzu. *Death by Violence.*
1963, bronze cast from clay model. This
is a study for one of a series of panels for
the doors of St. Peter's. The confining
spatial limitations of relief sculpture are
evident. To create a greater feeling of
mass, Manzu used sharply incised
modeling that, in technique as well as in
effect, is similar to the engraved lines of
the printmaker's plate. The crisp incising
creates sharp value contrasts that accent
movement as well as depth.

Art Resource, New York.

9.41
**Paul Nesse. *Portrait of Ron Russel.*
1974, painted plaster, life size.** Artists select a surface character for their work that expresses their conception of the subject's character and/or physical characteristics.
Courtesy of the artist.

9.42
José de Rivera. *Brussels Construction.* 1958, stainless steel, 118.1 × 200.6 cm.
The concept of attracting observers to a continuous series of rewarding visual experiences as they move about a static three-dimensional work of art led to the principle of kinetic or mobile art, as with this sculpture set on a slowly turning motorized plinth.

Texture

Textures enrich a surface, compliment the medium, and enhance expression and content. Textured surfaces range from the hard glossiness of glass or polished marble to the roughness of fingerprinted clay or weathered wood (fig. 9.41). Certain surfaces are indigenous to media, and traditionally these intrinsic textures are respected. The artist usually employs texture as a distillate of the distinctive qualities of the subject. The sleek suppleness of a seal, for example, seems to call for a polished surface, but the character of a rugged, forceful person suggests a rough-hewn treatment. However, artists sometimes surprise us with a different kind of treatment. The actual, simulated, and invented textures of graphic artists are also available to plastic artists and are developed from the textures inherent in plastic artists' materials.

Line

Line is a phenomenon that does not actually exist in nature or in the third dimension. It is primarily a graphic device used to indicate the meeting of planes or the outer edges of shapes. Its definition might be broadened, however, to mean the axis of a three-dimensional shape whose length is greater than its width. Within this context, line relates to the thin shapes of contemporary linear sculpture using wires and rods. Development of welding and soldering techniques made possible the shaping and joining of thin linear metals in sculpture. Such artists as José de Rivera and Richard Lippold have expanded the techniques of linear sculpture (fig. 9.42; see figs. 9.29 and 9.31).

Incising line in clay or in any other soft medium is similar to the graphic technique of drawing. In three-dimensional art, incised lines are commonly used to accent surfaces for interest and movement. Giacomo Manzu, a contemporary Italian artist, employs such lines to add sparkle to relief sculpture (fig. 9.39).

Color

Color is also indigenous to sculptural materials. Sometimes it is pleasant, as in the variegated veining of wood or stone (fig. 9.43), but it can also be bland and lacking in character, as in the flat chalkiness of plaster. Pigment is often added when the material needs enrichment or when the surface requires color to bring out the form more effectively. The elements of value and color are so interwoven in sculpture that artists often use the two terms interchangeably. Thus, an artist may refer to value contrasts as "color," actually thinking of both simultaneously. Many applications of color are attempts to capture the richness and form-flattering qualities of the patina found on bronzes oxidized by exposure to the atmosphere.

9.43
Isamu Noguchi. *The Opening.* **1970,**
French rose and Italian white marble.
This sculpture is enriched by the artist's
choice of materials of contrasting colors
and variegated graining.
Courtesy of the artist.

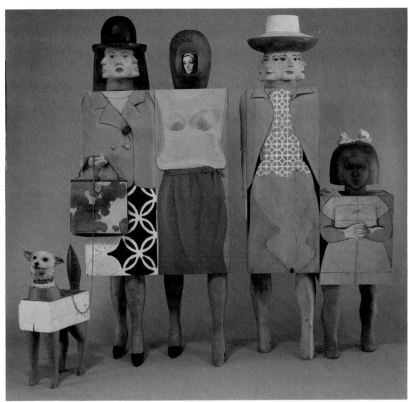

9.44
Marisol. *Women and Dog.* **1964; wood, plaster, synthetic polymer, and miscellaneous**
items; 72 × 82 × 16 in. This example of Pop art reveals the willingness of some
contemporary artists to use bright color to heighten three-dimensional characteristics of
form at the same time that it enriches surfaces. The form further suggests sources in
previous twentieth-century styles, while the use of combine-assemblage tends to fuse the
medias of sculpture and painting into one.
Courtesy Collection of the Whitney Museum of American Art. Purchase, with funds from the Friends of
the Whitney Museum of American Art, 64.17.

This approach stresses color that is
subordinate to the structure of the piece.
In certain historical periods (for example,
early Greek art), application of bright
color was commonplace. Some revival of
this technique is evident in contemporary
works. In every case the basic criterion
for the use of color is compatibility with
the form of the work (fig. 9.44).

Time

Time is an element unique to the three-
dimensional arts. It is involved in graphic
arts only insofar as contemplation and
reflection on meaning are concerned. The
physical act of viewing a graphic work as
a totality requires only a moment.
However, in a plastic work, the added
dimension means that the work must turn
or that we must move around it to see it
completely. The artist wants the time
required to inspect the work to be a
continuum of rewarding visual variation.
Each sequence or interval of the viewing
experience must display interesting
relationships and lure the observer further
around the work, extending the time
spent on it.

In the case of *kinetic* sculpture, the
artwork itself, not the observer, moves.
Such works require time for their
movements. Mobiles, for example, present
a constantly changing, almost infinite
series of views (fig. 9.45; see fig. 10.96).

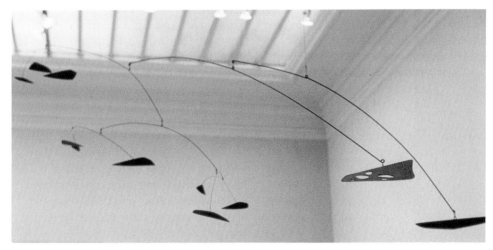

9.45
Alexander Calder. *Mobile: Horizontal Black with Red Sieve.* **1957, painted steel,**
approximately 9 ft. long, 5½ ft. high. This noted artist introduced physically moving
sculptures called mobiles. Movement requires time for observation of the movement, thus
introducing a new dimension to art in addition to height, width, and space. The result is a
constantly changing, almost infinite series of views of the parts of the mobile.
The Toledo Museum of Art, Toledo, Ohio. Museum Purchase.

9.46
**James De Woody. *Big Egypt.* 1985,
black oxidized steel, 72 × 30 × 30 in.**
Big Egypt is an example of a tectonic
arrangement. James De Woody has cut
planes that project in and out of his
surfaces without penetrating voids or
opening spaces. This is sometimes
referred to as closed composition.
Courtesy of Arthur Roger Gallery, New Orleans,
Louisiana.

9.47
**Kenneth Snelson. *Free Ride Home.* 1974, aluminum and stainless steel, 30 × 60 × 60
ft.** Kenneth Snelson has developed sculptures that are ''open,'' or atectonic spatially.
Storm King Art Center, Mountainville, NY. Purchase 1975.64. Photography by David Finn.

Principles of three-dimensional order

Organizing three-dimensional art is the
same as organizing two-dimensional art.
However, three-dimensional forms, with
their unique spatial properties, call for
somewhat different applications of the
principles.

Three-dimensional artists deal with
forms that have multiple views.
Composing is more complex. What might
be a satisfactory solution for an
arrangement with one view would only be
a partial answer when dealing with
multiple-viewed configurations.
Adjustments are required to totally unify
a piece. Compositionally, a three-
dimensional work may be *tectonic* (closed,
massive, and simple, with few and limited
projections; fig. 9.46) or *atectonic* (open,
to a large degree, with frequent extensive
penetrations and thin projections; fig.
9.47). Tectonic and atectonic arrange-
ments can be found in nearly all three-
dimensional art, and each of these
arrangements can be used individually to
achieve different expressive and spatial
effects.

Balance

When considering balance and the
extension of spatial effects in three-
dimensional art, some special conditions
should be examined. For example, the
symmetry of a three-dimensional piece
exists only as can be seen from front or
back. A work that appears symmetrical
from front or back could not be
symmetrical from top or side positions
(fig. 9.48). Two types of balance are
possible in actual space: *asymmetrical
balance* (fig. 9.49) and *radial balance*. Of
the two, radial balance is more formal,
while asymmetrical balance is irregular.
Radial balance is spherical, with the
fulcrum in the center (fig. 9.50). The
parts that radiate from this point are
usually similar in their formations.
However, more artists use asymmetrical
balance because it provides the greatest
individual latitude and form variety.

Proportion

When viewing a three-dimensional work,
the significance of proportion seems to
prevail. The one-on-one relationship of
actually experiencing a three-dimensional
work brings out a special feeling for
tension, balance, and scale. Proportion is
involved in determining the basic form; it
sets the standard and permeates the other
principles. Repetition and rhythm have
relationships that include proportional
similarities. Predictable rhythm
incorporates proportional transitions that
aid in giving flow to form (fig. 9.51).

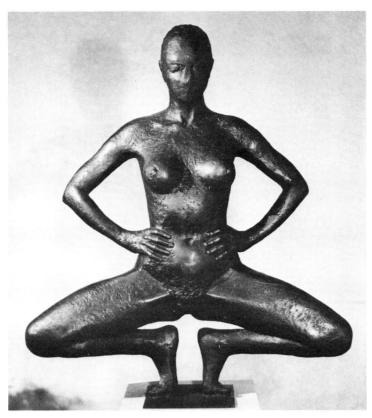

9.48
Edward Glauder. *Bo.* 1982, bronze, 18 in. high. Edward Glauder modeled a symmetrically arranged figure as is seen in this view of his sculpture. However, if this figure were viewed from the left, right, or top, it would no longer be seen as symmetrical but as asymmetrical.

Courtesy of Jack Rutberg Fine Arts, Inc.

9.49
Robert Hudson. *Through the Window.* 1988, polychrome steel and rubber, 93 × 82 × 53 in. In this sculpture we see a variety of form parts. We also see an excellent example of an asymmetrically balanced sculpture.

Frumkin/Adams Gallery, New York.

9.50
Mark di Suvero. *Erk Thru Able Last.* 1987, steel. The center of this sculpture is the fulcrum identified by the contrasting rounded, curled parts. All of the diagonal beams radiate in outwardly thrusting directions.

Oil & Steel Gallery. Photo credit: G. Bellamy.

9.51
Beverly Pepper. *Ventaglio.* **1967, stainless steel with blue enamel, 8 ft. high.**
The rhythmical repetition of the frames in Beverly Pepper's sculpture creates an exciting, flowing movement.
André Emmerich Gallery.

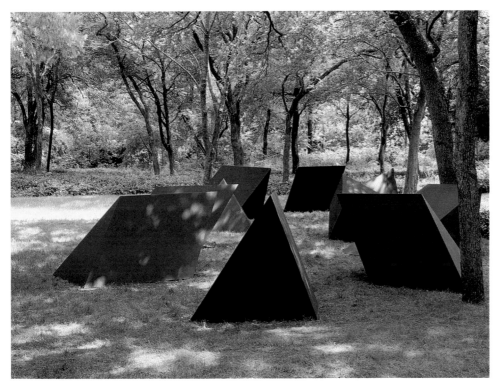

9.52
Tony Smith. *Ten Elements*. 1975–79 (fabricated 1980), painted aluminum, tallest element 50 in., shortest element 42 in. Tony Smith has created many artworks that represent nothing more than large-scale, starkly simple geometric shapes. In this backyard group, he has repeated ten different shapes that spatially interact. The economic means of Smith, a Minimalist, unify a complex arrangement.
From the Patsy R. and Raymond D. Nasher Collection, Dallas, TX.

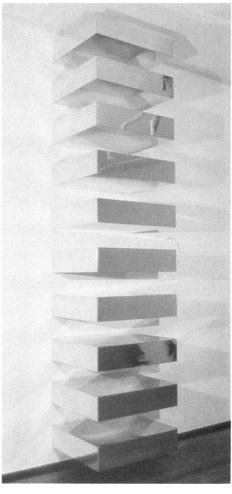

9.53
Donald Judd. *Untitled, 1978*. Brass, 10 boxes, 6 × 27 × 24 in. Judd is primarily interested in perceptually explicit shapes, reflective surfaces, and vertical interplay.
Courtesy of Donald Judd.

Economy

Included within the group known as Primary Structurists or Minimalists are three-dimensional artists who emphasize the principle of economy in their works because they, like their fellow painters, want to create stark, simple, geometric shapes. These minimalists strip their shapes of any emotional, psychological, or symbolic accompaniments and eliminate physical irrelevancies. For further emphasis they also feature large size. Tony Smith has reduced his shapes to simple geometric forms (fig. 9.52), while Richard Sherra has used standing planes. Donald Judd and Carl Andre align their primary shapes in vertical and horizontal rows, thereby interrelating economy with repetition and rhythm (fig. 9.53).

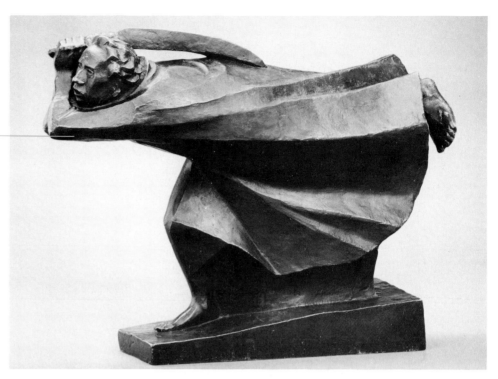

9.54

Ernst Barlach. *The Avenger.* **1914, bronze, 17½ × 8½ × 23½ in.** This figure is not actually moving, but it does suggest a gesture of forward thrust. Movement is implied by the long sweeping horizontal and diagonal directions that are cut by the edges of the robe and the projection of the head and shoulders.

Gift of Mrs. George Kamperman in memory of her husband, Dr. George Kamperman.

Movement

Two types of movement are used by three-dimensional artists. *Implied* movement, the most common type (fig. 9.54), is illusionary, but *actual* movement is special and involves the total work. Actual movements that take place in kinetic art are set into motion by air, water, or mechanical devices. Alexander Calder, the innovator of mobile sculptures, at first used motors to drive his pieces but later used air currents generated by human body motion, wind, air conditioning, or heating (see figs. 9.45 and 10.68). George Rickey, a contemporary sculptor, works with wind and air propulsion (see fig. 10.96). Water has been used as a propellant in other three-dimensional works. Jean Tinguely, José de Rivera, and Pol Bury propel their sculptures with motor drives (fig. 9.55; see figs. 9.42 and 10.88). Computer-activated kinetics are now being marketed. The principle of movement is inherently related to the art elements of time and space.

When properly combined, the principles of order produce vibrant forms. In the three-dimensional field, new conceptual uses of time, space, and movement have changed definitions and meanings that had endured for centuries. Three-dimensional art need no longer be considered a stepchild of graphic art.

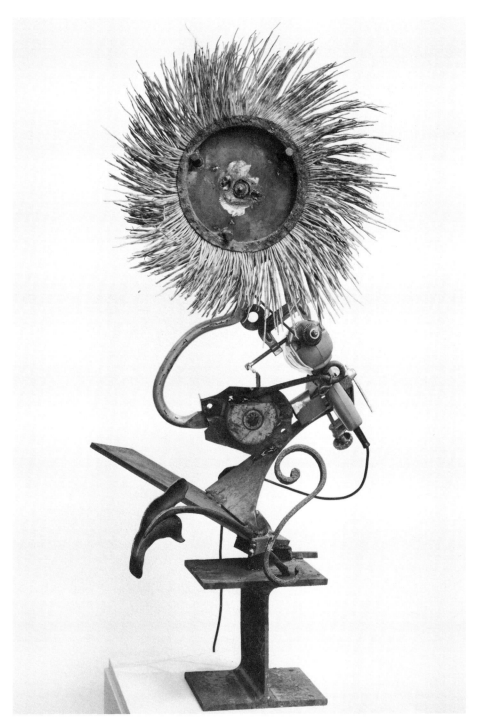

9.55

Jean Tinguely. *O Sole Mio.* **1982; metal, steel; paint, plastic, drill, clamp; 40 × 22 ×
20 in.** For Jean Tinguely, the machine is an instrument for the poet/artist. He produces
machine-driven sculptures that involve kinetic anti-machine ironies, mechanical breakdowns,
and appropriate rattling noises.

© The Detroit Institute of Arts. Gift of the City of Montreux, Switzerland, Detroit Renaissance, and the
artist.

10
CONTENT AND STYLE

Introduction to content and style

This chapter is concerned with the third component of a work of art, which we call content, meaning, or expression. Analyzing historical traditions increases our understanding of art forms and what the artist is trying to express through them. This chapter has been restricted to an accounting of recent art (from the early nineteenth century to the present day), because that seems most appropriate for a beginning text devoted primarily to practice. Those who desire to study art history in more depth will find, if they have not already, many excellent general and specific sources, such as libraries and museums, upon which they can draw.

Definitions

The fixing of an image, whether with oil pigment on canvas or pencil on drawing paper, is only one aspect of artistic creation. The character or personality of a formal image that results from this activity is determined as much by the artist's mental and emotional response to a subject as by his or her choice of media and manipulation of tools. This mental and emotional response, formed through media and technique, is what we mean by the terms content and style.

Content, or meaning, is primarily concerned with the intangible quotient of creativity. It is comprised of the unique qualities of meaning or mood that result from the formal crystallization of an image by an artist. Art critics and art historians consider not only the content of works of art, but the style in which that content is couched, in order to distinguish whether individual artists are ordinary, very good, or truly marked with genius. Style can be called the expressive form, or the characteristics of form and meaning, in particular works of art. Where content is an attempt to say something about a subject in terms of an artist's own time, style refers to the identifiable, often repeated traits found in the artist's handling of artistic forms, and is directly responsive to the use of the elements of form studied in previous chapters.

The two broad classifications of style are: individual and group. An artist, especially a good one, usually shows differences in his or her work from those produced by other contemporary artists. This is known as individual style. Group style, on the other hand, reflects society as a whole. Group expressions usually come into being with the birth and growth of a culture, and are based on the related characteristics observable in the work of individual artists within that culture. The individual differences of style of artists within the group may be identified, as well as their similarities.

Particular artists are usually known for both their individual and group styles. Varied names have been given to group styles, such as Egyptian, Renaissance, and Modern. Individual artists are usually known by their style characteristics within a group. Occasionally, when an artist from the past is not known by name, but has become identified with certain traits, that individual's manner within the group has been given an identifying style name. Examples are the "Master of the Rampin Horseman" in Ancient Greek times and the "Master of the Blessed Clare" in the proto-Renaissance of fourteenth-century Italy (fig. 10.1; see fig. 8.13).

Ancient Greek art is a good example of what we mean by a group's expression. The expression of Greek culture at its highest level of achievement resulted in a generally realistic style we call *Idealism*. In the fifth century B.C., when idealism had fully developed, Greek artists tended to see humanity transfigured by a noble destiny. This contrasted with the paramount belief in a religious destiny that had stimulated the art of preceding civilizations, such as those in Egypt and the Mideast.

Within group expressions, however, social changes affect the general style so that variations in attitude toward subject, form, and content are discernible. Variations of this kind can be traced in Greek art from a lively conceptualism in earlier times (seventh century B.C. to early fifth century B.C.; fig. 10.2), when artists used the human figure primarily as a semiabstract symbol, to more realistic

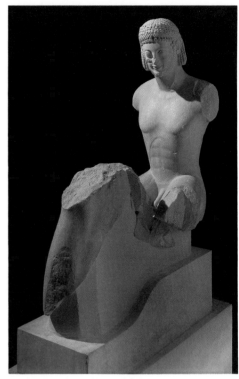

10.1

Master of the Rampin Horseman. *Rampin Horseman.* **Circa 550** B.C., **sculpture from the old Acropolis, Athens, Greece.** The styles of artists from ancient times can often be determined if enough remains exist on which to identify certain artistic traits. Even when not known by name, such artists were sometimes given a "style" name. In this case, the master sculptor was named from an inscription on the Acropolis.

and ideal tendencies in the fifth to fourth centuries B.C. The idealism of this so-called Classic Age perceived the human being as the spiritual embodiment of everything noble, heroic, or godlike. The human forms created were, therefore, handsome and mature, with perfect proportions and no perceivable imperfections (fig. 10.3).

The Classic Age was followed by the Hellenistic Age (fourth through third centuries B.C.), so called because it tried to recapture the spirit of the Classic Age of Hellenic (Greek) culture by imitating its art, poetry, and other cultural attributes. But there was no longer the same feeling, or knowledge, that had made the earlier time so outstanding.

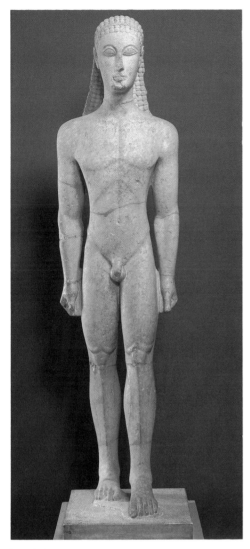

10.2
Artist unknown. Figure of a youth, or kouros. Circa 615–600 B.C. This is an example of early Greek art when the social and artistic background of the times had led to a balance between abstract symbols and realistic style.

Metropolitan Museum of Art, Fletcher Fund, 1932 (32.11.1).

Consequently, high artistic standards were gradually lost in favor of purely associational, imitative, and academic or rule-related standards for quality in art. For example, statues of the gods had to be designated by name, because so many new ones, as well as new ideas from foreign lands, were being absorbed by the new Hellenistic culture. Many more worldly ideas and events were being experienced and had to be digested. It no longer sufficed to show gods or people as reserved, heroic controllers of destiny.

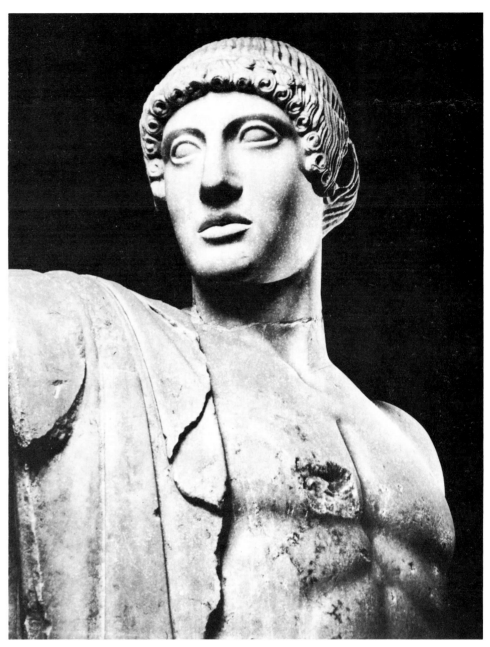

10.3
Sometimes attributed to Phidias of Athens. *Apollo* **(detail). Circa 460 B.C., from center of west pediment of the Temple of Zeus, Olympia, Greece.** In this work, Greek art had reached the style of idealized realism known as Classical. All later group styles were measured against this one and were called "classical" if their content had similar qualities of rationality, poise, and nobility.

Art Resource, New York.

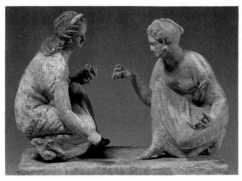

10.4

Artist unknown. Two girls playing knucklebones. Third century B.C., clay, from Capua. Greece had become so cosmopolitan by the late fourth century B.C. that its idealistic style had given way to an extremely realistic one more expressive of the average human being's emotions and daily activities.

London, British Museum, D.161. Photo: Max Hirmer.

Thus, the idealistic manner gave way to one more expressive of the average human being's emotions and daily activities in an extremely realistic manner (fig. 10.4). People, even war heroes, were no longer portrayed only as powerful, mature adults. Instead, men were shown in more youthful poses and activities, and were even softly feminized at times, while women were not always portrayed as beautiful and charming, but also as old people, or very young people, engaged in common pursuits. And when a wealthy individual wanted a statue by a famous artist of the past to decorate his estate, a good imitation could be readily made in one of the commercialized studios. Cuteness, sentimentality, and all the lesser qualities in art became the name of the game.

Individual expressiveness in handling subject, form, and content, and the resulting styles, seem more appropriate to our own time than to the group expressions of the past. This is no doubt due to present-day extollment of self-assertion and individualism. Although general categories of artistic style have been established for nineteenth- and twentieth-century art, hosts of variations within these basic trends are discernible.

The contemporary accent on individuality has resulted in a greater diversity of artistic expression since the mid-nineteenth century than was seen previously.

A summary of the movements, or styles, in the art of today and the recent past will help us realize that the traditions of the more distant past have not suffered wholesale rejection. Actually, many of those traditions have merely been reevaluated in light of modern tastes. The changing concepts of physical beauty down through the ages illustrate that each period has its own standards of taste; for example, women in paintings by Rubens look rather bulky compared to our modern concept of fashion-figure slimness. In a like manner, certain artists of the past, once rejected, are now preferred over their more popular contemporaries. Occasionally, an entire artistic tradition, originally thought to be of great significance, is relegated to a lower level of consideration. No tradition of the past, whatever its direction, should be completely rejected, because elements of beauty or quality can be found in each of them. It is essentially a matter of orienting ourselves to see those qualities as their creator(s) saw them. This imaginative manner helps explain why once-rejected traditions are now wholly acceptable and even preferred to those that were formerly considered of greater significance.

Nineteenth-century styles

Most forms of expression in nineteenth-century art contributed in some degree to the character of art in the present century. On the one hand, twentieth-century Western art can be considered a reaction to all art created since the latter half of the eighteenth century. On the other hand, it is possible to see that present-day art also developed out of past traditions.

Until the middle of the last century, artists were still directly inspired by the appearance of the world around them.

The invention of the camera, however, made possible the exact imitation of natural appearance. Also, by that time, artists had so completely solved the problem of representing reality that they were compelled to search for new directions of expression. Some turned to introspection in their search for new forms; others reevaluated concepts found in art images formed prior to the Renaissance, such as the ideals of early Greek art before the Classic Age, forms of expression used by early civilizations, and styles characteristic of the Medieval period. Also, photographs of hitherto unknown art manners (particularly African, East Asian, and Native American), provided a background for evolution in new directions.

Economic influences, many of which still affect today's art, also played a part in this search for new principles of expression. From about the time of the High Renaissance during the 1600s in Italy until the 1850s, artists came to depend more and more for their economic welfare on the patronage of wealthy clientele. Rather than asserting their own inventiveness and individuality, some artists gradually adopted the less aesthetic viewpoints of their patrons—wealthy aristocrats and burghers. Many artists were content to supply works of art designed to satisfy and flatter the vanity of their patrons. A few great artists, naturally, were not bound by such low standards of creativity and drew their inspiration from the environment and society around them, or from content that had greater universality.

Neoclassicism

The Neoclassical stylistic movement, like so many others until almost mid-twentieth century, originated in France. France had been the recognized epicenter of the arts in Europe since the seventeenth century. Beginning in the eighteenth century and lasting well into the early nineteenth, Neoclassical artists sought freedom from the economic bondage inflicted by their

wealthy, aristocratic patrons, just as society as a whole was seeking freedom from human bondage to that same class by revolutionary means. Reaction to the earlier, patronized form of art resulted in the founding of formal institutions such as the French Academy. The art of the academy was characterized by rules for achieving "correct" works that contained messages of a high moral order. The rules for achieving that kind of art were based on Europe's somewhat faulty knowledge of the ancient classical ages of Greece and Rome. What Rome was like before it became an empire set the standard for artists. Barely knowing about ancient Greece, they attributed most of the art that had been discovered since the Renaissance in Italy to Rome. They associated republican Rome with a time of great heroes and heroines. Thus, Neoclassicism preserved the outward effect of a classical style founded primarily on Roman copies of Greek art.

The artists in the Neoclassical movement did not reject patronage so much as they substituted the new class of wealthy bankers and merchants for the nobles of the old French monarchy. Such prominent artists as Jacques-Louis David and Jean A. D. Ingres largely replaced patrons from the effete French aristocracy with those from the Napoleonic state and the upper middle class (figs. 10.5 and 10.6). In the styles of ancient classical art, they found a message of heroic achievement similar to their own achievement in overcoming the French Empire to establish a republic. The new French Republic was supposedly shaped in the image of the Roman Republic, considered a much purer time than the Roman Empire. And in holding off the criticism and antagonism of the rest of Europe, the people and artists of France saw a similarity to the difficulties experienced by the Roman Republic in establishing freedom from the Etruscans.

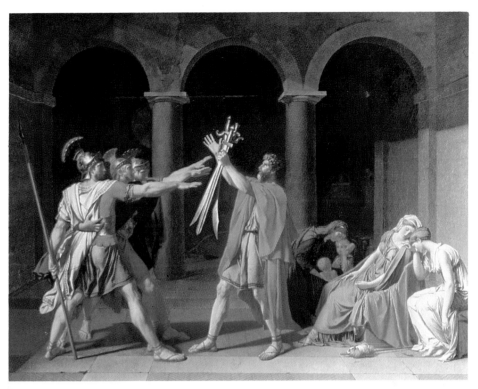

10.5
Jacques-Louis David. *The Oath of the Horatii.* **1786, oil on canvas, 51¼ × 65⅝ in.** A cold, formal ordering of shapes with emphasis on the sharpness of drawing characterized the Neoclassical form of expression. Both style and subject matter seemed to derive from ancient Greek and Roman sculpture.
The Toledo Museum of Art, Toledo, Ohio. Gift of Edward Drummond Libbey.

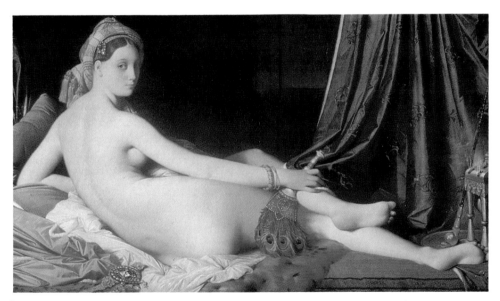

10.6
Jean Auguste Dominique Ingres. *La Grande Odalisque.* **1814, oil, 35¼ × 63¾ in.** The Neoclassicist Ingres tried to be a doctrinaire follower of classical expression, but often tended toward romantic subjects and their attendant sensual expression or content. "Odalisque" was a term meaning harem girl, or concubine, in a Turkish seraglio.
Art Resource, New York.

Romanticism

The first group of artists to reject any kind of servitude to a patron, or even to a class of patrons, were the Romantics. They can be considered the first revolutionaries of modern times because of their concern with the work of art itself rather than with its significance for a patron or even for an observer. True revolutionaries realize that they do not have to seek an audience; if they have something worthwhile to say, people will eventually be convinced of their viewpoint. This has become one of the fundamental principles underlying the creative art of our time. As a result of this revolt, artists have based their expression upon their own inspiration and their study of past traditions; they are again tuned to the world of all human experience. However, artists have found many contradictions in this world, and as a result, we find many contradictions in present-day art.

The most important artists of the Romantic group were Eugène Delacroix in France, Francisco Goya in Spain, Joseph M. W. Turner in England, and Albert Pinkham Ryder in the United States. The paintings of these men show the characteristics of the movement (figs. 10.7, 10.8, and 10.9), which often depended for subject on literature such as novels, journalism, and history.

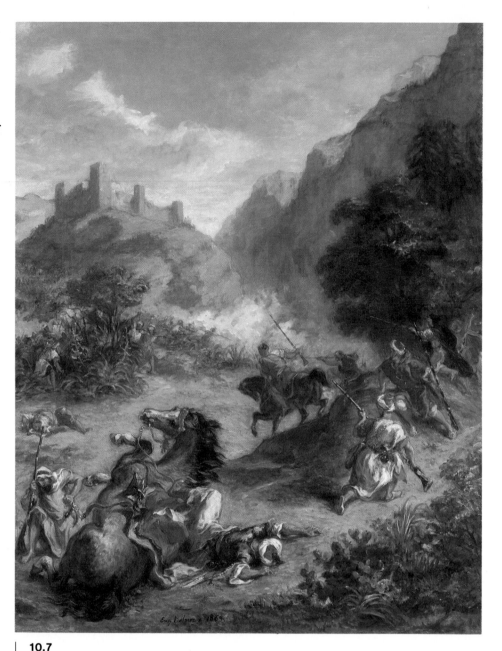

10.7

Eugène Delacroix. *Arabs Skirmishing in the Mountains.* 1863, oil on canvas, 36⅝ × 29⅝ in. Subject matter depicting violent action in exotic foreign settings was often found in paintings of the Romantic movement. Although relaxed in style, they were generally bold in technique, with an emphasis on bright colors.

National Gallery of Art, Washington, D.C. Chester Dale Fund.

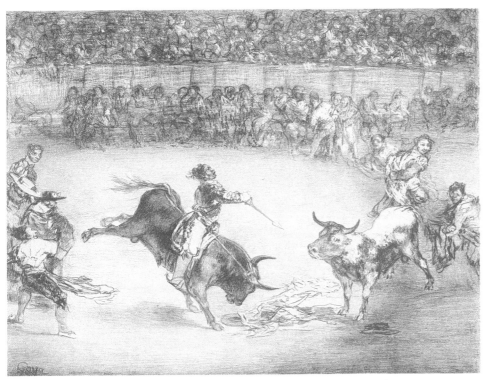

10.8
Francisco Goya. *El Famoso Americano Mariano Ceballos.* **Circa 1815, print (etching),**
12¼ × 15¾ in. The romanticism of Goya is displayed in both his choice of subject matter
and his dramatic use of light-and-dark values.

Philadelphia Museum of Art. Purchase. The McIlhenny Fund.

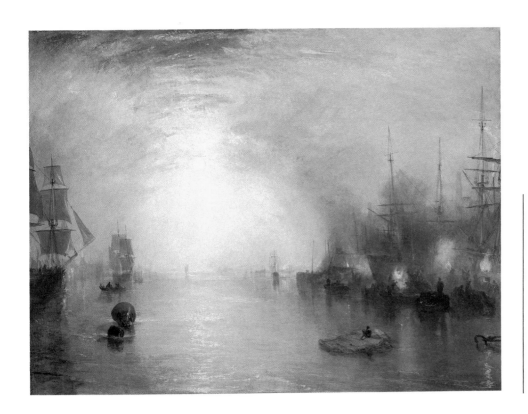

10.9
Joseph Mallord William Turner.
Keelmen Heaving in Coals by Moonlight.
Probably 1835, oil on canvas, 36¼ ×
48¼ in. A historical theme and a
seminarrative presentation of subject are
qualities found in many works of the
Romantic movement. By using color to
produce atmospheric effects, Turner
anticipated the techniques of later
Impressionists. Like them, he placed less
emphasis on formal organization.

National Gallery of Art, Washington, D.C.
Widener Collection.

Realism and Naturalism

Whereas the art of the Romantics was a reaction to the pseudoclassic, academic formulas of Neoclassicism, the Realist movement was a reaction against the exotic escapism and literary tendencies of Romanticism. Wishing to avoid the pretentious attitudes of the previous group, and stimulated by the prestige of science, the Realists wanted to show the world as they thought it appeared to the average layperson. They tried to avoid mere surface appearances and to give a sense of immediacy they found missing in the idealistic expression of Romantic and Neoclassic artists (fig. 10.10; see fig. 8.14). A related group, now known as Naturalists, wanted to go beyond the results achieved by the Realists. Their attempts to make a visual copy of nature, exact in all its minute details, were probably influenced by the results obtained with the newly invented camera (figs. 10.11 and 10.12).

Impressionism

The nineteenth-century Impressionist movement made a strong shift toward our contemporary view of art. The form of the work (materials and methods) was emphasized rather than significant subjects from nature. Where previous movements had developed the trend toward freedom of choice in subject, the Impressionists contributed a new technical approach to painting that stressed the artist's interest in achieving a certain appearance of the art object itself as well as in simulating nature. Impressionism also represented the transition between tradition and revolution. The Impressionists still wished to show nature in its most characteristic way, but they were mildly revolutionary in using technical aids to represent special conditions of light and atmosphere.

The Impressionists' interest in the illusion of light and atmosphere required intensive study of the scientific light theory of color and of the effect of light on the color of objects. The Impressionists discovered the principle of juxtaposing complementary colors in large areas for

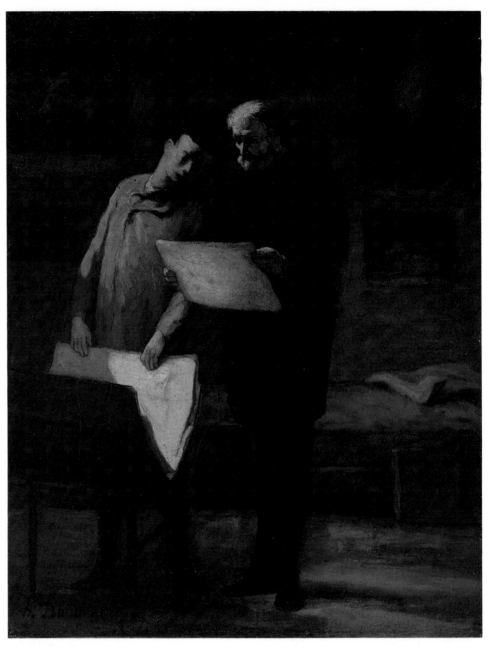

10.10
Honoré Daumier. *Advice to a Young Artist*. Probably after 1860, oil on canvas, 16⅛ × 12⅞ in. Influenced by a climate of scientific positivism, the artists of the Realist movement tried to record the world as it appeared to the eye, but interpreted it with overtones of timeless quality. This painting by Daumier suggests not so much the particular appearance of costume and setting but rather the universal quality in the subject—the idea that the working people of all ages have similar characteristics.
National Gallery of Art, Washington, D.C. Gift of Duncan Phillips.

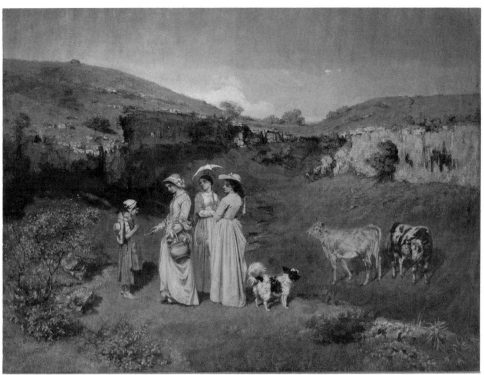

10.11

Gustave Courbet. *Young Ladies from the Village.* **1851–52, oil on canvas, 76¾ ×
102¾ in.** Courbet was the leading early exponent of Naturalist painting in Europe. Critics
harshly condemned him for painting ''ugly'' pictures of common folk at their activities, as in
this painting of his sisters walking in a valley near their home at Ornans.

Metropolitan Museum of Art. Gift of Harry Payne Bingham, 1940 (40.175).

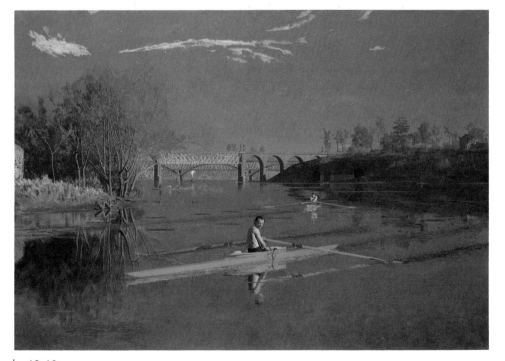

10.12

Thomas Eakins. *Max Schmitt in a Single Scull.* **1871, oil on canvas, 32½ × 46¼ in.**
The Naturalist artists were Realists who became interested in particularizing people and
events through a carefully descriptive style of expression. The oarsmen here are minutely
described by the artist as specific people performing a particular activity in a particular
setting.

Metropolitan Museum of Art, New York. Purchase, Alfred N. Punnett Fund and George D. Pratt, 1934
(34.92).

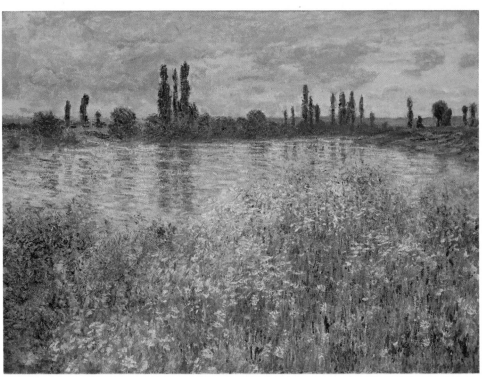

10.13

Claude Monet. *Banks of the Seine, Vetheuil.* **Circa 1880, oil on canvas, 28⅞ × 39⅝ in.** The selection of subject in this painting is typical of the Impressionist movement. The bright scene and the shimmering water offered an opportunity to express light and atmosphere through a scientific approach to the use of color.

National Gallery of Art, Washington, D.C. Chester Dale Collection.

greater brilliance; they interpreted shadows as composed of colors complementary to the hue of the object casting those shadows. To achieve the vibratory character of light, they revived the old technique of *taché* painting in which pigment is put on the canvas in thick spots that catch actual light and reflect it from the surface. The tachist method of painting seems to have been invented by the Venetians of the sixteenth century and can be seen in the work of Titian (see fig. 5.9). Later application is found in the paintings of Hals, Goya, and Constable. The Impressionists employed the style in a new way by using complementary hues in the dabs of pigment. When seen from a distance, these spots tend to form tones fused from the separate hues.

Local color was all-important to the Impressionists because their whole intent was to capture the transitory effects of

sunlight and shadow or of any kind of weather condition. Landscape became the favorite subject of the Impressionist painter due to the variability of local color under changing weather conditions.

Traditional methods of artistic interpretation underwent a second alteration when the Impressionists discovered the fascinating possibilities of unexpected angles of composition. The new photographic views of the natural scene were often different from the conventional arrangements that had been used by artists for many years. Japanese block-prints, imported into France for the first time, also encouraged new views. These prints often placed a dramatic decorative emphasis on high-angle views or on views looking down on landscape subjects and people. They were also frequently cropped down for shipment to Europe, resulting in curious truncated compositions that seemed unique to Western artists.

Artists representative of Impressionism in France about 1870 were Claude Monet, Camille Pissarro, and (in some paintings) Pierre-Auguste Renoir (figs. 10.13 and 10.14; see figs. 4.3, 7.15, 7.16, and 7.24). Sometimes Edgar Degas is included as an Impressionist of movement (i.e., ballet dancers, fig. 10.15).

Deficiencies in Impressionist theory caused some artists in the group to separate and pursue their own directions. One principal flaw was the loss of shape and design resulting from the acceptance of surface illusion alone. This was due to the way light and atmosphere seemed to make objects evaporate or become indistinct in Impressionist paintings. A second deficiency was related to the effect that outdoor lighting has on the way an artist sees color. In strong sunlight it was difficult to avoid making greens too raw, and there was a tendency to overload the canvas with yellows.

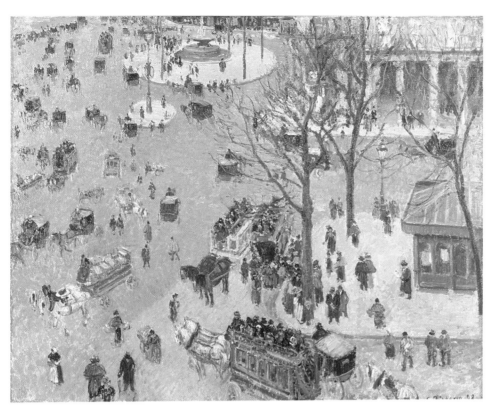

10.14

Camille Pissarro, French (b. West Indies). *La Place du Theatre Francais.* **1898, oil on canvas, height 28½ in., width 36¼ in.** In this painting the Impressionist Pissarro shows a high-angle view of the Parisian street, a technique that was influenced by Japanese prints.

The Los Angeles County Museum of Art, Mr. and Mrs. George Gard De Sylva Collection, M.46.3.2.

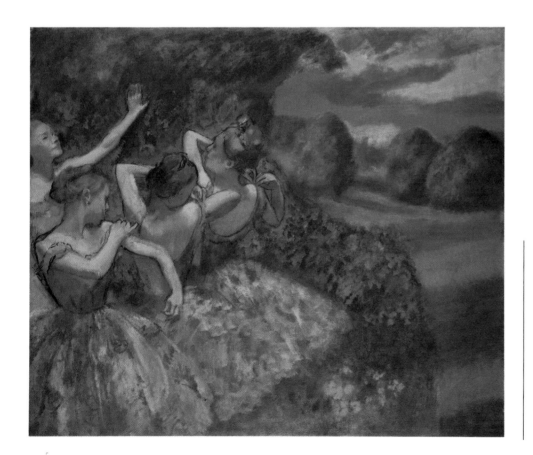

10.15

Edgar Degas. *Four Dancers.* **Circa 1899, oil on canvas, 59½ × 71 in.** Two aspects of the Impressionist artist's recording of natural form can be found in this painting. First, it demonstrates the customary interest in the effects of light. Second, the painting shows a high-angle viewpoint of composition derived either from Japanese prints or from the accidental effects characteristic of photography.

National Gallery of Art, Washington, D.C. Chester Dale Collection.

Post-Impressionism

Late in the nineteenth century, painters who had once been inspired by Impressionist theories began to abandon many of the principles of that movement. The most important artists in this reaction were Paul Cézanne, Paul Gauguin, and Vincent van Gogh. From these three pioneers stem the major expressions and directions of twentieth-century art. This group of artists was later classified under the term Post-Impressionist, an ambiguous title at best, since it does not satisfactorily indicate the far-reaching objectives of the movement. These artists sought (1) a return to the structural organization of pictorial form, (2) an emphasis on decorative organization for the sake of unity as well as for the enchanting patterns that might result, and (3) a more or less conscious exaggeration of natural appearances for emotionally suggestive effects, which is commonly called distortion (see fig. 8.46). Cézanne represents primarily the first of these aims, Gauguin, the second, and Van Gogh, the third; each, however, incorporated some aspect of the others' objectives in his form of expression. These similarities cause them to be grouped in the same stylistic movement, although, unlike the Impressionists, they worked independently toward their goals.

Cézanne was the dominant artist of the Post-Impressionist movement. In a manner contrary to the haphazard organization and ephemeral forms of the Impressionists, he saw a work of art in terms of the interrelationships of all of its parts. He retained the individual color spots of the former group, but used them as building blocks in the total physical structure of his paintings (see fig. 7.14). Although he might be called an analyst rather than a recorder of reality (like the Impressionists and Naturalists), Cézanne went beyond mere analysis. Reality for him was not the object in nature from which he drew his inspiration, but all of the artistic conclusions arrived at in the completed work. He conceived of reality as the totality of expression derived from the appearance of nature as it was transformed by the artist's mind and hand. Therefore, although Cézanne found his beginning point in nature (as was traditional), he became the first artist of modern times to consider the appearance of his pictorial form more important than the forms of nature (see fig. 2.60).

In searching for his own kind of reality, Cézanne looked beneath the surface matter of the world for universal, changeless form. He once wrote to a friend that he found all nature reducible to simple geometric shapes such as cones, spheres, and cubes. The essentialness of these forms seemed more permanent to Cézanne than the transient face of nature (fig. 10.16). Due to the intellectual processes involved in his realizations of form, he is considered a classicist in spirit. Nevertheless, he became the forerunner of modern Cubism as well as other intellectualized abstract forms of the twentieth century.

In contrast to the architectural character of Cézanne's images, the works of Paul Gauguin show the invention of a vivid, symbolic world of decorative patterns (fig. 10.17; see figs. 2.14 and 4.13). The patterns owe particular character to the type of form expression found in medieval mosaics and enamels. Although Gauguin's themes were inspired by the primitive peoples of the Pacific islands, his works always demonstrate a sophistication typical of most Western art. An underlying suavity tempers Gauguin's work and gives it a quality reminiscent of the old masters' paintings, in spite of his strong color and free patterns. The decorative style of the French Fauves in the early twentieth century stems primarily from the work of Paul Gauguin.

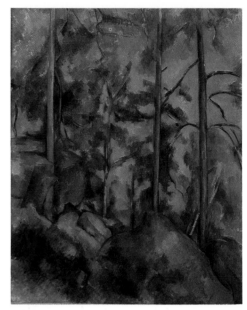

10.16
Paul Cézanne. *Pines and Rocks (Fontainebleau?).* 1896–99, oil on canvas, 32 × 25¾ in. Cézanne tried to show the essence of natural forms rather than mere surface description. In this painting he simplified the tree and rock shapes to produce a solid compositional unity.

Collection, The Museum of Modern Art, New York. Lillie P. Bliss Collection.

The work of Vincent van Gogh, the third pioneer Post-Impressionist, represents the beginning of the new, highly charged, subjective expression we find in many forms of contemporary painting. The character of twentieth-century Expressionism owes a great deal to the impetuous brush strokes and dramatic distortions of color and object forms used first by Van Gogh (fig. 10.18; see figs. 1.5, 3.1, 6.6, and 7.18).

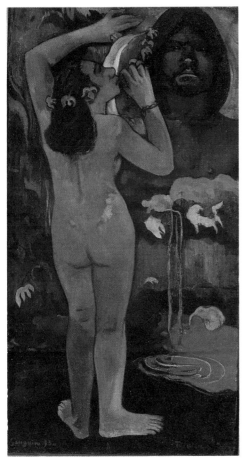

10.17
Paul Gauguin. *The Moon and the Earth.*
1893, oil on burlap, 45 × 24½ in. Color
and form are freely interpreted here to
suggest the naive qualities of an
uncivilized people. The relationships of
these elements are expressed using an
overall decorative structure that adds to
the general effect of tranquility.

Collection, The Museum of Modern Art, New
York. Lillie P. Bliss Collection.

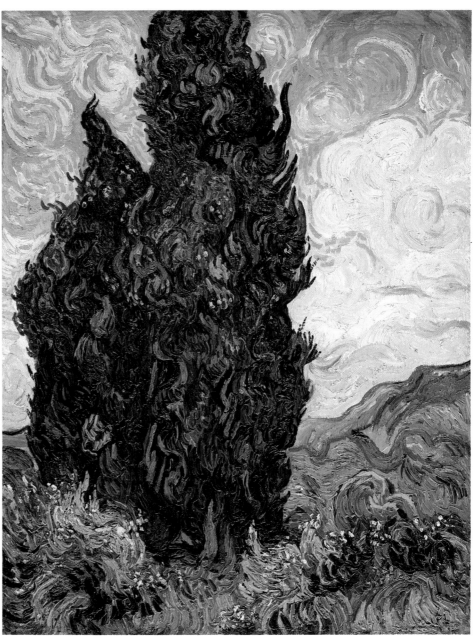

10.18
Vincent van Gogh. *Cypresses.* 1889, oils. This highly personal style exaggerates the
organic forces of nature and makes them dramatically expressive. The heavy, swirling
applications of paint enhance the movements extracted from the natural form.
The Metropolitan Museum of Art, New York, Rogers Fund, 1949.

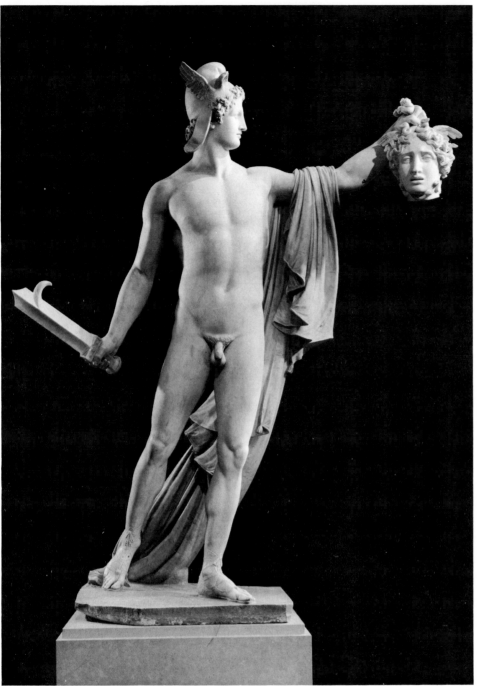

10.19

Antonio Canova. *Perseus with the Head of Medusa.* Circa 1808, marble, 86⅝ in. high.
Although he was the best of the Neoclassical sculptors, Canova's great technical facility lacked meaningful values that would have made his art truly outstanding. He repeated themes that were centuries old and hackneyed.

The Metropolitan Museum of Art, Fletcher Fund, 1967 (67.110).

Nineteenth-century sculpture

At this point we turn to nineteenth-century sculpture to trace the factors leading to the changing values of the twentieth century. But first we should point out the varying viewpoints and procedures of painters and sculptors. The major differences between painting and sculpture lie in the kinds of materials used and in their differing concepts of space.

Painters work with flexible materials in an additive manner. They invent not only their own illusion of space but also the kinds of three-dimensional shapes that occupy that space. On the other hand, sculptors work with tangible materials, creating images by manipulating actual masses and volumes in real space. Obviously, the thinking of sculptors would normally be dominated by the weight and mass of the materials they employ. Yet, paradoxically, the thinking of nineteenth-century sculptors was primarily painterly, or additive, because clay modeling, an additive, rather than a subtractive process, was dominant during that time.

Another factor leading to revolutionary changes in sculpture during the early twentieth century involved the inhibitions imposed by the vested authority of various European academies. More so than in painting, commissions to sculptors were awarded on the basis of fidelity to nature and observance of the classical principle of using the human figure to personify abstract ideals or symbolic meanings. Is it any wonder that the best sculptural talent was submerged by such strictures on originality of expression, or that sculptors, more than painters in the nineteenth century, lost sight of the older values so fundamental to their craft?

There was a void in innovative sculpture during the nineteenth century until Auguste Rodin. True, some artists could handle the tools of sculpture with virtuoso dexterity, and their handling of resistant materials like marble or malleable materials like clay or plaster was often admirable. But unfortunately, the thinking behind their work was not definably different from ideas that had

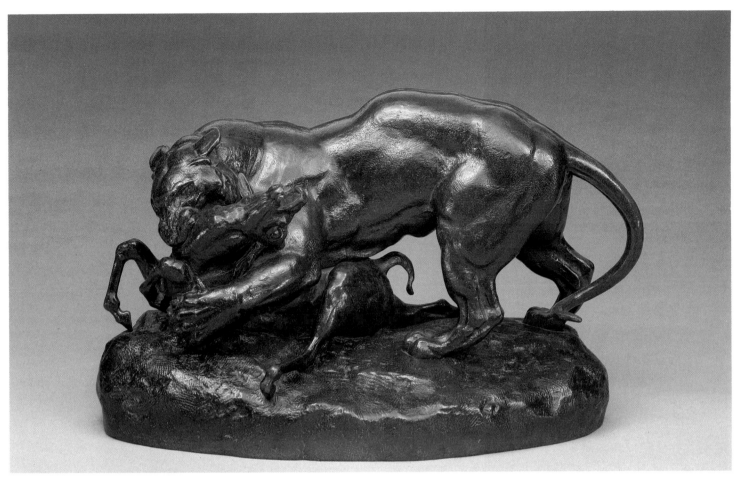

10.20
Antoine Louis Barye. *Tiger Devouring an Antelope.* **1851, bronze, 13 × 22½ × 11⅝ in.** Barye's emotionalized romantic form is similar in dynamism to the intense coloristic qualities of Romantic painters such as Delacroix and Turner.
Philadelphia Museum of Art. The W. P. Wilstach Collection.

been in existence for three hundred years (or since the early Renaissance). Antonio Canova, the outstanding early nineteenth-century classical sculptor, and Jacques-Louis David, his counterpart as a painter, reestablished the classical ideal of allegorical figure representation. However, if we compare Canova with any of the great originators of the past, such as Donatello or Michelangelo, he pales into insignificance. His figures seem artistically lifeless. Their expression depends on attention to surface detail and on mannered gestures demonstrating a somewhat borrowed attitude toward representing the human form, rather than on a new way of using sculptural materials to express human life (fig. 10.19).

The Romantic sculptor Antoine Louis Barye seems more original in his grasp of the essentially dynamic, monumental, and ferocious character of animal life, his favorite subject (fig. 10.20). But the idea behind Barye's use of animals in combat or feeding on their prey followed the essentially Romantic principle of evoking human emotional parallels—an artistic principle that had been expounded by the great Dutch philosopher Baruch Spinoza in the seventeenth century. Old values and thinking were merely being reiterated; new forms expressive of the human condition in the nineteenth century were not being invented.

Of all nineteenth-century sculptors, only Auguste Rodin was a dominant figure. Rodin looked to the future as well as to the past. He was, in the historical sense, the link between traditional forms of representation and the modern trend toward exploiting form, materials, and expression for their own inherent values.

Although he was never a direct follower of the Impressionist movement, Rodin often worked in a similar manner. But he went far beyond Impressionism. His search for new ways to express emotional states directly through form was one of the crucial directions that evolved in the early part of the twentieth century. Rodin's attitude in this respect is similar to the endeavors of expressionistic Post-Impressionist painters such as Vincent van Gogh and Toulouse-Lautrec.

Rodin's impressionistic effects derive from the way light falls upon his figures to suggest musculature and bone structure. He expanded this impression of form to express the inner condition of humanity as it was understood toward the end of the century (an often-used theme of Symbolist painters—followers of Paul Gauguin, such as Pierre Bonnard).

In his late work Rodin also tended to see sculptural form in terms of fragmentary objects, probably the result of criticism that his early work was too literal. Rodin's *Age of Bronze* (1876; fig. 10.21) was so implicitly naturalistic that salon critics insinuated he had cast it from a living model. Tremendously upset by this criticism, Rodin moved away from literal effects toward the expression of psychological or emotional states. During this change he rediscovered the principle of suspended, or fleeting movement, due partly to its exploration by some contemporary painters (Degas, Toulouse-Lautrec) and partly to his own study of the great seventeenth-century sculptor Giovanni Lorenzo Bernini. Rodin greatly admired Michelangelo also and tried to restore sculptural values that he had discovered in Michelangelo's work and felt had been lost since that time. These values included a feeling for the ponderousness and texture of stone and for the contrast between highly polished surfaces and unfinished roughness.

In his renewal of old values, Rodin became interested in the interplay between negative space and mass and between hollows and protuberances. Clay and wax remained his favorite materials for sketching or creating new forms, and he carried the great malleability of these materials into finished bronze castings so well that the observer can feel the sensations of thrust and pressure used in the forming process. Thus, Rodin no longer took the primarily modeling approach of his nineteenth-century predecessors.

Certainly, Rodin was a paradox during his lifetime since he was first denounced for being too natural, and then, in his late work, criticized for creating unnatural distortions. He ran the gamut from sweetly bland sculptures in marble and plaster to others that suggested mauled, distorted, amputated bodies—fragments of human form in plaster and bronze. From Michelangelo he learned the trick of letting a figure or head emerge from a roughly finished (or unfinished!) block of stone (fig. 10.22). These figures and parts of figures suggest human striving against fateful forces. Expressionistic sculpture was initiated by the strange psychological effect of such works, because some early twentieth-century sculptors used fragments and figural distortions mainly for emotional effect.

Like Michelangelo, Rodin enlarged limbs, or he gave them a painful twist, as had Bernini. He also gave figures unnatural torsion and dimension to emphasize potential power and inner torment. Thus, the tense, turbulent, distorted side of Rodin's work predicted the future and paved the way for the sculptors of the twentieth century to escape the academic inhibitions of the nineteenth century. Rodin's career also reconfirms the fact that an individual genius always leads the way to new ideas and forms. Most artists, substantive though they may be, profit from only one or two of the directions foreseen by the genius.

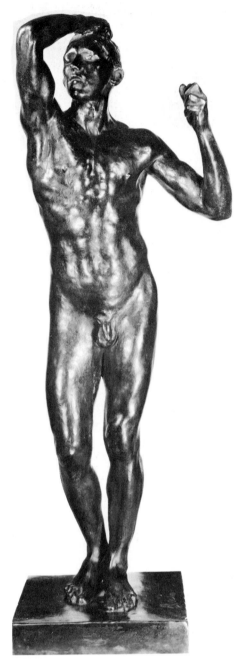

10.21

Auguste Rodin. *Age of Bronze.* 1876, bronze, 25½ × 9 ⁵⁄₁₆ × 7½ in. Rodin was excited by the possibility of expressing human psychological states. In early works such as this, he used a quasi-impressionistic effect of natural light on human anatomy to suggest the outward form of mental processes.

Detroit Institute of Arts. Life Interest Gift of Robert H. Tannahill.

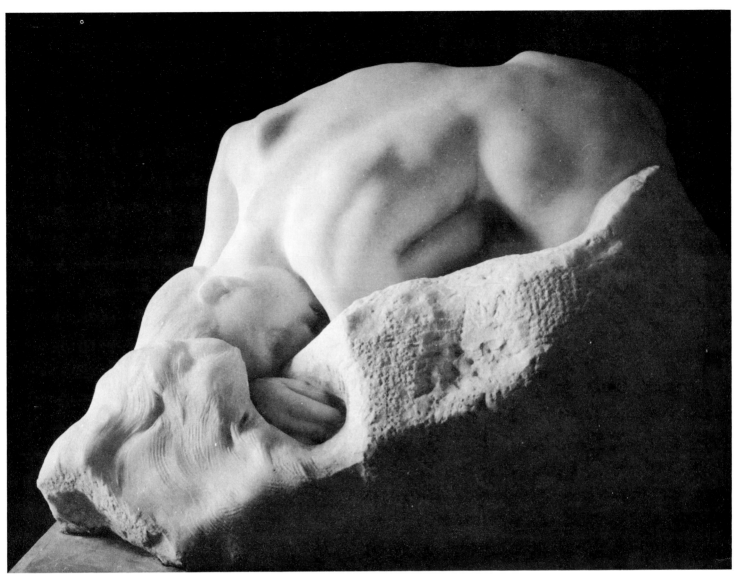

10.22
Auguste Rodin. *Danaïde.* **1885, marble.** This example of the sculptor's later work reflects
Michelangelo's influence in its partially revealed form emerging from the roughly finished
stone. The psychological effect of such a work helped bring about twentieth-century
Expressionist art.

Giraudon/Art Resource, New York.

Early twentieth-century styles

Expressionism

French and German Expressionism, perhaps the most significant phase in the evolution of newer art forms, began as the first decade of the twentieth century was almost over. The young artists of this movement were the first to declare so numerously their complete freedom to work in a manner consonant with their feelings about a subject. In a sense, these artists were merely more liberal Romantics. However, it was possible to be more liberal only after those intervening years of change had introduced new ways of seeing and feeling.

The twentieth century saw the growth of a new awareness related to the many changes taking place, or about to take place, in the whole order of existence. Cézanne, Gauguin, and Van Gogh had opened the door through which hosts of young artists were eager to move, anxious to explore a new world of artistic sensations, diversions, and mysteries. The shape of this new artistic world was signaled by an explosion of color and an exciting style of drawing that ran the gamut from the graceful curves of Matisse to the bold slashings of Kokoschka.

French Expressionism: Fauves

The members of the earliest Expressionist group were called "Le Cage aux Fauves" (the cage of wild beasts) because of the wild appearance of their paintings compared to the academic formalism that was expected by the general public of the period. Whereas the public had been only dimly aware of Cézanne and Van Gogh as revolutionaries, they could not ignore this host of new young painters who threw Paris into a turmoil with group exhibitions, pamphleteering, and other forms of personal publicity. At first the Fauves seemed to be trying to live up to their name. However, within a period of only seven years, they had lost their original vigor and were considered rather calm compared to the newer movements that were evolving. Fauvism is a form of expression that tries to arrive at the emotional essence of a subject rather than to show its external appearance. Its characteristic style is decorative, colorful, spontaneous, and intuitional. When an Expressionist artist's emotional excitement is communicated to the spectator, the work of art can be called successful.

The color, brilliance, and persuading sophistication found in the work of Henri Matisse, nominal leader of the Fauvist group, were largely influenced by Persian and Middle Eastern art (fig. 10.23; see figs. 2.66, 4.7, 5.17, and 8.2). The group as a whole felt similar influences, often searching for patterns in the museums dedicated to older and more remote group expressions. The Fauves were inspired by the work of the Byzantines, the Coptic Christians, and the Greek artists of the archaic age, as well as by the primitive tribal arts of Africa, Oceania, and Native America. The influence of African masks and sculpture can be detected in the masklike, impersonal human faces found in Matisse's paintings. Behind this impersonal effect lies a sense of mystery or threat engendered by the enigmatic quality of an alien style of expression.

Despite the strong, vibrant color generally preferred by the Expressionists, Matisse, Utrillo, Vlaminck, and Modigliani often built charming, decorative structures that continued the long tradition of classical restraint found in French and Italian art (fig. 10.24; see figs. 7.23 and 8.8). Georges Rouault, on the other hand, is an exception in French Expressionism, his work being more dramatic like that of the German artists. His paintings express a violent reaction to the hypocrisy and materialism of his time through a favorite use of thick, crumbling reds and blacks. His images of Christ are symbols of man's inhumanity to man. His portrayal of judges reveals the crime and corruption that can reach even into areas where justice should prevail (fig. 10.25; see fig. 7.28). Rouault's artistic comments on the French leaders of the day were anything but complimentary.

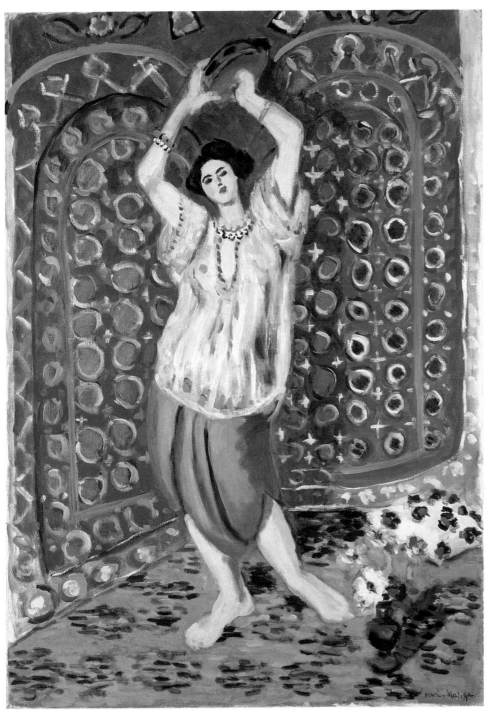

10.23
Henri Matisse. *Odalisque with Tambourine: Harmony in Blue.* 1926, oil on canvas, 36 × 25½ in. The Fauve Expressionists, led by Matisse, tried to show the emotional essence of a subject rather than its external appearance. Matisse also exhibits the characteristic decorative, colorful, spontaneous, and intuitional qualities of this French Expressionist style.
Courtesy of the Norton Simon Art Foundation.

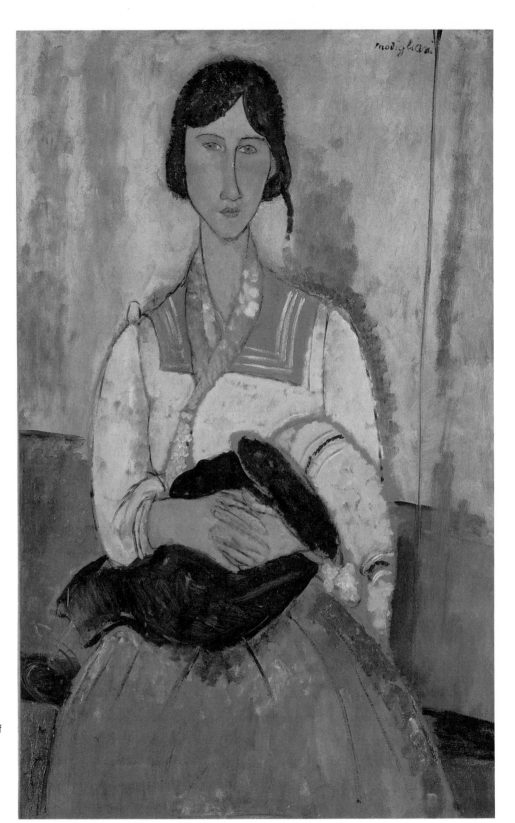

10.24

Amedeo Modigliani. *Gypsy Woman with Baby.* **1919, oil on canvas, 45⅝ × 28¾ in.** The artist's painting stresses sensitive shape arrangement and subtle modeling of form within a shallow space concept. His interpretation of the figure is a personal mannerism suggesting the influence of Gothic and black African sculpture.

National Gallery of Art, Washington, D.C. Chester Dale Collection.

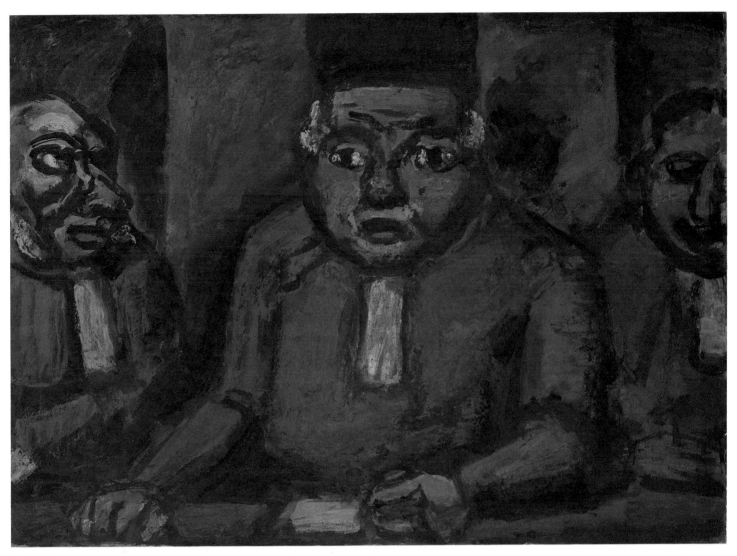

10.25
Georges Rouault. *The Three Judges.* 1913, gouache and oil on cardboard, 29⅞ ×
41⅝ in. Rouault's intensity of feeling is expressed by the use of somber reds framed in
black and nocturnal blue. Rouault's work lacks the ingratiating character found in the other
French artists of the movement.

Collection, The Museum of Modern Art, New York. Sam A. Lewisohn Bequest.

German Expressionism: Die Brucke, Die Blaue Reiter, and Die Neu Sachlichkeit

The artists of Germany felt that they, as prophets of new, unknown artistic values, must destroy the conventions that bound the art of their time. The foundation of painting in Europe for the next fifty years was provided by three groups of German artists: Die Brucke (The Bridge), Die Blaue Reiter (The Blue Knights), and Die Neu Sachlichkeit (The New Objectivity). The Expressionism of these artists, drawn from an environment that seemed complacent toward social and political injustices, was ultimately an art of protest, but it was also an attempt by German Expressionists to assert their basic urge for expression as directly as possible. The combination of their driving, creative urge and their desire to protest became the foundation for a number of movements in German art. The resulting art forms had a vehemence, drama, gruesomeness, and fanaticism never completely achieved by the *raison* (reason) of French art.

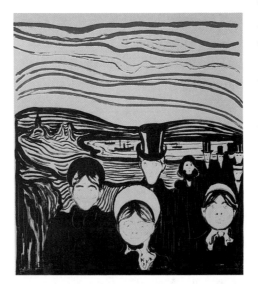

10.26
Edvard Munch. *Anxiety* from *L'Album des Peintres-Graveurs*. Paris, Ambroise Vollard, 1896. Lithograph, printed in color, 16⅜ × 15⅝ in. Some of the unhappy experiences in the life of this artist are presented with characteristic emotional exaggeration. Childish terrors and medieval superstitions are interwoven in a form expressive of frightful conditions.
Collection, The Museum of Modern Art, New York. Abby Aldrich Rockefeller Fund.

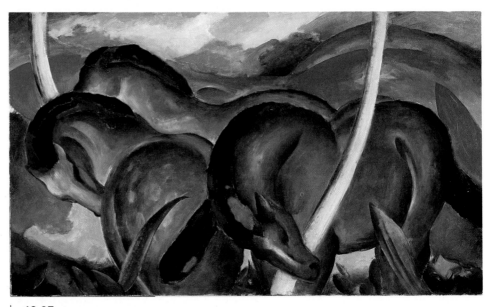

10.27
Franz Marc. *Die grossen blauen Pferde (The Large Blue Horses)*. 1911, oil on canvas, 40¾ × 70⅞ in. Marc was the closest Expressionist painter to lyric, nineteenth-century Romanticism. Tormented by self-doubts, he used his love of animals to symbolize his terrible uncertainties and find peace. Marc's death in the Battle of Verdun during World War I, before his art had fully matured, was tragically ironic.
Collection Walker Art Center, Minneapolis. Gift of the T. B. Walker Foundation, Gilbert M. Walker Fund, 1942.

The young German Expressionists identified with the religious mysticism of the Middle Ages as well as with the tribal arts of primitive peoples. Many followed the manner of children, with a naive but direct emotional identification with environment. For example, the art of Emil Nolde is similar in feeling to the mystic art of the Middle Ages, while Edvard Munch based many of his creations on medieval and primitive folk art traditions. Franz Marc used his love of animals, painted in mood-provoking colors, as symbols of peace and spirituality. Protests against Prussian jingoism became the subject matter of the paintings of George Grosz and Otto Dix (figs. 10.26, 10.27, and 10.28; see fig. 7.20).

Max Beckmann, although not part of any organized Expressionist group, was somewhat kindred in spirit to Otto Dix. Following World War I, Dix worked in a style that satirized the swampy, degraded underworld of political society. Beckmann cultivated a similar style of frank, satirical veracity but modified its emotional intensity with the calm, geometric arrangement he had learned from Cubism. This latter quality gives a certainty of execution to his manner of painting that is quite reminiscent of the work of the old masters (fig. 10.29).

10.28

George Grosz. *Fit for Active Service.* 1916–17, pen, brush, and india ink, 20 × 14⅜ in. In this work, characteristic German emotionalism is forced to new limits of satire as a result of the artist's personal experiences during World War I. Expressionism, which shows moral indignation at its peak, now becomes an instrument of social protest. Niceties of color are ignored in favor of harsh, biting black lines.

Collection, The Museum of Modern Art, New York. A. Conger Goodyear Fund.

10.29

Max Beckmann. *Departure.* 1932–33, oil on canvas, triptych: center panel 7 ft. ¾ in. × 45⅜ in.; both side panels 7 ft. ¾ in. × 39¼ in. Here, style is emotionally intensified through strong contrasts of value and the impasto with which the artist has applied his pigment. However, this intensity of expression is partially modified by the cool, orderly arrangement derived from Cubism.

Collection, The Museum of Modern Art, New York. Given anonymously (by exchange).

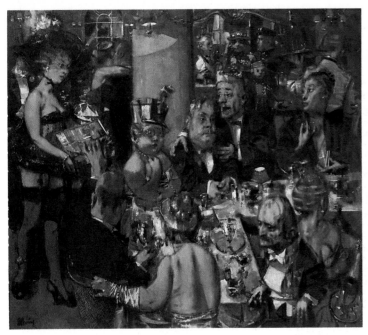

10.30
Jack Levine. *Election Night.* **1954, oil on canvas, 63⅛ × 72½ in.** Influenced by the social and political problems of the post-World War II period, the artist arrived at a distinctive manner that combines a complicated and glowing technique with an expressionistic pungency of feeling.

Collection, The Museum of Modern Art, New York. Gift of Joseph H. Hirshhorn.

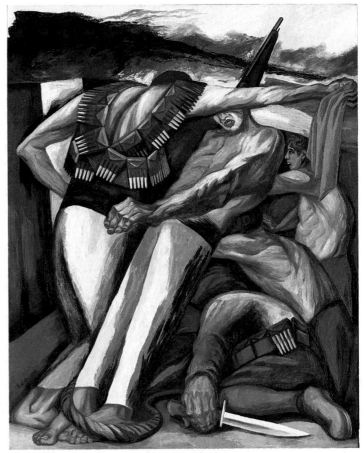

10.31
José Clemente Orozco. *Barricade.* **1931, oil on canvas, 55 × 45 in.** Slashing diagonal lines combine with agitated hues and values to express this artist's feelings about the furor of the Mexican revolution in the early twentieth century.

Collection, The Museum of Modern Art, New York. Given anonymously.

Expressionism in the United States and Mexico

The expressionistic style had adherents in the Americas as well as in Europe. The Great Depression of the 1930s influenced such artists as Max Weber and Ben Shahn to make mournful and satiric comments on American society (see fig. 2.34). Philip Evergood and Jack Levine, expressionistic artists in the late forties and early fifties, made similar commentary on the world situation during the social and political confusion of the Cold War years (fig. 10.30).

Mexico during the 1920s and 1930s underwent an artistic renaissance that many artists found fruitful ground for an expressionistic style which identified with the problems inherent in increased freedom for the Indian and mestizo classes. José Orozco, whose art evolved during this period, became the greatest exponent of Expressionism in the Western Hemisphere. Inspired by the rapidly changing social order in Mexico, he produced work whose quality of expression was similar to that of Rouault in Europe. Something of the same black tragedy can be seen in the work of both artists, although at the same time their styles differ in form and meaning (fig. 10.31; see fig. 2.26).

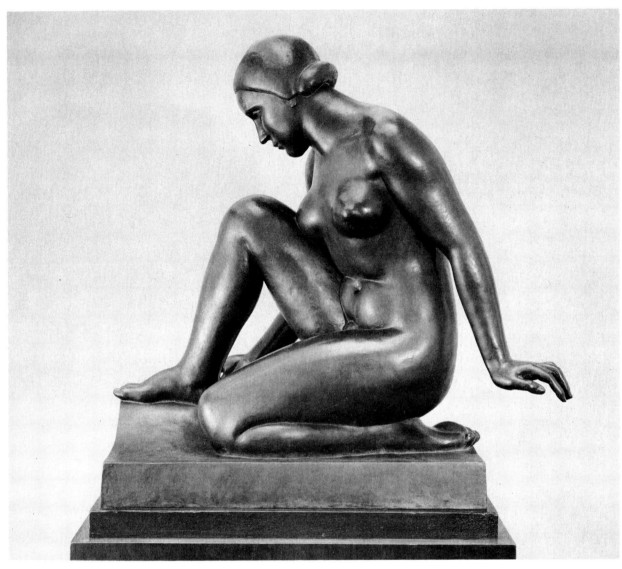

10.32
Aristide Maillol. *Monument to Debussy.* 1931, bronze base, 15⅜ × 29½ × 35 in.
Maillol combined classical concepts with a sense of contemporary monumental form.
The Toledo Museum of Art, Toledo, Ohio. Gift of Edward Drummond Libbey.

Post-Impressionist and Expressionist sculpture

New concepts in painting remained ahead of those in sculpture until about the 1950s, but a continuous interchange of ideas guaranteed that similar lines of development were parallel in the two groups.

By 1900, revolutionary changes were discernible as sculptors began to react to contemporary thought and experience rather than to ancient myth and legend. Sculpture then took three general directions: (1) The human figure was retained but simplified to express only the essential structure and material used; (2) forms were abstracted from nature, or new forms of a highly formal or structured character were invented; and (3) experimentation with new materials produced new shapes and techniques.

No Post-Impressionist movement took place in sculpture, but the works of artists such as Aristide Maillol, Gaston Lachaise, and Wilhelm Lehmbruck suggest a new interest in the totality of form and an accent on the intrinsic beauty of materials—trends that are similar to the new synthesis of form from nature in Post-Impressionist painting.

Maillol pioneered simplification of figural form to recover a sense of sculptural monumentality that would reassert the essential blockiness of stone and the agelessness suggested by bronze and lead. He began the trend away from academic representation of the human figure by using slightly exaggerated proportions, and he also achieved a classical sense of serenity suggestive of the works of Cézanne and Seurat (fig. 10.32).

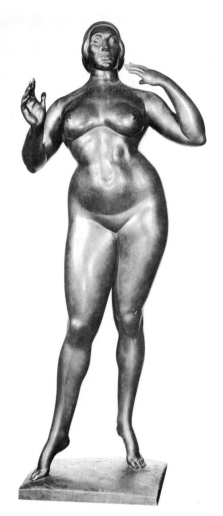

10.33
Gaston Lachaise. *Standing Woman.*
1927, bronze, 185.4 × 71.1 cm.; base
43.8 × 53.3 cm. This ponderous figure
was given a feeling of lightly balanced
poise.

Gaston Lachaise, a Franco-American
sculptor, created weighty, voluminous
female figures that evoke the sensuous
through exaggerated, but rhythmically
balanced, proportions. At times his sense
of poise gave figures a feeling of aerial
suspension seemingly at odds with the
amplitude of his forms but reconciled by
his exquisite sense of balance and the
finish he gave to metal (fig. 10.33).

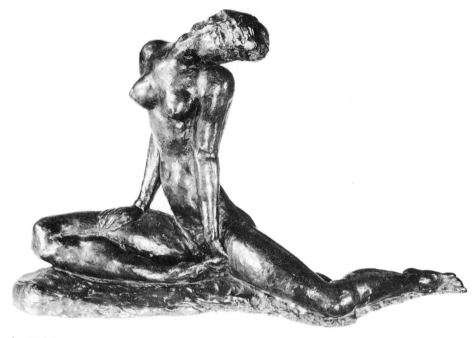

10.34
Wilhelm Lehmbruck. *Seated Bather.* **1913–14, metal, bronze, cast patina, 11 × 17⅝**
× 5½ in. This work exemplifies the mildly expressionistic style that dominated the early
twentieth-century pioneering phase of contemporary sculpture.
Detroit Institute of Arts. Bequest of Robert H. Tannahill.

Lachaise and Lehmbruck both worked
in a manner similar to the more emotional
aspects of Post-Impressionism,
comparable in some ways to the painters
Gauguin or Van Gogh. Lehmbruck
evolved a style of elongated figures that
were suavely charming or nostalgic and
melancholy. Like Lachaise, he distributed
the masses of his figural forms
rhythmically, but he used a strong vertical
axis, unlike Lachaise's variable axis.
Where Lachaise used rounded masses,
Lehmbruck created relatively sparse
forms that were almost stripped of fleshy
connotation (fig. 10.34).

Just as there was no clearly defined
Post-Impressionist movement in sculpture,
neither was there a perceivable
Expressionist school. Several sculptors
worked in a manner expressed by the
Blaue-Reiters in Germany as "stripping
away surface reality to arrive at
underlying truths." Generally speaking,
however, Expressionist sculptors were less

disposed than painters toward violent
distortion of form to reveal the psyche.
Lachaise and Lehmbruck are sometimes
called Expressionists because of their
moderate distortion of human form.

Jacob Epstein, an Anglo-American
sculptor, developed an expressionistic, as
well as an abstract, manner during his
lifetime. His Expressionist works, usually
cast in bronze, were based on an
exaggerated clay-pellet technique. These
works seem distantly related in emotional
impact and technique to the style of
Rodin. But when Epstein carved in stone,
his approach was more often formal and
semiabstract, rather than emotional (fig.
10.35).

A more recent sculptor whose work is
reminiscent of this mildly expressionistic
idiom of early twentieth-century sculpture
is the American graphic artist and
sculptor Leonard Baskin. Baskin is
concerned with the tragic tension between
humans and their environment, which he

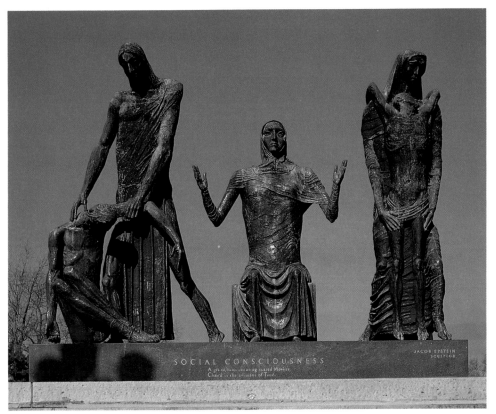

10.35
Jacob Epstein. *Social Consciousness.* **Circa 1954–55, bronze.** Multiple figures can be used to express human, as well as formal, relationships.
Philadelphia Museum of Art. Fairmount Park Association.

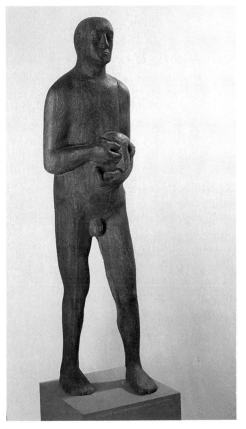

10.36
Leonard Baskin. *Man with a Dead Bird.* **1951–56, walnut, 64 × 18½ in.** Probably better known for his dramatic prints and drawings, Baskin in some early sculptures seems to have been making a statement about humankind's baneful effect on the environment.
Collection, The Museum of Modern Art, New York. A. Conger Goodyear Fund.

expresses through figures of people, birds, and other animals. He also portrays cultural heroes and heroines from myth and legend through studies of whole or partial figures, giving them a very modern expressionist content (fig. 10.36).

The Italian artist Marino Marini also worked in a manner of slight distortion in his best-known works—equestrian figures produced in the late 1940s and early 1950s. The slightly abstract shapes of horse and rider may be related to Wassily Kandinsky's rider series of 1909–10 and seem to imply Marini's concern with the impersonality of modern life (fig. 10.37). Marini's sculpture became increasingly abstract in later years.

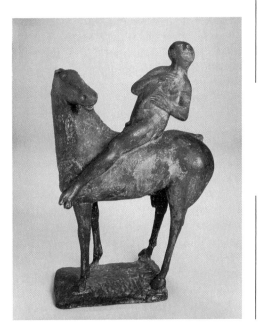

10.37
Marino Marini. *Horse and Rider.* **Circa 1947, bronze, 99 × 68.6 cm.** The tradition of equestrian sculpture is joined to twentieth-century abstraction and formal tension.
Gift of Mrs. Wolfgang Schoenborn, 1971.881. © 1988 The Art Institute of Chicago. All Rights Reserved.

Abstract Art

Cubism

Around 1906 in Paris, a new attitude toward nature was observed in the work of certain artists. Before Cézanne, European artists had tended to see nature in terms of material surfaces. Cézanne began to search for reality (the universal unvariables) beneath these material surfaces. He observed and emphasized the basic structure of nature. This new way of seeing developed gradually over a period of about twenty-five years, paralleling the changing concepts of reality in science. Cézanne had stated, for instance, that the artist should seek the universal forms of nature in the cube, the cone, and the sphere. Artistic exploration founded directly on this concept evolved in the styles of certain Fauve Expressionists and finally resulted in a new style labeled Cubism.

Among the most active of the young artists in the Fauve movement from 1903 to 1906 was the Spaniard Pablo Picasso (see fig. 2.49). Due to his admiration for the work of Paul Cézanne or to his desire to challenge Henri Matisse's leadership of the Fauves, Picasso began looking for new possibilities of form expression. He based his explorations on volumetric illusions and the analysis of spatial structure. Like Cézanne, Picasso had become dissatisfied with the contemporary emphasis on external characteristics of objects and sought a method whereby he could express their internal structure. He eventually developed a painting technique that showed the structure of an object in space by portraying many facets of the same object at the same time on the same canvas. Many of his ideas for this type of pictorial expression are traceable not only to the influence of Cézanne, but to the style characteristics of primitive art, such as Archaic Greek sculpture or traditional African tribal sculpture (fig. 10.38; see figs. 2.67, 3.14, and 6.11 for Picasso's art after Cubism).

The most noticeable aspect of Cubist form as evolved by Picasso, his colleagues like Georges Braque, and their followers was the geometric faceting or crystallization of objective shapes. By this means, artists tried to arrive at a more permanent type of order than that found in the realistic representation of natural forms. At the same time, the traditional illusionistic rendering of space was reordered into what the artists felt was a more stable form of spatial relationships, independent of the vagaries of light and the distorted effects caused by geometric or linear perspective.

In his concern for arriving at a new aesthetic view of the structure of matter, Picasso often stripped away many aids to expression—for example, richness of color. However, in this process of reduction, he formulated a new artistic language that put an end to the adherence to surface appearance observable in almost all art since the time of the Renaissance. Paintings began to emphasize image-making devices for their own sake rather than to merely adapt these devices for the imitation of nature. Traditional renderings of natural appearances gave way to pure, or maximum, artistic form. This new emphasis on line, shape, value, texture, and color gave rise to a new set of terms to explain what the artist was trying to do—especially for those who were not prepared to accept complete purity of form. The terms Abstract art, or Nonobjective art, were applied to these new forms. Cubism, a semiabstract art form, was the forerunner of all the later forms of abstraction. In semiabstract art we can generally still recognize certain objects from nature; the transformation of such forms in the process of abstraction is meant to convey the artist's convictions about life and the material universe. Transformation of natural forms in art became a matter of degree that varied from the semiabstract styles of Cubism and Futurism to the pure abstraction of Wassily Kandinsky and Piet Mondrian.

Cubism, as the beginning of Abstract art, was of major importance. It was introduced to the world not only in the works of Picasso, but also in those of Georges Braque, a French artist who shared the same studio with Picasso between 1910 and 1912. Braque added a uniquely expressive quality to the Cubist approach of Picasso by attaching nonpainted, textured materials to the surface of his canvases—a technique called papier collé, or more popularly, collage (fig. 10.39; see chapter 6 and fig. 6.7). On the whole, Braque remained true to the typical French tradition of quietness and charm in content despite his use of the new Cubist forms. This contrasted with the more forceful, even explosive, quality found in some of Picasso's work. Braque's sense of relaxed beauty in the works executed during the peak of Cubist expression (1911–18) were engendered by his restrained manipulation of tasteful color and value patterns. The patterns were developed in terms of the finite volume of space, one of the chief Cubist idioms. (See figs. 4.10 and 7.19 for Braque's painting after Cubism.)

Two other Cubists of note were Fernand Léger, another French artist, and Juan Gris, a countryman of Picasso. These two preferred the rather austere expression of Picasso to the more violent side of his personality. Léger and Gris developed individual form qualities within the Cubist pattern that set them apart as important creators in their own right. Because of the impact of industry on society, Léger accepted the machine as a styling motif for Cubist form (fig. 10.40; see figs. 4.36 and 7.22). Gris, on the other hand, stayed close to nature, treating object volumes as decorative or two-dimensional shape patterns suggestive of recognizable objects. He developed these patterns in the direction of object recognition without resorting to direct imitation of surface appearances (see figs. 4.8, 5.16, and 8.49).

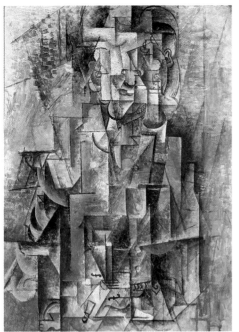

10.38

Pablo Picasso. *Man with Violin.* 1911, oil on canvas, 39¼ × 28⅞ in. The shapes in Picasso's facet-Cubist style are component planes coaxed forth from subject forms and freely rearranged to suit the artist's design concept. Some facets are retained in their original position, and certain elements of the figure are fleetingly recognizable.

Philadelphia Museum of Art. The Louise and Walter Arensberg Collection.

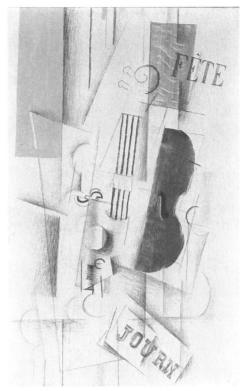

10.39

Georges Braque. *Musical Forms.* 1913, mixed media (paper, oil paint), 36¼ × 23½ in. Braque varies the usual Cubist handling of form with the inventive inclusion of textured foreign materials. Such textures added a new beauty of surface manipulation to the repertoire of contemporary art.

Philadelphia Museum of Art. The Louise and Walter Arensberg Collection.

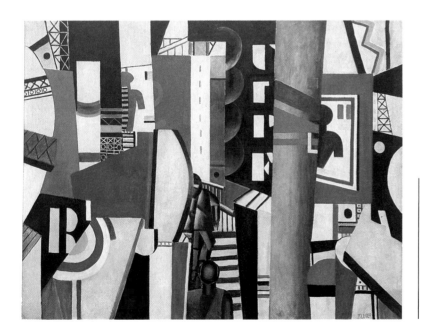

10.40

Fernand Léger. *The City.* 1919, oil on canvas, 90¾ × 117¼ in. The rigidity and simple geometric character of industrial structures were ideally suited to the Cubist style. Léger's paintings follow this principle and become true products of a machine-age aesthetic.

Philadelphia Museum of Art. The A. E. Gallatin Collection.

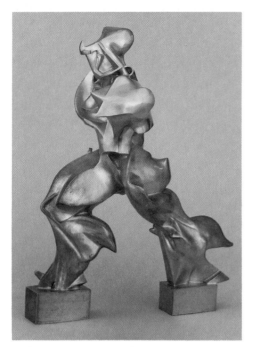

10.41

Umberto Boccioni. *Unique Forms of Continuity in Space.* **1913, bronze (cast 1931), 43⅞ × 34⅞ × 15¾ in.** Boccioni was a leading founder and member of the Futurist group. An accomplished painter and sculptor, he was constantly concerned with the dynamics of movement.

Collection, The Museum of Modern Art, New York. Acquired through the Lillie P. Bliss Bequest.

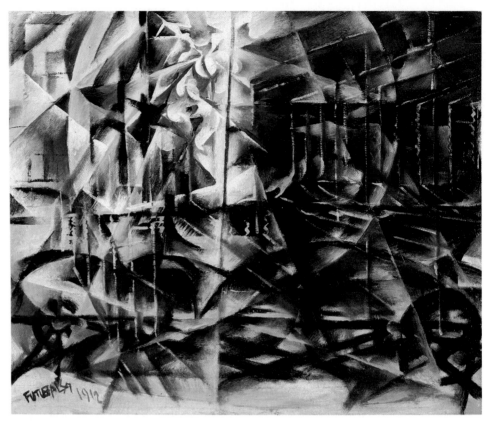

10.42

Giacomo Balla. *Speeding Automobile.* **1912, oil on wood, 21⅞ × 27⅛ in.** This artist's handling of the image of a speeding machine is characteristic of the Futurist idiom. Incorporated into the dynamic form is a sense of the hysterical approach to violence and the psychological impact of tensions in modern times.

Collection, The Museum of Modern Art, New York. Purchase.

Futurism

Futurism, like Cubism, remained a submovement within the overall Abstract category. Futurism was actually a form of Cubism remodeled by certain Italian artists who had been to Paris during the excitement caused by Picasso and Braque. Among the more important artists in this movement were Umberto Boccioni, Giacomo Balla, and Gino Severini (figs. 10.41 and 10.42; see figs. 8.54 and 8.55).These artists studied in France, and on their return to Italy, were much intrigued by the rapid advances that had been made in domestic industry. Together with the poet Marino Marinetti, they formed a union of ideas. Their expression was formulated on the basis of the modern machine, the speed and violence of contemporary life, and the psychological effects of this ferment on human mentality and activity. Boccioni,

Severini, and their followers attempted to show the beauty and activity of modern machinery at work by using sheaves of lines and planes that created an effect of dynamic movement and tension within the canvas. The translation of rapid motion into artistic terms was their constant preoccupation. The Futurists also attempted to interpret contemporary violence, such as riots, strikes, and war, that would presumably affect future events.

The fervor of the Futurists was not matched by their artistic contributions. The artists merely energized the somewhat static geometry of Cubism and brought back richer coloring. Perhaps the group's attention to the machine was its most important contribution, for other artists and the public became more aware of the nature of their time. Following the traditional mission of art, the art of the Futurists expressed the age in which it was created.

Pure Abstraction

During the period from 1910 to 1918, the chief goal of artists throughout Europe was to completely eliminate nature from art. Inspired primarily by the experiments of Picasso, artists explored Pure Abstraction in two main directions. Some, like the Russian Wassily Kandinsky, preferred an emotional, sensuous Expressionism, which later influenced American abstract painting. Others, such as Mondrian, were more interested in the cold precision of geometric arrangement. Kandinsky's best-known work featured powerful rhythms and loose biomorphic shapes that had a feeling of great spontaneity (fig. 10.43; see fig. 8.31). Although it was rarely evident, Kandinsky's paintings usually originated from specific conditions or circumstances. The artist always attempted to interpret his response in terms of pure visual language without reference to outward

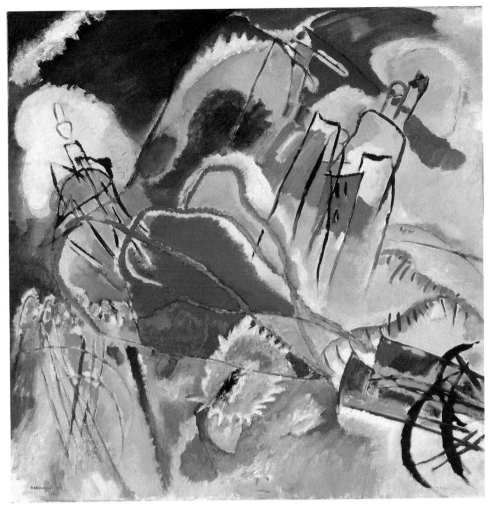

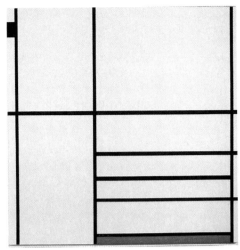

appearance. Kandinsky's loose, direct
manner is essentially that of a romantic;
his appeal is directed at pure emotion. To
assess his works the observer must have
had similar experiences to those
motivating the artist. Later, while
working at the German Bauhaus (an
architectural school that stressed the
unity of all art in terms of design),
Kandinsky's work was influenced by the
Geometric Abstraction practiced by some
of the artists there.

The most representative exponent of
Geometric Abstraction was Piet Mondrian
of Holland. Like Kandinsky, Mondrian
dealt with the pure elements of form, but
unlike Kandinsky, he purged them of the
emotional extremes of Romanticism.
Mondrian's art is the unemotional
rationalization of line, shape, value, and
color pushed to maximum optical purity
(fig. 10.44). In such work, meaning or
content is inherent in the precise
relationships established. This direction
seemed sterile and shallow to artists and
critics alike when it first appeared. That it
was, instead, momentous and rich in
possibilities is proven by its tremendous
impact on thousands of artists. The
dissidents taking verbal slaps at
Geometric Abstraction were soon in the
minority.

Nonobjective art

The abstract art discussed so far in this chapter originated from nature; the next development was so-called Nonobjective painting, which presumed to divorce itself from nature altogether and to originate entirely (insofar as this can be determined) within the mind of the artist. The differences between Pure Abstraction and Nonobjective works of art are not readily apparent; perhaps an attempt to differentiate is of theoretical interest only. Both concepts opened up a new realm of aesthetic endeavor, and exploration in this area continues to the present time. The term nonobjective does not mean that the artist has no objective. The artist definitely communicates, but without resorting to objective reporting. Ideas about the use of the elements of form, unencumbered by literal objects, became subjects for nonobjective artists. Obviously, these artists were inspired by qualities attainable through manipulation of pure form. A certain amount of pure abstract and nonobjective work is more imitative than original. It is easy to produce synthetic abstract art that is an end in itself. However, abstraction is more properly employed as a creative process, and this calls for the maximum power of the artist (fig. 10.44).

A great part of what we see in our world today derived its personality from the continuing influence of the abstract concept. Modern designers have readily assimilated abstract theories of form in buildings, furniture, textiles, advertising, machines, and costuming, to name only a few areas. Stylistically, the gap between fine art and art of a commercial or industrial nature has constantly narrowed. This may be due in part to abstract art developing out of an environment in which the practical function of the machine had become an unconscious, as well as a conscious, part of life. In a sense, the abstract artist created a machine-age aesthetic.

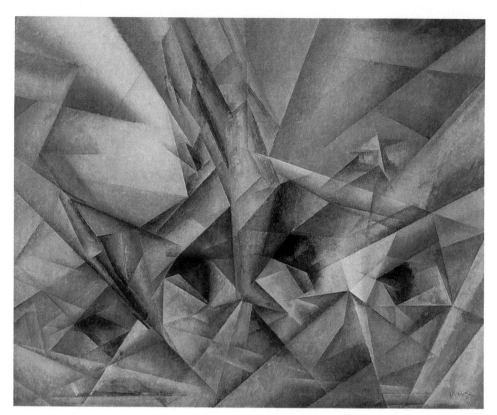

10.45

Lyonel Feininger. *Bridge V.* 1919, oil on canvas, 31½ × 39¾ in. American artists, inheriting a tradition of native romantic realism, seemed reluctant to accept pure Abstract Expression. Inspired by the dramatic shapes found in human structures, but informed by the careful designs of Cubism, Feininger eventually merged these two forms of expression in a semiabstract style.

Philadelphia Museum of Art. Purchased. The Bloomfield Moore Fund.

Abstract art in the United States

Abstract art was slow in coming to America, but shortly after World War II, the movement gathered momentum. The influence of European expatriate artists was an important factor. Actually, during the period between the two world wars many American artists were affected by the structural order of Cubism. Arthur Dove (who actually began pure abstraction in 1912), John Marin, Lyonel Feininger, Georgia O'Keeffe, Stuart Davis, and Marsden Hartley were among the early pioneers of Abstraction in the United States (fig. 10.45; see figs. 2.35, 4.18, and 4.28). In a peculiarly American way, however, they refrained from surrendering completely to pure abstraction and retained a strongly personalized vision.

After World War II a new generation of younger American artists renounced the last ties with nature. Some of the leaders in this movement of the mid-1940s were Irene Rice Pereira, Loren MacIver, Bradley Walker Tomlin, and Mark Rothko (figs. 10.46 and 10.47). Toward the end of the forties, a new impulse, stemming from a mixture of Abstraction, Surrealism, and Expressionism, became apparent. Pure Geometric Abstraction slipped almost indistinguishably into this new movement called Abstract Expressionism. We must now go back in time to see how this came about.

10.46

I. Rice Pereira. *Daybreak.* **No date, oil on canvas, 40 × 60 in.** This painter developed a style of abstraction that investigated space, light, and dimensions—all of which are inherent in the structure of the painting itself. Her work is one of the unique variations that the general concept of abstraction has followed in the United States.

Metropolitan Museum of Art, New York. The Edward Joseph Gallagher III Memorial Collection, 1955 (55.13.3).

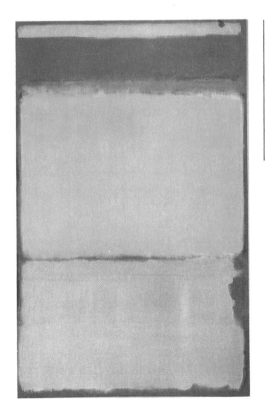

10.47

Mark Rothko. *No. 10.* **1950, oil on canvas, 7 ft. 6⅜ in. × 57⅛ in.** Using apparently simple masses of color on a large scale, the artist is able to evoke emotional sensations in the observer. Rothko was one of the American artists who worked in the Pure-Abstract idiom.

Collection, The Museum of Modern Art, New York. Gift of Philip Johnson.

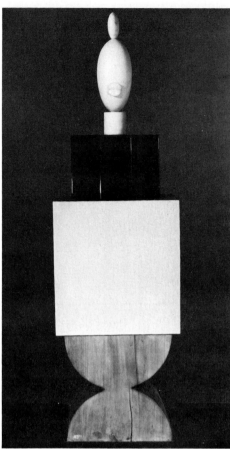

10.48
Constantin Brancusi. *The White Negress (La Negresse Blanche).* 1928, white marble, 49.5 × 14.6 × 19 cm. Brancusi abstracted down to essential forms, with great concern for the properties of his medium.

10.49
Naum Gabo. *Linear Construction #2.* 1949, lucite and nylon, 101.6 × 50.8 × 50.8 cm. Gabo, with his brother Pevsner, pioneered in the use of new materials, voids, and nonobjective structure.

Abstract sculpture

Picasso's collages and constructions in the Cubism of 1912–14 opened the way for a wide range of abstract sculptural forms. Perhaps the most important early Abstract sculptor was the Franco-Rumanian Constantin Brancusi, an artist who as early as 1913 chose to free sculpture from mere representation. His works, such as *The White Negress* (1928; fig. 10.48) and the even more famous *Bird in Space* (1919), reveal an effective and sensuous charm due to their flowing, geometrical poise and emphasis on beautifully finished materials. Brancusi usually preferred to work in the near-abstract but always considered the shape and the texture and handling of materials to be more significant than the representation of subject.

Another pioneer Abstract sculptor was the Russian-born artist Alexander Archipenko. Archipenko belonged to the so-called School of Paris during the Cubist period of Picasso and Braque. His significant contribution was the use of negative space (the void) in sculpture, as in *Woman Doing Her Hair* (1916; see fig. 9.28), in which a hollow replaces the face. Archipenko also explored new materials and technology, occasionally incorporating machine-made parts into a work.

The same Cubist intellectual and artistic ferment that led Archipenko to explore human-made materials and Brancusi to pioneer in using power tools also led the Russian brothers Naum Gabo and Antoine Pevsner to their very important Constructivist concepts. This movement was founded by Vladimir Tatlin, but it is usually associated with Gabo and Pevsner because they issued the definitive manifesto in 1920 that proclaimed pure form as the new realism in art. Gabo was the more exciting, being the inventor of nonobjective and nonvolumetric forms (three-dimensional forms that do not enclose space but interact with it; fig. 10.49). Pevsner worked more in solid masses, nearer to sculpture of a traditional kind. Many artists were connected with the Constructivist movement: Rodchenko, Albers, and Moholy-Nagy, to name a few.

The common denominator in the work of all Abstract sculptors during the period of 1900–30 was an expression that emphasized materials and de-emphasized the division between the fine arts and the functional arts. This was essentially the point of view held also by the Constructivists and the Bauhaus.

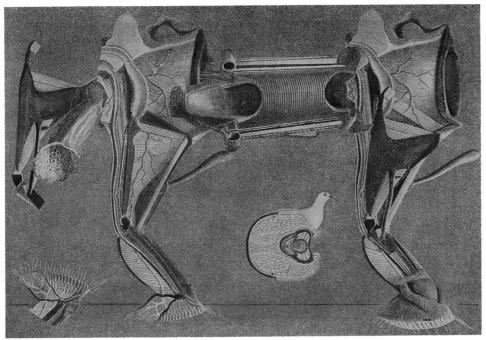

10.50

Max Ernst. *The Horse, He's Sick.* **1920, collage (pasted paper, pencil, and ink),
5¾ × 8½ in.** As a part of the Dadaists' debunking of all twentieth-century art forms, a
natural organism is here turned into a mechanical absurdity. At the same time, the use of
pasted photoengravings is a nonsensical twist of the collage technique first invented by the
Cubist Braque.

Collection, The Museum of Modern Art, New York. Purchase.

Fantastic art

The third major direction for twentieth-
century art became recognizable about
1914, the first year of World War I. The
war had evidently begun to raise
questions about humans' ability to master
the machine, suggesting that individual
freedoms might actually be destroyed in
an age of technology. As a kind of
antidote to the machine cult in abstract
art, certain writers, poets, and artists
began to extol artistic forms that
reemphasized the emotional, subconscious
side of creativity. During this period, for
instance, Picasso's art moved away from
the ennobled, monumental structures of
early Cubism and took on structural
perversions that eventually were the basis
for Dadaism's destructive, cynical, and
absurd parodies on the cult of materialism
in society (see fig. 8.43).

In the past a certain amount of artistic
endeavor had been devoted to the creative
invention of weird and fantastic images.

The centaurs of the ancient Greeks, the
beast-symbols of human sin in medieval
manuscripts and sculpture, the
superstitions and alchemist's nightmares
of Jerome Bosch in the early sixteenth
century, and the fantasies of Goya in the
late eighteenth and early nineteenth
centuries are a few of the prototypes of
twentieth-century fantasy.

Dadaism

The World War I years nurtured the
growth of an art that emphasized the
irrational side of human behavior. Neutral
Switzerland had become a mecca for
poets, writers, artists, liberals, and
political exiles who sought refuge from
persecution or from the terrors of modern
warfare. Out of the intellectual ferment
motivated largely by disillusionment with
the role of reason in society and art arose
Dada. Dada was a semiphilosophic creed
that ridiculed and protested against the
products of reason, morality, and social

order which the proponents believed had
degenerated and brought the world to
war. Thus the Dadaists maintained that a
complete erasure of accepted institutions
and conventions was needed; only on
completely virgin soil could humankind
rebuild a more desirable society. The
Dadaists, therefore, embarked on
programmatic undermining of traditional
civilized mores by cynically deriding all of
society's manifestations, among them
artists and their art.

Duchamp, Picabia, Ernst, and others
began to fashion machinelike forms that
suggested the robotizing of humanity.
Later, with even more remarkable
ingenuity, they created biomorphic images
that discredited the semiorganic qualities
of Kandinsky's romanticized abstract art
(fig. 10.50; see fig. 2.28). These inventions
were meant to show disrespect for the
experimental forms of the art leaders of
the new century and to shock a public
already disturbed by a visual revolution.

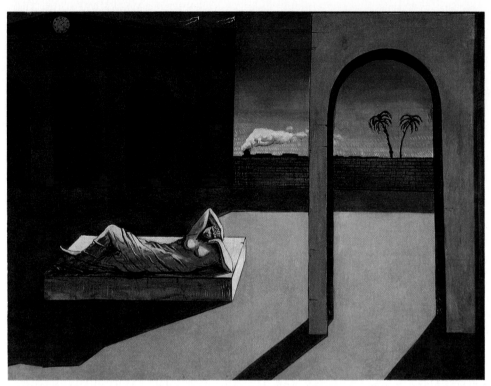

10.51

Giorgio de Chirico. *The Soothsayer's Recompense.* **1913, oil on canvas, 58⅜ × 71 in.**
This picture combines symbols of the past (classical statue and Renaissance architecture)
with forms of the modern world (railroad train) to create a feeling of vast timelessness and
universality. In this way, de Chirico was able to emphasize the reality of a personal
symbolism.

Philadelphia Museum of Art. The Louise and Walter Arensberg Collection.

The basic premise of this bizarre
movement was that all Dadaists had
complete freedom to attack the old order.
In principle, there was no limit to the
disorder that might be projected into
painting, poetry, and general social
behavior. Dadaism left a bad attitude
toward modern art amongst the public.
For many years people tended to classify
all twentieth-century works of art with
the outlandish forms created by the
Dadaists. Actually, the disorder of the
movement eventually led to its demise.
Dada was pure negativism, an exhibition
of the absurd. Being against art, its only
medium was nonsense publicly displayed
to discredit all forms of sense. The main
value of Dadaism today is historical, since
it was the principal source of Surrealism
and a new liberator of expressive freedom.

Individual fantasists

Fantasy was a general tendency in
western Europe during the period of Dada
satire. This fantasy took individual, but
quite influential, directions in the hands of
certain artists who were not a part of the
Dada movement. Giorgio de Chirico, an
Italian, placed incongruous modern
machines in ancient, shadowed plazas
(fig. 10.51; see fig. 5.7). He seemed to
imply the decadence of the modern world
using the vaguely classical image of silent
squares inhabited by statuelike remnants
of an unknown people. The frozen,
unprogressive, and even trancelike effect
of his images suggests a wistful desire to
recover the past.

Paul Klee, a Swiss, created an art of
witty, abstract imagery based on
Expressionism and Cubism. His work

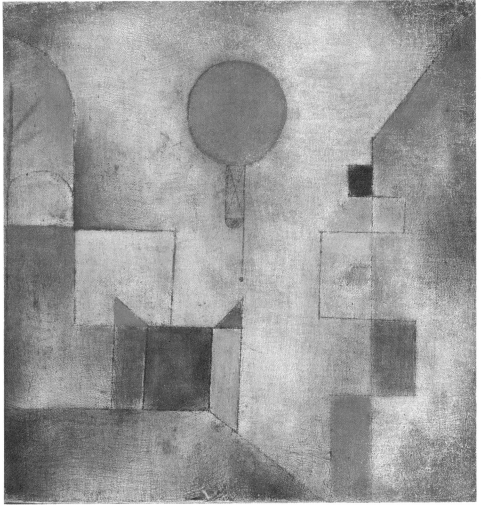

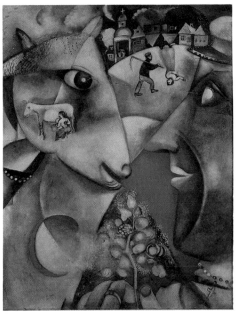

10.53
Marc Chagall. *I and the Village*. 1911, oil on canvas, 6 ft. 3⅝ in. × 59⅝ in. The fairy-tale world of the imagination is found in this example by an artist who evades fixed classification. Recent technological concepts are reflected in the freely interpreted transparent objects and in the disregard for gravity.

Collection, The Museum of Modern Art, New York. Mrs. Simon Guggenheim Fund.

10.52
Paul Klee. *Red Balloon*. 1922, oil (and oil transfer drawing?) on chalk-primed linen gauze, mounted on board, 12½ × 12¼ in. Many artists developed fusions of twentieth-century concepts that defy classification insofar as any one category of expression is concerned. This reproduction combines the refined synthesis of relaxed Cubism forms with the naive charm of children's art.

The Solomon R. Guggenheim Museum, New York. Photo: David Heald.

pokes gentle but penetrating fun at the cult of the machine and smiles shyly at human pretensions. The implication is that there is more to extrasensorial perception than modern humanity's addiction to practicality allows us to believe (fig. 10.52; see fig. 2.18).

Marc Chagall, Russian born but a resident of France and the United States, originally worked in an Expressionist manner. His stay in France brought him under the discipline of Cubism.

Eventually, he joined the two styles in his own brand of romanticized poetic art that has an Alice-in-Wonderland quality. Chagall freely x-rayed people and floated them about in a gravity-free world. The first contact with Chagall usually brings a chuckle to the spectator. On better acquaintance, his underlying humanitarianism is revealed (fig. 10.53).

Surrealism

Surrealism evolved about 1924 from the art of the individual fantasists and Dadaists. With the end of World War I, came a semblance of stability, and the public became complacent about the ills of modern society. The Surrealists reacted to this by attempting to reassert "the importance of the individual's psychic life, and intended to preserve the life of the imagination against the threatening pressures and tensions of the contemporary world."[1]

Whereas the Dadaists had tried to debunk meaning in art as a part of the leftover traditions of a corrupt society they hoped to demolish, the Surrealists tried to build a new art tradition out of works that fused the conscious and unconscious levels of human awareness. Generally speaking, both Dadaism and Surrealism were continuations of the counterattack (first instigated by the Romantics of the nineteenth century) against an increasingly mechanized and materialistic society. The Romantics had often created hallucinatory imagery in which the Surrealist also delights. In so doing, they gave evidence of the growing belief that humanity could not solve every problem by means of science, and that little-known, seemingly unsolvable problems existed within the human mind. Sigmund Freud's theories of dreams and their meanings lent strong credence to this belief. Operating on this thesis, Surrealistic artists created a new pantheon of subconscious imagery that was claimed to be more real than activities and behavior on the conscious level. The Surrealists believed that only in dreams, which arise from the mind below the conscious level (nightmares or daydreams), had humans retained their personal liberties. In their art the Surrealists cultivated images that arose unbidden from the mind. These images were recorded through automatic

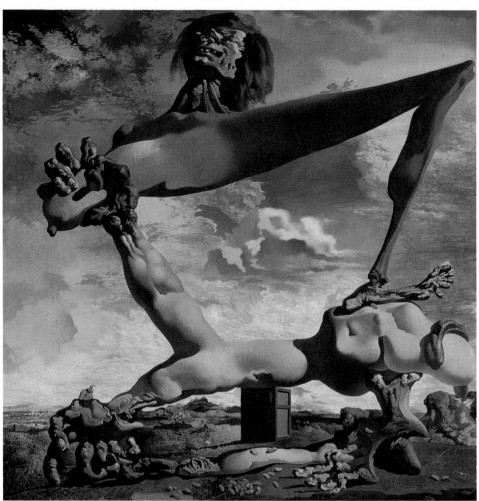

10.54

Salvador Dali. *Soft Construction with Boiled Beans: Premonition of Civil War*. 1936, oil. A naturalistic technique combined with abstract tendencies gives a nightmarish mood to the political commentary in this painting. This approach to form is typical of Surrealist artists such as Dali in the early 1920s.

Philadelphia Museum of Art. The Louise and Walter Arensberg Collection.

techniques of drawing and painting. Such images bring to attention the heretofore unrecognized arbitrariness of our senses concerning reality by exploring incongruous relationships of normal objects in abnormal settings and vice versa. The Surrealists juxtaposed commonsense notions of space, time, and scale in unfamiliar ways.

Max Ernst's *frottages* (invented about 1925) utilized a technique used by the Surrealists to shut off the conscious mind.

Frottages were rubbings made on rough surfaces with crayon, pencil, or similar media. In the resulting impressions, the artist would search for a variety of images while in a state of feverish mental intoxication. A process bordering on self-hypnosis was practiced to arrive at this state. No doubt some artists used drugs and/or alcohol. Artists such as Salvador Dali affected a similar creative fever but used a meticulous, naturalistic technique to give authenticity to their improbable, weird, and shocking images (fig. 10.54).

[1] Charles McCurdy, ed. *Modern Art: A Pictorial Anthology.* New York: Macmillan, 1958, pp.40–41.

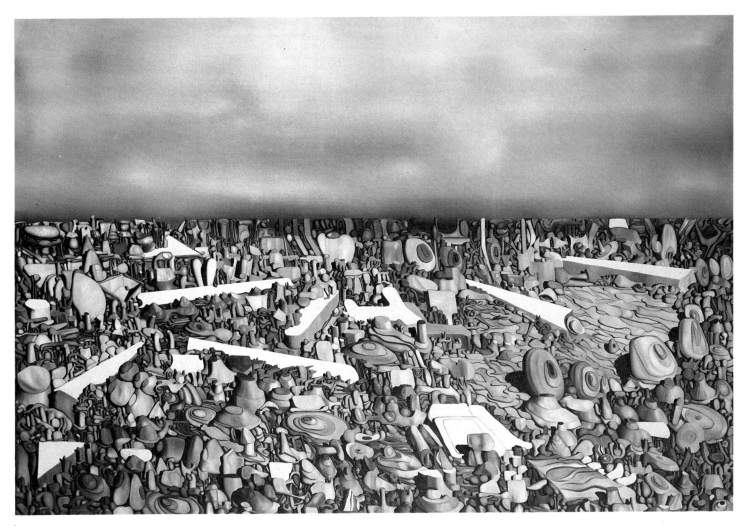

10.55

Yves Tanguy. *Multiplication of the Arcs.* **1954, oil on canvas, 40 × 60 in.** Working with nonfigurative objects in a polished technique, the Surrealist Tanguy invents a world that appears to be peopled with lifelike gems.

Collection, The Museum of Modern Art, New York. Mrs. Simon Guggenheim Fund.

Yves Tanguy employed a method similar to Ernst's. Allowing his hand to wander in free and unconscious doodlings, he used his creative visualization to bring on nonfigurative objects that suggested life. Tanguy's pictorial shapes have the appearance of sentient, alien organisms living in a mystical twilight land (fig. 10.55; see fig. 4.6).

Many artists have been Surrealists, but Ernst, Dali, and Tanguy were the most influential, thanks to their unflagging invention of arresting images. The influence of these outstanding artists extended to the great number of other artists who did not hold to the restrictions of the orthodox Surrealist brotherhood as set forth in Andre Breton's manifesto of 1924. Many of these artists used some of the methods of the group while designing in a formal manner (an approach disdained by orthodox Surrealists), thus combining the methods of the Abstractionists, the Surrealists, and the Expressionists.

Surrealist sculpture

Not many twentieth-century sculptors were pure Surrealists when we consider the character of their art. The effect of Surrealism on the work of many painters and sculptors was variable. Generally, however, the trends of the first two decades merged to such an extent that classification into specific categories is not possible. This tendency increased after the mid-twentieth century and led to the complex, interwoven movements of the 1960s, 1970s, and 1980s.

Alberto Giacometti, a Swiss sculptor who spent much of his career in France, was perhaps one of the greatest Surrealistic sculptors of this century. The evolvement of his personal style was affected by such diverse influences as Lehmbruck's mild Expressionism, Cubism, and Constructivism. Like other twentieth-century sculptors, Giacometti was fascinated not only by the effects of new materials, but also by the effect of light and space on form. By 1934 he had reached his mature style of elongated, slender figures pared away until almost nothing remained of substantial form. In their arrested movement, these figures suggest poignant sadness and isolation (fig. 10.56). Giacometti's indirect method of approaching content stemmed from Surrealism and was related to the stream of consciousness theory supported by early twentieth-century psychologists.

The first sculptor to explore direct metal sculpture (welding) was the Spanish artist Julio González. In the late 1920s González began to substitute outlines for masses and planes and even allowed the tendrils of metal to stop short of completion so that they were completed by implication. His sense of the dematerialization of form is similar to Giacometti's but is more often infected with a humorous suggestivity that hinges on the edge of consciousness. González's work influenced Picasso's experiments with sculpture in the 1930s, and González was in turn influenced by Picasso (fig. 10.57).

The French artist Hans Jean Arp also explored Surrealistic preconscious suggestion and the effect of the unexpected, or surprising, form. Before Arp's Surrealistic direction, he explored most of the avant-garde movements of the early twentieth century: Cubism, Blaue Reiter, Dada, Constructivism, and the like. Arp was a cofounder of the Zurich Dada movement in 1916. He was well known for his abstract collages and reliefs, such as *Mountain Table Anchor Navel* of 1925, before he turned to ovoidal sculptural forms in the 1930s. These later works reveal the influence of Brancusi and prehistoric Cycladic Island sculpture. In fact, Arp's ovoidal shapes became so famous that almost all kinds of rounded, biomorphic shapes were called "Arp Shapes" for a time (fig. 10.58).

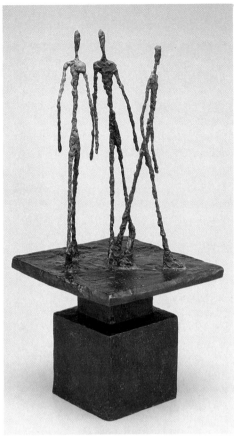

10.56
Alberto Giacometti. *Three Walking Men (Group 3 Hommes II).* **1949, bronze, 75.9 × 46.6 cm.** Giacometti emphasizes the lonely vulnerability of humanity by reducing his figures to near-invisibility and emphasizing the great spaces between them.

Ayer Fund, 1951. 256. © 1988 The Art Institute of Chicago. All Rights Reserved.

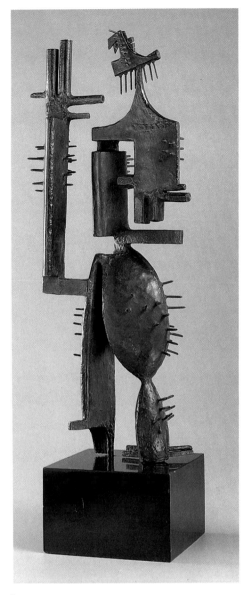

10.57
Julio González. *Cactus Man #1.* **1939–40, bronze, 25½ in. high.** Expressively textured surfaces appealed greatly to this Spanish artist who was the earliest modern sculptor to introduce welding as part of his repertoire. He also used suggestive qualities in his sometimes surrealistic approach to form.

Purchase, Horsely and Anne Townsend, The Montreal Museum of Fine Arts Collection 1962.1333. Photography: Christine Guest. Copyright ARS N.Y./ADAGP, 1989.

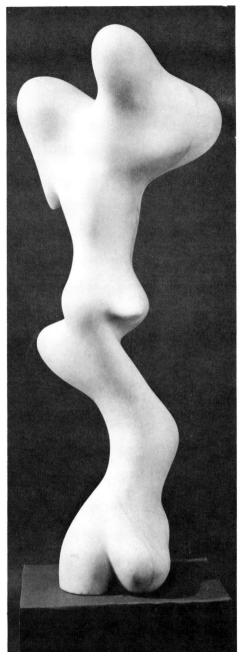

10.58
Hans Jean Arp. *Growth.* **1960, white marble, 43 in. high.** Arp's supple biomorphic shapes contrast sharply with the rigidity of Cubist-inspired sculptors such as Archipenko.

Grant J. Pick Purchase Fund, 1965.357. © 1988 The Art Institute of Chicago. All Rights Reserved.

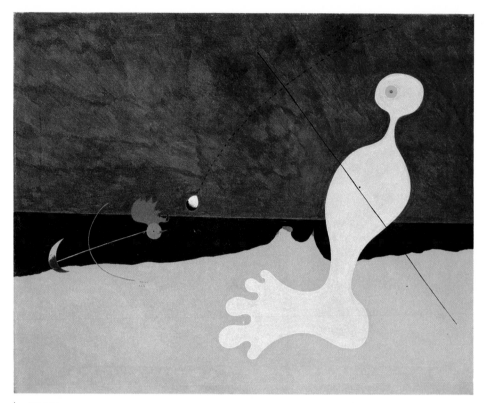

10.59

Joan Miró. *Person Throwing a Stone at a Bird.* **1926, oil on canvas, 29 × 36¼ in.** Miró combines sophisticated color and biomorphic shapes with simple childlike images in this painting that is in many respects similar to Klee's *Red Balloon* (see fig. 10.52). The Abstract Surrealism of Miró is, in general, semirepresentational in character.

Collection, The Museum of Modern Art, New York. Purchase.

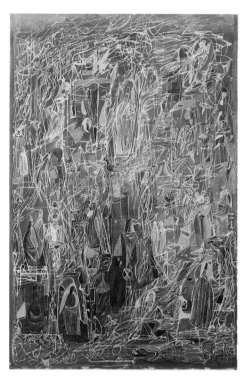

10.60

Mark Tobey. *Threading Light.* **1942, tempera on cardboard, 29⅝ × 19½ in.** Tobey was not directly a member of the small group of young Americans who founded the Abstract Expressionist movement in the immediate post-World War II years, but he seems to be formally related. He originated his own method of linear expression in painting (called "white writing"), which causes accretions of line to waver on the edge of shape recognition only to slip off into abstract controlled-tension between surface and space.

Collection, The Museum of Modern Art, New York. Purchase.

Art forms of the 1940s and 1950s

A host of artists mixed certain aspects of the three major movements of the early twentieth century. Generally speaking, these artists found Pure Abstraction too impersonal, machinelike, and dehumanizing. On the other hand, they felt that Surrealism disregarded the desire for order that has traditionally been fundamental to art.

Abstract Surrealism

Among the artists who chose a harmony of shape relationships stemming from Abstraction, then mixed it with Surrealism's unbidden imagery were Joan Miró of Spain, Rufino Tamayo of Mexico, Matta Echaurren of Chile, Mark Tobey of the United States, and some ex-Europeans, such as Willem de Kooning,

Arshile Gorky, and Hans Hoffman. The latter three artists lived in the United States after World War II. Others who came during the war helped pioneer the first American art movement, called Abstract Expressionism (figs. 10.59, 10.60, 10.61, and 10.62; see figs. 4.1 and 4.5).

Abstract Expressionism

Abstract Expressionism was a coalescence of three major movements that had peaked in the 1930s: Expressionism, Abstraction, and Surrealism. The Abstract Expressionists wanted to express their emotional and spiritual states of being without necessarily referring to nature or representational form. As a movement, Abstract Expressionism began in the 1940s and reached major proportions by 1950. Its artistic founders were primarily painters concentrated in

New York City toward the end of World War II, but by the 1950s artists were working in various media in this manner all over the United States, as well as in western Europe.

As the movement developed, it divided into two basic groups: a generally romantic group (often called *Action painters*) and a more classical group closely allied to the geometric branch of pre-World War II Abstraction. In the first group were such artists as Jackson Pollock, Franz Kline, and Clifford Still. These artists turned to an artistic manner that is reminiscent of the emotional content of Kandinsky's early works

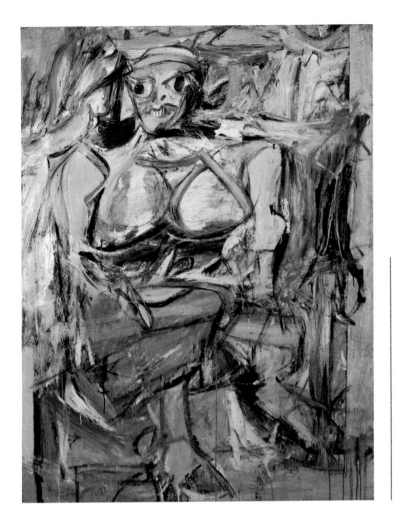

10.61

Willem de Kooning. *Woman, I.* **1950–52, oil on canvas, 6′3⅞ × 58″.** This artist summarizes most aspects of the romantic, or action, group of Abstract Expressionism: revelation of the ego through the act of painting; neglect of academic or formal organization in favor of bold, direct, free gestures that are instinctively organized; and willingness to explore unknown and indescribable effects and experiences. Even though de Kooning seems to use the figure, its representational value is subordinated to the motivating activity of pure painting.

Collection, The Museum of Modern Art, New York. Purchase.

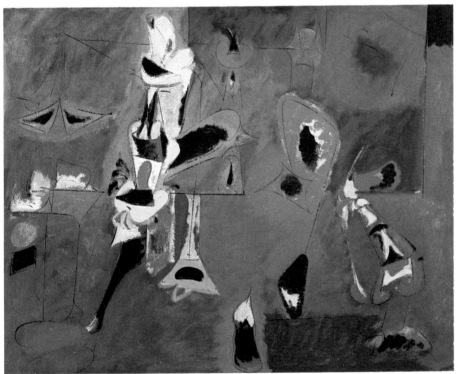

10.62

Arshile Gorky. *Agony.* **1947, oil on canvas, 40 × 50½ in.** A combined engineering and artistic background in his student days, plus the stimulation of Surrealism's unbidden imagery, led this artist into the emotionalized phase of Abstract Expressionism. A peculiar quality in his work is the precision and stability that becomes unsettled and unsettling, marking a personal life of inevitable change and tragedy. Gorky was an important influence on the younger generation of American Abstract Expressionists in the 1940s.

Collection, The Museum of Modern Art, New York. A. Conger Goodyear Fund.

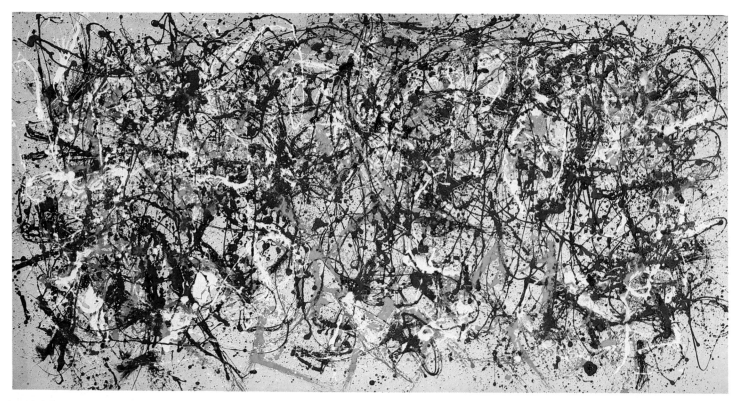

10.63

**Jackson Pollock. *Autumn Rhythm.*
1957, oil on canvas, 105 × 207 in.** This
artist is considered the prime example of
youthful Abstract Expressionist Action
painters in the late 1940s. He is noted
primarily for creating swirling
nonrepresentational images in linear skeins
of fast-drying paint dripped directly onto
canvases through controlled gestures of
his tools.

Metropolitan Museum of Art, New York. George
A. Hearn Fund, 1957.

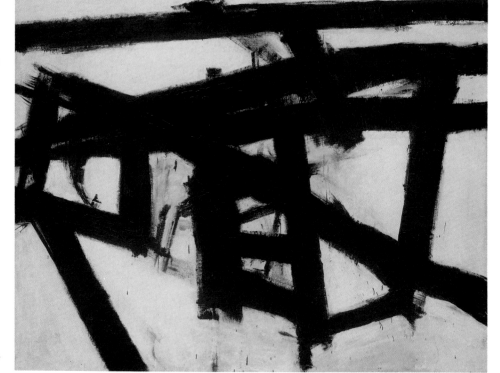

10.64

**Franz Kline. *Mahoning.* 1956, oil, 80 ×
100 in.** The artist was more interested in
the actual physical action involved in this
type of expression than in the character of
the resulting painting.

Collection of the Whitney Museum of American
Art. Purchase with Funds from the Friends of the
Whitney Museum of American Art, 57.10.

(before 1921), and even so unlikely a source as Monet suggested a kindred technical method. Confusion, fear, and uncertainty about humanity's place in a world threatened by thermonuclear holocaust may have led such painters to reject most of the forms of previous twentieth-century art and, as a kind of personal catharsis, to express their belief in the "value of doing" at the expense of disciplined design. For example, Jackson Pollock, frequently cited as the chief exponent of the Action painting trend in Abstract Expressionism, created swirling, nonrepresentational images out of linear skeins of fast-drying paint dripped directly onto large canvases, thereby expressing the reality of self in the act of creation (fig. 10.63).

Franz Kline, another member of the Action group, took a slightly different direction but with the similar intention of expressing self through direct contact with the forms created. His drawings were made with gestures of a brush on newsprint, then cut up and reassembled to provide a sense of power and intensified personal rapport. Kline used these "sketches" as guides and enlarged them on big canvases without actually copying them. House painters' brushes and savage slashings in black and white, or sometimes in color, became monumental projections of Kline's inward experiences (fig. 10.64).

The daring and willingness to explore the unknown that such artists displayed in revealing their ego were also expected of the viewer. This conscious attempt to involve the spectator in art is, perhaps, the leitmotif of direction in the second half of the twentieth century, going far beyond a similar endeavor in seventeenth-century European religious art. Perhaps one reason for recent efforts to involve the viewer is that artists foresaw urban sprawl, with its pressure and tension, causing humanity to seek isolation; involvement in art had to be forced upon people, somewhat like a tonic, for their own good.

The second group of artists within Abstract Expressionism was given to a more restrained manner allied to the geometric branch of prewar Abstraction. They included Robert Motherwell, Ad Reinhardt, Mark Rothko, and Carl Holty, to name a few (fig. 10.65; see figs. 2.24 and 10.47). Many of these artists were motivated by the subtle color relationships of Joseph Albers, a former teacher at the Bauhaus and an emigré to the United States during World War II (see fig. 4.34). Hans Hofmann was another influence (see fig. 8.44).

All of these artists appear concerned with reducing form to the sensation of color or value alone. They tend to create broad areas of color, or shapes so closely related in value and/or color that they are not immediately detectable. Both types of painting enwrap the spectator and make him or her a part of the painting as an experienced sensation. The intention seems akin to that of the Action painters discussed previously, but these paintings are not violent recollections of the emotional fervor of painting; rather they are quiet insinuations on the viewer's being.

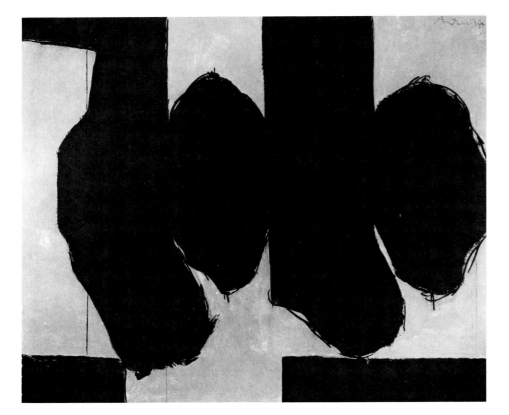

10.65
Robert Motherwell. *Elegy to the Spanish Republic #131.* **1974, oil on canvas, 96 × 120 in.** Motherwell's work is characterized by an intimacy and heroic scale commonly found in contemporary Abstract Expressionism.
Detroit Institute of Arts, Founders Society. Purchase. W. Hawkins Ferry Fund.

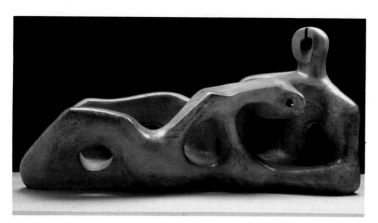

10.66
Henry Moore. *Reclining Figure.* **1939,
carved elm wood, 37 × 79 × 30 in.**
Moore's work is a synthesis of influences
from primitive sculpture and a lifelong
study of the forms of nature.

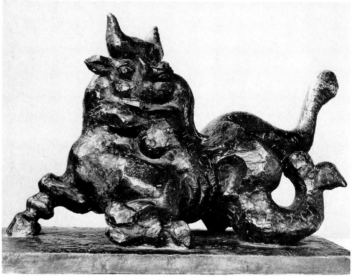

10.67
Jacques Lipchitz. *Rape of Europa.*
1938, bronze, 40.6 × 58.4 cm. After an
early exposure to Cubism, Lipchitz
developed his unique sculptural shapes
and personal symbolism, but his Cubist
background always served as a
disciplinary force.

Abstract Surrealist and Abstract Expressionist sculpture

Many sculptors worked in forms allied to
Abstract Surrealism, ranging from the
organically sleek figures of the
Englishman Henry Moore to the open
wire sculptures of González and Picasso
in the 1930s, which influenced Alexander
Calder in creating the mobile. González,
as the pioneer of welded sculpture, must
also be credited with instilling the
attitude of a younger generation of
sculptors like Theodore Roszak and David
Smith, who in using González's
technique, came as close as their medium
of bronze, iron, and steel permitted to the
Action painting of the Abstract
Expressionists of the late 1940s and early
1950s. Dadaism and Surrealism
influenced some of the "junk" sculpture
of men like John Chamberlain, Richard
Stankiewicz, and Robert Mallary.

Henry Moore merged the vitality and
expressive potential of González and Arp
with older traditions, such as Egyptian,
primitive, and pre-Columbian sculpture
that he had discovered as a student.
Moore's objective over the years was to
create lively forms, not lifelike forms. His
sculptures emphasize the natural qualities
of the selected materials; only secondarily
do they resemble human forms. In this
respect, his frequently repeated theme of
the reclining nude seems to retain in stone
a geologically inspired character and in
wood a feeling of organic growth and an
emphasis on the natural grain (fig. 10.66).
Moore was primarily responsible for re-
establishing British art on the
international scene, and he laid the basis
for the great vitality English sculpture
and painting have shown in the twentieth
century.

The Lithuanian sculptor Jacques
Lipchitz, who worked in France before
World War I and was at that time
strongly influenced by Cubism, began to
be concerned with the Surrealistic idiom
in the 1930s. He developed a highly
robust configuration of freely flowing,
knotted, twisted masses that suggest at
various times the agonies of birth and
death, the suffering of psychic torture, or
the creation of nameless new species of
mythological monsters. The horrors of the
Jewish holocaust under the Nazis in the
second World War were in the minds of
many of these artists also. From
Surrealism, Lipchitz had learned to
exploit the semiautomatic principle too,
kneading his favorite sketching medium
of clay into shapeless blobs without
forethought and then, through the
accident of suggested form, devising his
final images (fig. 10.67). Lipchitz came to
the United States in 1941 and strongly
influenced a younger generation of
American Abstract Surrealist sculptors.
He also had significant influence
internationally.

The most important American pioneer
of Abstract Surrealistic sculpture was the
Philadelphia-born artist Alexander
Calder. Calder's father was a sculptor in
a conservative nineteenth-century Realist
style. Calder reacted at first to this
academic conservatism by studying

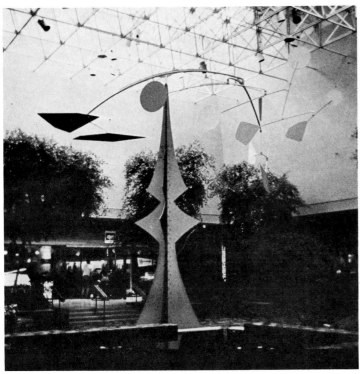

10.68
Alexander Calder. *Oscar.* **1971,
polychromed steel and wire,
approximately 28 ft. high.** A late work by
the famous inventor of movable sculpture,
combines portions of moving (mobile) and
static (stabile) forms.

The Franklin Park Mall, Toledo, Ohio.

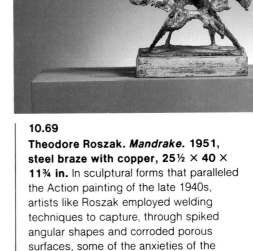

10.69
Theodore Roszak. *Mandrake.* **1951,
steel braze with copper, 25½ × 40 ×
11¾ in.** In sculptural forms that paralleled
the Action painting of the late 1940s,
artists like Roszak employed welding
techniques to capture, through spiked
angular shapes and corroded porous
surfaces, some of the anxieties of the
nuclear age.

The Cleveland Museum of Art. Gift of the
Cleveland Society for Contemporary Art, 64.4.

engineering. He also studied for a time at
the Art Student's League in New York
before going to Paris in 1926 where he
began to create the animal wire sculpture
that won him almost immediate
recognition. In the late 1920s Calder was
mingling in Dada, Surrealistic, and Neo-
Plasticist circles, meeting people like
Miró, Mondrian, González, and Arp. This
apparently caused him to drop figurative
forms for free-form abstract shapes of
sheet metal and wire. By 1930 he had
created the first of his mobiles, after
previously employing motors and pulleys
to move his kinetic assemblages. The
delicate balance and perfect engineering
of the mobiles needed only air current to
create rhythmic, varied motion that
constantly produced new compositions and
relationships of shapes in space (see fig.
9.45). Thus, Calder achieved the fourth
dimension of time and movement in space
for which artists, with their implied

kinetics, had searched since the
beginnings of Impressionism.

Calder evolved three basic types of
assemblages:

1. The *stabile* is usually attached to a
 base, rests on the ground, and does
 not move. However, some later
 ones were made with moving parts.
2. The *mobile* hangs in the air,
 usually from a ceiling.
3. The *constellation* is a form of
 mobile but is usually suspended on
 one or more arms from a wall.

Mobiles are probably the most widely
appreciated form of Modern art, and
Calder is thus considered by many to be
the most important American artist of the
present century. From 1933 until his
death in 1976, Calder divided his time
between farms in Connecticut and France
where he created, toward the end of his

career, monumental stabiles and stabile/
mobiles of welded iron, some of which
were architectural in size (fig. 10.68).

Some of the most interesting new
shapes and techniques in sculpture of the
late 1940s and early 1950s suggested
affinity with Abstract Expressionistic
painting. One artist whose creations imply
this contact is the Polish-born sculptor
Theodore Roszak. Roszak began his
career before World War II as a
Constructivist of severely geometric
shapes but later underwent a complete
change. He became engrossed in
portraying the conflict inherent in natural
phenomena as a reflection of humanity's
potential to destroy itself. Roszak
employed coarse, eroded, scarred, and
pitted textures, as in *Mandrake* (1951),
which, with its spiked and anguished
skeletal angularities, expresses some of
the terror of the nuclear age (fig. 10.69).

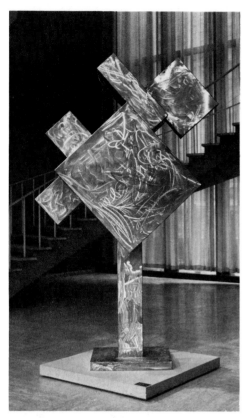

10.70

David Smith. *Cubi VII, March 28.* **1963, stainless steel, 282.9 cm. high.** Smith was rarely concerned with likeness to natural objects. Instead, he used nonobjective forms and tried to give them a life of their own through the animation created by his sense of arrangement.

Grant J. Pick Purchase Fund, 1964.1141. © 1988 The Art Institute of Chicago. All Rights Reserved.

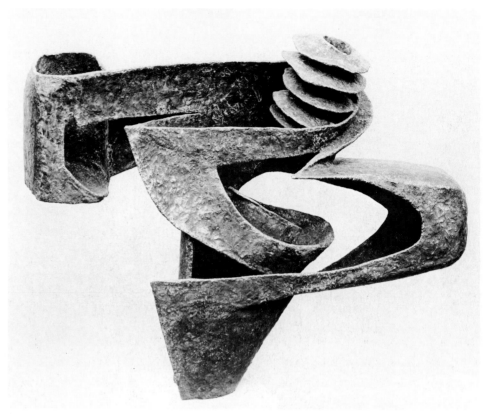

10.71

Seymour Lipton. *Earth Loom.* **Twentieth century; metal, bronze, cast metal, copper-nickel, monel; 32 × 38 in.** In this surreal abstract sculpture are combined life-suggestive shapes and tenser rectilinear thrust—an influence, perhaps, from earlier Constructivist tendencies.

Detroit Institute of Arts. Founders Society Purchase, Friends of Modern Art Fund.

The promising career of David Smith, an Indiana native and a student at the Art Student's League in New York during the 1930s, was cut short by a fatal automobile accident in 1965. He was the earliest American sculptor to use welding, creating powerful statements in wrought iron and steel that at first held organic and surrealistic elements. His later works showed more Cubist-Constructivist use of volumetric shape systems strongly reminiscent of Action painters like Clifford Still and Franz Kline. Smith's ruggedness and the slashing diagonals of his metal cubes on tall poles and stands are remindful particularly of Kline's black diagonals against their flat-white canvas surfaces. Smith's last cubic style before his death also influenced the following generation of young sculptors who got away from the open, flowing sculptural trend of the 1950s (fig. 10.70).

Other artists often used biomorphics with varying degrees of openness or closedness, suggesting involvement with Surrealistic preconscious imagery resolved by Cubist, Constructivist, or Abstract formality. They include Egyptian-born Ibram Lassaw, Seymour Lipton, and Richard Lippold to name a few (fig. 10.71; see figs. 9.29 and 9.31). On the other hand, Reuben Nakian appears to be more a product of the free-form manner expressed by earlier twentieth-century artists such as Gaston Lachaise and Jacques Lipchitz. However, Nakian prefers the porous surfaces used by his peers in the 1950s to the smoothly refined surfaces used by his teacher Lachaise or those used by the Primary Structurists of the 1960s (fig. 10.72).

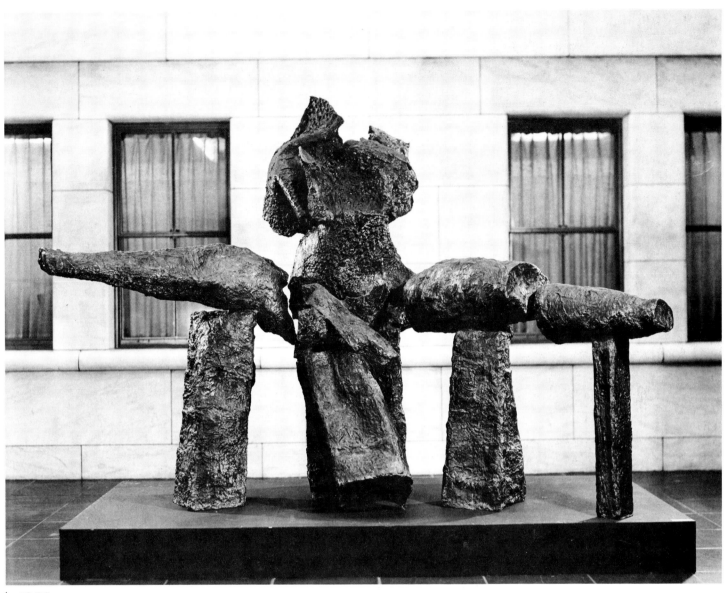

10.72
Reuben Nakian. *Goddess of the Golden Thighs.* 1964–66, metal, bronze cast,
8 ft. 8½ in. × 12 ft. Although he studied under Gaston Lachaise, Nakian roughcast his
sculptural forms to take full advantage of the emotion-evoking qualities of the resulting
texture, rather than use the more smoothly finished forms employed by his teacher. His
abstractions also suggest surreal-like inward forces that assert a life of their own.
Detroit Institute of Arts. Founders Society Purchase, W. Hawkins Ferry Fund.

Art forms of the 1960s and 1970s

Throughout history, new generations of artists have commonly become dissatisfied with the direction taken by their elders and have struck out in new directions. The feeling that inherited methods and media had reached a state of perfection or had exhausted their possibilities was especially keen among artists of the twentieth century and became increasingly so after mid-century. A strong motivation for change was the development of motion pictures as well as other technological advances in machinery, electronics, and space flight.

Drawn by technological innovations, artists have met the desire for change by no longer observing the separate categories of painting and sculpture, but instead merging the two in assemblages that are a bit of both. This mixture of heretofore separate disciplines has its closest parallel in the baroque art of the seventeenth century, in which a similar intermingling of traditionally separate media and disciplines took place. Some artists are also exploring film, video, dance, theater, and (recently) laser, holograms, and computer-generated art.

Post-Painterly Abstraction: Hard-Edge painters, Color Field painters, and Minimalists

The first serious challenge to the dominance of Abstract Expressionism after World War II came from a group of painters known as the Post-Painterly Abstractionists. This category breaks down into Hard-Edge painters, Color Field painters, and Minimalists. All were influenced by early twentieth-century Geometric Abstraction, particularly Joseph Albers (see Abstract Expressionism). During the 1930s, Albers, a product of the Bauhaus tradition (see page 178), did a series of paintings called *Homage to the Square,* which were definitive of his mature style (see fig. 4.34). In this series he showed interest in Gestalt psychology as expressed through the effects of optical illusion. He created passive, free-floating

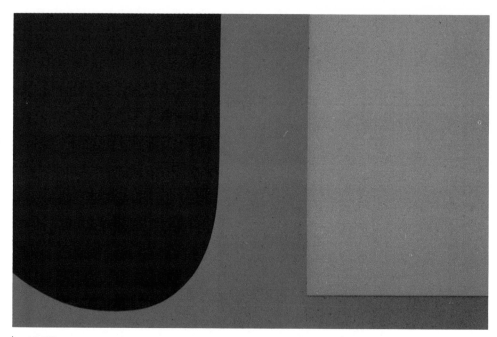

10.73

Ellsworth Kelly. *Red, Blue, Green.* 1963, oil on canvas, 94 × 136 in. Kelly was a pioneer of Hard-Edge painting, descended from Geometric Abstract artists like Mondrian and Joseph Albers, who challenged the painterly Action painters of the late forties and fifties to find a new direction away from Abstract Expressionism.

Collection La Jolla Museum of Contemporary Art. Gift of Dr. and Mrs. Jack Ferris. © 1963 Ellsworth Kelly. Photograph: Philipp Scholz Ritterman.

square shapes that had just enough contrast of value, hue, and intensity with surrounding colors that they seemed to emerge slightly from the background.

Albers's successors, Hard-Edge painters like Ellsworth Kelly, stress definition of edges that set off shapes in their canvas more explicitly than do the Color Field painters (fig. 10.73). The Color Field artists include Barnett Newman, Kenneth Noland, Morris Louis, Frank Stella, and Larry Poons (figs. 10.74, 10.75, and 10.76; see figs. 2.8 and 2.19). Newman, who can be considered one of the originators of Color Field painting in the early 1950s, allowed the shape of the canvas to dictate the pictorial form. He divided the canvas either horizontally or vertically with a line or lines of intense color set off by slight changes in nuance in the resulting shape of the color field.

Minimalists, of whom the nonconformist New Yorker Ad Reinhardt was a chief exponent in the late 1950s, painted pictures in such close values that only

after intense concentration could the spectator determine that any shapes, lines, or other elements of form were present at all. Jules Olitsky was also an exponent of Minimalist work in the 1960s, as seen in his *Emma* (1966) (fig. 10.77; see fig. 2.24).

Another characteristic of Post-Painterly Abstraction was the tendency to either thin down the pigments to stain, soak the canvas in color, or lay color on in such thin layers as to make the work entirely without texture except for that of the canvas support (ground) on which it was painted. Morris Louis's *Number 99* (1959) is an example (see fig. 10.76).

Most present-day art is concerned with ways of seeing as much as with what is seen. To put it another way, artists are much more concerned with the processing of the art object than with its form and meaning. This tends to reduce the former requirements for acquired skill.

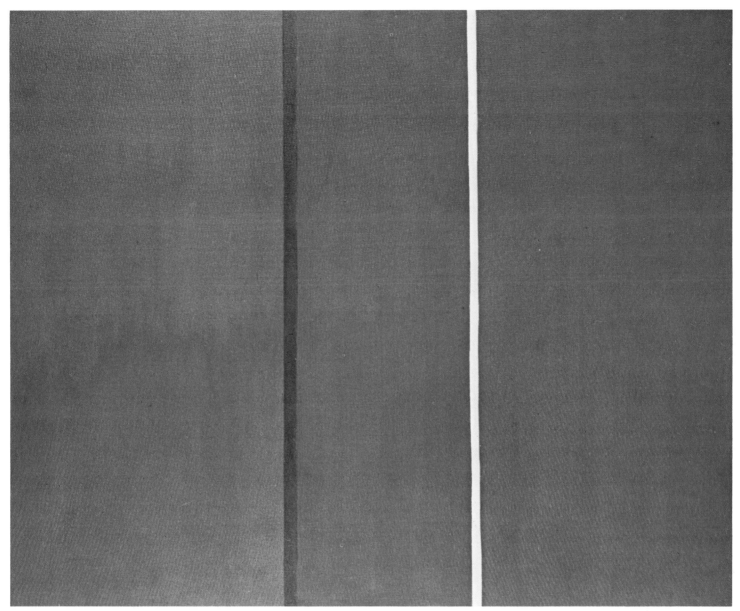

10.74
Barnett Newman. *Covenant.* **1949, oil on canvas, 47¾ × 59⅝ in.** This example is characteristic of Newman, an early Color Field painter. Such works generally feature carefully placed stripes superimposed on a flat color.

Hirshhorn Museum and Sculpture Garden, Smithsonian Institution. Gift of Joseph H. Hirshhorn, 1972.

10.75
Kenneth Noland. *Purple in the Shadow of Red.* 1963, acrylic on canvas, 6 × 6 ft. Color
Field painters of the late 1950s and early 1960s discovered the power of pure color surfaces
differentiated only by hard-edged lines, or shapes, of intense hues. The hues give a feeling
that the art object is an extension of modern technology. The works are based on early
twentieth-century nonobjective forms like those of Malevich and Rodchenko. A similar idea
was carried into sculpture by the Primary Structurists.
Detroit Institute of Arts. Founders Society Purchase, Dr. and Mrs. George Kamperman.

10.76
Morris Louis. *Number 99.* **1959, acrylic on canvas, 99 × 142 in.** Louis was of an older generation of artists related to Abstract Expressionism (such as Kline and Rothko) who became identified with the Post-Painterly Abstractionists. As a Field Painter, he was among the pioneers who flooded canvas surfaces with stains of pigment, which calmed the impetuosity of action paintings and created a new emphasis on the detached objectivity of the work of art. As opposed to Hard-Edge painters like Kelly, Newman, or Noland, Louis's stripes and shapes become softly focused and sometimes almost intangible, thus influencing Minimal art. He was also among the earliest painters of the mid-twentieth century to explore the technique of spray painting.
Contemporary Collection of the Cleveland Museum of Art, 68.110.

10.77
Jules Olitsky. *Emma.* **1966, acrylic on canvas, 84 × 36 in.** Here, characteristics of Minimalism are shown in the relatively insignificant changes in hue and value. An intensely concentrated effort must be made to determine that the field is differentiated in any manner at all from the dominantly dark value of the color.
Courtesy of Mr. and Mrs. S. Brooks Barron, Detroit, Michigan.

Neo-Dada, combine or assemblage, Pop, Happenings, and Op art

Neo-Dada, another branch of Post-Painterly Abstraction, led directly to a significant trend of the 1950s and 1960s—Pop art. Robert Rauschenberg was one of the first to drift away from pure Abstract Expressionism. He combined pure, fluid brushwork in pigments with foreign materials like old mattresses, wireless sets, photographic images, animals, and the like attached to the canvas. From his combine-paintings also came much of the new art of assemblage (fig. 10.78; see fig. 6.8).

Jasper Johns, an American artist more satirical in his approach than Rauschenberg, was equally important in pointing the new direction away from Abstract Expressionism. He chose as his chief motif single images of commonplace objects that had lost their effectiveness, such as the United States flag, targets, and the like (fig. 10.79).

The trend away from Abstract Expressionism in various forms culminated in the early 1960s in two main international movements called Pop art and Op art. The term Pop stands for "popular art" or even for "pop bottle art," judging by the frequency with which such mundane objects appeared. The movement as a whole originated in England in the fifties and then became rather naturally acclimated to the United States. In it, images made popular by mass media advertising and comic strips, and by other everyday objects, such as pop bottles, beer cans, and supermarket products, are presented in bizarre combinations, distortions, or exaggerations of size, always rendered with fidelity to the original human-made object. These works, as in Andrew Warhol's Campbell's Soup cans or Roy Lichtenstein's grotesquely magnified comic-strip heroes and villains, cause the viewer to do a double take (figs. 10.80 and 10.81). As with Abstract Expressionism, the observer is involved directly in the work of art—not only as an experienced sensation of the art form itself but by the frequency with which the observer sees these commonplace items.

10.78
Robert Rauschenberg. *Monogram with Ram.* 1955–59, construction (free-standing combine), 42 × 63¼ × 64½ in. In this combine-painting which merges into three-dimensional assemblage, the drift away from the pure painting of the 1950s is revealed. Such a work provided precedents for the Pop art movement shortly thereafter.
Courtesy the National Museum, Stockholm, Sweden.

The blurring between art and real life in Pop art is more pronounced in the Pop-originated Happening. Happenings were a form of participatory art in which spectators, as well as artists, engaged. They have been defined as an assemblage on the move, bringing in motion, time, and space, a concern of artists for centuries, but one that has reached new fruition in the present century.

Happenings were also based on the ancient concept of drawing spectators into the heart of a work of art so that they could experience it more directly. This concept reached its first climax in baroque art in the seventeenth century when, as mentioned earlier in this chapter, the disciplines overseen by the medieval guilds had finally lost their technical control over the artist. From the Renaissance on, the religious iconography and media used by artists were intermingled in an artistic fabric (the church building) that was unified within

itself, but was dependent for completion on the spectator's participation in the artistic experience.

Since similar experiences were promoted by the Dadaists in 1916, some of the Pop artists were also called Neo-Dadaists. But whereas Dada was nihilistic, self-exterminating, and satirical, Pop art had little of this purpose. Instead, it encouraged an awareness and acceptance of the fact that mass media communications have a tremendous impact on our daily lives. There was a kind of joyful enthusiasm for exploring the possibilities implied by the daily images and objects of a metropolitan society and culture. From billboards to bar interiors, from grocery store cans and boxes to the bathtubs and sinks of the average house interior, came the realistic subjects of Pop art as a reaction to the inwardly directed Abstract Expressionists and their offshoots. Significant artists of Pop persuasion besides Warhol and

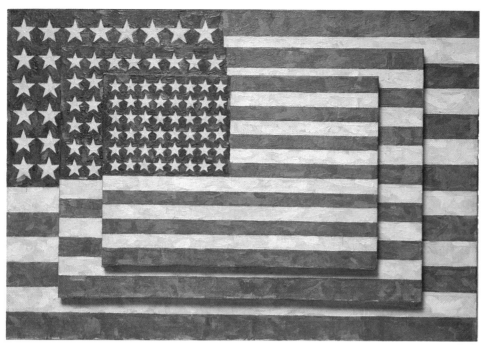

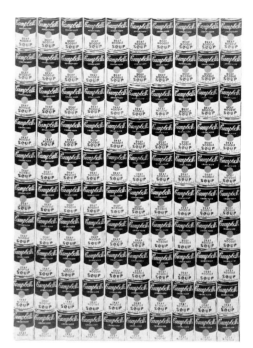

10.79

Jasper Johns. *Three Flags.* **1958, encaustic on metal, 30⅞ × 45½ × 5 in.** Johns causes us to see the flag in a new artistic way, apart from its normal association as a patriotic symbol. Painted in a robust manner, this work is typical of his use of commonplace objects in the trend away from Abstraction that led to Pop art realism.

Collection of the Whitney Museum of American Art. 50th Anniversary Gift of the Gilman Foundation, Inc., The Lauder Foundation, A. Alfred Taubman, an anonymous donor, and purchase 80.32.

10.80

Andrew Warhol. *100 Cans.* **1962, oil on canvas, 72 × 52 in.** Warhol's *100 Cans* beat a repetitive visual tatoo that derives from the insistence of similar commercial imagery in our daily lives. Repetition of a more or less monotonous kind was one of the principles of form exploited first by the Pop artists and later by artists of various other styles.

Albright-Knox Gallery, Buffalo, New York. Gift of Seymour H. Knox, 1963.

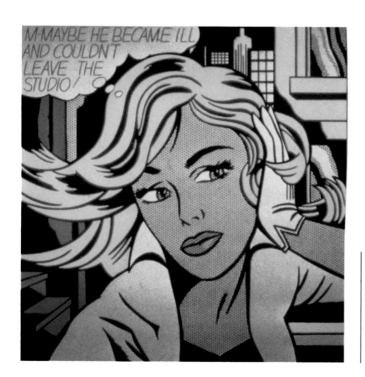

10.81

Roy Lichenstein. *M-Maybe.* **1965, oil and magna on canvas, 60 × 60 in.** Lichenstein's use of magnified comic-strip heroes and heroines is typical of this Pop art movement.

© Roy Lichenstein. Courtesy Leo Castelli Gallery.

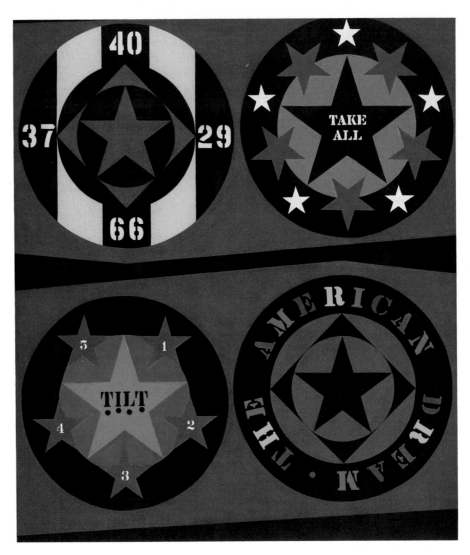

10.82

Robert Indiana. *The American Dream I.*
1961, oil on canvas, 6 ft. × 60⅛ in. This
is an example of Pop art. Indiana utilizes
the Pop convention of commonly seen
advertising images. He mixes this with
slogan-conscious idioms of daily American
life to create new experiences in which the
conventional becomes unconventional.
Collection, The Museum of Modern Art, New
York. Larry Aldrich Foundation Fund.

Lichtenstein are Jim Dine, Robert
Indiana, Tom Wesselman, Claes
Oldenburg, and George Segal. Several,
especially Oldenburg and Segal, are
sculptors or assemblers, fields in which
Pop art has made inroads as much as in
painting (figs. 10.82 and 10.83).

The popularity of assemblage and the
enhancement of the Dada idea of the
"found object" led to the junk ethos in
metal and other material form
combinations. The Dadaists and Picasso
also pioneered the use of found objects as
objects of art (for example, Picasso's
Bull's Head, 1943, the handlebars and
seat of a bicycle, in Galerie Louise Leiris,
Paris); but ultimately, all similar forms of
art stem from Picasso and Braque's
experiments with the collage in the early
part of the century. It is not too surprising

to find, therefore, that the junk used by
later twentieth-century artists, deriving as
they did from these earlier experiments,
often included scrapped fragments of
human-made objects such as automobiles,
farm machinery, factory parts, airplanes,
and bicycles.

John Chamberlain's sculptures made
from the parts of wrecked automobiles,
and those that Richard Stankiewicz
created by welding together old boilers,
sinks, and the like, are a kind of comment
on consumer culture that also occurs in
Pop art (fig. 10.84). The artists just
mentioned are American, but Europeans
like César work along similar lines.
César's *compressions derigées* are objects
made with the giant baling machines that
compress junked automobiles and other
scrap into small size.

10.83 (left)

Claes Oldenburg. *Falling Shoestring Potatoes.* 1966, painted canvas, kapok, 108 × 46 × 42 in. Pop artists generally disregard all form considerations, which they believe create a barrier between the observer and the everyday objects that serve as subjects. Pop art is an art of "now" things.

Collection, Walker Art Center, Minneapolis. Gift of the T. B. Walker Foundation, 1966.

10.84 (above)

John Chamberlain. *Untitled.* 1958–59, painted and welded metal, 32½ × 26½ in. The popularity of assemblage, enhanced by the Dadaist idea of the "found object," led to the junk ethos of metal and other material form combinations. During the 1950s and 1960s, artists of this persuasion, like Chamberlain, who works with bent and crushed metal from old automobiles, have also been called Neo-Dadaists.

Cleveland Museum of Art. Purchase, Andrew R. and Martha Holden Jennings Fund.

10.85

Edward Kienholz. *The Wait.* 1964–65, mixed media (tableau), 80 × 148 × 78 in. This artist belongs to a branch of assemblage art sometimes known as environments. His tableaus of the old, the derelict, and the mentally ill are comments on the sickness, tawdriness, and melancholy of modern society.

Collection of the Whitney Museum of American Art. Gift of the Howard and Jean Lipman Foundation, Inc., 66.49.

Edward Kienholz's works, which he calls tableaus, also fall into the category of assemblages. His combinations of materials have something of the shock value of Dada art, making pungent comment on the sickness, tawdriness, and melancholy of modern society (fig. 10.85).

Op art stands for "optical" and, again, seems an extension and modification of earlier twentieth-century Geometric Abstraction and Nonobjectivity. Artists in the movement (many again influenced by Albers), such as Victor Vasarely, Richard Anuskiewicz, George Ortman, Agam, and Bridget Riley, employ precise shapes and sometimes wriggly lines or concentric patterns that have a direct impact on the physiology and psychology of sight (figs. 10.86 and 10.87; see figs. 2.16 and 2.44). They have explored moiré patterns and have formed groups that seem almost more dedicated to the scientific investigation of vision than to its intuitive expression in art.

10.86
Agam (Yaacov Gipstein). *Double Metamorphosis II.* **1964, oil on corrugated aluminum in eleven parts, 8 ft. 10 in. × 13 ft. 2¼ in.** This Op artist explores not only the psychology of sight but the physical effect that viewing his forms of art may generate. In some ways the forms of Op art seem an extension of earlier twentieth-century geometric abstract art.

Collection, The Museum of Modern Art, New York. Gift of Mr. and Mrs. George M. Jaffin.

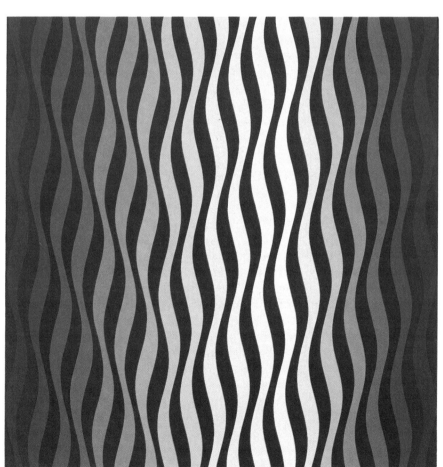

10.87
Bridget Riley. *Drift No. 2.* **1966, acrylic on canvas, 91½ × 89½ in.** Op artists generally use geometric shapes, organizing them into patterns that produce fluctuating, ambiguous, and tantalizing visual effects very similar to those observed in moiré patterns.

Albright-Knox Art Gallery, Buffalo, New York. Gift of Seymour H. Knox, 1967.

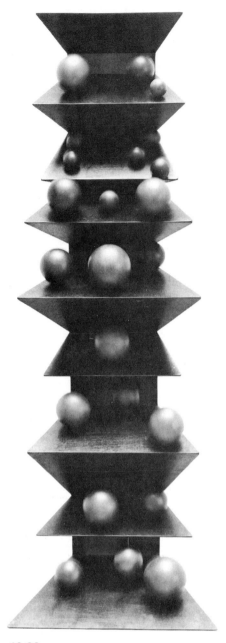

10.88

Pol Bury. *Staircase*. 1965, wood with motor, 78⅝ in. high. Here is an example of an art form in which the ball shapes actually move. Movement had precedent in both late nineteenth- and early twentieth-century sculpture and painting. A growing number of technologically oriented artists exploit the possibilities of such kinetic art today.

Collection, the Solomon R. Guggenheim Museum, New York. Photo by Carmelo Guadagno.

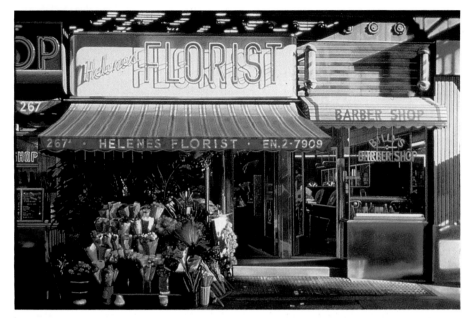

10.89

Richard Estes. *Helene's Florist*. 1971, oil on canvas, 48 × 72 in. The meticulously rendered images attempt to reach the degree of reality found in photography.

The Toledo Museum of Art, Toledo, Ohio. Gift of Edward Drummond Libbey.

Kinetic sculpture

Kinetic forms of art are those that create movement. Although partly derived from Calder's motor-driven *Circus* of the 1920s and later mobiles, they also owe their origins to Op art. Kinetic art almost entirely uses a mechanical means to give motion to the art object. And even though Kinetic art owes something of its origins to Op art, Op art remains primarily a static form, using various realistic devices to suggest movement. Kinetic art is thus another art form that derived from the concern with space and time that began with some types of Impressionism in the late nineteenth century and continued with Futurism, Dadaism, and Calder in the early twentieth century. Dadaists, under the aegis of their nonsense credo, with which they wished to destroy civilization and art in order to start over building a better world, created movement, or kinetics, as in Marcel Duchamp's swirling designs played on a phonograph turntable.

Present-day artists use random movement as well as movement controlled by mechanical or electronic means to produce Kinetic art. Jean Tinguely's mechanisms summarize this trend. He created large, slack, junky-appearing contrivances that outdid the imaginary cartoons of Rube Goldberg of the 1920s and 1930s. Tinguely's creations sometimes moved about, but more often merely stood and shook, as if they were going to throw away the gears and cogs that ran them. In fact, Tinguely's most famous kinetic construction of this kind (*Homage to New York*) did just that, destroying itself in the garden of the Museum of Modern Art in New York City in 1960.

Other artists, such as Takis and Pol Bury, exploit similar possibilities in more elegant forms that seem, at times, almost immaterial. Takis, for example, has used small metal shapes suspended on rods, whose movement can hardly be detected without close study, while Bury often uses biomorphic wood shapes that are motorized to make slight movement (fig. 10.88). Other artists explore the

suggested movement in the work of Minimalist and Optical artists, and do achieve movement—but to a limited degree.

Some artists, such as Chryssa, Dan Flavin, and Nicholas Schoeffer, explore the combination of light, movement, and sound electronically produced to create kinetic fantasies. Chryssa uses the technology of the neon light in his fluorescent kinetics, as does Flavin (see fig. 4.4). Schoeffer more frequently uses movement, electronic sounds, and lighting.

New Realism

A general trend in the 1960s was the extension of Pop art into meticulously rendered images of reality. The movement was led by such artists as Wayne Thiebaud, Mel Ramos, Philip Pearlstein, Richard Estes, Gary Schumer, Chuck Close, Richard Lindner, and Robert Cottingham (fig. 10.89; see figs. 2.55, 2.56, 5.6, and 6.10). Artists of this persuasion are designated New Realists. They depend on both photography and images like those in commercial advertising to gain their meticulous artistic ends. Unlike the Pop artists, they show average people at their everyday activities.

There has been a high level of interest in realistic art throughout the twentieth century, particularly in the United States. This can be witnessed not only in the unabated popularity of Andrew Wyeth, but also in the resurging interest in artists like Grant Wood and George Bellows of the earlier part of the century (see figs. 2.22 and 2.40). On occasion, nineteenth-century Realism, from the Pre-Raphaelites through the Impressionists, has also returned to favor.

Like Pop art, New Realism has its sculptural participants. The sculptors refined the styles of Segal and Oldenburg and made even more lifelike images in fiberglass and resins. Very popular in this area during the late 1960s and early 1970s were Frank Gallo, John De Andrea, and more recently, Duane Hanson (fig. 10.90). Trompe l'oeil verisimilitude reaches a new level of virtuosity and tour-de-force in such three-dimensional illusions.

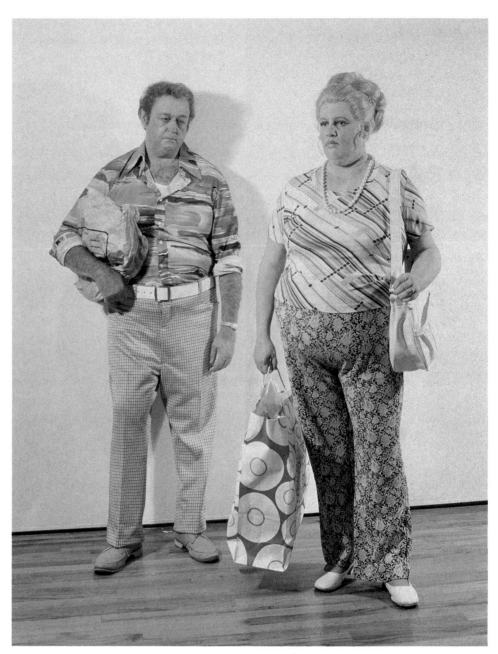

10.90

Duane Hanson. _Couple with Shopping Bags._ 1976, polyvinyl/polychromed in oil, life size. This work belongs in the context of photorealism painting, but it incorporates more illusions than painting can. Duane Hanson's three-dimensional, lifelike, life-size figures are cast in colored polyester resin and fiberglass to look like real skin and are clothed in real garments. Hanson's human reproductions are detailed so meticulously that one reacts to them first as real people, only later as sculpture.

Courtesy O.K. Harris Works of Art, New York.

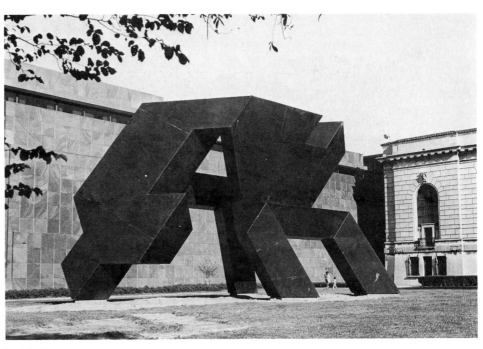

10.91
Tony Smith. *Gracehoper.* **1961; metal, steel, paint welded; 23 × 22 × 46 ft.** This primary sculptural structure utilizes size and a simplified geometric volume to make a visual impact on the observer.
Detroit Institute of Arts. Purchase. Donation from W. Hawkins Ferry and Founders' Society Fund.

Primary Structurist, Minimalist, and Neo-Constructivist sculpture

The Post-Painterly Abstractionists are paralleled by a group of sculptors that includes Robert Morris, Donald Judd, Tony Smith, Anthony Caro, and others who carry the late mechanomorphic cubes of David Smith into blunt sculptures of simplified geometric volumes that seem stripped of all psychological or symbolic content (figs. 10.91 and 10.92). They are called Primary Structurists. Quite often, they have rejected metal and welding for materials hitherto uncommon in sculpture, such as cardboard, masonite, plywood, and the like. Some artists, for example, Larry Bell and Sylvia Stone, have used hard sheet plastic (Plexiglas) or tinted glass to create transparent volumes that enclose space (fig. 10.93).

The Primary Structurists also seem to obliterate the core. The objects they create express through the power of simple volumes all that they want to say. Some are merely boxes of gigantic size. (Size is one of the characteristics of much of the sculpture in the late 1960s and 1970s.) At first, Donald Judd created loaf-shaped boxes hung on a wall (relief fashion) that were repeated a number of times (see fig. 9.53). Later he turned to large, open-centered concrete boxes that are repeated.

Repetition of similar forms seems a carryover of similar ideas from Pop art (for example, Warhol's Campbell's Soup cans). Carl Andre also used repeats of different materials in rows; sometimes they were laid on the floor of the gallery, at other times they were placed outdoors. Sol de Witt employed this principle of interval and repetition in boxlike slatted

sculptures faintly reminiscent of bird cages piled up. Clement Meadmore added a sudden twist in direction to his Primary Structures or Constructions so that they appear to be tied in a knot.

The Primary Structurists are often categorized as Minimalists due to the simplicity of their forms, which have connections with the Minimalist painters (see Ad Reinhardt and Jules Olitsky, "Post-Painterly Abstraction"). In their stress on pure form, such artists reject the ideal that human personality counts for much in the work of art. This is a reminder of antecedents—purists like Mondrian and the painters of the Nonobjective movement circa 1930–50 (see "Pure Abstraction" and "Nonobjective art"). It is also a reaction to the associational suggestivity found in welded sculpture, particularly the Expressionist kind.

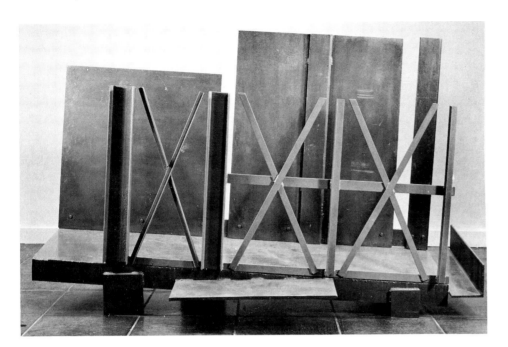

10.92

Anthony Caro. *Up Front.* 1971, sheet metal and steel beams, 69 × 47 × 110 in. This work by the Primary Structurist Caro owes some of its bluntness of expression and direct simplicity of form to the later work of David Smith. Its quality of technological precision, however, contrasts with the haphazard, ready-made castoffs of present-day technological society as suggested by the ethos of Neo-Dadaism and junk art.

Detroit Institute of Arts. Purchase. Contributions for W. Hawkins Ferry and Mr. and Mrs. Richard Manoogian.

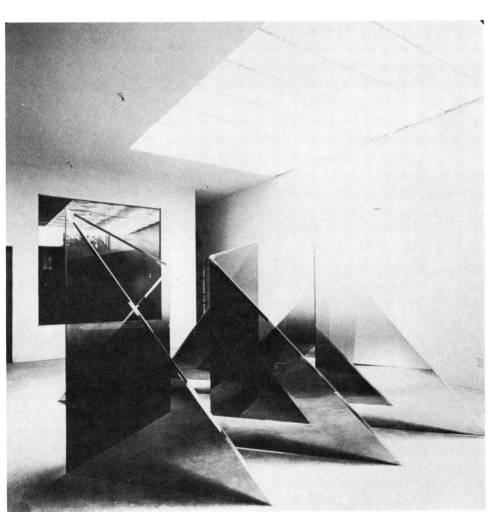

10.93

Larry Bell. *Untitled.* 1977, vaporized metal on plate glass, three panels: 1.5 × 5 ft. × ⅜ in.; 2.6 × 5 ft. × ⅜ in.; 3.5 × 6 ft. × ⅜ in. The Primary Structurists use simple monumental forms exploiting a wide variety of materials.

Courtesy the Marian Goodman Gallery, New York. Private collection. Victoria, Texas.

However, another branch of the Primary Structurist movement seems more inclined toward open spatial forms in preference to the simplified enveloping boxes and planes of the first group. They have been variously called Minimalists, Environmentalists, and Neo-Constructivists. When we are right on top of contemporary creativity, we lack the hindsight necessary to distinguish major directions from one another, so no distinctive classification has been given to these artists as yet. Nonetheless, they concentrate on large, spatially open, rectilinear, and curvilinear forms. Sometimes these sculptures feature beamlike arms or girderlike extensions into space, and at other times curving planes, or flat planes with curving edges, that are interrelated. These sculptures are at times related to the walls, floor, or ceiling of a room (as in the exhibition space of a gallery or museum) and at other times (especially in the 1970s) only appropriate in scale to an outdoor environment. Like the boxier, volumetric Primary Structurists, these artists' creations also reject any connotations of human personality. Attention is concentrated on a machinelike impersonality that is apparently a part of our cultural heritage. Despite this attitude, some persons may sense a more romantic quality due to the very free spatial play in these works.

The one dominant characteristic in all these recent sculptures is their orientation to space. The mass depicted by earlier sculptors has been replaced by a contemporary preoccupation with size and space. Space may be incorporated as a part within the sculptural pieces, or it may involve a flow or thrust into the natural environment. Many such works are located on university campuses, at outdoor settings of museums, and sometimes in front of, or related in some other manner to, city office buildings.

Examples of these most recent trends are Lyman Kipp's vertical, flat sheets of metal; Lila Katzen's large, open-rolled, sheet-metal forms; Mark di Suvero's variously angled I-beam girder structures; and Kenneth Snelson's hanging tubes with cables (figs. 10.94 and 10.95; see figs. 9.6 and 9.50).

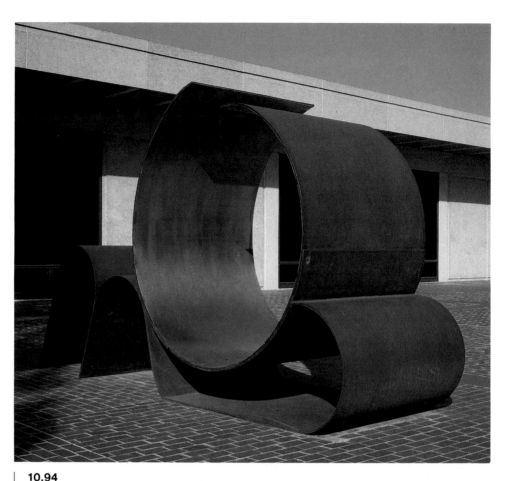

10.94
Lila Katzen, American (b. 1932). *Oracle.* **1974, Corten and stainless steel, 11 ft. ✕ 17 ft. ✕ 5 ft.** These flowing sheet metal forms set in outdoor space are typical of the works of Katzen.
The University of Iowa Museum of Art, Museum Purchase, 1976.88.

A few of the boxes, and occasionally some of the more rectilinear sculptures, stress brightly colored surfaces, while others are neutral or void of color. Without doubt, many have impact, but some of the boxier forms often transmit a feeling of sameness or monotony. At times, the processing of such an object seems more important than its form and its effect on the vision and response of the observer. A few of these objects, especially the rectilinear constructions, involve kinetic movement. George Rickey's work is a distinguished example of this type of contemporary sculpture (fig. 10.96).

Another characteristic of modern sculpture that needs to be emphasized is the apparent virility of the forms and the lively crosscurrents that are carried from one category of form to another. For this reason it is difficult to classify much of what is going on in the field of sculpture.

Sculptors continually change their approaches, slipping from one style into another. Louise Nevelson, for instance, began by using smooth abstract shapes comparable to those of Henry Moore. Later, she moved toward assemblage, fitting together ready-made wooden shapes, such as knobs, bannisters, moldings, and posts gleaned from demolished houses and old furniture. These fragments were associated in boxlike forms compartmentalized into various-sized rectangles and squares that became large screens or freestanding walls. These complex pieces were usually painted a uniform color, which stressed the relationship of the parts as a unified total. Her relationships and complexities seem in keeping with the recent trend toward processing rather than form. But her final results are often more exciting than those of the Primary Structurists (fig. 10.97).

10.95
Mark di Suvero. *Homage to Charlie Parker.* 1970s, steel, 13 ft. 3 in. × 35 ft. 8 in. × 21 ft. This piece is typical of many contemporary sculptures in its largeness of scale, preoccupation with space, and choice of environmental setting.

Collection of the Oakland Museum. Gift of the artitst, the Women's Board of the Oakland Museum Association, and the National Endowment for the Arts.

10.96
George Rickey. *Two Red Lines II.* 1966, painted steel, 32 ft. Many of Rickey's works are kinetic, being constructed so as to utilize the wind to provide constantly changing aspects.

Collection of the Oakland Art Museum.

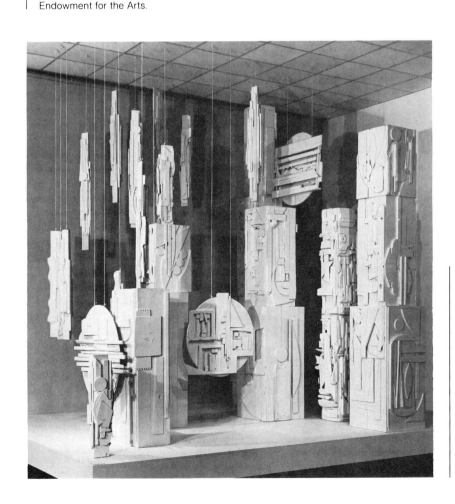

10.97
Louise Nevelson. *American-Dawn.* 1962, painted wood, 548.6 × 426.7 cm. This example of the assemblage concept in today's art is by a well-known sculptress. She utilizes separate, columnarlike shapes that build up to a unified but dynamic verticalized accent. The shapes contrast with the more frequently used boxlike screens that enclose smaller sculptural units in other works.

Grant J. Pick Purchase Fund, 1967.387. © 1988 The Art Institute of Chicago. All Rights Reserved.

Environmentalism: Earthworks

Environmental art takes its name from the fact that it surrounds the spectator. The artwork becomes a slice of (artificial) life, which is completed by spectators because of the stress placed on the details of the created forms around them. Environmental artists believe that not only should the spectators' vision be engaged in works of art, but also their physical bodies, and senses of touch, smell, and hearing. Although Dadaists like Kurt Schwitters and Marcel Duchamp created the first twentieth-century environments, the Pop artists must be credited with renewing this form of art in the 1960s and 1970s. Lucas Samaris's *Mirrored Room* is a good example of an environment that, like the Constructivists, the Neo-Constructivists, and the Minimalist/Primary Structurists, de-emphasizes artistic personality (fig. 10.98). The desire to express purity of form more than to project the artist's character has been a continual ideal in twentieth-century art since the innovations of Cubism and Abstract art between 1906 and 1918.

Environments in various materials emerged from the static assemblages of the 1950s and 1960s. The Pop art concept of literal images was enlarged to encompass the spectator. These images, originally the most commonplace items in our culture, were removed from their normal settings and given the supposed legitimacy of pure art. The spectator's involvement included the principle of space/time—the action involved in either creating or looking at works of art.

In addition to Samaris, other artists who produce environments, while they also create other kinds of art, are Christo, Claes Oldenburg, Howard Woody, and Bruce Nauman. Christo has continuously explored the environment, from the great balloons featured at the Whitney Gallery in 1968 to his recent surrounding of islands off the coast of Florida with sheets of plastic (fig. 10.99). One of his works, in which he used metal posts and sheet plastic to enhance the contours of some hills and valleys near Petaluma, California, in 1976, is shown in figure 1.6, along with examples of drawings

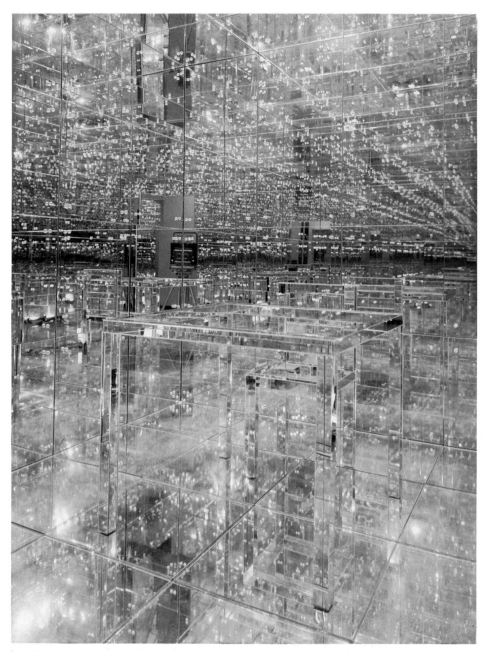

10.98
Lucas Samaris. *Mirrored Room*. 1966, mirrors on wooden frame, 8 × 8 × 10 ft. This is an example of environmental art, which, using size and structure, seems to enclose or actually does enclose the observer within the form of the work.
Albright-Knox Art Gallery, Buffalo, New York. Gift of Seymour H. Knox, 1966.

and/or paintings that he uses as working models preceding the final environmental projects. These are also sold to raise money for the supplies and helpers required to execute Christo's monumentally scaled art. Carrying out the actual environmental form takes on the character of a Happening or Action art.

Another pioneer among the Environmentalists was the sculptor Robert Smithson, whose *Spiral Jetty,* created at Great Salt Lake, Utah, in 1970, played an important part in such large-scale environments (fig. 10.100). Claes Oldenburg, the well-known Pop artist, also explored environments, as in the giant lipstick tube monument he created for Yale University.

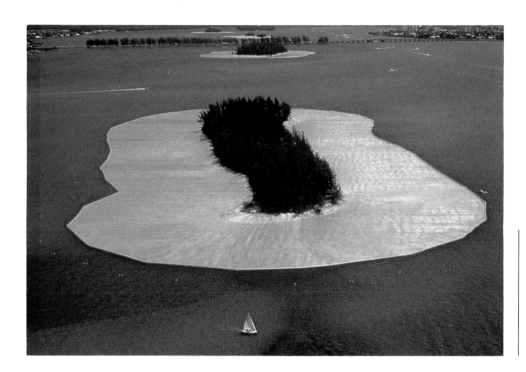

10.99
Christo. *Surrounded Islands.* **1980–83, Biscayne Bay, Greater Miami, Florida, woven plastic fiber.** Christo has continuously explored the environment and the relationship of art forms to it, as in this recent work.

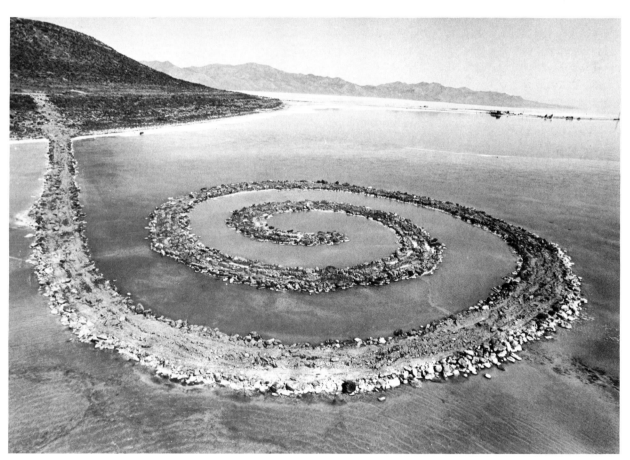

10.100
Robert Smithson. *Spiral Jetty.* **1970; Great Salt Lake, Utah; rock, salt crystals, earth, algae, coil; 1500 ft.** Students of art must be willing to concede the possible validity of many unfamiliar forms of individual expression.

The Minimalist/Primary Structurist emphasis on the large scale of their "pure" forms also helped lead to a branch of Environmental art called Earthworks or Earth art. The displacement of the natural and/or prepared land and space necessary for setting or exhibiting large-scale outdoor sculptures drew attention to the places where they would be situated. Some artists soon conceived that the manipulation of the setting, or natural environment itself, was significant as a work of art in its own right.

The exact incidence of Earthwork art is difficult to pinpoint, although it appears to have developed in the late 1960s. In 1967 Claes Oldenburg dug holes, which he called "invisible sculptures," in New York City's Central Park. Michael Heizer, for example, dug five twelve-foot trenches that he lined with wood in the Black Rock Desert of Nevada in 1969. The concept of "bigger is better" has also taken hold in Earthworks, since cranes and power shovels have been used by the artists/directors to produce their works.

Process and Conceptual art

As we have found, the Minimalist/Primary Structurists of the 1960s and 1970s emphasized the purity of formal meaning in simple volumes, while the Action Painters in Abstract Expressionism earlier had advocated raising the creative act over formal expression in the arts. In these movements a great deal of artistic energy has been expended toward exploring the creative process and the conception of works of art. These forms of art have been called Process art and Conceptual art. Both, in a strict sense, would downgrade the importance of the artist and the final form or object of the visual art. Process artists believe that all art is primarily experienced as an act of producing. The interpretations applied to the final form do not seem important to them. This is, perhaps, the final evolution of the attitude that once claimed that all art went far beyond what the artist was trying to express in a form (under the analysis or interpretation of various observers, from critics to connoisseurs).

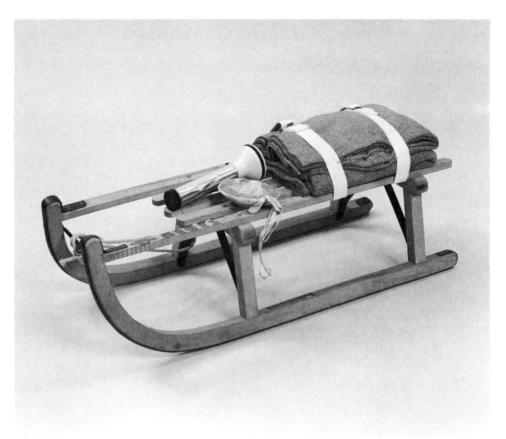

10.101

Joseph Beuys. *Rescue Sled.* 1969; wood, metal, rope, blanket, flashlight, wax; 35 cm. long. Conceptualists such as Beuys believe ideas are more important than artistic products. Commonplace objects often symbolize complex meanings. Here, for example, the sled represents a simple form of moving transportation, the fat symbolizes food, the felt blanket shelter, and the flashlight orientation.

Process art is a continuation of (and a new name for) the Pop Happenings of the 1950s and early 1960s.

Conceptual art is an extension of Process thinking. Conceptual artists believe that the act of making a final object is not as important as the idea, or concept, that lies behind a work of art. Thus artists who conceived of filling the air with oxygen or steam vapor in the early 1960s (which they called Universal art, because the vapors would expand endlessly into the universe) were forerunners of what we now call Conceptual art. Today this form of art, like Process art, sometimes involves action by the artist alone, but more often involves helpers and/or an audience. In one sense, Christo's environments can be considered conceptual forms of art since

they require a director who has conceived of the work and those who assist in recording the idea in whatever form it may take.

The German Conceptualist Joseph Beuys states, as in his *Rescue Sled,* the theory that ideas and production are more important than the medium or form of an artist's work. He claims that every act of society is a work of art. Materials such as the rolls of felt, pieces of animal fat, and flashlights that appear in his work, while not the ordinary media of traditional artists, are meant to express complex, deep-seated ideas or meanings. They are metaphorical statements about survival in a world that has been on the brink of catastrophe since the invention of nuclear weapons in the second World War (fig. 10.101).

10.102
Michael Goldberg. *Le Grotte Vecchie I.* 1981, bronze powder, alkyd spray, pastel, acrylic on canvas. The work of Goldberg and other artists indicates a recent revival of interest in combining varied media and techniques in the same work of art. This revival has occurred after a pause during the sixties and seventies when acrylics were often used alone as a dominant medium.

Albright-Knox, Buffalo, New York. George B. and Jenny R. Mathews Fund.

Art forms of the 1980s

One note of difference in the pictorial arts of the eighties that did not seem quite so manifest in the sixties is a return to the use of a variety of media and techniques in a single format. For example, where acrylic painting dominated the pictorial arts in the 1960s, we now often have conte crayon, pastels, paper collage, powdered metallics, oils, and acrylics all in the same work of art. It is as if young artists are rediscovering the use and value of such media and exploring them in juxtaposition. Mel Bochner's *Vertigo* (1982) and Michael Goldberg's *Le Grotte Vecchie I* (1981) are recent examples of this mixed-media approach in different styles (fig. 10.102; see fig. 3.7).

As indicated previously, the closer we approach our own lifetimes, the more difficult it becomes to predict the major directions in the arts of the future. We need the hindsight of several years before we can determine major or minor developments. The 1940s through the 1970s were filled with a diversity of manners in all media rather than any narrowing down to one or two major styles. Visual art continues to be as diverse in the 1980s as in the past, which speaks to its healthy condition.

10.103

Enzo Cucchi. *Paesaggio Barbaro.* **1983, oil on canvas, 51 × 62¾ in.** Enzo Cucchi, a recently discovered Italian Neo-Expressionist, paints heavily pigmented canvases contrasting living creatures with symbols of death, abandonment, and decay.

Courtesy Sperone Westwater Gallery. Collection: Angela Westwater, New York.

Neo-Expressionism

From 1980 to 1982 certain New York promoters (in an apparently declining art market) attempted to change the depersonalized expression that was taking place in much recent art by presenting artists in a mode called Neo-Expressionism. This deliberate effort to establish a new movement, rather than to let it grow out of artists' changing attitudes, is something new. Is art now to be dominated by the market to an extent that will inhibit the natural growth of creativity, just as did patronage by a certain class of people in the eighteenth and nineteenth centuries? We will have to wait and see if this trend continues. The most we can say as this is being written is that Neo-Expressionism seems to be losing cohesion and significance as a major new direction in the visual arts.

The so-called discoveries expressed by the "new" Neo-Expressionist style were at first attributed to Europeans when Italian artists Enzo Cucchi and Sandro Chia were given exhibits in New York in 1981.

A great amount of effusive praise was written indicating that Cucchi and Chia were leading the way to a new manner (fig. 10.103; see fig. 7.27). Then, in 1982, some German Neo-Expressionists were also "discovered." Among these were A. R. Penck, Rainier Fetting, and George Baselitz. The common denominator of style the promoters of Neo-Expressionism saw in these artists was their general tendency to re-echo the emotional fervor of early twentieth-century Expressionists (particularly the Germans such as Nolde, Schmidt-Rotluff, etc.). At the same time Julian Schnabel, a young American artist born in Texas but working in Europe, was "discovered" as a native U.S. exponent of this style (fig. 10.104). The generally emotionalized style of the Neo-Expressionists has certainly not fulfilled the hype surrounding them in the early part of the decade.

There has been, it would seem, a slight reaction to the realist trend with more abstract and near-abstract work in hard-edged and softer manners being created today. Even Schnabel seems to be trying these approaches in the last couple of years. The international summer show at the Guggenheim in 1983, reinforced by the biennial show at the Whitney Museum of American Art in 1987, indicates that most artists abroad and in this country are creating works similar in form to the many styles of art introduced over the past thirty to forty years. As yet no major change in the visual arts is apparent, but as we stated at the beginning of this text, interest in art has certainly increased in recent years. Sales of the late masters of the nineteenth century have reached phenomenal proportions; for example, Van Gogh's painting *The Irises* was recently auctioned for more than fifty million dollars. Although artists are more likely to make a go of an art career nowadays than in the time of Van Gogh, their chances of success still remain uncertain. Despite this, approximately 200,000 practicing artists in the United States today are dedicating their lives to fulfilling the pleasure that art can bring to people's lives—undoubtedly a need that no other field of endeavor can provide.

10.104
Julian Schnabel. *Affection for Surfing.* 1983, mixed media, 108 × 228 × 24 in. Julian
Schnabel, one of the Neo-Expressionists of the early 1980s, used size and bulky collage to
symbolize the discarded materials of a dying civilization.
Pace Gallery, New York.

CHRONOLOGICAL
OUTLINE
OF
WESTERN ART

200,000 B.C.	**Prehistoric Art**	Paleolithic, old Stone Age.
		Flint-tool industries.
25,000		Art beginnings, cave painting.
10,000		Neolithic, new Stone Age.
4000	**Ancient Art**	Egyptian, Old Kingdom.
3000		Middle East, Sumerian.
2800		*Aegean art,* Cretan (Minoan I and II).
2300		Middle East, Akkadian.
2100		Egyptian, Middle Kingdom.
1800		*Aegean art,* Mycenaen Age (in Greece), Cretan (Minoan III).
1700		Middle East, Babylonian.
1580		Egyptian, New Empire.
1200		
1100		*Aegean art,* Homeric Age. Italy, *Etruscan art.*
1090		Egyptian, decadence and foreign influences.
900		Middle East, Assyrian Empire.
750		*Greek art,* Archaic Age. Italy, *Etrusco-Roman.*
606		Middle East, Neo-Babylonian.
530		Middle East, Persian Empire.
470		Greece, *Classical Age.*
332		Egypt, Graeco-Egyptian Ptolemaic.
323		Greece, *Hellenistic Age.*
280		Roman art, Republican and Graeco-Roman.
30		Imperial Roman art.
300 A.D.	**Medieval Art**	Late Imperial Roman art, *Early Christian art* in Italy.
330		Middle East, *Early Byzantine art;* Egypt, *Coptic art.*
		Early Christian art in western Europe, decline of Rome.
400		Migratory, barbarian arts (Celts, Saxons, Vikings, Huns, Goths).
550		*Muslim* or *Islamic art,* northern Africa, southern Spain (*Moorish art*).
768		*Carolingian art,* France, Germany, northern Italy.
800		*Developed Byzantine art,* Middle East, Greece, Russia, parts of Italy (Venice, Ravenna, Rome, Sicily).
900		*Ottonian art*—mostly in Germany.
1000		*Romanesque art* (Roman-like, or modified Roman art in France, England, northern Spain, Italy, and Germany).
1150		*Gothic art* in Europe.
1300	**Renaissance Art**	*Proto-Renaissance,* Italy: Giotto, Duccio, Nicolo Pisano (sculpture).
1400		*Early Renaissance,* Italy: Masaccio, Donatello, Francesca, Leonardo, etc.
		Renaissance in West modified by vestiges of Medievalism: van Eyck, Weyden, van der Goes, etc.
1500		*High Renaissance:* Michelangelo, Raphael, Titian, Tintoretto; western Europe influenced by Italy.
1520		*Mannerism* and *Early Baroque,* Italy: Caravaggio.

1600	**Baroque Art**	*Baroque art* in Europe: Rubens, Van Dyck, Rembrandt, Hals (Netherlands); Velásquez, Ribera (Spain); Poussin, Lorrain (France); Bernini (sculpture, Italy). *Early Colonial art,* Americas.
1700		*Rococo art,* primarily French: Watteau, Boucher, Fragonard, Chardin; but spreads to other European countries: Canaletto, Guardi, Tiepolo (Italy); Hogarth, Gainsborough, Reynolds (England). *Colonial art,* Americas.
1800	**Nineteenth-century Art**	*Neoclassicism:* David, Ingres (France); Canova (sculpture, Italy).
1820		*Romanticism:* Gericault, Delacroix (France); Goya (Spain); Turner (England); Ryder (United States); Barye (sculpture, France).
1850		*Realism* and *Naturalism:* Daumier, Courbet, Manet (France); Homer, Eakins (United States); Constable (England).
1870		*Impressionism:* Monet, Pissarro, Renoir, Degas (France); Sisley (England); Hassam, Twachtman (United States); Medardo-Rosso (sculpture, Italy); Rodin (sculpture, France).
1880		*Post-Impressionism:* Cézanne, Seurat, Gauguin, Van Gogh, Toulouse-Lautrec (France).
1900	**Twentieth-century Art**	Sculptors working in a *Post-Impressionist* manner: Maillol (France); Lachaise (United States); Lehmbruck, Marcks, Kolbe (Germany).
1901		*Expressionism:* Picasso* (Blue, Rose, and Negro periods). *Les Fauves:* Matisse, Rouault, Vlaminck, Modigliani, Dufy, Utrillo (France). Recent *French Expressionists:* (1930) Soutine, Buffet, Balthus. *German Expressionists:* Nolde, Kirchner, Kokoschka, Schmidt-Rotluff, Marc, Jawlensky, Macke, Beckmann, Grosz, Dix; Munch (Norway). *American Expressionists:* Weber, Shahn, Levine, Avery, Baskin; Orozoco (Mexico). *Sculpture:* Marini (Italy); Epstein (England); Zorach (United States).
1906	**Abstract Art (early phase)**	*Cubism:* Picasso,* Braque, Léger, Gris (France); Laurens (sculpture, France). *Futurism:* Balla, Boccioni (sculpture and painting), Carra, Severini (Italy).
1910–50		*Developed Abstract and Nonobjective art:* Kandinsky, Albers (Germany); Moholy-Nagy (Hungary); *Constructivism:* Larionov, Malevich, Tatlin (Russia); Delaunay (France); Nicholson (England); *De Stijl:* Mondrian, Van Doesburg, Van Tongerloo (Holland); Dove, Marin, Feininger, Frank Stella, O'Keeffe, MacDonald-Wright, Stuart Davis, Demuth, Hartley, Knaths, Diller, Pereira, MacIver, Tomlin, Rothko (United States). *Sculpture:* Brancusi, Archipenko, Arp (France); Epstein, Passmore (England); de Rivera, Nevelson, Hajdu, Noguchi (United States); Gabo, Pevsner (Russian-Constructivists, United States).
ca. 1910	**Fantasy in Art**	*Individual fantasists:* Henri Rousseau (French primitive); de Chirico (Italy); Chagall (France); Klee (Switzerland/Germany).
1914		*Dada:* Tzara, Duchamp, Picabia, Arp (France); Ernst, Schwitters (Germany).
1924		*Surrealism:* Ernst (Germany); Delvaux, Masson (France); Dali (Spain, United States); Magritte (Belgium); Bacon (England).

*Artists frequently change their styles, thus some names may appear under more than one category of form-style. Most notable in this respect is Pablo Ruiz Picasso.

1925		*Sculpture:* Giacometti (Switzerland); González (Spain); Arp (France).
		Surrealistic Abstraction: Picasso* (France); Miró (Spain); Tamayo (Mexico); Matta (Chile, United States); Baziotes, Tobey, Gorky, Rothko, Hofmann, DeKooning (United States).
		Sculpture: Moore, Hepworth (England); Lipchitz (Lithuania, United States, France); Calder (United States).
1930–40	**Traditional Realism**	*Regionalists:* John Sloan, Grant Wood, Thomas Hart Benton (United States); Andrew Wyeth (independent realist, United States).
1945	**Post-World War II Trends**	*Abstract Expressionism* and *Action painting:* Pollock, Motherwell, Kline, Still, Reinhardt, Frankenthaler, Tworkov, Holty, Rothko (United States); Mathieu, Soulages, Manessier (France); Vieira da Silva (Portugal); de Stael, Appel (Holland); Okada (Japan); Tapies (Spain).
		Sculpture: Roszak, David Smith, Lipton, Lassaw, Lippold, Nakian (United States); Richier (France).
1950	**Post-Painterly Abstraction**	*Color Field* and *Hard-Edge* painters (all United States): Louis, Newman, Kelly, Noland, Stella, Poons, Ron Davis.
		Minimalists: Olitsky, Reinhardt (United States); Yves Klein (France).
		Sculpture: Judd, Tony Smith, Rosenthal, Andre (United States).
		Primary-Structurists (some called *Neo-Constructivists* and/or *Environmentalists*): Bontecou, Di Suvero, Nevelson, Bell, Stone, de Witt, Meadmore, Kipp, Katzen, Snelson, Rickey (United States): Paolozzi, King (England); Bill (Switzerland).
1955		*Neo-Dada* and *Funk art* (collage-assemblage): Johns, Rauschenberg (United States); Dubuffet (France).
		Sculpture: Kienholz, Stankiewicz, Mallary, Chamberlain (United States); César (France).
		Pop art and *Happenings:* Warhol, Lichtenstein, Dine, Indiana, Kaprow, Oldenburg, Segal, Grooms, Marisol, Wesselman, Rosenquist (United States); Hamilton, Kitaj, Smith (England).
		Op art: Vasarely (France); Anuskiewicz, Ortmann, Stanczak (United States); Agam (Israel); Riley, Denny (England).
1965–80		*New Realism:* Pearlstein, Ramos, Katz, Theibaud, Lindner, Close, Cottingham, Estes (United States).
		Sculpture: Gallo, de Andrea, Hanson (United States).
		Technological art (kinetics, neon, sound): Wolfert (color organ, 1930–63); Tinguely (Switzerland, United States); Chryssa (Greece); Samaris, Sonnier, Riegack, Flavin, Rickey (United States); Hess (Germany, United States); Soto (Venezuela); Castro-Cid (Chile); Le Parc (Argentina); Takis (Greece).
		Environments, Land art, or *Earthworks; Process and Conceptual art:* Lansman, Andre, Christo, Smithson, Serra, Lewitt, Heizer, Oldenburg, Kipp, Di Suvero; Katzen, Snelson, Rickey, Woody, Nauman (United States); Beuys, Kiefer (Germany).
1980–88		*Neo-Expressionism:* Schnabel (United States); Cucchi, Chia (Italy); Penck, Kiefer, Baselitz (Germany).

GLOSSARY

abstract, abstraction A term given to forms created by the artist but derived from objects actually observed or experienced. Abstraction usually involves a simplification and/or rearrangement of natural objects to meet the needs of artistic organization or expression. Sometimes there is so little resemblance to the original object that the shapes seem to have no relationship to anything ever experienced in the natural environment.

abstract texture A texture derived from the pattern observed in an actual texture, which is then altered by the artist to better suit his or her artistic needs.

academic A term applied to any kind of art that stresses the use of accepted rules for technique and form organization. It represents the exact opposite of the *creative* approach, which results in a vital, individual style of expression.

accent Any stress or emphasis given to elements of a composition that makes them attract more attention than other features surrounding or close to them. Accent can be created by a brighter color, darker tone, greater size, or any other means that expresses difference.

achromatic Relating to differences of lightness and darkness; the absence of color.

actual texture A surface that is experienced through the sense of touch (as opposed to surfaces visually imitated by the artist).

addition In three-dimensional art, a term that means a building up, an assembly, or a putting on of material.

aesthetic, aesthetics The theory of the artistic or the "beautiful"; traditionally a branch of philosophy, but now a compound of the philosophy, psychology, and sociology of art. As such, aesthetics is no longer solely confined to determining what is beautiful in art, but attempts to discover the origins of sensitivity to art forms and the relationship of art to other phases of culture (such as science, industry, morality, philosophy, and religion). Frequently used in this book to mean concern with artistic qualities of form as opposed to descriptive form or mere recording of facts in visual form. (See *objective*.)

amorphous Without clarity of definition; formless, indistinct, and of uncertain dimension. (See *shape, amorphic*.)

analogous colors Closely related colors, especially those in which we can see one common hue; colors that are neighbors on the color wheel.

approximate symmetry The use of similar imagery on either side of a central axis. The visual relationships may give a feeling of resembling each other, but are varied to prevent visual monotony.

artificial texture Any actual texture created by humans, as opposed to that produced by nature.

asymmetrical balance A form of balance attained when visual units are placed in different positions within the pictorial field so as to create a sense of equilibrium in the total imagery without repeating the placement of the units with respect to the central axis.

atectonic The opposite of *tectonic*; a quality of three-dimensional complexity involving fairly frequent and often considerable extension into space and producing a feeling of openness.

atmospheric (aerial) perspective The illusion of deep space produced in graphic works by lightening values, softening contours, reducing value contrasts, and neutralizing colors in objects as they recede.

balance A feeling of equilibrium in weight, attention, or attraction of the various visual elements within an artwork as a means of accomplishing organic unity.

Bauhaus Originally a German school of architecture that flourished between World War I and World War II. The Bauhaus attracted many of the leading experimental artists from both the two- and three-dimensional fields.

biomorphic shape Irregular shape that resembles the freely developed curves found in live organisms.

calligraphy The use of flowing, rhythmical lines that intrigue the eye as they enrich surfaces. Calligraphy is highly personal in nature, similar to the individual qualities found in handwriting.

casting A sculptural technique in which liquid materials are shaped by being poured into a mold.

cast shadow The dark area created on a surface when an object is placed between that surface and a light source.

chiaroscuro A technique of representation that concentrates on the effects of blending the light and shade on objects to create the illusion of their three-dimensionality and their placement in space or atmosphere.

chromatic Relating to color.

classical Art forms that are characterized by a rational, controlled, clear, and intellectual approach. The term derives from the ancient art of Greece during the fifth to fourth centuries B.C. The term classical has an even more general connotation, meaning an example or model of first rank or highest class for any kind of form—literary, artistic, natural, or

otherwise. Classicism is the application of or adherence to the principles of Greek culture by later cultural systems such as Roman classicism, Renaissance classicism, or the art of the Neoclassic movements of the early nineteenth century. (See chapter 10, Content and Style.)

collage An art form in which the artist creates the image, or a portion of it, by adhering real materials that possess actual textures to the picture plane surface.

color The character of a surface resulting from the response of vision to the wavelength of light that is reflected from that surface and is identified as red, or green, or blue, etc.

color tonality An orderly planning in terms of a particular selection and arrangement of color schemes or color combinations; involves hue, value, and intensity relationships.

color triad A group of three colors spaced an equal distance apart on the color wheel. The twelve-color wheel has a primary triad, a secondary triad, and two intermediate triads.

complementary colors Two colors that are directly opposite each other on the color wheel. A *primary color* is complementary to a *secondary color* that is a mixture of the two remaining primaries.

composition The act of organizing all of the elements of a work of art into a harmoniously unified whole. Each element used may have intrinsic characteristics that create interest, but must function in such a way that the whole is more important than its parts.

concept A comprehensive idea or generalization that brings diverse elements into some basic relationship.

content The essential meaning, significance, or aesthetic value of an art form. Content refers to the sensory, psychological, or emotional properties we tend to feel in a work of art as opposed to our perception of only its descriptive aspects.

contour In art, the outer edge of an object or shape that is most often defined by line. Considered by some to be synonymous with *outline*. The edge also may be indicated by the extremities of value, texture, color, or mass.

craftsmanship Aptitude, skill, or manual dexterity in the use of tools and materials.

cross-contour A line that can define surface undulations between the outermost edges of shapes or objects.

Cubism A term given to the artistic style that generally uses two-dimensional geometric shapes.

curvilinear Stressing the use of curved lines, as opposed to *rectilinear*, which stresses straight lines.

Dada A nihilistic, anti-art, anti-everything movement resulting from the social, political, and psychological dislocations of World War I. The movement is important historically as a generating force for Surrealism. Dada literally means "hobbyhorse."

decorative The quality that emphasizes the two-dimensional nature of any of the visual elements. Decoration enriches a surface without denying the essential flatness of its nature.

decorative shape A two-dimensional shape that appears to lie flat on the picture plane.

decorative space A concept in which the visual elements have interval relationships in terms of a two-dimensional plane or surface.

decorative value A term given to a two-dimensional light-and-dark pattern. Decorative value usually refers to areas of dark or light definitely confined within boundaries, rather than gradually blended in tone.

descriptive art A manner or attitude based upon adherence to visual appearances.

design A framework or scheme of pictorial construction on which artists base the formal organization of their total work. In a broader sense, design may be considered synonymous with the term *form*.

distortion Any change made by an artist in the size, position, or general character of forms based on visual perception, when those forms are organized into a pictorial image. Any personal or subjective interpretation of natural forms necessarily involves a degree of distortion.

dominance The principle of visual organization that suggests certain elements should assume more importance than others in the same composition. Dominance contributes to organic unity because one main feature is emphasized and other elements are subordinated to it. The principle applies in both representational and nonrepresentational work.

elements of art The basic visual signs as they are combined into optical units used by the artist to communicate or express creative ideas. The combination of the basic elements of line, shape, value, texture, and color represent the visual language of the artist.

expression A general term meaning the special characteristics that mark the work of an artist or group of artists. The manner in which artists attempt to say something about their time in terms of the artistic imagery then considered to be of aesthetic merit.

When a work of art remains largely realistic in form but strongly emotional or intellectual in content, we call the work expressive. In a more general usage of the term, all art can be so characterized when the goal is an intrinsic or self-sufficient aesthetic meaning. Opposed to this would be art with extrinsic, practical ends; for example, commercial art, with its easily read message, is intended to promote the product rather than the work of art itself.

Expressionistic art is art in which there is a desire to express what is felt rather than perceived or reasoned. Expressionistic form is defined by an obvious exaggeration of natural objects for the purpose of emphasizing an emotion, mood, or concept. It can be better understood as a more vehement kind of Romanticism. The term *Expressionism* is best applied to a movement in art of the early twentieth century, although it can be used to describe all art of this character.

fantasy (in art) Departure from accepted appearances or relationships for the sake of psychological expression; may exist within any art style, but is usually thought of in connection with unencumbered flights of pictorial imagery, freely interpreted or invented.

Fauvism A name (meaning "wild beasts") for an art movement that began in Paris about 1905. It was expressionistic art in a general sense but more decorative and with more of a French quality of orderliness and charm than in German Expressionism. (See chapter 10, Content and Style.)

form The arbitrary organization or inventive arrangement of all the visual elements according to principles that will develop organic unity in the total work of art; the total organization of a work of art.

formal An orderly system of organization as opposed to a less disciplined system.

form-meaning Another term for *content*, the third component of a work of art as defined in this book. Since artists create artistic forms that cause spectator reactions, form-meaning implies that such reactions result from the associations and/or sensory experience the observer finds in those forms.

four-dimensional space A highly imaginative treatment of forms that gives a sense of intervals of time or motion.

fractional representation A device used by various cultures (notably the Egyptians) in which several spatial aspects of the same subject are combined in the same image.

Futurism A submovement within the framework of abstract directions taken by many twentieth-century artists. The imagery of Futurist artists was based on an interest in time, motion, and rhythm, which they felt were manifested in the machinery and human activities of modern times and their extension into the future.

genre Subject matter that concerns everyday life, domestic scenes, sentimental family relationships, etc.

geometric perspective See *perspective*.

geometric shape A shape that appears related to geometry. Geometric shapes are usually simple, such as the triangle, the rectangle, and the circle.

glyptic 1. A term referring to the quality of an art material like stone, wood, or metal that can be carved or engraved. 2. An art form that retains the tactile, color, and tensile qualities of the material from which it was created. 3. The quality of hardness, solidity, or resistance found in carved or engraved materials.

graphic art 1. Any of the visual arts that involve the application of lines or strokes to a two-dimensional surface. 2. The two-dimensional use of the elements. 3. Two-dimensional art forms such as drawings, paintings, and prints. 4. Also may refer to the techniques of printing as used in newspapers, books, and magazines.

harmony The related qualities of the visual elements of a composition. Harmony is achieved by repetition of characteristics that are the same or similar.

highlight The portion of an object that, from the observer's position, receives the greatest amount of direct light.

hue Used to designate the common name of a color and to indicate its position in the spectrum or on the color wheel. Hue is determined by the specific wavelength of the color in a ray of light.

illusionism The imitation of visual reality created on the flat surface of the picture plane by the use of perspective, light-and-dark shading, etc.

illustration(al) An art practice, usually commercial in character, based on anecdotes or story situations and stressing subject in preference to serious considerations of aesthetic quality; noneloquent, nonformal, easily understood, and temporary, rather than sustained or universal.

image An arresting aspect; a mentally envisioned object or plan given concrete appearance through the use of an art medium; the general appearance of a work (en toto).

impression, Impressionism A strong immediate effect produced in the mind by an outward or inward agency. Artists may have worked in this general sense (as Impressionists) at any time in history. The specific movement known as Impressionism was a late nineteenth-century movement, primarily connected with such painters as Claude Monet and Camille Pissarro. (See chapter 10, Content and Style.)

infinite space A pictorial concept in which space has an endless effect similar to that found in the natural environment. The picture frame serves as a window through which one can see an endless recession of form in three-dimensional space.

intensity The saturation or strength of a color determined by the quality of light reflected from it. A vivid color is of high intensity; a dull color, of low intensity.

interpenetration The movement of planes, objects, or shapes through each other, locking them together within a specific area of space.

intuitive space The illusion of space resulting from the exercise of the artist's instincts in manipulating certain space-producing devices, including overlapping, transparency, interpenetration, inclined planes, disproportionate scale, fractional representation, and the inherent spatial properties of the art elements.

invented texture Patterns created by the repetition of lines, values, colors, or shapes on a small scale over the surface of an area. They are uniquely the products of the artist's imagination.

line The path of a moving point; that is, a mark made by a tool or instrument as it is drawn across a surface. Line is usually made visible by the fact that it contrasts in value with the surface on which it is drawn.

linear perspective See *perspective*.

local (objective) color The natural color of an object as seen by the eye (green grass, blue sky, red fire, etc.).

local value The characteristic value of an area or surface that is determined by its particular pigmentation. For example, a shape painted with gray pigment will reflect only a certain amount of light even when that light strikes it directly.

manipulation To shape by skilled use of the hands; sometimes used to mean modeling. (See *modeling*.)

mass In graphic art, a three-dimensional form that appears to stand out from the space surrounding it. In the plastic arts, the physical bulk of a solid body of material. In pictorial art, the illusion of a solid body of matter, i.e., shapes, value, color, or textural areas.

medium, media The material(s) and tool(s) used by the artist to create the visual elements perceived by the viewer of the artwork.

mobile A three-dimensional moving sculpture.

modeling A sculptural term meaning to shape a pliable material.

moments of force Direction and degree of energy implied by the art elements in specific pictorial situations; amounts of visual thrust produced by such matters as dimension, placement, and accent.

motif A visual element or combination of elements that is repeated often enough in a composition to make it the dominating feature of the artist's expression. Motif is similar to theme or melody in a musical composition.

narrative art A form of art that depends on subject matter to tell a story. At its best, such art is more concerned with aesthetic qualities than with the story; at its worst, it is a documentary description of the facts of the story without regard for aesthetic form.

naturalism The approach to art in which all forms used by the artist are essentially descriptive representations of things visually experienced. True naturalism contains no interpretation introduced by the artist for expressive purposes. The complete recording

of the visual effects of nature is a physical impossibility, and naturalistic style thus becomes a matter of degree.

natural texture Textures that are created as the result of natural processes.

negative areas The unoccupied or empty spaces left after the positive shapes have been laid down by the artist. However, because these areas have boundaries, they also function as shapes in the total pictorial structure.

neutralized color A color that has been grayed or reduced in intensity by being mixed with any of the neutrals or with a complementary color.

neutrals Surface hues that do not reflect any single wavelength of light, but rather all of them at once. No single color is noticed—only a sense of light or dark, such as white, gray, or black.

nonobjective An approach to art in which the visual signs are entirely imaginative and not derived from anything ever seen by the artist. The shapes, their organization, and their treatment by the artist are entirely personalized and consequently not associated by the observer with any previously experienced natural objects.

nonrepresentational The opposite of representational (see *representation*). Works of art that have no forms reminiscent of actual objects or things (see *abstraction* and *nonobjective*).

objective An impersonal statement of observed facts. In art, the exact rendering by the artist of surface characteristics without interpreting or altering the visual image.

objective color See *local color.*

optical perception A way of seeing in which the mind has no other function than the natural one of providing the visual sensation of object recognition. *Conceptual perception*, on the other hand, refers to the artist's imagination and creative vision.

organic unity A condition in a work of art in which all of its parts are so vital and interdependent that it seems to take on a life of its own.

organizational control Specific or planned relationships of the art elements in pictorial space.

orthographic drawing A two-dimensional graphic representation of an object showing a plan, a vertical elevation, and/or a section.

paint quality The use of paint to enrich a surface through textural interest. Interest is created by ingenuity in handling paint for its intrinsic character.

papier collé A technique of visual expression in which scraps of paper having various textures are pasted to the picture surface to enrich or embellish certain areas. The textures are often not textures at all, but decorative patterns, similar to the artist's invented textures (for example, the printing on a piece of adhered newspaper).

patina A film, usually greenish, that results from oxidation of bronze or other metallic material; colored pigments, usually earthy, applied to a sculptural surface.

pattern The obvious emphasis on certain visual form relationships and certain directional movements within the picture field. Pattern also refers to the repetition of elements or the combination of elements in a readily recognizable systematic organization.

perception The act of taking notice; recognition of an object, quality, or idea through the use of the physical and/or mental faculties.

perspective A pictorial system for creating the illusion of three-dimensional space and objects on a two-dimensional surface. *Aerial* or *atmospheric perspective* uses value, texture, and color modification to suggest or enhance the effect of space. *Linear perspective* refers to the drawing of objects in line to suggest their three-dimensionality and effect of existence in space. *Geometric perspective* is a drawing system based on geometry and used for creating the illusion of three-dimensional space and objects on the two-dimensional surface of the picture plane.

pictorial area The area within which the design exists; generally of measurable dimensions and bounded by a mat, frame, or lines.

picture frame The outermost limits or boundary of the picture plane.

picture plane The actual flat surface on which the artist executes a pictorial image. In some cases the picture plane acts merely as a transparent plane of reference to establish the illusion of forms existing in a three-dimensional space.

pigments Color substances, usually powdery in nature, that are combined with liquid vehicles to produce paint.

planar Having to do with planes. (See *plane.*)

plane A shape that is essentially two-dimensional, having height and width.

plastic art 1. The three-dimensional use of the elements. 2. On a two-dimensional surface, plasticity is always an illusion created by using the visual elements in special ways. 3. Three-dimensional art forms such as architecture, sculpture, and ceramics.

plastic shape 1. In the graphic arts, any shape suggesting the illusion of a three-dimensional shape surrounded by space. 2. In the plastic arts, any shape comprising height, width, and thickness.

plastic space A concept in which the visual elements on the surface of the picture plane are made to give the illusion of having relationships in depth as well as in length and breadth.

positive shapes The enclosed areas that represent the selection of shapes chosen by the artist to create the imagery in an artwork. Positive shapes may suggest recognizable objects or may merely be planned nonrepresentational shapes.

primary colors Red, yellow, and blue; the three colors in the spectrum that cannot be produced by a mixture of pigments.

primitive art The art of people with a tribal social order or a Neolithic stage of culture. Primitive art is characterized by a heightened emphasis on form and a mysterious but vehement expression or content. A secondary meaning is found in the work of such artists as Henri Rousseau and Grandma Moses. This kind of primitive art shows a naiveté of form and expression closely related to the untrained but often sensitive imagery of folk art.

proportion The comparison of elements one to another in terms of their properties of size, quantity, and degree of emphasis. Proportion can be expressed in terms of a definite ratio, such as "twice as big," or can be more loosely indicated in such expressions as "darker than," "more neutralized," or "more important than."

Realism A style of art that retains the basic impression of visual reality but, in addition, attempts to relate and interpret the universal meanings that lie beneath surface appearances.

reality See *visual reality.*

rectilinear shape A shape whose boundaries usually consist entirely of straight lines.

relief (sculptural) Partial projection from a main mass, with the degree of projection determining the type of relief; limited three-dimensional masses bound to a parent surface.

repetition The use of the same visual effect a number of times in the same composition. Repetition may produce the dominance of one visual idea, a feeling of harmonious relationship, an obviously planned pattern, or a rhythmic movement.

representation A manner of expression by the artist in which the subject matter is presented through the visual elements so that the observer is reminded of actual objects.

rhythm A continuance, a flow, or a feeling of movement achieved by repetition of regulated visual units; the use of measured accents.

romantic, Romanticism A philosophical attitude towards life that can occur during any period. In art, the romantic form is characterized by an experimental point of view and extolls spontaneity of expression, intuitive imagination, and the picturesque rather than a carefully organized, rational approach (*classical* attitude). The Romantic movement of nineteenth-century artists, such as Delacroix, Gericault, Turner, and others, is characterized by such an approach to form. (See chapter 10, Content and Style.)

saturation See *intensity*.

sculpture The art of shaping expressive three-dimensional forms. "Man's expression to man through three-dimensional form" (Jules Struppeck, *The Creation of Sculpture,* 1952).

shadow, shade, shading The darker value on the surface of a form that gives the illusion that a certain portion is turned away from the source of light.

shallow space The illusion of limited depth. With shallow space, the imagery has only a semidetachment from the picture plane.

shape An area that stands out from the space next to or around it because of a defined boundary or because of difference in value, color, or texture. An *amorphic shape* has imprecise or unclear edges. *Three-dimensional shape* refers to a solid or the illusion of a solid. *Two-dimensional shape* is an area confined to length and width and set apart by contrasts of value, texture, or color.

silhouette The area existing between or bounded by the contours, or edges, of an object; the total shape.

simulated texture The copying, or imitation, of object surfaces.

simultaneity In art, use of separate views, representing different points in time and space, which are brought together to create one integrated image.

simultaneous contrast Intensified contrast that results whenever two different color tones come into direct contact. It is also found whenever two contrasting values are brought into contact, as when one side of a cube is brightly lit and the one next to it is in shadow; at the point of contact, the brighter plane will momentarily look lighter, while the shadow plane will momentarily look darker (shadow edge).

space Can be characterized as boundless or unlimited extension in all directions; void of matter. Artists use the term to describe the interval, or measurable distance, between preestablished points. *Decorative space* is limited to length and breadth. *Four-dimensional space* conveys the dimension of time as well as length, breadth, and thickness or depth. *Infinite space* is a pictorial concept in which the illusion of space has the quality of endlessness found in the natural environment. *Plastic space* involves length, breadth, and thickness or depth. *Shallow space* is sometimes called "limited depth" because the artist controls the use of the visual elements so that no point or form is so remote that it does not take place in the pattern of the picture surface. *Intuitive space* is the instinctive use of the elements to create the illusion of space. *Three-dimensional space* possesses thickness or depth as well as length and breadth. *Two-dimensional space* possesses only length and breadth.

spectrum The band of individual colors that results when a beam of light is broken into its component wavelengths of hues.

split-complement A color and the two colors on each side of its complement.

style The artistic character and dominant form trends noted in art movements or during specific periods of history. Style may also mean artists' expressive use of media to give their works individual character.

subject In a descriptive style of art, subject refers to the persons or objects represented, as well as to the artist's experiences that serve as inspiration. In abstract or nonobjective forms of art, subject refers merely to the basic character of all the visual signs employed by the artist. In this case the subject has little to do with anything experienced in the natural environment.

subjective Personal as opposed to impersonal; an individual attitude or bias through which the artist feels free to change or modify natural visual characteristics. In this approach, the artist is able to emphasize personal emotions aroused by the characteristics of natural form.

subjective colors Selected colors that have nothing to do with objective reality, but instead express the feelings of the artist.

substitution A sculptural term meaning the replacement of one material or medium by another. (See also *casting*.)

subtraction A sculptural term meaning to carve or cut away materials.

Surrealism A style of artistic expression that emphasizes fantasy and whose subjects are usually the experiences revealed by the subconscious mind.

symbol Representation of a quality or situation through the use of an intermediate agent; the word is not the object or idea itself but a sign of it (for example, the owl represents wisdom); indirect understanding, as opposed to direct understanding through form-meaning or content.

symmetrical balance A form of balance achieved by placing identical compositional units in mirrorlike repetition on either side of a central axis.

tactile A quality experienced through the sense of touch.

technique The manner and skill with which artists employ their tools and materials to achieve a predetermined expressive effect. The ways of using media can affect the aesthetic quality of an artist's total concept.

tectonic Pertaining to the quality of simple massiveness; lacking any significant extension.

tenebrism A style of painting that exaggerates or emphasizes the effects of chiaroscuro. Larger amounts of dark value are placed close to smaller areas of highly contrasting lights in order to concentrate attention on certain important features.

tension (pictorial) Dynamic interrelationships of force as manifested by the moments of force inherent in the art elements; semiarchitectural stresses affecting balance.

texture The surface feel of an object or the representation of surface character. Texture is the actual and visual feel of surface areas as they are arranged and altered by natural forces or through the artist's manipulation of the art elements. *Abstract texture* is derived from a pattern seen in an actual texture, which is altered by artists to better suit their needs. *Actual texture* is a surface that stimulates a tactile response when actually touched. *Invented texture* refers to patterns sometimes

derived from actual textures, frequently varied to fit form needs, and often freely created without reference to any item. *Simulated texture* is a representation of an actual texture created by carefully copying the light-and-dark pattern characteristic of its surface.

three-dimensional shape A shape having height, width, and depth. (See also *plastic shape*.)

three-dimensional space A sensation of space that seems to have thickness and depth as well as length and breadth.

three-dimensional value pattern The illusion of objects existing in depth that is created by value relationships.

tonality A particular selection and arrangement of color schemes or color combinations. Tonality is concerned not only with hue, but also with value and intensity relationships.

tone The character of color or value of a surface that is determined by the light reflected from it. The medium that has been applied to the surface can create this character.

transparency A situation in which a distant plane or shape can be seen through a nearer one.

trompe l'oeil A technique that copies nature with such exactitude that the subject depicted can be mistaken for a natural form.

two-dimensional See *shape, space,* and *value pattern.*

two-dimensional shape An area confined to length and width and set apart by contrasts of line, value, color, and/or texture.

two-dimensional space Measurable distances on a surface that show length and breadth but lack any illusion of thickness or depth.

two-dimensional value pattern Value relationships in which the changes of light and dark seem to occur only on the surface of the picture plane.

unity The total effect of a work of art that results from the interrelationships of all its component parts, with the appropriate ratio between harmony and variety giving a sense of oneness.

value The relative degree of lightness or darkness given to an area by the amount of light reflected from it; the characteristic of color in terms of lightness or darkness and determined by the amount or quantity of light reflected by the color.

value pattern The total effect of the relationships of light and dark given to areas within the pictorial field. *Three-dimensional value relationships* are planned to create an illusion of objects existing in depth back of the picture plane. In *two-dimensional value relationships,* the changes of light and dark seem to occur only on the surface of the picture plane.

variety The use of opposing, contrasting, changing, elaborating, or diversifying elements in a composition to add individualism and interest. The counterweight of *harmony* in a work of art.

visual reality The objective (insofar as possible) optical image; obvious appearances; naturalism in the sense of the physically observed.

void The penetration of an object to its other side, thus allowing for the passage of space through it; an enclosed negative shape.

volume A three-dimensional shape that occupies a quantity of space. On a flat surface the artist can only create the illusion of a volume.

BIBLIOGRAPHY

Anderson, Donald M. *Elements of Design.* New York: Holt, Rinehart & Winston, 1961.

Armstrong, Tom. *200 Years of American Art,* Catalogue for Whitney Museum of American Art. Boston, Mass.: The Godine Press, 1976.

Arnason, H. H. *History of Modern Art.* Englewood Cliffs, N.J.: Prentice-Hall, 1968.

Arnheim, Rudolph. *Art and Visual Perception.* Berkeley, Calif.: University of California Press, 1954.

Babcock, Gregory. *The New Art.* New York: E. P. Dutton & Co., 1966.

Bates, Kenneth F. *Basic Design: Principle and Practice.* New York: Funk & Wagnalls, 1975.

Beam, P. C. *Language of Art.* New York: John Wiley & Sons, 1958.

Bethers, Ray. *Composition in Pictures.* New York: Pitman Publishing Corporation, 1956.

Betti, Claudia, and Sale, Teel. *A Contemporary Approach: Drawing.* New York: Holt, Rinehart & Winston, 1980.

Bevlin, Marjorie E. *Design through Discovery.* New York: Holt, Rinehart & Winston, 1980.

Birren, Faber. *Creative Color.* New York: Van Nostrand Reinhold Company, 1961.

Block, Jonathan, et al. *Understanding Three Dimensions.* Englewood Cliffs, N.J.: Prentice-Hall, 1987.

Bloomer, Carolyn M. *Principles of Visual Perception.* New York: Van Nostrand Reinhold Company, 1976.

Bro, L. V. *Drawing, A Studio Guide.* New York: W. W. Norton & Co., 1978.

Burnham, Jack. *Beyond Modern Sculpture.* New York: George Braziller, 1968.

Canaday, John. *Mainstreams of Modern Art.* New York: Henry Holt and Company, 1959.

———. *What Is Art?* New York: Alfred A. Knopf, 1980.

Capers, Roberta M., and Maddox, J. *Images and Imagination: An Introduction to Art.* New York: John Wiley & Sons, 1965.

Carpenter, James M. *Visual Art: An Introduction.* New York: Harcourt Brace Jovanovich, 1982.

Chaet, Bernhard. *The Art of Drawing.* New York: Holt, Rinehart & Winston, 1970.

Chilvers, Ian, et al. *The Oxford Dictionary of Art.* New York: Oxford University Press, 1988.

Cleaver, Dale G. *Art: An Introduction.* New York: Harcourt Brace Jovanovich, 1972.

Coleman, Ronald. *Sculpture: A Basic Handbook for Students.* Dubuque, Ia.: Wm. C. Brown Publishers, 1980.

Collier, Graham. *Form, Space, and Vision.* Englewood Cliffs, N.J.: Prentice-Hall, 1972.

Compton, Michael. *Pop Art.* London: Hamlyn Publishing, Ltd., 1970.

Davis, Phil. *Photography.* Dubuque, Ia.: Wm. C. Brown Publishers, 1979.

Edwards, Betty. *Drawing on the Right Side of the Brain.* Los Angeles: J. P. Tarcher, 1979.

Elsen, Albert E. *Origins of Modern Sculpture.* New York: George Braziller, 1974.

Emerson, Sybil. *Design: A Creative Approach.* Scranton, Pa.: International Textbook Company, 1951.

Faulkner, Ray, et al. *Art Today: An Introduction to the Visual Arts.* New York: Holt, Rinehart & Winston, 1987.

Gilbert, Rita, et al. *Living with Art.* New York: Alfred Knopf, 1988.

Goldstein, Nathan. *The Art of Responsive Drawing.* Englewood Cliffs, N.J.: Prentice-Hall, 1977.

Hanks, Kurt, et al. *Design Yourself.* Los Altos, Calif.: William Kaufmann, Inc., 1977.

Harlan, Calvin. *Vision and Invention: A Course in Art Fundamentals.* Englewood Cliffs, N.J.: Prentice-Hall, 1970.

Heller, Jules. *Printmaking Today.* New York: Holt, Rinehart & Winston, 1972.

Hibbard, Howard. *The Metropolitan Museum of Art.* New York: Harper, 1980.

Hunter, Samuel. *American Art of the 20th Century.* New York: Harry N. Abrams, 1972.

Itten, Johannes. *The Art of Color.* New York: Van Nostrand Reinhold Company, 1970.

———. *Design and Form.* New York: Van Nostrand Reinhold Company, 1975.

Janis, Harriet, and Blesh, Rudi. *Collage: Personalities, Concepts, Techniques.* Philadelphia, Pa.: Chilton Book Company, 1962.

Kepes, Gyorgy. *Language of Vision.* Chicago: Paul Theobald and Company, 1951.

Knobler, Nathan. *The Visual Dialogue.* New York: Holt, Rinehart & Winston, 1980.

Kuh, Katherine. *Art Has Many Faces.* New York: Harper & Row Publishers, 1957.

Lauer, David. *Design Basics.* New York: Holt, Rinehart & Winston, 1979.

Lerner, Abram; Nochlin, Linda; et al. *The Hirshhorn Museum and Sculpture Garden.* New York: Harry N. Abrams, 1974.

Longman, Lester. *History and Appreciation of Art.* Dubuque, Ia.: Wm. C. Brown Publishers, 1949.

Lowry, Bates. *Visual Experience: An Introduction to Art.* New York: Harry N. Abrams, 1961.

Lucie-Smith, Edward. *Late Modern: The Visual Arts Since 1945.* New York: Praeger Publishers, 1969.

———. *The Thames and Hudson Dictionary of Art Terms.* New York: Thames and Hudson, 1984.

McCurdy, Charles, ed. *Modern Art: A Pictorial Anthology.* New York: Macmillan, 1958.

Mendelowitz, Daniel M. *A Guide to Drawing.* New York: Holt, Rinehart & Winston, 1976.

Moholy-Nagy, L. *Vision in Motion,* 5th ed. Chicago: Paul Theobald and Company, 1956.

Nelson, Roy P. *Design of Advertising.* Dubuque, Ia.: Wm. C. Brown Publishers, 1967.

Preble, Duane. *We Create, Art Creates Us.* New York: Harper & Row Publishers, 1976.

———. *Art Forms.* New York: Harper & Row Publishers, 1978.

Rasmussen, Henry N. *Art Structure.* New York: McGraw-Hill Book Company, 1951.

Read, Herbert. *A Concise History of Modern Painting.* New York: Praeger Publishers, 1959.

———. *A Concise History of Modern Sculpture.* New York: Praeger Publishers, 1964.

Renner, Paul. *Color, Order, and Harmony.* New York: Van Nostrand Reinhold Company, 1965.

Saff, Donald, and Sacilotto, Deli. *Printmaking.* New York: Holt, Rinehart & Winston, 1978.

Scott, Robert G. *Design Fundamentals.* New York: McGraw-Hill Book Company, 1951.

Seiberling, Frank. *Looking into Art.* New York: Holt, Rinehart & Winston, 1959.

Seuphor, Michel. *The Sculpture of This Century.* New York: George Braziller, 1961.

Simmons, Seymour, III, and Winer, Marc S. A. *Drawing: The Creative Process.* Englewood Cliffs, N.J.: Prentice-Hall, 1977.

Sparke, Penny, et al. *Design Source Book.* Secaucus, N.J.: Chartwell Books, 1986.

Struppeck, Jules. *The Creation of Sculpture.* New York: Henry Holt and Company, 1952.

Wickiser, Ralph L. *An Introduction to Art Activities.* New York: Henry Holt and Company, 1947.

Wingler, M. Hans. *The Bauhaus.* Cambridge, Ma.: First M.I.T. Press Paperback, 1986.

Wong, Wucius. *Principles of Three Dimensional Design.* New York: Van Nostrand Reinhold Company, 1977.

Zelanski, Paul, et al. *Shaping Space.* New York: Holt, Reinhart & Winston, 1987.

Media Index

Artists' Works Index

General Index